Ans
Westra

Ans Westra

A Life In Photography
Paul Moon

MASSEY UNIVERSITY PRESS

Contents

Arrival 7
1. Origins 11
2. The Family of Man 20
3. Te Ao Hou: The New World 29
4. The Friendly Islands 58
5. Whitewash? 69
6. Good Keen Men 91
7. The Country I Live In 122
8. Close to Home 153
9. The Thick of It 169
10. Retrospection 201
11. Broken Ends 240
Departure 271

Notes 274
Bibliography 298
Glossary 313
Acknowledgements 315
Index 318

Arrival

In February 2023 I went to meet Ans Westra at her home in Lower Hutt. As she opened the door, the light from the entrance melted away into a gloom at the end of the narrow hallway. In a courteous, clipped Dutch accent she offered advice about where to step as I followed her inside.

We threaded our way past a plaster elephant head, a Bakelite radio, assorted vases, baskets of firewood, piles of books and files, and floral arrangements in varying states of dehydration towards a couple of old armchairs. She tucked herself into one of them and motioned for me to sit in the other. The pale morning sun slanted through a side window and a mixed fragrance of old paper, worn upholstery and overripe flowers hung in the air.

Almost every space was occupied in this forbidding jungle of bric-a-brac. 'Just things I've picked up over the years,' she said, half apologetically, as she caught me surveying the surrounds.[1]

The conversation flowed easily, although there were occasional moments when it slowed to a trickle. Initially we were both poking and prodding to get a sense of each other — cautiously open to the possibility of a rapport developing. She patiently explained some technical aspects of her cameras, and at times was disarmingly candid about her life. As we swapped stories I noticed that even when recounting some of the more challenging episodes from her past she often wore a look of placid resignation rather than regret. Early on, I realised that this was a woman who had not let adverse experiences derail her.

Sometimes when I asked a question she sat in silence, her mind miles away in the past. Then when she opened the aperture on a memory, her head tilted slightly and an almost beatific smile spread across the soft features of her face. But not always. Some memories were clearly difficult — like the outrage that erupted in 1964 following the publication of *Washday at the Pa*.

Occasionally I caught her giving me a sustained, scrutinising stare, looking me up and down as though framing me for a photograph. That was always part of her technique. 'You always look. You look at what makes a good photo,' she explained, with a burst of enthusiasm that testified to the almost intoxicating effect the practice of her art had on her. 'I see something that works. I see an image and I respond to it. I've always had that eye. I always recognised the images I wanted to take . . . I don't do it consciously or try to figure it out. I act instinctively . . . spontaneously . . . You recognise a moment in time.'

Sometimes she missed the moment, 'but I don't want to go back and set it up because then it's artificial', she said. Her photographs emerged from a process of 'being quiet, observing people first, being open-minded, non-judgemental and going with the flow'. Authenticity was a maxim throughout her long career. 'What I was always fighting for was people relaxing, not posing to be photographed. I would try to make them carry on with what they were doing.' The ultimate purpose of her art remained the same:

> . . . to make people see what I see. It's so often about people's interaction — their natural responses such as caring. All that comes out in the pictures . . . People can recognise and respond to the special quality. I don't want to point out what is beautiful or what is evil. I want to point out the reality, and that is what is beautiful really . . . The photos have to explain themselves, and they can't do this when the people in them are showing off how clever they are or how beautiful they are, or whatever.

At the start of her career, when most professional photographers were churning out studio portraits of society's great and good, along with photographs of weddings and christenings and posed family groups in a production line of stern glares and sweet poses, Ans Westra was drawn to the intriguing tension and candidness of 'ordinary' New Zealanders — a sort of visual documentation of the country's 'real' inhabitants in their natural (if mundane) environment.

Her gift had always been to make the ordinary seem extraordinary. As we talked, I was struck by her sincerity and warmth, though I was aware that not everyone has seen her in this way. I had been cautioned by some (most of whom have never met her) that she could be prickly and stand-offish. This was not my experience. In the past there had been a prolonged and difficult time when her life's work was criticised by some as being culturally inappropriate because she was a Pākehā photographing Māori, and this perhaps engendered an element of defensiveness in some encounters.

―――

THIS BIOGRAPHY, AN ACCOUNT of Ans Westra's life through her eyes, is designed to be a corrective to such misrepresentations of her work. Westra's accomplishments are formidable. Over nearly 70 years she took an estimated 325,000 photographs of aspects of New Zealand life.[2] Collectively, these are the closest the country has to a national photo album.

Perhaps it was partly because Westra was an immigrant that her eye landed on images and her mind composed scenes of the country and its inhabitants overlooked by locals. Her work also detailed the social anatomy of sections of New Zealand society in ways that eluded other photographers. 'Being from Europe, I was aware of things that seemed different here,' she told me, 'but I didn't deliberately photograph things I thought were different . . . I am curious about all people — why they are, who they are, what they are . . . I want to understand humanity, and when I have taken the right pictures, I understand humanity a bit more.'

She endured more than her fair share of vocal criticism from various quarters, and developed — or perhaps always had — a thick-skinned determination. One longtime friend noted that beneath her quiet demeanour was 'a kind of toughness . . . almost like a hidden iron rod that isn't easily put off'.[3] A difficult childhood no doubt contributed to that. She tried not to let the criticism get to her. 'It's actually very helpful because you get to know the opinion of your work. I'm open to it. But I don't feel I have to defend my position, or why I took a picture,' she told me.

Even in what would be her final days, just two months away from turning 87, Westra was refusing to allow the walls of her life to close in. On another visit I found her preparing for her next project — a photographic collection that would focus on children. She had documented thousands of people in photographs, but there would always be many more she hadn't yet got to . . .

Photography had become a way of having relationships with people. 'If I'm at a party and I don't have a camera with me, then I don't feel comfortable . . . I have to have a purpose, and the purpose to photograph, and through the photographs to get to know the people and to learn,' she said.[4]

ANS WESTRA DIED WHILE this book was being written. Fortunately a wealth of material, including interview transcripts, meant the work could continue, but in some places the narrative is a bit like a patchwork quilt stitched together from documentary fragments. The end result is a mosaic of her life, largely constructed around her own memories and perceptions. And if some of the mystery of Ans Westra remains? I put this possibility to her just four days before her death. With a dry chuckle and broadening smile, she responded, 'Good!'

1. Origins

Anna (Ans) Jacoba Westra entered the world on 28 April 1936 in Leiden, the Netherlands — a university town proud of its academic pedigree (Einstein had lectured there just 16 years earlier), and for being the birthplace of the country's greatest artist, Rembrandt van Rijn. Leiden had also enjoyed a prolonged period of prosperity enabled by being in the orbit of Amsterdam, roughly 50 kilometres north-east.

For centuries, Amsterdam had been at the centre of Dutch mercantilism, but by the opening years of the twentieth century the Golden Age had taken on a more tarnished complexion. With few opportunities at home, Ans' father, Pieter Westra, travelled to Canada as a teenager, following the well-worn route of those seeking fortunes in what was still regarded in Europe as the New World.

Pieter's decision to emigrate was no opportunistic whim. Almost two decades earlier, his father, Hans, a Leiden schoolmaster, had decided to move the whole family to Canada. They had got as far as boarding the ship when authorities received medical test results suggesting that Hans might have tuberculosis. It is not difficult to imagine the disappointment the family felt as they were forced to disembark, the dream of a new life across the Atlantic in tatters. Instead of returning to Leiden, the Westras settled in the north of the Netherlands, where Pieter was born shortly after.

Hans had resumed work as a teacher; four years later he died from tuberculosis. Pieter was so distraught that he climbed the little church tower

in the village where they lived 'to try and join him going up to heaven'.[1] Only the timely arrival of the fire brigade delayed his ascension.

At the age of 15, having abandoned formal education, Pieter decided to revive his father's quest by joining another family sailing to Canada. This time, he hoped, a Westra would succeed in reaching the New World. A streak of furtiveness in his character was evident when the ship docked and Pieter offered to take care of all the customs requirements on behalf of the family with whom he was travelling. The father gratefully accepted the offer and handed over all the documentation. This was the last they ever saw of Pieter Westra. Using their papers, and probably posing as one of them, Pieter was now on Canadian soil, and ready to make his fortune.

He soon discovered, however, that the grass was no greener on the other side of the Atlantic. After a year eking out a living in various labouring jobs, drudgery and impoverishment tipped his initial optimism over into despondency. He realised he needed a plan. In the years that followed, he went about establishing a number of businesses from which he squeezed out sufficient profit to send money back to his mother in Leiden.[2]

But just as he was gaining an economic foothold, the Depression struck. Canada's 'Dirty Thirties', named for the succession of droughts that parched the prairies, exacerbated the effects of the worldwide financial collapse and unemployment surged into the millions. No sector escaped the economic and human catastrophe.[3] Pieter decided to cut his losses and return to the Netherlands.

Back in Leiden, in 1932, he met Hendrika van Dorn and the two were soon married. But there were tensions in the relationship from the outset. Both were impulsive individuals, and the ugly tail of the Depression undoubtedly placed strains on the marriage. Shortages and struggle were the norm, and without a trade or profession to fall back on, Pieter once again had to be resourceful.[4] Thankfully, he had some savings from his Canadian businesses and began manufacturing costume jewellery. Many families were selling off their precious jewellery to make ends meet and there was an appetite for inexpensive replacements.

The venture soon expanded to include the production of leather handbags and suitcases. In partnership with a German businessman, Pieter expanded the enterprise to The Hague (15 kilometres south-west of Leiden), where they opened premises in the main street. He also kept the Leiden shop, and it was behind that shop that Ans Westra was born.

Less than a fortnight after her fourth birthday, Hitler's battalions burst into the Netherlands, and four days later the country capitulated. Luftwaffe planes pummelled Rotterdam (25 kilometres south of Leiden), paratroopers descended from the skies, tanks rumbled through the streets, and thousands of SS and Wehrmacht forces flooded in as the army of occupation.[5]

Westra's memory of this turning point in Dutch history and her own life is vivid:

> What was very common in Holland was at the front door a little mirror so the person upstairs could see who was ringing the doorbell. They were illegal and I remember this German knocking on the door and when my mother didn't come quick enough he shot the mirror. I was myself nearly shot. A soldier had been to C&A, the big clothes shop, and had left his bicycle outside, and somebody trying to escape grabbed it and took off. When he found his bicycle gone he came running down our little cobbled street and I was just standing in the door trying to open it coming home from school and I looked in the barrel of the gun, so it went *twooooo* — it just missed me. Mother told me off, she said, 'Why didn't you go across the road where there was an open doorway of the cycle repair place?' I said, 'If I had, I wouldn't be here, Mum.'[6]

Less suspicion was likely to fall on a child than on an adult, and so Ans was enlisted by one of the underground groups opposed to the occupation. At the age of eight, she was helping distribute anti-Nazi material around her neighbourhood, a task that could result in execution or being sent to slave labour in German ammunition factories for any adult caught in the act.

Certain traumatic events inevitably imprinted themselves in the mind of the young Dutch girl. 'The army rolled in with big tanks, and I saw a small child of about my age going under [a tank]. I said to my mother, "Did you notice that? Do you remember?" I can still see that picture, and she said, "Oh no, that didn't happen." But it was all so vivid.'[7]

Pieter continued to do business throughout the war, although the German occupation made it challenging. Circumstances were a bit more financially fraught, but the family was far from the breadline. 'We had to do what we could, reknitting old cardigans or whatever, to survive, but we never got hungry,' Ans recalled.[8] By this time the Nazi occupiers were rounding up Leiden's Jews and sending them to the death camps. Pieter, not one to let an opportunity go by, bought some of the houses they left behind, presumably at heavily discounted prices. (After the war the Dutch government enacted provisions for restitution, along with retrospective taxes on profits made during the war, and Pieter was caught by this policy.[9] 'I remember being in the office room behind the shop with him when this bill came in and it was something like 200,000 guilders [around NZ$1.2 million],' Ans recalled. 'I saw him turn green with shock.')[10]

BOTH PIETER AND HENDRIKA were unfaithful to each other during this period. Pieter often travelled away from home and had affairs to which Hendrika mostly resigned herself. Then she herself became pregnant to an older man and had an abortion that nearly killed her. There could be no more children and Ans was to remain an only child. In Ans' words, 'The only one. The precious only one.'[11]

By 1947, when Ans was 11, her parents' marriage had reached the point of disintegration and Hendrika asked for a divorce. From then on Ans lived mainly with her mother. 'I have vivid memories of my mother's parents pleading with her not to go ahead with this divorce,' Ans recalled, explaining that they were strong believers in the sanctity of marriage, but eventually

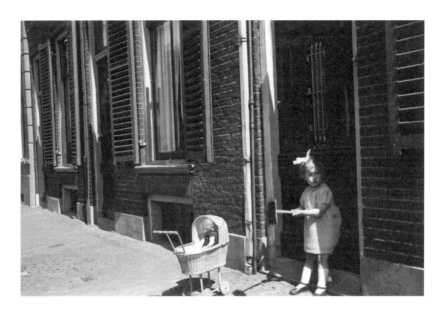

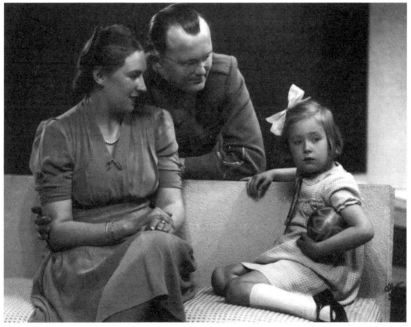

Ans in her Leiden neighbourhood (above) and with her parents, Pieter and Hendrika, in the late 1930s.

they came around to the idea — so long as Hendrika found Pieter a new wife. She travelled to Amsterdam to meet a marriage broker, who had on his books a widowed Jewish woman named Jetta, who had a young son and who had managed to escape capture by the Germans. Pieter married Jetta 'in a quick rush', thereby satisfying his in-laws' demand.

It was then Hendrika's turn to find a replacement spouse. Around 1948, while Ans was away at a Girl Guides camp, her mother suddenly remarried. She was told the news when she arrived back home. 'They perhaps thought it was easier to do this while I was not around,' Ans reasoned.[12]

Her mother's new husband, Abel, was 'damaged . . . The war may have caused his damage, but he was possibly like that already. He had been to prison after the war for collaborating with the Germans.'[13]

'Straight after, when the war finished,' she explained with almost anthropological interest, 'there were so many damaged people, and I became curious about them . . . The young blond German soldier sitting in the back of the tram talking to my mother was saying how he missed his family, and those sorts of things stay with you. They were also people, and they came from families.' She was prepared to overlook external differences in order to try to understand the essence of the human condition.

Schooling had been intermittent during the war, and when schools reopened it was only for limited hours. Ans felt psychologically imprisoned for the duration. 'The shops closed, the schools closed, I had no playmates whatsoever. There just were no other children left in the centre of town. All the other children had gone with their families to where they could find food easier.'[14]

When the family moved briefly from Leiden to Haarlem in 1947 there was a reprieve:

> When we had moved into Haarlem, I had been way ahead in my schooling and there were no girls in my area. I joined a team of boys and behind the house were railway yards and we would go on these trundlers behind the trains. We would go into the bunkers

and make little fires and find bullets and throw them in. We did all sorts of naughty wee things.[15]

There were also trips to the windswept dunes at Zandvoort, where Ans could enjoy carefree moments with her friends, running around the sand dunes and gazing across the seemingly endless expanse of the North Sea.

With her return to Leiden and the collapse of her parents' marriage, that brief interlude of normality had come to an end. 'I grew up pretty isolated. I would come home from school and just go and amuse myself — make things by myself.' Whenever there was an opportunity for some sort of social engagement she rushed at it. 'After the war, when a few more children had come back, I packed them all up and took them to buy lollies. I was their leader!'[16]

ANS' FORMAL EDUCATION HAD begun the same year the Germans invaded. Hendrika had enrolled her in a Montessori school because she felt Ans needed to be around other children of the same age, but she changed her mind about the school after a week and enrolled her instead in a pre-school where, among other creative activities, she got to try clay modelling. 'I was given a lump of clay and I made a face. Just observing features. And that went around the whole school as "Look, she's actually looked," so from then on I thought, *Okay, I can do that.* I was four.'[17]

Her father was still part of her life and continued to exercise some influence over her. 'I have a sense for design', Ans said, 'because after the war he [Pieter] had these little buildings in another town and he made that into a big shop.' Her father's jewellery and leather goods were not at the luxury end of the market but they did incorporate good design, and this paternal artistry clearly insinuated itself into the young Ans.

But any semblance of a positive relationship with her father was undermined by her stepfather, who was determined to inflict harm on Pieter. Just as Pieter was on the cusp of expanding his business, Abel informed the

tax department about alleged irregularities in Pieter's financial activities. Fearing imprisonment, Ans' father took his remaining stock and fled to Indonesia with his new wife, Jetta (who had been born there), and their four-month-old baby, Arvid Westra, Ans' half-brother.

Abel had successfully driven Pieter from Ans' life. '[Abel] was a strange mixture of a person,' she told me. More than that, he was a paedophile.

> When he married my mother it was during the polio epidemic and he got a job as a swimming instructor for polio patients. The job only lasted two weeks because they found that he couldn't be trusted with the small children. Now my mother actually stopped him. She had that over him. 'If you touch my daughter one more time . . .' because he had had a go . . . These things are terrible, and you can cry your eyes out over having gone through it, but it wasn't like that at all. It was all an adventure. I don't know why.[18]

Whether her stepfather's actions actually left barely any lasting effect, or whether Ans' impassive recounting of these events was a way of compartmentalising the trauma, we cannot know. Abel's volatile relationship with Hendrika, along with his various predilections, were aspects of his behaviour that Ans, at least partially, came to regard as being part of the rough and tumble of childhood. She later concluded that Abel was bipolar:

> He would be quite loving [to Hendrika] and then the next thing he would be chasing her and making her do all the work. Mother was sort of beginning to lean on me — [asking] why? Why this, why that? . . . Anyway, Abel at one point he had a fall . . . he was lying there stretched out, and Mother handed me the fry-pan to clobber him. She hated him; felt trapped.[19]

DURING HER TEENAGE YEARS some of Ans' earlier loneliness receded in the face of her curiosity about people.

> It's because of the way I grew up. There were very few people who were different, so there was in me a curiosity to understand people — where they came from, what was happening for them, why were people different and why did they have different values? And I wanted to know and to learn from it — and people are still teaching me about what is important to them.[20]

So when her mother offered her a reward for completing her third-form (year 9) studies, she asked for a camera, and went on to test the small Agfa bellows foldable camera by taking photographs of her aunts' houses, and of rooflines in Leiden, searching out interesting patterns to capture on film. One image in particular gave her a sense of accomplishment. It was of a sunset, and she was so pleased with it that she took it to the local camera shop to have it enlarged and gave it to her maternal grandparents as a gift.

2. The Family of Man

The end of her secondary schooling at the end of 1952 was for Ans Westra not some fearful plunge into adulthood, but rather more of a gentle glide from one stage of life to the next. Her early schooling had been intermittent (courtesy of the war), and in her teenage years it was consistent but not especially inspiring. At the age of 16 she left school and a year later moved to Rotterdam, where she boarded while attending the art school Industrieschool voor Meisjes. Her arrival in the port city in January 1953 coincided with the great North Sea flood, in which over 1800 people were killed by surging seawater during a particularly brutal winter storm.[1]

It was out of this disastrous deluge that the opportunity had emerged for Ans to continue her studies. Struggling farmers throughout the country suddenly required extra labour to assist with the clean-up, and money was now in short supply for many families. As a result there were an unanticipated number of vacancies at the Industrieschool voor Meisjes as prospective students opted to work instead, which meant Ans easily secured a place. Among the subjects taught over the four-year programme were embroidery and other textile arts, drawing and fine art.[2] The quality of instruction was uneven, Ans later noted: 'The teachers . . . were highly unsuitable . . . there was one really good one but the drawing teacher and the embroidery teacher had other priorities.'[3]

Part of the curriculum involved students travelling to different parts

of Europe, surveying small samples of the continent's built heritage. Ans enjoyed art history, and she loved travelling, so she wondered about a career that combined the two.

During her time in Rotterdam, Abel took her to the *Family of Man* exhibition in the Stedelijk Museum in Amsterdam.[4] The exhibition of 503 photographs focusing on people's everyday lives in 68 countries had a pronounced theme of the universalism of human experience and a profound effect on her.

The curator of the exhibition (and author of the accompanying book), Edward Steichen, described his approach to selecting the particular images that were selected for display:

> We are seeking photographs covering the gamut of human relations, particularly the hard-to-find photographs of the everydayness in the relationships of man to himself, to his family, to the community, and to the world we live in. Our field is from babies to philosophers, from the kindergarten to the university, from the child's home-made toys to scientific research, from tribal councils of primitive peoples to the councils of the United Nations. We are interested in lovers and marriage and child-bearing, in the family unit with its joys, trials, and tribulations, its deep-rooted devotions and its antagonisms . . . We are concerned with the individual family unit as it exists all over the world and its reactions to the beginnings of life and following through to death and burial.[5]

The Family of Man's photographs, which were ultimately seen by 9 million people globally, awakened Ans' mind to some of the possibilities of the relatively new genre of photography. As she emerged from the exhibition, her imagination was almost transfigured: 'I always wanted to travel, and I wanted to have a way of expressing myself', and photography seemed the perfect medium. 'I felt overpowered by it . . . It was so much you were

Ans in her teens in the Netherlands, late 1940s.

staggered by it . . . It was marvellous to see what you could do recording life. Just everyday happenings. The whole cycle of life.'[6]

Ans did not want to emulate the images in the exhibition. 'I thought, oh no, that's the wrong approach. I can put my mark on my work.' Not long before, working hard to save money from working during her holidays, she had managed to buy herself a twin-lens reflex Rolleiflex camera.[7]

The other moment of photographic revelation came when she discovered the book *Wij Zijn 17* (*We Are 17*), by the Dutch photographer Johan van der Keuken. Published in 1955, this book consisted of photographs of postwar Dutch youth taken when van der Keuken himself was aged 17.[8] Most of the scenes in this remarkable book were staged, but van der Keuken's arrangements, and the various moods he succeeded in conveying in these often highly sophisticated images, left a deep impression. 'They were very sort of solemn portraits.' She scrutinised their composition and concluded that she could experiment to achieve similar types of image.[9]

Inspired by the fact that van der Keuken was two years younger than her and yet had already achieved some prominence in documentary photography, Ans began taking images of her friends, endeavouring to emulate van der Keuken's technique while at the same time working out what it was that made certain compositions worthy of being photographed in her own mind. She discovered she had a 'feel' for photography: 'I tried to carry on with drawing . . . but photography was really what I could say the most with, so I pursued it.'[10]

———

IN 1950 ANS' PERSONAL life was suddenly ruffled by the news that her father, Pieter, was leaving Indonesia. The political situation in that country was rapidly deteriorating, and he had discovered that Jetta was having an affair. (Although, as Ans later observed: 'That's his story; what happened we don't know.') Rather than returning home to the Netherlands, Pieter had decided to move to New Zealand.

In the early 1950s the New Zealand government embarked on a campaign to encourage Dutch immigration, chiefly to address labour shortages.[11] The Netherlands was still grappling with the aftermath of war and, more recently, the devastating flooding; Pieter sensed that New Zealand might offer him more opportunities. Ans and her father had maintained a steady correspondence and he wrote to tell her that when she turned 21, and had finished her exams, he would pay for her to have a six-month holiday in his new home country.

Ans did not hesitate, seeing an opportunity not only for travel but also for further honing her photographic skills. She hastily arranged travel documents and booked a passage on the Royal Rotterdam Lloyd shipping line's *Sibajak*, which berthed in Wellington in December 1957.[12]

'I came to New Zealand with a good camera,' she recalled. 'I had brought some colour film because I was going on the immigrants' ship — things like crossing the equator, [sailing] through the Panama Canal. They're very colourful.' Not all of these images have survived, but those that have point to Ans' deepening enthusiasm for this artform, and her interest in the people around her as much as the dramatic scenery or unusual locations.

The contrasts in scale between her old home and her new one took a while to sink in. New Zealand's land area of 268,000 square kilometres was six and a half times that of the Netherlands, but at 2 million people, its population was a fraction of the Netherlands' 11 million.

Pieter Westra travelled to Wellington by train to meet his daughter, and almost immediately they headed back to Auckland, where Pieter was renting a house in the west Auckland suburb of Glen Eden. On that 12-hour train journey he explained his side of the marriage break-up with her mother to her. The memory stuck with her: 'He had this — this is a very Dutch thing — you don't just say something once, you say it at least three times and it might sink in.' She described the 'discussion' as analogous to 'being brainwashed'.[13]

There was a spare bedroom in the Glen Eden house but Pieter Westra made it clear that she would need to get a job and pay rent. Pieter was by now married for a third time. He and his wife, Jackie, had two small children,

Ans in Wellington in the late 1950s.

Robert and Yvonne, and hoped that Ans would do much of the housework. It was not a happy home situation, principally because of her father's relentless efforts to justify his role in their shared past. His defensive monologues dominated her first weeks in the country: 'He was forever saying that he'd left the business in Leiden to pay for my education, and my mother's claim that she had saved the money [was rubbish]. There was all of that. At one point my father said to me that he'd only got me to New Zealand to take away the last thing that he could hurt my mother with.'[14]

Her patience snapped. She packed her suitcase and announced that she was leaving. His response was 'Oh no, don't go. Jackie will never forgive me.'[15]

Ans traipsed around Auckland in an unsuccessful search for any sort of photography-related work. Eventually, desperate for money, she took a job on the production line at Crown Lynn, one of the largest ceramics factories in the Southern Hemisphere.[16] She learned to manufacture plates and cups, and line them with gold etching. '[W]ith a fine brush you would put that against the spinning cup and you had a line . . . and then I learnt how to put patterns on. They go over the glaze and then it gets fired again and sinks under the glaze.' It was hardly an emporium of creativity, but Ans was gradually accumulating 'little skills'.[17] The pay was modest, the work generally tedious, but in the process she got to meet two of the country's foremost studio potters: Doreen Blumhardt and Helen Mason.[18] As inspirational as these artists were, Ans eventually decided her future did not lie in ceramics.

It was now six months since her arrival, and she was becoming disillusioned with New Zealand — or at least with her current situation. Auckland did offer one consolation: its coast. Some weekends she would visit the city's wild west coast beaches and explore the marine debris that washed up on the shore. 'I was intrigued with all the bits of driftwood I would find, and shells — shells from the Pacific.' She took some shells home and her half-sister Yvonne, who was 20 years younger, 'managed to get into my room one time and [found] these tiny little shells . . . She picked them up and she wanted to keep them but she didn't know where to put [them], so she put [them] up her nose.'[19]

The beaches notwithstanding, by the autumn of 1958 Ans was starting to feel that her life had detoured into a cul-de-sac. Her job was unsatisfying, and although she had returned to her father's house, her home life was increasingly unbearable, and the volcanic force of creativity that was building inside her still had no outlet. New Zealand felt like a socially stifling 'dated back-water where nothing ever happened. There was none of the life we had in Europe.'[20] She decided to return to the Netherlands. Her father was firmly opposed, mainly, according to Ans, because he was afraid that Ans' mother would discover that, despite his boasts, Pieter had not made a success of his life.

Ans had little contact with the Dutch expatriate community while she was in Auckland, one notable exception being the friendship she established with Kees (Cornelis) Hos, who had emigrated from the Netherlands with his wife, Tine, the previous year. Hos had taught at the Royal Academy of Art in The Hague, and in 1957 he had opened the New Vision Gallery in Takapuna, on Auckland's North Shore. (It later moved to His Majesty's Arcade, just off Auckland's Queen Street, where it would show a mix of painters and craft artists that included Philip Clairmont, Gordon Walters, Theo Schoon, Len Castle, Barry Cleavin, Don Driver, Ted Dutch, Milan Mrkusich, John Parker and Philip Trusttum.)[21]

———

ANS'S SHORT STINT WORKING at the Bauhaus-influenced New Vision,[22] must have encouraged her to believe it was possible to establish some sort of artistic career in New Zealand. But as the months in Glen Eden wore on while she saved for her fare back to Leiden, it dawned on her that the same lack of opportunities had been the very reason she had left the Netherlands in the first place, and she had invested a lot in her early months in New Zealand. She reappraised her situation. She had, she decided, to improve her English, try to find work, and come to terms with a very different cultural terrain.

A big Māori family lived next door, and often when her father came home from work one of the children would cheerily yell: 'Hi Peter, how are you?' Ans' father detested this degree of familiarity, and Ans was intrigued by the interaction. 'I was just seeing the contrast between the stiff upper lip — basically, when visitors came, the kids had to put little gloves on to perform on the piano. That was my father's place, and then over the fence [was] this happy, bouncy family. I thought, "That's how I would like my family to be."'[23]

Reluctant to give up on New Zealand just yet, in 1958, as a last-ditch measure, Westra moved to Wellington, where she hoped there would be more work in photography and she would be free from her father's daily presence.

Part of the attraction of the country had been its sparse population — 'Society was so small-scale . . . [it] was easier for me because you got to know a lot of people'[24] — which enabled a form of social intimacy that had been lacking back home. But above all, it was far enough away geographically from the Netherlands that she finally felt able to start expanding the boundaries of her identity. New Zealand was becoming a place of refuge from unresolved aspects of her past. Ans Westra began a process of exploration, discovery and escape.

Years later, she observed at a school reunion that most of the others in her class had gone on to become teachers, had got married, and had settled down to lives of what she regarded as mundane domesticity. Her own trajectory had been so different, and, looking back at her former classmates, she described their choices as indicative of their 'insecurity'. Their lives were a distinct counterpoint to the burgeoning rebelliousness that accompanied Ans' early years in New Zealand. By her own admission, among her former friends from Rotterdam she 'wasn't very popular', chiefly, she surmised, because she possessed 'that sort of desire to be freethinking'.[25]

Ans soon became swept up in the new possibilities Wellington offered. 'I found my way and my place here,' she declared of her new home.[26] Outwardly, at least, she had successfully amputated herself from her past, and was facing a future that, while uncertain, at the very least seemed to offer her the opportunity of fresh experiences.

3. Te Ao Hou: The New World

The biographical trail of Ans Westra's early years in New Zealand is sparse. Her own account betrays a tendency to avert her gaze from difficult personal events such as the death of her mother. The more fraught the recollection, the more skeletal its retelling.

What is certain is that when she travelled by bus to Wellington in 1958, her intentions were to see more of the country, and find whatever employment she could in order to save for a ticket back to the Netherlands. She did not plan to make Wellington her permanent home.[1] Part of the reason was that the type of photography she wanted to pursue was not the sort from which she believed she could make a living in New Zealand.

Full-time photography work involved photographing school classes, sports teams, weddings and studio portraits, which would be an excruciating existence. Ans craved the limitless possibilities of capturing the vibrancy and noise of the world. But how could she make a living at that?

She toyed with the idea of museum work and concluded that photographing artefacts could end up being just as stultifying as portrait work. Then in 1960 came a breakthrough with her first sale of work to the quarterly journal *Te Ao Hou: The New World*, published by the Department of Maori Affairs. The magazine had been established in 1952, and was significant for having content in te reo Māori as well as in English, and for promoting work by Māori authors.[2] In their first editorial, *Te Ao Hou*'s editors described the journal as 'a magazine for the Maori people', and expressed

the hope that 'Pakehas will . . . find much in it that may interest them and broaden their knowledge of the Maori'. The publication was 'planned mainly to provide interesting and informative reading for Maori homes. *Te Ao Hou* should become like a "marae" on paper, where all questions of interest to the Maori can be discussed . . .'

The journal's founders hoped 'to be able to rely on contributions, especially from Maoris, [of] articles, poems, drawings, photos, or anything else of interest . . . When contributions are accepted, they will be paid for.'[3]

The photographs Ans had sent them were the product of a hitchhiking trip around parts of the North Island, taking photographs along the way. 'I just travelled around. I was trying to see more of the country. Eventually I thought I would be better off having a car, so I stayed in paid employment until I could afford a car. I wanted to have more freedom. I slept in the car.'[4]

Te Ao Hou bought more photos but not enough to provide Ans with a living. 'They didn't really employ me, they just paid me for the work they published, which more or less covered expenses . . . It was a mutually beneficial arrangement. *Te Ao Hou* couldn't afford anyone to go on the road and be fully paid. They were working on a very small budget.'[5] But if the pay was meagre, it was more than compensated for by the freedom to travel and explore facets of the country's indigenous culture, all the time honing her photographic technique and approach.

She took on a string of jobs, counting 13 at one point. 'It was all so easy, you could walk from one to another.'[6] It may have been 'easy', but it was hardly a secure living. Yet Ans saw only opportunity.

The purpose of *Te Ao Hou* was to promote Māori creativity, especially in writing. However, when it came to photography, the editors initially were more concerned with Māori being the *subject* of the images than the creators of them. The door being left slightly ajar in this way allowed Ans to step into a world with which she had no familiarity.

She had initiated the contact herself when she approached the journal's editor, Erik Schwimmer, in 1960. In her words, she 'took some pretty pictures of Māori kids to him, and he bought them for covers, and that was the

beginning'.[7] There was a bit more to it — she had in fact been given guidance on which parts of the country to travel to, and which Māori communities to contact, by the anthropologist Margaret Orbell, a subsequent editor of *Te Ao Hou*.

The cover photos of the June and September 1960 issues were credited to 'A young Dutch photographer, Miss A. Westra, in New Zealand visiting relatives'. Immediately, readers familiar with *Te Ao Hou* would have been struck by the departure in style. Up until this time, the magazine's cover images had tended to be staged and austere representations of modernisation and accomplishment, often featuring cultural rites, rituals and pageantry. The cover of the September 1960 edition, by contrast, featured a close-cropped image of a Māori girl wth a mischevious grin, stripped of any embellishments or visual prompts.[8] For Ans, that was the point. It was the impishness and distilled joy on the girl's face that mattered, and nothing more.

Even the choice of location provided a point of difference. Ans photographed these children in Rotorua outside St Faith's Church in Ōhinemutu — a Tudor revival building that would have served as an engaging background. Had she wanted a more indigenous flavour, she could have chosen the adjacent Ngāti Whakaue wharenui, Te Papaiouru. For a more dramatic, otherworldly backdrop, the area was alive with sulphurous vents hissing steam. But no. Ans filled the frame with that smiling face, conveying elation.

———

IT MUST HAVE SEEMED like the best of all worlds for the budding photographer. Ans was advancing into a branch of photography where she could breathe creativity into her work, and she was being paid — modestly — for her efforts. She got a flat at 1 Allenby Terrace, Wellington, in the heart of the city, and slowly began to put down roots there. She became good friends with an English nurse who came to flat with her. Ans later looked back on this early acquaintance with fondness. 'She met a Fijian

chief at the chess club and she married him, and that was a real love affair. I gave her away; I was the matron of honour and the photographer.'[9]

Ans was also beginning to develop her method. Through taking numerous pictures in a particular location she would build up what she called a 'photo story' — an approach that remained with her for the rest of her life. 'It's not single pictures, it is a story told in pictures. I got good at it. I seemed to have an ability, despite my height when I was tall, to not be noticed. "Oh, was she there?" This fly on the wall.'[10] She was attracted to the idea that when she arranged images in a particular sequence, exploiting similarities and contrasts between them, a narrative would emerge. If the sequences were altered, new combinations would appear and a different overall meaning would emerge.

Thus, Ans began to compose photographs with a view to their strength both as individual images and as part of a carefully choreographed collection, very much in keeping with the modern photography appearing at the time in magazines such as *LIFE*, *Picture Post* and *Paris Match*.[11]

―――

WHEN SHE HAD FIRST arrived in the capital Ans had joined the Wellington Camera Club. It was an opportunity not just to discuss ideas with like-minded enthusiasts, and to dip her toe into the artistic currents of other photographers, but also to develop a network that might lead to work.[12] John B. Turner — photographer, art critic, writer, academic and later one of Ans' closest friends — noted that these clubs 'were serious about their photography and focused on two things — firstly, [proving] that their means of expression was an art — and secondly [gathering] more converts. If they had the numbers, they reckoned, they would be taken seriously as artists.'[13]

Ans immediately found value in the club on a practical level. Numerous related skills could be learned and honed in the clubs. 'They taught you where you'd made mistakes, what you'd done wrong . . . all the photographers there were incredibly helpful towards the young ones,' she said. She used

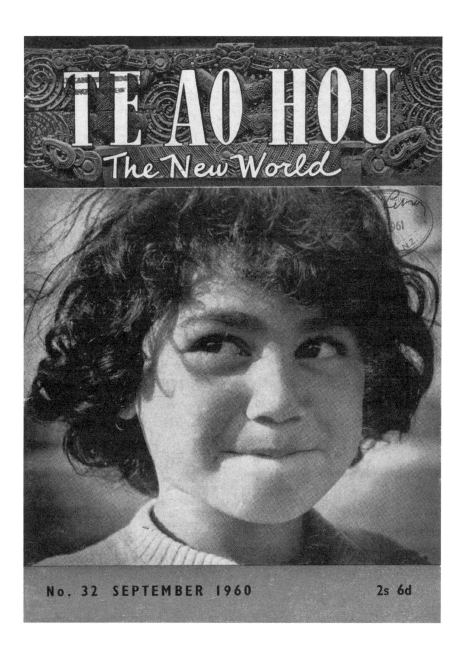

The cover of the September 1960 edition of *Te Ao Hou*.

their competitions 'as a learning curve, and the thing was you had to process [the film] yourself. You couldn't go to the chemist or the photo shop or WPS [Wellington Photographic Society] or whoever.'[14]

Her skills soon began to improve. 'I started in the B grade, which was normal,' she said. 'But in those days, you had the likes of John Salmon and Ronald Woolf in the club who were, for the new people, very helpful. They would tell you what cameras to use, what you were doing wrong, how to print.' It was clearly an ideal environment for beginners, but Ans claimed, with typical self-deprecation, that her early success in competitions was in part due to her understanding the judges' preferences. 'I sort of worked out what the judges liked for the competitions, and I managed to win virtually all the cups in the end . . . Of course you're just sniffing out what they like.'[15]

Not that she was particularly competitive. 'I didn't really feel the need to be conforming or competing with people. I was quite happy on my own, which was lucky because I find relationships get in the way of my work very often.'[16] She did, however, find 'a kind of soulmate' in Fred Freeman — a retired railway worker and communist who had a particular interest in photographing Māori youth.[17]

For all their benefits, though, camera clubs also often came with particular inheritances. The predilection for landscape photography in the 1930s, for example, had led to an urge to mimic English rural vistas in images of New Zealand landscapes. New Zealand photographers, however, were faced with the problem of having no such elements of antiquity — ancient buildings and decayed stone walls — to incorporate in their works.

They overcame the absence of such physical relics in two main ways. The first was to abandon the attempt altogether, instead representing the country's natural environment as it was: wild, entangled, mysterious, unpredictable — the antithesis of the British interpretation of nature as polite, ordered and tamed. The second was to substitute England's ivy-covered abbeys and Druid groves with an indigenous alternative: the remnants of pre-colonial Māori society; remote, decaying rural marae could appear every bit as ancient and evocative as England's ancient ruins.[18]

The postwar period was not the end of this approach, but new ways and styles of depicting the country arrived even so. Les Cleveland's collection of images of the West Coast, for example, which he began photographing in 1953 (and later published under the title *The Silent Land*), relied on a slightly picturesque approach, substituting decaying buildings in abandoned mining towns for the ancient ruin. Meanwhile, others, including John Pascoe, Pius Blank, Theo Schoon and Hester Carsten, began exploring the role of photography in issues such as conservation, indigeneity, poverty and urbanisation.[19] Ans had joined the Wellington photography community just as approaches to the art were fanning out in many new directions.

The social side of the camera club was barely a consideration. 'I have always had very little social contact really. The odd friend stays completely outside of my interests in photography. I meet a lot of people through work, but we hardly go out and see people socially because it's almost a burden — it takes my time away.'[20] Her commitment to forging a career in photography was assuming ever-growing proportions.

Her single-mindedness became a signature. Ans once expressed her frustration about how life (including family life) ate into the time she had available for photography. 'The kids get tired or heartily fed up with the sight of a camera,' she acknowledged in 1979. 'Photography is something I need to do, and I feel unfulfilled if I spend all of my emotional energy on the children. I have things of my own that are important to me. I could never be completely devoted to a man, or children.'[21]

In Ans' mind, photography had chosen her as much as she had chosen it. She felt beholden to the work; it was out of the question to accord it a back seat in her life. The writer and critic Desmond Kelly probably summed this up the most succinctly: 'I don't think she ever lived as happily as when she was photographing.'[22] Photography quickly became a crutch — a need as much as a practice, and one that propped her up psychologically for the rest of her life.

OVER THE NEXT FOUR years Ans worked in several of Wellington's best-known photographic studios (including Polyphoto and Rembrandt's),[23] improving her technical skills in the processing of images while earning a basic living. Her account of this period reveals some of the limitations photographers faced in New Zealand at a time of heavy tariffs on imports. 'Films were beginning to become [more readily] available . . . but cameras were still particularly difficult to get, and very expensive. People would travel overseas and bring a camera back with a roll of film in it, and that way they could avoid paying duty . . . so we listed [these cameras] as "near new".'[24] Facilities in darkrooms could be very rudimentary. In one place she was given after-hours access to a broom cupboard to use as a darkroom. Ans was not worried: it got the job done.[25]

She was working at Rembrandt's when she conceived a new photographic project: a series of self-portraits documenting her own daily life.[26] The impetus came in a letter from her mother, who was curious to know what life was like in New Zealand. Ans added captions in Dutch to each of the photographs, her way of telling her mother about life in her new home.[27]

In 1960, the same year her work first featured on the cover of *Te Ao Hou*, Ans' efforts at developing a distinctive photographic style were further rewarded with a prize from the British magazine *Photography*, for a series she called *Assignment No. 2*. The monetary award was welcome, but more valuable was the recognition that her work was truly of an international standard.

In February of the following year her work came to wider notice within New Zealand when she won the monochrome print section of a photographic competition run by the Arts Committee of the Festival of Wellington.[28] The theme was 'Wellington Streets', and the winners were announced by senior government economist W. B. (Bill) Sutch. Ans won 'a camera valued at £20', but once again the main prize was the recognition. She finally began to believe that a career in art and documentary photography was attainable.

But was she a professional or an amateur photographer? She was not always sure of the answer herself:

> I feel that the vision between amateur and professional is basically that the amateur does it for the love of it and not for the monetary reward. It's not counting. With the children it often was, can I afford another film, or do I feed the kids? And I found ways and means of feeding the kids like picking blackberries or finding mushrooms, having Christmas in a tent somewhere on the beach while I photographed. I found that I knew my children and could trust them and could leave them for short periods. At the same time . . . well, we would be driving somewhere and Jacob the youngest would put his hands in front of my eyes. 'Don't look, Mummy,' [he would say] when we passed another marae where something was happening.

GRADUALLY ANS WAS BEGINNING to place her fingers on the cultural pulse of Māori New Zealand — which many Pākehā lazily presumed had practically ceased as the forces of cultural assimilation closed in. Ans did not view Māori as a race on the cusp of cultural oblivion. Her photography betrayed not even a hint of the narrative of Māori 'extinction' that had captivated the country in the late nineteenth and early twentieth century. Rather, the cultural milieu she was venturing into was every bit as alive as any other group in the country — expanding and adjusting and conflicted as all societies are — and her understanding of this process is one of the motifs running through her work.

Some time in the 1960s she decided to learn te reo, and in the process managed to rid herself of a stammer she had developed in childhood. 'Really it didn't go until I went to Māori lessons . . . They give you a Māori name, you see, when you start this intensive course. I think it's a bit like Italian, you sing it and that gets you out of the stammer.'[29]

At these lessons she learned to deliver her pepeha — the brief self-

introduction encapsulating an individual's ancestry, place of origin and other cues to their social and cultural context.

> I had to introduce myself, and we were told, 'You can do that any way... You can do it in any language.' So I did it in Dutch. My father, my mountain, my river, and suddenly there was this young Māori answering me in perfect Dutch. He'd worked on the wharves in Holland... But I also had to do it in Māori... well, I think I managed it.[30]

In October 1961 she travelled 560 kilometres north to the Tūrangawaewae marae at Ngāruawāhia for the first of several coronation anniversary ceremonies she would photograph for Te Kīngitanga (the King Movement).[31] One day she was at work in the studio when 'an old Māori came to the shop, a Mr Baker; and he gave me an introduction to Ngāruawāhia, which was not allowing photographers in at the time. I remember this beautiful letter he gave me, [describing me as] "the best photographer of the Pacific". So I went with this good letter to Ngāruawāhia and started photographing straight away.'[32]

Well, almost straight away. She was put in what she described as a 'cultural quarantine' when she first arrived, and only after a committee had carefully considered her and the letter of introduction did they grant her permission to photograph the proceedings.[33]

Many of the photographs she took on this and subsequent visits were unremarkable documentary images of the location and of the various formal events. However, amidst these conventional shots were a few that gave a taste of her developing ability to compose scenes that were evocative not just of the pageantry of the event, but also of the range of responses to it: two clench-lipped men looking on sternly; a group of elderly women, heads covered in shawls, in a state of late-afternoon contentment; two kuia engaged in a hongi, their faces intricate maps of emotions. The viewer is no longer a casual bystander but an intimate spectator, observing at close quarters the off-guard moments of those present.

Although the intended viewers of these works were the (mainly Māori) readers of *Te Ao Hou*, for others, this small collection of images would have represented a fleeting glimpse of an unknown world.³⁴ They served as an early example of Ans' ability to 'capture the mood . . . the human spirit . . . the inner world' of the people and places in a way that no other photographer in the country could match.³⁵

The art of proximity was crucial to the way she enshrined those delicately poetic moments of her subjects watching, talking, relaxing, discerning, laughing, reflecting; and she worked hard to cultivate that art.

Later in life she would appear at a location almost like a faint mist that had drifted in — silent and barely noticed by those around her. In the early 1960s, however, as she was getting accustomed to working among Māori, a bit more arrangement went into it. She did not want to appear intrusive.

'At Ngāruawāhia, again on the marae,' she revealed, 'I tried photographing these women . . . and I actually made a cardboard lens . . . as if I was [pretending to photograph] them . . . and this old lady knew what I was up to. She picked it. I [took] a wonderful photo of her giggling.' The woman told Ans there was no need for subterfuge — she should simply go ahead and take photographs. Ans was relieved. 'I felt accepted. That was the critical thing.'

Over time, any barriers between her and her Māori subjects — some inherently cultural, and some self-imposed — slowly broke down. 'I had enough respect . . . they recognised me. They came to me, and they said, "You're probably the only person that can photograph during this welcoming ceremony."'³⁶

Her exclusive access to Ngāruawāhia, though, did not last long. On her second visit she saw 'this ginger-haired man photographing with an assistant holding an umbrella over his head to keep the sun off — it was a multi-coloured umbrella — so here was [the photographer] Brian Brake. We seemed to be doing the same sort of thing. When the people lined up at the dining halls with their fascinating faces, we were both there photographing.'³⁷ Their meeting was anything but collegial. 'We just glared at each other.' Not a word was spoken.³⁸

IN THE 1960S AND 1970s female art and documentary photographers were underrepresented in the profession internationally.[39] Yet New Zealand's small population, together with the fact that many such photographers were cultural outliers (immigrants or members of the 'counterculture'), their concentration in three main geographical areas (Auckland, Wellington and Canterbury) and a national spirit of egalitarianism[40] made for some degree of solidarity among the female practitioners.

Ans was conscious of being in a minority in the profession, but saw her gender as a bonus, giving her a particular way of looking at and appreciating her subjects. 'I've never wanted to be treated any different because I'm a woman — it's been an advantage if anything. I feel I am closer to life, as a woman. I've experienced having children so I can identify more with the whole emotional side of people.' There were other advantages. 'The fact that I'm a woman with a camera has made me less of a threat, so I've been more easily accepted. Maybe I've been taken less seriously, but that was good in my case, because people took less notice of me.'[41]

Her relationship with the feminist movements of the period was incidental and intermittent and she did not allow feminist principles to overshadow her approach. Nor did she set out to use photography as a means of making statements about women. However, she was a voracious reader on all manner of intellectual topics,[42] and amassed a large collection of books in the process. One concept that captured her interest was the notion of the female gaze,[43] 'a new way of seeing and experiencing'[44] that did not defer instinctively to patriarchal dominance in terms of subject selection and composition. Ans, who did not feel bound by any particular ideological or gender perspective, was never overtly anti the male gaze, but rather she was instinctively female. Her photography was defined by what she wanted to depict. Her 'gaze' was complex and sometimes even ambiguous.

Looking back on this period, Ans summarised her role as 'a picture maker, the picture taker', and emphasised that a certain detachment was a crucial part of her work. 'It's a . . . responsibility even, to be as honest as possible. Not bringing in your own prejudices, your own opinion, your

own morals . . . Not to be judgemental. I'm just soaking it up, what's around it. That's as honest as I can come really.' Rather than superimposing any ideological lens on her work, Ans wanted her photographs to 'speak for themselves' and to be open 'to various interpretations but all of them valid'.[45]

> I try not to bring my European background into what I want to photograph, what I'm interested in, what I'm showing. I try to be as objective as possible. Of course, inevitably you are influential. Maybe I just have a more motherly, female vision but that's me. I try not to be judgemental, try not to do more than actually recording.[46]

It wasn't always easy to maintain that detachment, requiring the photographer to resist

> even just forming an opinion because you've witnessed something and think that it will always be like that for everybody . . . You can't do that. You can't bring your own opinion into it to that extent because then would people trust that opinion, that judgement that you express in your pictures? . . . You've got to try and keep an open mind and show that through the pictures. Of course, I'm more excited by people who are a little different, and that comes across. You try not to exploit the people you photograph simply by doing it. It's a hard ask of the photographer . . .[47]

Ans was aware of her privilege in being allowed to photograph at Ngāruawāhia, and determined to confine her role to one of neutral observer.

> When I came here, the thing that I sought out was Māori, because nobody else went to photograph there . . . I stood out, I suppose, and got noticed, and had free access, and that became my stronghold. We all have the same human values. Kinship,

> children and so on, are important to everyone. Wherever I went, I never wanted to change anyone. I didn't say 'you get education or shape up or work harder'. I accept who people are and why they are like that, and how they had to come to terms with things in their own way.[48]

She was also beginning to appreciate the changing nature of Māori society at this time, and the importance of recording the dynamics of this change. Since the end of the Second World War there had been an exodus of particularly younger Māori from their rural homes to the cities (especially Auckland), in search of employment and a less traditional lifestyle. A telling phrase that entered the vocabulary of many Māori from this time was 'back home'. Ans observed 'those ones in the city long[ing] for what they had left behind', and took many photographs capturing the confluence of rural and urban Māori culture in this state of flux. Part of her genius was to identify, almost instinctively, where such cultural fault-lines lay, and set about assembling their constituent elements in a single image.

She was well aware of the importance of what she was memorialising. As soon as she processed her film in the darkroom she would recognise the strength of her photos, and she knew no one else was making work like it. Perhaps taking van der Keuken's early success as a cue, by late 1962 she was formulating plans to produce a book containing a selection of her images of Māori. Although it would not materialise for several years, the thought — which she shared with the editor of *Te Ao Hou* — discloses a kernel of ambition, and an urge to have an appreciative audience.

TE AO HOU BEGAN to request more and more photographs, and by 1963 the geographical spread of her assignments had broadened considerably. In February that year she was despatched to Waitangi to cover the visit of Queen Elizabeth II to the Treaty Grounds, and her photos eventually

featured in other publications and became part of the official record of the royal tour.[49]

Waitangi was memorable for Ans, not only because of the presence of the royals. She drove up from Wellington in her own car, and not far from her destination the engine faltered after a hose started to leak. The next thing she knew, her car was hurtling into a ditch. She eventually lined up to meet the Queen with a black eye and wearing 'an old Girl Guide skirt'. 'I must have looked a bit scruffy,' she recalled. Her Majesty 'took one look at me and burst out laughing'.[50]

She took two kinds of photo during that visit to Waitangi. Her conventional scenes of the royal party being ushered around the grounds and meeting various local dignitaries were indistinguishable from the sort of work other professional photographers produced. But while the royal visitors were sauntering around the Treaty Grounds, Ans pointed her camera in the direction of some of the thousands of spectators. In one image, which featured in *Te Ao Hou* in March 1963, there are roughly 50 people in a crowd scene. Most of those in the background are Pākehā, standing behind a roped-off area. In front of them, seated on the ground, are about a dozen, mainly elderly, Māori.

The viewer can read as much or as little as they wish into these divisions: standing and sitting, behind the rope or in front, Pākehā and Māori, young and old. The photographer is aware of the divisions and the tensions between them, but she is not telling you what to think. This patient observation of people, coupled with an abandonment of any sense of self-importance, proved to be the ideal formula for Ans Westra's expanding work in the Māori world.

In 1956, when she saw the *Family of Man* exhibition in Amsterdam she had been almost overwhelmed by its scale, and she had wondered whether the opportunities for further work in the field of documentary photography had been exhausted. But when she began to move in small Māori communities, Ans could see that there was so much still undocumented. She explained the philosophy that guided this approach, particularly when

photographing Māori: 'You can see from my pictures that I am in sympathy with them, I treasure them, I put them on a pedestal. That's one good thing with the Rollei — that you look slightly up.'[51]

OF COURSE HER STYLE continued to evolve, and became at times quite experimental. A dramatic example of this had appeared in the June 1962 edition of *Te Ao Hou* with her photographs of a passion play performed in Hastings at Easter that year by a cast of Māori actors.[52] The repeated performances of the play over a week attracted a total audience of 10,000, with the proceeds going to the Maori Education Foundation.

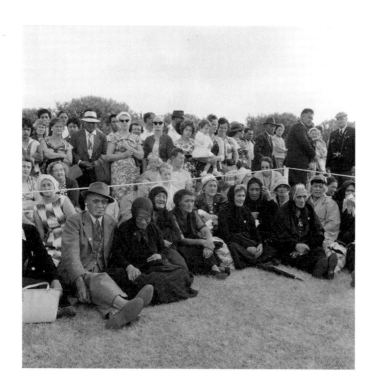

Māori gathering at Waitangi to see Queen Elizabeth on the first event of the Royal Tour of 1963, published in the March edition of *Te Ao Hou*.

Just two of Ans' photographs of this event were published, but they represented an important advance in her stylistic palette. The first image was of the actor playing Christ, his head crowned with dangerously realistic thorns, and his body struggling to shoulder a heavy cross. His face is a model of anguish, but perhaps the most striking, even shocking, feature is the menacing shadow cast on the crucifix by his head. It is in the mould of German Expressionism, with an exaggerated emphasis on horror and isolation, the close-up having the effect of distorting the reality of the scene.[53]

Expressionist works, which rose to popularity in the 1920s, gave viewers a sense of the inner feeling of the subject/s. The angle and composition of Ans' image diminish or remove the normal elements of orientation in order to heighten a sense of unease, violence, danger or melancholy, all enhanced by the photo being in black and white. Ans' Christ was a sombre figure through which viewers were drawn to reflect on their own mortality.

Her other image depicted Christ immediately after the crucifixion, several women attending to his corpse. Here Ans made a cultural leap by alluding to the sort of scene that would have been familiar to readers of *Te Ao Hou*: the ritual of tangihanga or traditional Māori funeral rites. The mourning women, their heads veiled, gathering around the body, were an echo of the ritual around a death on the marae.

ON 25 JANUARY 1963 the annual celebration of Tahupōtiki Wiremu Rātana's birthday was held at Rātana pā, just south of Whanganui, and Ans was present to record the event for *Te Ao Hou*. Rātana (1873–1939) claimed to have had a vision in 1918 in which he was commanded to heal his people and bring them back to God. The religious movement he went on to establish combined Christianity and Māori spiritual elements. By the 1930s the Rātana movement had begun to align itself closely with the Labour Party, making it the most overtly political of all religious groups in the country.[54]

Rātana's birthday grew to become the annual celebration of the faith

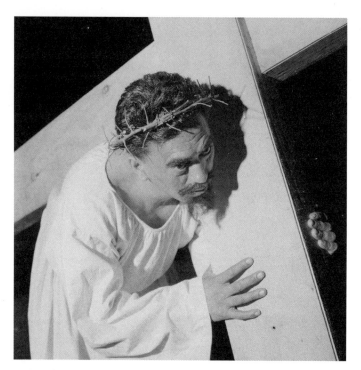

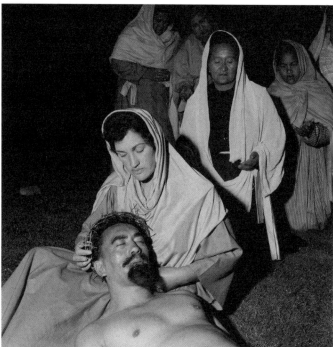

Performers in a production of a passion play in Hastings, featured in *Te Ao Hou* in June 1962.

and involved almost a week of festivities drawing in thousands of church members. A significant aspect of the sect was its pan-tribal nature — another of those evolutionary developments in Māori society that was gaining momentum in this period.

Any photographer at this annual event would be spoilt for choice when it came to options for images, but the space constraints of *Te Ao Hou* meant that only a few photos could be included. However, 1963 would be the first time there had been any. Ans met Puhi Rātahi, the church's president, and when she became the first person to be granted permission to photograph the ceremony inside the temple at Rātana pā it was an undoubted tribute to her steadfast work in several Māori communities around the country.

The first of the two images of the Rātana festivities that featured in the March 1963 edition of *Te Ao Hou* showed the temple's interior with the service in full flight. It is a view from an elevated angle, with the cluster of clerics in the centre flanked by a choir on one side and a brass band on the other, while a packed congregation is pressed into every space in the foreground. Ans explained how this image came about:

> Margaret Orbell, who was the editor of *Te Ao Hou*, had told me that if you can get up to the balcony of the temple that you could see these groups of āwhina in different colours walking into the temple. And okay, I was allowed on that balcony and then I saw they had louvre windows, so I carefully removed two slats of glass and I photographed also in the temple. Apparently [a previous] photographer ... had tried photographing in the temple and ... the film hadn't come out — there was some mistake in it or whatever. My pictures came out and once the church office saw the enlargement [in] the magazine ... they ordered a big print of it, and I could say, 'T. W. Rātana smiled at me.' I was given permission.

The duration of this permission was another matter. In the years that followed there was a shift in attitudes towards photography, particularly

in places that were regarded as culturally or spiritually significant. 'Now there are restricted areas,' Ans conceded.

> When I came back to Rātana quite a bit later, the new president [Mrs Te Reo Hura] sent a message . . . 'She has no right to my image.' It's a very interesting way of putting it. Okay, if she doesn't want to be photographed, plenty of other people [do]. I did self-portraits amongst them all . . . I also slept on the marae of course, and that already creates a bond. You have your mattress on the floor and you're amongst them, you're one of them more and more and more, and the more the merrier.[55]

There was space in the article that first year for just one more image, and Ans' choice was interesting. The options were extensive, ranging from people camping and brass bands performing to crowds mingling, food being prepared and various liturgical processions. But having photographed the mass gathering in the temple, she wanted the second image to be more intimate, and suggestive rather than descriptive in nature, and so she chose an image of two female devotees dressed in religious habits.

The juxtapositions in this image were numerous: young and old; a concealed grin and an almost saintly smile. Together, the two embodied the traditional and the modern in Māori society. There is also the suggestion of a form of apostolic succession in this scene, with the elderly woman and the young girl reading from the same text (just out of frame). In contrast to the photograph of the bustling congregation in the temple, this image had a serenity. In only two photographs, Ans conveyed to readers the spectrum of experience on display at this commemorative event.

Soon after attending the Rātana celebrations she travelled to the Bay of Plenty settlement of Rūātoki, about 20 kilometres south of Whakatāne, to cover another religious event — the biannual meeting of the Ringatū Church. Like Rātana, Ringatū was a hybrid faith that grafted elements of traditional Māori practices and beliefs onto Christianity. However, Ringatū was distinct

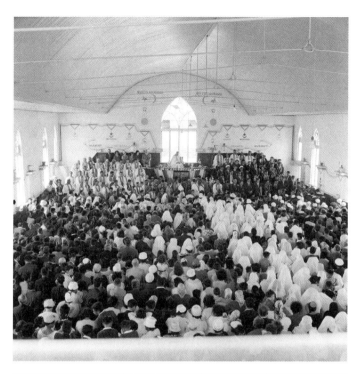

Images included in a *Te Ao Hou* feature on the Rātana Church celebrations in March 1963.

not only in its canon but also in its origins, its political orientation and its geographical base.

The faith had been founded by the military leader and self-declared prophet Te Kooti Arikirangi Te Tūruki, who preached, among much else, about Māori being delivered to a promised land (drawing on Old Testament narratives). This held obvious appeal for a people who had been forced off their traditional tribal territories, and whose land had subsequently been appropriated by the Crown and sold off to settlers.[56]

Ringatū was less pan-tribal than Rātana, and most of its adherents were drawn from the vicinity of Te Urewera. And, by location and inclination, its members were more isolated from Pākehā society, leaving an impression that they were secretive (although it would be more accurate to say that its members valued privacy in their religious activities).[57] Once again, Ans Westra was granted unprecedented access to photograph a major gathering of a Māori religious movement. And once again, her artistic eye depicted elements of this assembly in ways that incorporated the formal aspects of the event and intimate moments.

For all the empathy Ans evinced with religious subjects, she remained a life-long atheist who from time to time expressed impatience with religion.

> My father was from one religion in Holland and my mother from a much more liberal one, and my father decided not to have me baptised. 'No, she can choose for herself,' [he said]. Well, I never have. I want to be neutral. I don't specifically want to belong. [I] got into an argument with a Baptist minister in Wellington and we had a landlord who was a Catholic priest exploiting everybody. I mean, there's so many foibles in human nature.[58]

Secularism was a place Ans considered neutral, even if, ironically, some of her greatest artistry was exhibited in her photographs of religious subjects, and many viewers sense an element of spirituality in some of her photography. In the final year of her life she stated: 'We can only believe

what we believe in. I'm not a Christian, I don't belong to any religion as such. I've been my own judge of what's right and what's wrong.'[59]

IN HER PHOTOGRAPHS OF Māori in the first half of the 1960s, Ans was driven to portray that which was different or unfamiliar, which she knew in some way unsettled Pākehā assumptions about Māori. It is hard to avoid the feeling that she saw herself as a cultural explorer, venturing into new terrain in order to 'discover' what was unknown to her own group, document it, and report back. And, as with explorers in the colonial era, such undertakings seldom went smoothly for their entire duration.

In 1962 she had a rough ride over the cultural topography at Minginui, a remote Urewera settlement about 100 kilometres south of Whakatāne. Ans herself described the location as 'one of those places that stayed out of the circuit of post offices [and] schools', and where the 'houses are not beautified'. What brought her there was the request of a local — a Pākehā who had married into the hapū — who was organising a petition to improve the provision of electricity to the area. He thought some photographs of the place might add force to the petitioners' plea.

Ans arrived to stay at the house of the whānau organising the petition, but the reception she received on driving around the small impoverished settlement was not what she had expected. 'You would go in a car through the village and people would shout out, "We are not poor!"' So she kept a low profile for a while. Shortly afterwards, though, a senior member of the community died and a tangi was held.

Ans photographed the tangi with permission, but it did not go well. 'I overstepped the mark. I got carried away photographing, having the freedom to move, having people know me, and [an] old lady gave me the bad eye — you know, the stare. "Out."' The kuia jabbed her finger at Ans' face, ordering her to leave. The photographer had come too close to the casket, breaching the kawa or protocols of the community.

She took this rebuke in her stride, and accepted that she had caused offence by her actions. However, she kept the photographs she had taken, and was genuinely surprised when the local residents did not want to see them. 'It was such an interesting conflict really,' is how she put it. Traversing the borderlands between Māori and Pākehā as frequently as Ans did was bound eventually to result in such a situation. Ans saw her actions as 'innocent' and 'silly', but she was not overly troubled by the incident. 'Oh well, it happened . . . it's so easy to do.'[60]

One wonders whether an offer on her part to destroy the images that had caused offence in order to atone for her cultural breach might have resolved the issue. We will never know.

———

FOR MANY MĀORI, increased Māori urbanisation or 'the drift to the cities' in the 1950s and 1960s ended the social seclusion they had enjoyed in their rural homes, and along with it the web of community support that was a feature of almost every aspect of their lives. Life in the country's cities was quite different. Financial hardship, squalid living conditions and varying degrees of stereotyping and prejudice were all challenges Māori faced on a daily basis. Many were unqualified and even unskilled, and they found it hard to find paid work and became stereotyped as poor employees, delinquents and even criminals.

Various officials, community leaders and the migrants themselves butted heads in trying to determine the best way to manage this unprecedented movement of Māori. Hapū and iwi allegiances remained in place, but pan-tribalism was becoming a growing feature of day-to-day life for many urban Māori. One of the fruits of this development was the construction in 1947 of the Maori Community Centre, on the corner of Fanshawe and Halsey streets in Auckland. Administered by a conglomerate of various Māori organisations, it was a place for social gatherings, meals, tangi, kapa haka, sports and church services.[61]

By the late 1960s, membership of the centre had started to decline, but at the beginning of the decade it was still one of those liminal spaces that bridged the traditional rural and modern urban worlds of Māori. Ans Westra's visit in the winter of 1962 resulted in a collection of photographs for *Te Ao Hou* that documented the centre at the peak of its popularity. No one knew its demise was imminent, so her timing was extremely fortuitous and the body of work highly significant. Here was a snapshot of an era when the traditional and urban Māori worlds overlaid each other, producing a particular type of hybrid community never seen before.

Even at a distance of six decades it is possible to sense from these photos the circumstances that these cultural migrants were experiencing. Somehow Ans was able to forge a connection. She recognised in them the universal desire to find a place to call home. That night at the Maori Community Centre she photographed young people dancing ('twisting expertly to a beaty tune from the Playdates')[62] and socialising, and who obviously felt at home in these surroundings. At the same time this was a gestational phase for most of those attending, and with hindsight it is possible to sense an underlying melancholy in many of the pictures. The intoxicating fun of these dances (sometimes attracting up to 1000 people) was inevitably followed by the sober reality of living in a culturally neutered suburbia.

The adjustments that these young people were forced to make as part of establishing their new lives in the cities inevitably resulted in some casualties, especially as they were beyond the protective reach of their whānau back home. The temptations and threats were everywhere. In 1951 a group of concerned Māori women responded by forming the Māori Women's Welfare League. The League was especially active in Auckland and Wellington, where its members worked to tackle drunkenness and 'immoral' behaviour. They lobbied to create more apprenticeships for young Māori, and more roles for Māori teachers, as well as advocating for better health care for Māori mothers.

On an autumn day in Wellington in 1962, the Māori Women's Welfare League held a garden party — that most colonial-inspired of activities — to

raise funds for the Maori Education Foundation. Ans was invited to photograph the event. As well as shooting images of League members in unguarded moments, she snapped a memorable picture of a pre-school girl who was looking slightly plaintively at someone out of frame, evidently unaware of being photographed.[63] Ans explained later that she had been trying

> to understand the child from within . . . where they're coming from, why they are like they are. It's a big challenge to get into the mind of someone that you photograph . . . With children you virtually have to become a child, which suits me in a way . . . It's just an excuse really to have a challenge of observing, and capturing — to capture the moment, to capture the expression and try not to be judgemental. Have that open mind working.

Children reacted differently to adults when a photographer was in the vicinity, Ans found. Instead of shielding themselves, they had a tendency to show off. Children generally liked posing for the camera, and it was a 'challenge' to get them to the point where they forgot about being photographed. 'Eventually, if you're patient enough, [they] get bored with you and switch off you, so then you capture your moment, you capture what you want. That unguarded moment.'[64]

THE STREAM OF COMMISSIONS from *Te Ao Hou* continued to flow, and in December 1963 Ans submitted an article on the Te Whānau-ā-Apanui painter and sculptor Paratene Matchitt, for the first time supplying the text as well as the photographs. This piece was also significant because it was one artist writing about another, and then creating images of that art in another medium — a sort of cross-pollination of artistic forms.

The article took a conventional approach, covering the basic aspects of Matchitt's life and briefly discussing his art. But there is also a sense in which

Ans Westra was invited to photograph a garden party held by the Māori Women's Welfare League in Wellington in 1962.

Ans was projecting herself onto the page. Like her, Matchitt's formal education in his chosen artform was limited. She wrote that '[a]part from his time in Dunedin he has had no formal training in art, and it is only during the past two years that he has exhibited his work. But he is already becoming widely known as an artist, and he has received a number of commissions for his sculpture.'[65]

Likewise, she noted that Matchitt's figurative art involved looking at Māori subjects 'in an entirely original way', and that 'his interpretation is an entirely new one; like all good artists, he is interested in doing something which has not been done before.' Both statements could easily apply to her and her own work.[66]

Ans' response to Matchitt's paintings offers an insight into the emotional effect certain art had on her, and possibly the sort of effect she sought to achieve in her own work. In commenting on *Te wehenga o Rangi*

Para Matchitt, (Te Whānau-ā-Apanui, Te Whakatōhea, Ngāti Porou), Hamilton, 1963.

rāua ko Papa — one of Matchitt's entries in the 1963 National Bank mural competition — she wrote, 'I wonder if any of the other people who saw the exhibition felt as I did', and suggested that she found it 'more satisfying than the more academic and anecdotal painting which won the competition'. Her distaste for the academic approach to art — where fashion often trumps effect — was plain. In her work she was expressing her view on the fickle, vanity-laden, overcommercialised art world, in which an ally one day could be an adversary the next. Ans sensed in Matchitt's work something in her own: a form of art that was built to endure, not just entertain.

BY 1964 ANS WESTRA had settled into what might have seemed like a successful career. Although still largely unknown to the public, apart from readers of *Te Ao Hou*, her fellow camera club enthusiasts and those few people aware of the prizes she had won, she was managing to scrape by on the income she received from her commissions, coupled with her work in various photo studios. And, excitingly, her artistic abilities were blossoming. She was not drowning in commissions, but this was more than compensated for by the fact that those she did land enabled her to travel widely, often to locations and events of which very few Pākehā were even aware.

The result was a body of images that were, for the time, a high-water mark for art and documentary photography in the country.

Threading her way through a culture that was still largely unfamiliar to her, she had delivered a unique and vital documentary collection of aspects of the country's experiences. Her work was also beginning to challenge some of the clichéd views held by Pākehā New Zealanders about Māori. Even if viewers did not necessarily grasp the full cultural significance of the photographs they were seeing, Ans' images at the very least gave them cause to pause and reflect.

4. The Friendly Islands

In June 1773 Captain James Cook arrived at what he called the Friendly Islands, a name he gave the Tongan archipelago on the basis that 'a firm alliance and friendship seems to subsist among their inhabitants, and their courteous behaviour to strangers intitles [sic] them to that appellation'.[1] Stamping names on places was what explorers like Cook did in the eighteenth century, and was part of the process of codifying and classifying the non-European world into terms that Europe could accommodate. The name stuck, and nearly two centuries later appeared in the title of a children's publication written and photographed by Ans Westra, and issued by the Department of Education in 1964.

Viliami of the Friendly Islands[2] was based on an expedition Ans made to Tonga, Fiji and Sāmoa beginning on 24 July 1962.[3] At the start of that year she had decided on a holiday out of New Zealand. Several parts of the South Pacific appealed to her, but after reading an article in *National Geographic* about the traditional ways in which whales were hunted in Tonga, she decided she wanted to visit that island kingdom and photograph its whaling practices, in the hope of getting 'a foot into *National Geographic* magazine'.[4]

Before she went, Ans contacted the School Publications Branch of the Department of Education, which was then located in Upper Willis Street, in an old home that had become a 'hide-out for writers and artists'.[5] The staff there suggested she produce an article about her travels for a forthcoming edition of the *School Journal*. School Publications was also planning a series

of booklets aimed at eight-year-old readers, and became enthusiastic about a photobook from parts of the South Pacific.[6] They gave Ans some guidelines for the text and images. This was to be a back-up plan, she decided, in case the whaling story did not pan out.

She arrived in Tonga in whaling season. The waters were getting warmer but there were hardly any whales. It was a hot wait. 'This isn't going to work because I'll burn to a fritter,' she thought.[7] Her accommodation was in the capital, Nuku'alofa, and, as the days passed with no whales, she decided to look for alternative subjects.

> I wanted to be able to photograph intimately a family so I hired a bicycle . . . I ran off, and I had a little pup tent. In this village, the first village I came to, I said, 'Can I have my tent here?' 'Oh you won't be safe . . .' I said, 'No, I'll be fine.' 'Well, okay then.' I was allowed a little distance from the village, [and] there were two little boys parked outside my tent and they would bring me gifts of food. Every time I cycled a little distance, and I would go near a village, people would come out with gifts. So I cottoned onto Viliami, who was eight, and just followed him, and he was fine with it.[8]

The time Ans spent with Viliami and his family formed the basis of her 56-page publication for School Publications. The images were supposed to inform New Zealand school children about how their counterparts in Tonga lived — a sort of 'compare and contrast' exercise — but Ans consciously set out to accentuate differences. Privately she expressed the wish that the Tongans she photographed had turned out to be more 'primitive' than she found them to be. But at least she had been on the islands 'before tourists came, before the plane started flying there. Now it's an absolutely different society, changed by the rest of the world.'[9] The hope of finding a location where the fingers of Western civilisation had still not quite reached was something that Ans clung to for the sense of discovery it would have offered, but she was centuries too late.

The opening image of *Viliami of the Friendly Islands*, written and photographed by Ans Westra and published in 1964.

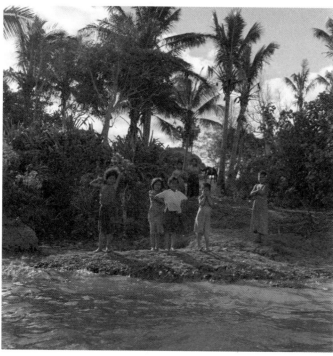

The cover image of *Viliami of the Friendly Islands*.

Ans' photographs were no tourist's view of Tongan village life. The opening picture, inside the front cover, was of Tongatapu, the main island of Tonga, but, as captured by Ans, it was little more than a barely perceptible smudge pinched between a slab of sea and an almost Turneresque sky, with swooping clouds dominating the scene. Having established the sense of isolation of this low-lying island, she followed it with images of Viliami and his family, with enough visual cues to impress on young New Zealanders that this was an exotic setting.

In keeping with much of her recent work, Ans eschewed the conventional portrait in favour of spontaneity. In the first photo, Viliami is looking to his left at something in the middle distance, with part of his body concealed by a plant. The following image is of his parents seated on the ground. His father, legs crossed, is peeling green bananas with a machete, and his mother is cleaning tapioca roots with a knife. Between them sits a dented old pot.

So far, so tropical, but then Ans pulled back from labouring the differences, and instead lunged at the familiar in a portrait of Viliami's sisters, the older one holding the younger one on her lap. It was the sort of staged photograph many New Zealand children would have participated in themselves at some point.

The following pages introduce other members of the family — children gathered around a pot, cooking dough mixed with coconut and sugar over an open fire for breakfast; Viliami's father blowing a shell horn to call the other men in the village to work planting yams. Viliami has a sore arm, which gets 'bandaged with tapa cloth', while another young boy opens a coconut and drinks the milk.

From the drudgery of work, Ans switched tempo. 'Tonight will be a big night,' she wrote. 'A concert party has arrived from Mu'a, another village. They have put up their curtains in front of our church. We children sit on our mats waiting for the big drum behind the curtain to announce the beginning of the concert.' Her somewhat lifeless prose was pitched at her young readership, and the images spread over the next several pages

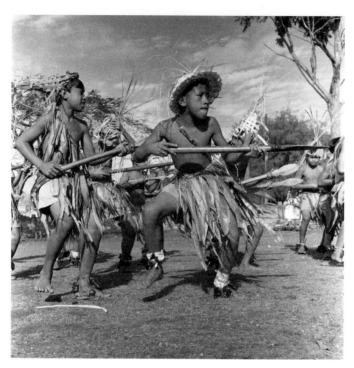

From *Viliami of the Friendly Islands*.

depicted scenes of 'a real Tongan dance' followed by a play about a hunter and a tiger.[10]

There is greater drama the next day, as Ans explains in slightly too indifferent a tone a tragedy that had struck: 'The next morning is a sad one. A little girl from our village has died during the night. Her relatives have sat with her all through the night crying for her and singing psalms. In the morning they carry her to her grave. All the villagers follow. Some little girls carry flowers.' Once the funeral service was over, '[T]he dead girl's family prepares a big meal for all the guests. The women worked quietly and speak softly. All day the village is very quiet.'[11]

For a photographer who is a visitor to another country, what are the bounds of propriety in such circumstances? In perhaps the only image in the publication that was truly ethically questionable, Ans positioned herself in front of the funeral procession, where three men held the coffin draped in a white shroud, and a trail of flower-bearing women followed behind. This image was certainly in keeping with the requirement to produce a documentary record, but there is a sense in which Ans the photographer was slightly too emotionally detached from the scene. At what point does photographing such solemn grief cross the boundary into taking advantage of that grief?

Of course that was not her intention. Did Ans' ability to switch off her emotional reactions and focus solely on the task at hand have its roots in the ability she developed to endure her own childhood trauma? Such an explanation does not make the photograph of the child's funeral any less confronting or troubling, but it is important to note that it was not the result of any sort of moral shortcoming on the photographer's part. On the next page, the narrative went from maudlin to mundane in a single sentence: 'The women roll dough and sugar into balls.'

The booklet skips through various scenes of daily village life: Viliami helping to cut and eat coconuts, cook a meal, and cross the lagoon in a canoe. Ans' photographs fortify the impression that Viliami spent his days rambling through this leafy island paradise, but the depiction of home life would have been a reality check for many New Zealand children. Austerity

and poverty in varying degrees conveyed a sense that life on the island, while friendly, lacked many of the home comforts they took for granted.

Saturday was washday at the village. This section of the booklet begins with a photograph of a family with buckets encircling a roughcast concrete water tank. This small reservoir was topped up regularly with water by wagon from Nuku'alofa, and on Saturdays people from the village would fill their buckets there, return home and heat the water on a fire. Then the weekly ablutions began: for clothes and people. 'The big girls and mothers do the washing,' Ans wrote. 'When they have finished it will be our turn to go into the tub. Grown-ups go into the special bath house, that is made from four poles stuck into the ground with plaited panels tied between them for walls. The baby has some sweet scented leaves in his washing water to make him smell nice.'[12]

For all the outward signs of difference between life in New Zealand and Tonga, in subtle ways Ans was also pointing to underlying similarities. The available technology may have been different, but in both countries Saturdays were set aside for cleaning and housework. And, likewise, Sunday was church day (although more so in Tonga than in New Zealand).

The final section of the booklet showed a drum being struck to call people to church. 'The drum is a hollow section of a tree trunk,' she informed her young readers. 'Sione hits it with a solid piece of wood and everyone in the village can hear its dull booming sound.' In both countries, churchgoers dressed in their 'Sunday best', and after the service they would enjoy a meal, which in the case of the village she described as 'the most wonderful food you can think of'.

At the end Ans threw in a photograph of Viliami and some of his friends doing a spear dance, taken almost at ground level to make the dance seem even more animated. This final outburst of exoticism left a sense of ambiguity for the reader. Tongan village life in some ways was so much like life in New Zealand, in other ways so radically different. Was the photographer focused more on the differences or the similarities? It is impossible to tell, and perhaps that was the point.[13]

The images in *Viliami of the Friendly Islands* — taken over the period of one week — became a collection of historical insights into daily life, a documentary record of a particular place and time that was a rare and special thing, difficult though that may be to believe for modern readers living in today's social media-infested world, where phone cameras are ubiquitous and mass circulation is the norm.

———

BUT FOR ALL ANS' patient involvement in and commitment to life in that village, there is still something missing from her account: the voices of the subjects themselves. And clearly detectable in some of her images a quest to locate the remnants of the idealised 'noble savage'. This concept had long been seductive to generations of Europeans, and even in the twentieth century was proving difficult to shake off entirely. To some degree Ans was caught up in this admiration for what she saw as a simpler, purer, less complicated and more liberated lifestyle. The focus on children in these photographs served to emphasise the idea of innocence.

She discovered that the ease with which she had entered into Māori communities was a transposable skill. She noted, for example, that when staying in the village in Tonga, a local family 'wanted me in when a girl of ten died of flu, they wanted me to still photograph the body and then they rolled that in tapa cloths and they had the funeral pyre sort of above ground'. Sixty years later she still had a sense of accomplishment about the sort of access she had secured. 'It was just an amazing sort of beginning,' she recalled.[14]

Viliami of the Friendly Islands was an educational project, but it was also a form of reality creation. It reinforced concepts of a stylised South Pacific utopia, which framed the way its residents were understood by outsiders. The book depicted an ethno-paradise regained. Some of the images — especially those of children — represented a culmination of Ans' compositional style to date, and her stay in Tonga embedded in her creative

consciousness certain themes to which she would return repeatedly in the following years.

Ideas such as rural serenity, dilapidation dressed up as domestic contentment and the universalism of childhood joy increasingly came to the fore in her work. And overarching all was an archetype of indigeneity that she was constructing. The ambition remained a work in progress throughout her life; she was driven to show to the European world unseen aspects of indigenous communities, and probably early on in this mission she fused in her mind the idea that capturing the unguarded moments of indigenous people was somehow equivalent to being culturally neutral.

Of course cultural neutrality is chimeral, but by being unobtrusive, inoffensive, honest, inquisitive and determined not to push any particular ideological barrow, Ans believed that she was producing work that was largely devoid of cultural bias. It was a naïve understanding, even for that era, but this in no way diminishes the historical, cultural and social value of the body of work she produced.

ON A SECOND LEG of her Pacific odyssey, Ans took a series of photographs for 'Children of Fiji', an article published in the *School Journal* in 1964.[15] These images turned out to be practically identical conceptually to those she took in Tonga in terms of subject selection and composition. Two distinct cultures from the region were thus fitted into a uniform cultural frame in her work.[16]

This was redolent of the European objectification of the Polynesian and Melanesian worlds that had prevailed for centuries. Until the latter part of the nineteenth century the indigenous inhabitants of the South Pacific were typically characterised and caricatured primarily as savage cannibals or lascivious wastrels (or a combination of both). However, as European dominion in the region expanded, explorers increasingly depicted the peoples of the region as endearing natives. They were still exotic, but now

in a safe, visitor-friendly way. Such representations were mirrored in many ways in New Zealand, where well into the second half of the twentieth century Māori continued to be cast in photographs and tourism artwork as 'guides, entertainers, carvers, and as components of the natural scenery'.[17]

Ans herself reacted to such stereotyping, pointing out that '[t]he existing books were showing a false, glamourised [sic] image of a culture that was kept alive just to show to the tourist — because it wasn't the real Maori culture at all'. She referred to what she believed was the 'real culture' that she had uncovered beneath the piles of kitschy tourist images. Like some cultural archaeologist, her explorations revealed, she said, 'what was left over of the olden times — what the real Maori was about'. In so doing, she formed her own European-inspired construct of this country's indigenous race.

This claim of exclusive understanding was buttressed by another claim: that of discovery. Ans referred to 'a lot of things that Europeans didn't know existed, like the Ringatu faith',[18] and that through her documentary photography, she was creating a visual record not only of those things of the Māori world that few if any other Europeans had encountered — such as a Ringatū religious service — but also of the types of scene that were close to disappearing altogether. There were echoes in this thinking of the dying-race narratives of Victorian New Zealand,[19] which encouraged a generation of anthropologists and artists to harvest information before their subject matter disappeared altogether.

Ans also occasionally expressed her apprehension about the imminent loss of Māori culture. 'There were a lot of old people and obviously they weren't going to be around very much longer,' was how she started out accounting for her choice of subject matter in this period.

> The moko was disappearing and a lot of the customs appeared to be dying out — that was the general feeling at the time . . . Once the Maori came into town they were assimilated. I wanted to document particularly Maori things — in the rural rather than the urban area, because that was where things still existed . . . In that

period especially, there was such a pressure on them to conform, to lose their identity. And there were still things left that were related to their history — there was a greater urgency then [to photograph this traditional world] than there is now.[20]

This sort of rescue narrative — photography as a form of cultural salvage — was not an especially dominant feature in Ans' photography of Māori in this era, but her stated desire to document that which was disappearing is discernible in some of her work, and helps account for the choice of particular scenes and, by implication, her decisions about what scenes to ignore.

———

BY 1963 ANS WAS back in New Zealand, where she spent several months preparing her text and photographs for publication the following year. At the same time she was chasing another commission from *Te Ao Hou*, and more work for School Publications. Her career was progressing slowly and steadily, but fate has a funny habit of capsizing certainties in ways that cannot be anticipated — or readily fixed.

5. Whitewash?

It was another Dutch national — Isaack Gilsemans — who became the first European to make a visual depiction of Māori. His 1642 sketch *A view of the Murderers' Bay, as you are at anchor here in 15 fathom* portrayed Māori in a way that dissolved any boundary between representation and vilification. It was a work of ethnographical caricature that debased the subjects while simultaneously attempting to assert the cultural supremacy of the artist.[1]

And so it started: centuries of Europeans directing their artistic gaze at New Zealand's indigenous population. Most eschewed the sort of animus that flowed from Gilsemans' pen, but interpreting the Māori world was an obstacle that confronted all Pākehā artists thereafter. In a sense, the situation was simpler in 1642. Back then, Māori were an unknown people to Europe, so artistic representations conformed to the rudimentary binary of civilised–savage. Māori language, culture, history, religion, poetry or art did not register until the nineteenth century, when Europeans began to comprehend some aspects of the Māori world. Even then, though, that cultural cataract remained for practically all non-Māori artists when portraying the country's indigenous people.

The arrival of photography was expected to change that. Clichés about the camera not lying, and the popularisation of the term 'photographic evidence', aimed to assure viewers that at last they would see the whole truth and nothing but the truth. Photographs supposedly erased any cultural

bias, and presented scenes that were value-free. Yet, for all the assurances of moral sterility and cultural neutrality, photography during the twentieth century became just as heavily weighed down with cultural presumptions and projections as any work of paint on canvas.

As artists immersed themselves more in the cultures they were depicting, the entanglements became denser, and notions of what constituted authenticity became more obscured. The notion of a generic gaze was fractured into numerous categories. The gaze could be disinterested, sensual, voyeuristic, avaricious, documentary, appealing for sympathy, or warning of danger. Furthermore, in the right circumstances, some of these categories could mingle, making the artist's motive more open to speculative interpretation.

At the epicentre of this complex discussion are issues relating to appropriation, representation and ownership, along with the concept of the Other. Sometimes a type of cultural dominance is evident to the viewer, but some argue that the fact that an artist depicting Māori is Pākehā is all that is needed to confirm that those Māori have been 'othered', and that these works exoticise or marginalise their subjects, no matter how much cultural empathy the artist may have had.

The risk in unleashing such arguments, and allowing them to roam freely, is that both the aesthetic merits of the art and its documentary importance can be subsumed by theoretical brawls from which no one emerges as a winner. And of course, the two need not be mutually exclusive. It is possible to critique the conceptual and cultural bases of a work of art, and at the same time appreciate its creative value. Ans' work from this period often secured images of ways of life that were fast becoming extinct. To reject it as cultural appropriation, or the result of a 'Pākehā gaze',[2] would leave an impoverished record of that era.[3]

ANS HAD NO INKLING when she took the short step from taking photographs for the Maori Affairs Department's *Te Ao Hou* to providing images for the Department of Education's *School Journal* that these weighty issues would suddenly crash her career, leaving a life-long imprint, both professional and personal. The work that launched the avalanche of controversy was *Washday at the Pa*, and the acrimony released following its publication gave rise to a cottage industry of increasingly festering recrimination. So why all the fuss?

The project started out ordinarily enough. The School Publications Branch had welcomed Ans' images of children in Fiji, and her more substantial *Viliami of the Friendly Islands*. In the case of the latter publication, Ans and others felt that the ingredients that had led to its success, in particular its focus on youth and everyday activities in a different cultural setting, were a recipe worth repeating in a New Zealand context. '*Washday* was really a continuation', is how she described the initial stages of her new project. 'School Publications had said, "Indian child in the corner dairy, whatever," — [spelling out] the various topics I could have. They hadn't quite counted on [what] *Washday* [came to be].'[4]

Ans had been working to immerse herself in the Māori world, driven partly by a desire to confront her own prejudiced views on ethnicity. Years before, when she was working for a photographic studio in Wellington, she had made casual reference during a staff meeting to wanting a cup of 'black Māori tea', and had found herself immediately shocked at what she had said. Soon after, she joined Ngāti Pōneke — a pan-iwi organisation for Māori youth based in Wellington. The group was advertising for members and Ans decided she would join.

Her memories of this involvement illustrate the extent to which Ans was committed to active participation rather than casual association with the group. She undertook an immersion course in te reo, received a Māori name (Ani), and became involved in various cultural performances. As part of one pōwhiri she even performed a dance. She was initially hesitant — 'I've always felt slightly gangly and sort of tall' — but when she told the

group, 'I can do a clog dance, and I can sing a Dutch song, I can do a rhythm', she found herself performing it in front of her hosts, much to their delight.⁵

Ans' membership of Ngāti Pōneke produced unexpected opportunities.

> I was made aware of the Waiwhetu Marae . . . [opening at] Christmas 1960 . . . in the Hutt Valley. I would travel on the train and just walk over to the marae and photograph the preparations for the opening, the painting of the marae . . . But what I used to simply love was that, okay they might be aware of your camera, but there were far more important things in life, so they blissfully ignored you on their own accord, not because I had to ask for that.⁶

She saw such associations of Māori in urban areas not as cauldrons of upward social mobility, greater prosperity and an entrée into the sort of enchanted suburban dream that some imagined awaited them, but rather as historical remnants, battered and scattered and far from home. Ans conceded that she harboured this 'strong feeling that things were going to change, that here was something historical that needed recording. They [Māori] were moving from the countryside into the cities. There was this sort of falling apart of tribal life at the time and Maori were losing their identity . . .'⁷

Through Ngāti Pōneke she photographed birthdays and weddings, which 'gave me some money when I was between jobs and I needed money for film. It also gave me material.'⁸ And it was in this 'material' that she sensed a whole world of opportunities opening up.

Ironically, Ans' participation in a culture that was alien to her own led to the first real signs of her feeling accepted in a community. The eternal outsider — whose professional career was about peering into the worlds of others — was beginning to feel like an insider. She felt she belonged. The welcome she received was genuine, and she responded in her own idiosyncratic manner.

> I took official photos for them, and photographed their functions. And if they went somewhere I went along. I went with them to Ngaruawahia a couple of times on their bus. That's when I really started photographing [Māori] . . . sleeping on the marae was marvellous, as I got to know the people. Once I was known and established and recognised with my camera there, I could go anywhere and I would meet the same people again and they would bring me in straight away.[9]

In this way she visited Ruatōria in 1963. She took a set of photographs of children at the local primary school, and the following day she came across some of the children walking along the road. As soon as they spotted her, they invited her home for a cup of tea and to meet the rest of their whānau. She asked if she could photograph them and they agreed, although at that stage she had no clear idea what she intended to do with the images.

Ans spent a couple of hours in and around the house, photographing anything that caught her eye. It was only after she had returned to Wellington and processed the photographs that inspiration struck. Having recently completed *Viliami of the Friendly Islands*, here was the opportunity for a Māori equivalent.

Ans' contact at School Publications was John Melser, who had a reputation as an advocate for the arts in the school curriculum,[10] and who needed little convincing to produce a *School Journal* based on her Ruatōria photographs. Ans set to work assembling the images and text for the booklet. Uncharacteristically, she decided to give the Te Runa whānau an autobiographical alias for publication — Wereta — and a fictional location: 'near Taihape'.

Although the chronology is not completely clear, it appears that by the time Ans was preparing *Washday at the Pa*, as it came to be called, *Viliami* was in production. Such fluidity was a normal part of a freelancing career at this time. Commissions overlapped and Ans became accustomed to working simultaneously on several projects.

By April 1964 she had completed *Washday* and it was at the printer, due for release two months later. In comparison with *Viliami of the Friendly Islands*, the photographs in *Washday at the Pa* were larger and dominated the bulletin,[11] and Ans had been much more frugal with her text; perhaps thinking the images would resonate more.

She had avoided any temptation to glamorise the circumstances and setting of the whānau. On the contrary, she appeared to emphasise elements that suggested poverty and decrepitude. For most of the tens of thousands of children who read *Washday at the Pa*, leafing through its pages would likely be an exercise in 'compare and contrast'.

The tone for the publication was firmly set with the cover image, a portrait of the mother with four children, taken in the doorway of their house. They are wearing old clothes and one of the girls has a scarf over her head, evocative of a style of dress prevalent in pre-war Māori society. The doorway that frames the whānau, literally and figuratively, has paint peeling from the heavily distressed weatherboards, and the steps to the front door are worn.

Ans was careful not to link the rural poverty in her pictures in *Washday* with any sort of moral failure. She even valorised some of the poverty on show, as if the moral of the story was that good character and a happy home are not dependent on material wealth. The text read: 'Hemi struggles into father's gumboots. They are much too big, of course, but when he turns the tops over he can manage them. And what a wonderful time they have sloshing about in the muddy puddles.' The water was 'icy cold', and one of the children in the accompanying photograph is wearing a jumper that is too short, and has a couple of large holes.

The motif of poor-but-happy continues, with the children walking barefoot through a near-freezing creek to get to the other side, where '[t]here is plenty of dry wood from the willow trees along the bank'. Then, with their arms full of firewood, the children return home.

One of the most prominent images is of the mother sitting on the ground outside the house, hand-washing the family's clothes in a metal baby bath. By 1970, six years after this photograph was published, over 90

per cent of New Zealand households had an electric washing machine, and so this scene and the photograph of clothes being hung to dry on a farm fence would have seemed like a throwback to another age.

There are images of fathers and uncles rounding up sheep, and children with elated smiles playing. Two images of the baby of the family being swung in a 'big flax shopping basket' were studies in uninhibited joy. There is food on the table, but there is a barely muffled impression of hardship in these pictures.

Towards the end of the booklet Ans placed an image that caused great controversy. The text reads: '"No good going to bed with cold feet," says Mutu. So she opens the lid of the stove and stands on it for a moment.' The photograph shows a child standing in bare feet on a metal plate that forms part of the stove.

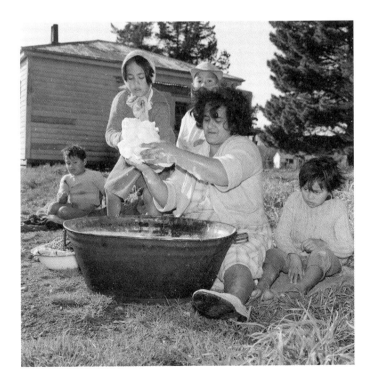

A photo from *Washday at the Pa*, published in 1964. The images featured the Te Runa family in Ruatōria and were taken in 1963.

WASHDAY AT THE PA had an initial print run of 39,500 copies. Of these, 2500 went on sale to the public, with the rest being distributed to primary schools throughout the country.[12] Although there had been subterranean murmurs within the Department of Education about the work while it was in production, there was no awareness among senior officials of it being anything more than casual comment — a vapour of low-level opposition that would soon dissipate.

Instead, these doubts turned out to be the harbinger of a collision between three tectonic forces in New Zealand society: a national Māori voice (representing especially urban Māori) that was asserting itself with renewed vigour; an emerging (mainly Pākehā) group of academics and commentators who were busy re-examining the country's race relations; and a 27-year-old Dutch New Zealand photographer who stood resolutely by her latest work of documentary photography.

The first sign of concerns over *Washday at the Pa* spilling over into the public domain came at the annual conference of the Māori Women's Welfare League in 1964. This still relatively new largely urban-based indigenous women's organisation, which advocated strongly for Māori and was eager to promote positive images of Māori families, took a dim view of *Washday*. Delegates' opinions ranged from mildly negative to completely derogatory, arguing that it portrayed a negative, dated and stereotypical view of Māori.[13]

During its July AGM one delegate argued that '[t]here are very few Maori people living in such conditions anywhere in New Zealand, even in remote areas', and asked the Education Department for 'an assurance that this booklet will be withdrawn from schools'.[14] Others suggested that Māori children might be victimised at school because of the booklet,[15] and noted that neither the Maori Affairs Department nor the Māori Women's Welfare League had been consulted when the work was commissioned or during production.

The League was a respected and effective advocate for Māori and its views could not simply be brushed aside. Moreover, it was not alone in its concerns. Within a week of the League's demand for the booklet to be

withdrawn, the Anglican Dean of Dunedin lent his support to the mounting campaign of criticism, faintly damning the work as 'hardly encouraging' to the 'very real efforts of the Maori to improve the welfare of his race'.[16]

On 3 August, Arthur Kinsella, the recently appointed Minister of Education, capitulated, announcing that *Washday at the Pa* would be withdrawn from schools. His statement began with a nominal concession:

> Nobody has denied that the family relationships portrayed in the bulletin are affectionate, good-humoured and co-operative ... The objections mainly referred to the family's living conditions, which were said to be untypical ... However, it is clear that the publication has given offence and I have therefore decided that it be withdrawn from the schools.

The £6000 cost of publication would be borne by the taxpayer, and all copies held by schools would be recalled and destroyed.[17] The director of the School Publications Branch then announced that if a private publisher reissued the work at any point, schools would be instructed to boycott it.[18] Kinsella further promised the League that the ministry would consult more widely in future before publishing any journal with Māori content.[19] Melser, who had commissioned the work, declined to make any comment to journalists, though he had previously described the booklet as focusing on the 'warmth and intimacy of family relationships'.[20]

Ans was reported to be 'really furious', and feeling almost marooned. She said the critics had missed the point of the booklet, which she had undertaken not for profit but rather because she was genuinely interested in documenting the lives of New Zealanders. She cited the nearly identical themes and similar subject matter in *Viliami of the Friendly Islands*, and emphasised that when it came to her work in Māori communities, 'I want to show their true way of living; I want to defend the true values of the Maori way of life.'[21]

However, she was not completely tone-deaf to the shifting attitudes towards the representation of Māori. For more than three centuries, Pākehā had been producing visual portrayals of New Zealand's indigenous population with little awareness of the cultural context. It was only a matter of time before Māori began to express a view on the matter. While Ans was infuriated by the decision to destroy her publication, she appreciated at least some of the sentiments of her opponents.

'I believe,' she announced, 'that something, even if it is artistically good, should not be published if it hurts the feelings of a lot of people.'[22] Already, though, she was in talks with the Caxton Press, which was eager to capitalise on the publicity around the work and issue a version that was beyond the grasp of government officials. From this distance it is difficult to reconcile Ans' public contrition with her private motives.

The editor of the Christchurch *Press* weighed in on the controversy on 11 August 1964, accusing Kinsella of 'timidity', and the League of having acquired 'a deplorably wrong sense of values'. Ans Westra had represented Māori as

> a jolly, normal, well-behaved family who work hard (Mr Wereta is a shearer), keep their homes and themselves scrupulously clean, and enjoy innocent, homely pleasures. In brief, they are thoroughly pleasant and agreeable New Zealanders. If all our people had the same qualities New Zealand would be a happier and better country, as happy and good as it should be.

Then, addressing the issue of the photograph of the child standing on the stove, which had irked so many members of the League because of its violation of tapu around cooking places, the editor concluded: 'One picture that will live in the memory of the few fortunate to see it is of the lovely little Mutu warming her feet on the stove before going to bed. It is a pity that she is not to be allowed to warm the hearts of New Zealand children.'[23] This was a widespread (though not universal) Pākehā reaction at the time.

Leading the charge for a Māori voice to be listened to — a rarity in New Zealand society in the 1960s — was Ruiha Sage, the newly elected president of the Māori Women's Welfare League. Sage countered Ans' outrage at the booklet's withdrawal by claiming that 'the fury of one person . . . had no comparison with the shame and anxiety she had caused among 300 Maori women at the last Dominion conference of the league'. The photographs in the work, she continued, 'especially the one showing a child standing in the lid of a copper stove for warmth, showed Miss Westra's ignorance of the true cult of the Maori . . . The body in relation to food utensils is tapu — that is something she will never understand.'[24]

Ans, for her part, claimed she did know of the tapu, and the photograph in question had not been her idea:

> [At the end of the book] they go to bed, with the various versions of why the child is standing on the lid of the stove. It was not an acceptable picture. You can say, okay, this is an area where food is prepared, you shouldn't be putting certain parts of your body there. And I was aware of that as something you can't do, but Mutu . . . the girl herself, said, 'I could do it.' You know, 'No spirit's got me . . . I could do that.'[25]

She insisted that she took photographs of scenes as she found them, and that this particular image was not staged and was non-partisan, but that mattered little to her critics.[26] Ans was castigated by the League's president for having tried to write a book 'on our true way of life' — a reprimand that invested *Washday at the Pa* with a purpose and a great deal more content than it actually possessed.

From this point, Sage's commentary became more condemnatory, accusing Ans, among other things, of a 'somewhat perverted sense of journalism'.[27] Looking back today her rhetoric — combative as it was often was — can be understood in the context of a newly formed Māori women's organisation standing up to express its views in a realm traditionally

dominated by male voices. In challenging an immigrant Pākehā woman, the League was strengthening its political muscle without the risk of offending groups on which it might rely for support.

At the end of August the New Zealand Maori Council waded in to support the League's position. In its newsletter the council insisted that the 'real' Māori 'is not the one living in an old shanty in some remote pa; it is not the one whose children run round in ragged clothes and whose wife does the washing in the backyard'. Instead, the 'real' Māori was 'the one who lives down the road and goes to work on the same bus as you, whose son is the local bandleader whose daughter beat your girl at school last year'.[28]

It would be wrong to imply, however, that there was a single, uniform Māori stance on *Washday at the Pa*. Artist Selwyn Muru 'spoke up against the banning of the book' and, in Ans' words, 'saw the value in my work'.[29] And a young teachers' college lecturer named Tipene O'Regan pointed out that when news of the booklet's recall was announced, his students rushed out to secure as many copies as they could. 'We were captivated by the sensitivity of her pictures,' he later said, 'and the images seemed to us to really talk of the Maori world that we were all hungering for.'[30] Ans did indeed receive the support of some Māori during that tumultuous period, but it was generally somewhat muted, and as far as public perception was concerned, the debate was clearly divided along ethnic lines.

For the rest of the year the letters to the editor columns in the nation's newspapers were choked with correspondence arguing the toss, but by early 1965 the controversy had died down. At the heart of the criticism of *Washday at the Pa* was a paradox. As a publication aimed at a mass (school-age) audience, it was seen by many (both Māori and Pākehā) as a throwback to an outdated depiction of the country's indigenous population as the rural primitive 'other', ignoring the rapid modernisation tens of thousands of Māori were undergoing in the 1960s. Surely, these opponents reasoned, no one needed a reminder of the poverty that so many Māori were leaving behind.

For others, however — particularly the numerous Māori who had left behind their rural background — Ans' photographs tugged at their senti-

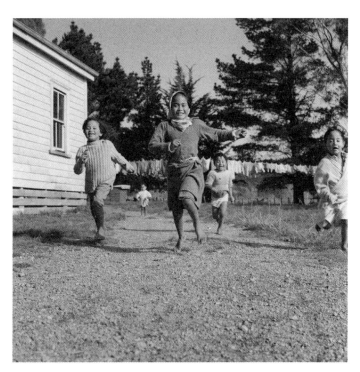

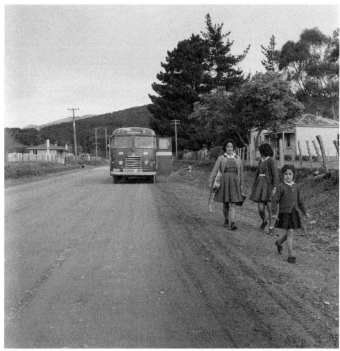

Photos from
Washday at the Pa.

mentality for their papakāinga. While outsiders might form an unfavourable impression of what 'back home' looked like, some of the new Māori migrants to the cities could see through the poverty and the dilapidation, and recall the love and intimacy of such settings.

Two of the School Publications editors at the time were poets James K. Baxter and Alistair Te Ariki Campbell, neither of whom had suggested any substantial edits or changes before publication. Baxter, however, perhaps more than any of Ans' other friends, felt torn. Privately he had expressed reservations about some of the images in the work, but he also saw its overall value. He came out publicly in favour of *Washday at the Pa* as a publication of some artistic merit, but criticised the workings of officialdom, and what he saw as a double standard applied by the officials who agreed to its publication:

> Over the past two decades Maori people have received a prolonged and didactic barrage of good advice on the best way to achieve first-class citizenship. From many quarters . . . they have absorbed the knowledge that some aspects of Maori life must be dispensed with. When a booklet is distributed to primary schools . . . showing Maoris in sub-standard housing, naturally they notice the housing, and the very ragged clothes of the children, rather than the particular merits of the photography . . . The Government cannot blow hot and cold with one breath; on the one hand urging rapid social change among Maori people, and on the other attempting to show a relatively primitive way of life as admirable.[31]

What Ans chose not to disclose publicly was that she had arranged for the whānau featured in *Washday at the Pa* to receive £20 (roughly equivalent to $1000 today) from the Department of Education for their participation in the project. However, officials procrastinated, and it was only when they returned the copyright for the work to Ans, with a sardonic 'Here you are, good luck', as she paraphrased it, that the money was released to the whānau.

In response, she received 'this beautiful letter from [one of the whānau] in copperplate saying, "It will be very useful, [as] we need to buy uniforms for the kids to go to school." I said, "They're going into town now and it will be so different."'[32]

There were other drops of consolation and vindication, too. She discovered, for example, that the photographs she had taken of the whānau were the only images they had of that period in their lives. She recounted how at one whānau reunion, photocopies of the book were made at the library and circulated because not everyone had a copy. And most movingly of all, a year after 'Mrs Wereta' died, a copy of one of Ans' photographs of her was placed on her headstone at its unveiling. A book that sparked one of the most political and heated debates about photography in the country's history ended up, for this whānau at least, making a private and meaningful contribution to their lives.

———

IN 2011 A REVISED version of *Washday at the Pa* was published by {Suite}.[33] Ans' original text had been removed and several previously unpublished images from the 1998 photoshoot were included. Ans was involved in the selection of these additional photographs, indicating that she remained unrepentant about her work almost half a century later.

She never abandoned her stance that *Washday at the Pa* was aimed as a corrective to some of the contemporaneous visual portrayals of Māori. In the 1960s New Zealand was still wrestling with the inheritance of tourism photographs of the late Victorian era, in which Māori were often cast as cultural ephemera — the sort of docile 'traditional' natives who made an exotic addition when framed on a mantelpiece. Ans was trying to kick loose from such depictions:

> What they were showing at the time were books of the Maori, but then really dressing them up in what was left of their costume,

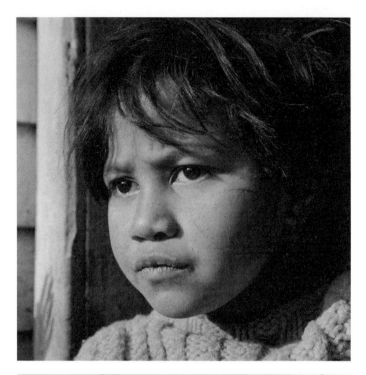

The back cover photo of *Washday at the Pa*.

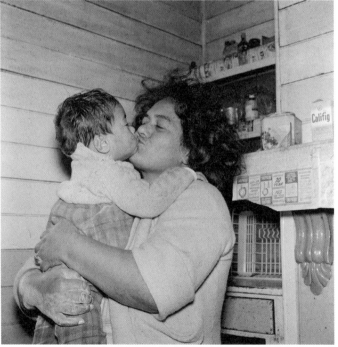

A photograph from the revised edition of *Washday at the Pa* published by Caxton Press in 1964.

> and posing them in a way that was pleasing to the tourist. They were totally contrived images. Whereas I was trying to record what made them as people, what made them different . . . And also trying to show that they were people like the rest of us on the one hand, and on the other side that they had something that was uniquely theirs.[34]

Ans' life-long claim to be a neutral observer, peering in from outside the culture to obtain non-partisan images, presumes there is such a thing as cultural objectivity. She gave no consideration to how her own cultural outlook influenced her choices during a shoot. Neil Pardington and Robert Leonard argued in an article in 1988 that Ans' sometimes self-professed ignorance of certain cultural codes enabled her to project her 'humanist mythology over Maori . . . totally'. Thus, in *Washday at the Pa*, 'she doesn't offer "realism" so much as an alternative mythology'.[35]

It is entirely possible that had *Washday at the Pa* been published initially by a private publisher, rather than by a branch of the government, none of the sound and fury would have ensued. The 1964 Caxton edition sold well, with no fuss evident.

———

IN THE FOLLOWING DECADE, Māori urbanisation spawned various activist groups, many of which echoed civil rights protest groups and militant black resistance organisations in the United States. Among much else, they became increasingly critical of manifestations of the 'Pākehā gaze' at the Māori world.[36] Assimilation was out, and self-determination was in. Under the ideological sway of overseas theorists such as Antonio Gramsci, Paulo Freire, Frantz Fanon and Michel Foucault, some activists divided the world into a binary of Māori and non-Māori, the latter having no entitlement to make any depiction or assessment of the former.

Ans Westra was unavoidably caught up in this turbulent current when

a new generation of activist academics attacked *Washday at the Pa* not over its documentary value or aesthetic merit, but rather for the fact of the photographer's ethnicity. She was labelled an 'outsider' who was lacking in a 'Maori mind',[37] and acting without 'dignity' by photographing a culture of which she had insufficient understanding.[38] Her work was said to be an expression of her 'cultural arrogance', and of 'neo-colonialism'.[39]

The decades following *Washday at the Pa* gave Ans time to reflect on that pivotal work. Had she ever questioned the decisions she made when taking those photographs, or subsequently writing the text, or preparing the work for publication? 'No,' was her unhesitating response. She had no regrets.

But she was aware of changes in temperament in the country as the sense of indigenous self-assertion took hold. 'Māori weren't quite as innocent and as welcoming as I'd known them in the early sixties . . . The language became important, the protest movements became important.' At the same time, while the shoulders of some of her potential subjects seemed to be getting colder, she was also aware of becoming typecast. 'I was known as a photographer of Māori and that limited my ability almost . . . I went to a Māori Women's Welfare League Conference at the Sheraton in Auckland and some teenagers were sitting in the entrance strumming guitar. They called out, "Washday at the Pa!" when I walked in. I was known as [that] photographer.'[40] She was aware of the irony of her situation. She had acquired a reputation for her attention to a culture, but sections of that culture were now looking back at her work and message with a more critical gaze.

It was not the case, however, that the divergence between Ans and her subjects widened inexorably. Not only did she remain welcome at hui where few if any other outsiders were allowed to take photographs, but some of the hardened opinions she had faced in the 1960s also softened over time. The most striking demonstration of that came from the Māori Women's Welfare League itself. In November 2011, at the time of the republication of *Washday*, the organisation publicly backtracked from its earlier position, with a spokesperson conceding that the whānau featured in the work 'had a

long and trusting relationship with Ans', and that '[i]f they want to agree to the pictures being used then it's their prerogative'.⁴¹

———

AS PERSUASIVE AS SOME of the academic critiques of *Washday at the Pa* might have been, many imputed various motives to Ans' work even when such motives were manifestly absent. When the attacks eventually ran out of steam, there seemed to be a ready supply of critics prepared to open up on new ideological fronts, some drifting a great distance from the booklet itself into a mist of abstractions.

And yet the stigma stubbornly refused to die. Ans' response became a sort of high-wire act — a deft balancing feat high above the fracas. Throughout, she believed that she herself had done nothing wrong, and blamed 'Māori radicals . . . [who] have put me in a position of being exploitative . . . I've given Māori access to their history as much as any New Zealander really . . . People are people.'⁴² It was hardly a knock-out blow, but she refused to own the motives critics ascribed to her. She merely stepped to one side, allowing their voices to disappear into the academic ether.

Still, *Washday at the Pa* remained for her an ever-present shadow. For the rest of her life, whenever Ans Westra's name was mentioned, *Washday* popped into people's minds. She turned her attention to new projects, relentlessly driven by the urge to create more art and documentary photography, but she could never quite free herself from the *Washday* controversy. On one occasion she was photographing somewhere when, she recalled, 'Somebody [came] up to me [and asked], "Who are those pictures for?" And I began to say, "They're for the National Library." "Oh, I thought so. You did that terrible book, *Washday at the Pa*, didn't you?" I mean there was such a back-swell from that.'⁴³

Some form of poetic revenge occurred in 1998, when Ans took a series of follow-up photographs of some of the surviving members of the whānau, 35 years on. The suggestion had come from her friend Jeanne Lomax, an

educator and oral historian, and photographer Eymard Bradley. Ans was keen. But would any of the whānau be willing to participate, especially given the rancour that had surrounded the project? Ans applied for Creative New Zealand funding and got to work.

'I got a contact address, and I went first to actually ask permission in that case, and said, "You can get a fee." Now the girl who was on the back of *Washday*, she said, "I don't want it. I don't want money. I'm happy where I am." Little kids [in a] house on the edge of a cornfield, and I said, "Oh come on." She had a little beer fridge — the door didn't shut properly and she had a broom handle to shut it. I said, "Look, get yourself a new little fridge." And then David [Alsop] went to see them as well and I made him take a whole lot of meat and stuff. Koha — you give back.'44

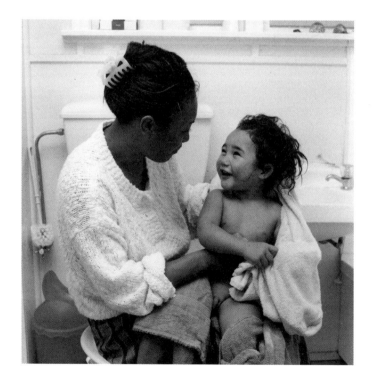

A niece of a woman who featured in the original edition of *Washday at the Pa* was photographed in Napier by Ans Westra in 1998 for the revised edition, published by {Suite} in 2011.

Naturally, people's circumstances had changed since 1963. Some whānau members had died, and others had moved away from Ruatōria. But, said Ans, 'in many way things hadn't [changed]. They still had the very large families, which was interesting. The one daughter who was the key figure in the story, she still had no wallpaper on her walls and said "that is what I remember from Mum. I don't want carpet, I don't want wallpaper, it's not important. That's not the childhood I remember, and I feel comfortable."'[45]

Two of the photographs Ans took in 1998 were included in the 2011 edition of *Washday at the Pa*. Although she had been careful to avoid staging the shots, there was a definite resonance with the 1963 images. One detail she did notice was that each member of the whānau she rephotographed 'had a line of washing out'. What else could she do but laugh?[46]

One photograph was of a niece of one of the women photographed in 1963, holding a just-bathed baby in a towel. The room looked warm; the surroundings were modern instead of tired and worn; and the clothing was new, but the message of this photograph was that all these distinctions were irrelevant. What really mattered, and what had mattered all along, was the expression of exuberant joy on the child's face, while the mother looked back with a soft gaze. The love between them was unmistakable.

Together, however, these new photographs represented the triumph of urbanisation and, to a degree, the cultural neutering that went along with it. The house interiors are identical to the housing of most Pākehā in the late 1990s. It is as though Ans was responding to her critics by saying, 'Here you are. You got what you wanted. Is a show of material success really the most important thing?'

Was she naïve? 'Yeah, possibly,' Ans responded when asked. 'I know [anthropologist] Margaret Mead says that I romanticised, but on the other hand, her view of the Pacific was equally romanticised and not directly accurate.'[47] Naïve she might have been, but she was always ready to stand her ground when it came to the value of her work.

BY THE TIME *Washday at the Pa* was reissued in 2011, enough time had passed that the images took on a different quality. They were now being viewed in a substantially altered social and cultural environment. They came across almost as museum specimens, carefully curated and encased, with their political force largely drained. This time, 50 years on, Ans' photographs provoked curiosity and interest among academics and the art community rather than condemnation.

For the rest of her life, Ans' response to the aftermath of *Washday at the Pa* remained consistent. She was outraged by the censorship, and dismissive of the reasons for it. She did not nurse grudges against those who had led the charge against the work, revealing a capacity for detachment that insulated her from the distress that would have sunk many other practitioners. In her mind, the experience of taking the photographs ultimately counterbalanced everything else. 'I certainly cherished it,' was how she recalled her brief time spent documenting the whānau.

What she cherished even more was the freedom she continued to enjoy to approach her work in the way she felt appropriate: 'I try to . . . put a stake in the ground for documentary photography. The way people are taught nowadays, well, they have no right to photograph anybody, they can only photograph themselves. If ever those photos are in a time capsule and aliens dig them out, they will get a very funny vision of our society, a totally untrue one.'[48]

As far as Ans was concerned, posterity would be the better for the existence of the photographs in *Washday at the Pa*.

6. Good Keen Men

August in Wellington in the 1960s. Looking out to Cook Strait the sea seems perpetually choppy. Raw winds funnel through the streets. Rain falls indiscriminately, and at night, those few who are forced to be outside huddle, shiver and scatter as soon as they can to whatever shelter is their destination.

In her flat on Allenby Terrace, directly in the shadow of the gothic-inspired St Mary of the Angels Catholic church, Ans Westra was holding gatherings of a particular stratum of the city's creative community. 'That was the segment of my life where . . . it was just hippy times, everything was acceptable,' was how she summed up the spirit of the age.[1] The storm over *Washday at the Pa* showed no signs of abating but Ans was doing her best to get on with her life.

'You would just put out word amongst the students, "Party tonight, 1 Allenby Terrace", and people would all come with . . . beer, whatever, and [there was] dancing, singing till all hours,' she recalled.

One of her regular guests was the high-profile and flamboyant Wellington doctor Erich Geiringer, who Ans remembered 'had a cape which was black on the outside and red on the inside and he would come swooping down after he'd seen a few patients'. Another among the diverse mix of guests was the young author Barry Crump, the author of four novels; his most famous, *A Good Keen Man*, had been published in 1960.

There were several of these parties at Ans' flat around the mid-1960s, featuring a varying cast of the creative and rebellious. Ans was sorely

tempted to take out her camera and record a few choice moments for posterity, but decided 'that would have disrupted [the ambience] because I would have needed to use [a] flash'. And some scenes really did not lend themselves to being documented. 'Barry [Crump] would drink till he would be sick, and then . . . he would drink some more. And chain-smoking.' And anyway, forgetting was part of the purpose of these parties.[2]

At one particular party, in August 1964, a few people were dancing, others were locked in conversation, smoke of various sorts hovered below the ceiling, when Ans discovered they had run out of beer. This was a problem because at the time pubs and bottle stores closed at 6 pm. A solution was fortunately at hand: 'Barry knew the barman at the hotel across the way. I had the Volkswagen parked on The Terrace, so we drove. I had a small bottle of gin which I emptied, and I still drove the car all right . . .'

As Ans was driving back home with the beer, Crump in the passenger seat, the conversation took a particular turn and she pulled over to the side of the road. 'I still know the exact spot,' she recounted much later. This roadside location, she continued matter-of-factly, was 'where I conceived Erik'.[3]

The two then returned to the party. Crump, perhaps sensing the possible consequences of the earlier moment of passion, 'dragged me over to Erich Geiringer', said Ans, for an impromptu medical consultation. Any hope of a lasting romance vanished as she heard Crump telling Geiringer, '"Better feed this woman up with the [pill]" . . . and it went through my head: "You might just be too late." And [Erich] . . . sort of grabbed my upper leg . . . through my skirt and said, "You've got a good one there Barry".

'I was by then in my late twenties and very ready to have a family, but not specifically looking for somebody to marry; that wasn't important.'[4] It was lucky she wasn't looking for a husband because the man who had just impregnated her was by most measures not the ideal choice. Crump disappeared from Ans' life shortly after that August party, but would reappear intermittently, in an occasional cameo role, usually unexpected, and not always welcome.

ANS' RELATIONSHIP WITH CRUMP — such as it was — endured for a few months after the party. He then visited her around November and said that they had to end their liaison as he had just met a former girlfriend and had discovered she was pregnant. The following month was the School Publications Christmas party.

> I told [him] I was expecting. He said, 'All right, we'll get married. The only problem is I'm still married to Fleur Adcock.' It had never occurred to me that we would marry, that I would be Mrs Crump. Anyway . . . I was in the Volkswagen, and he sort of patted my tummy and said, 'That baby will change your life.' He said, 'Better go to the welfare people and have it adopted.'

Ans initially was swayed, if not persuaded, by the suggestion:

> So I went to have a session with the Social Welfare people who said, 'For adoption we look for a suitable family. It would be great if we can find a Dutchman, preferably a tall Dutchman. You know — your build', because I wasn't short. 'It would be even better if we could find a photographer.' I had to laugh. I thought, you're not having my baby. They matched him up as far as they could, you know. They did their best. A tall photographer Dutchman, yes, thank you very much. I wanted my baby . . . If I couldn't have the father at least I could have the child.[5]

Early in 1965 Glen McDonald, a 16-year-old student at Wellington Girls' College, was boarding with Ans and was present on 7 May when Ans went into labour. Nearly half a century later, Ans' recollection of this event remained vivid. The baby was a few days overdue, and she had woken on a Saturday morning feeling an ache. Instead of going to the hospital, she set about cleaning the house. 'I was scrubbing the floors — the only thing I didn't do was finish a whole lot of prints on the drum glazer, which I should have done

because they were lost in the end. I didn't tell Glen the baby was coming.'

Ans and her boarder drove to Woolworths on Cuba Mall to buy some cat food, then took the car to the mechanic for servicing. Eventually Ans drove them to Hutt Hospital, pulling over to the side of the road each time she had a contraction. She would turn the engine off and 'wait it out'. 'By the time we got to the hospital we were in stitches with giggles and in the elevator to the maternity ward nobody believed the baby [was coming].'[6]

Erik Westra, Ans' first child, entered the world at eleven o'clock that evening, and shortly after, Erich Geiringer (who had delivered him) joked, 'You should have brought your camera', to which she replied, 'I did. It's all in my bag.' Geiringer asked a nurse to get it and Ans showed her how to set it up. She always kept the set of blurry shots of her new baby.

She named him for the Norse explorer Erik the Red — Eirik Rauð. His middle name was John, the same as his father's.[7] One of the first things Ans said after Erik was born was, 'Now I will never be alone.'[8] It was not a selfish or resentful statement, but rather a practical realisation that her life would now be irrevocably different; that she had a fellow traveller.

Speaking of the father, Ans had resigned herself many months earlier to the fact that they were not going to be a typical nuclear family. 'Barry was into smoking marijuana; I don't know if he was still drinking so much . . . He gave me marijuana, and because I'm not a smoker it did nothing for me.' The father of her child showed practically no interest in his son and his relationship with her was reaching its pitiful end:

> The last time I shared Barry's bed I was just crying the whole time because I knew it was the [end] and he said, 'Go into the bush and when you're on the top of a hill cry out at the top of your voice . . . [a] primal shout. Get it out.' And I tried. I went up a hill and I couldn't do it — there was this little voice — so I took Erik away and Barry didn't ask him over [again].

The next thing she knew, Crump had sold his house, bought a motorbike

and disappeared into the sunset. 'He went off to England,' she said wearily. Ans now had a family of her own, and appeared content with its compact nature. When she eventually told her own father that she had recently given birth, his reaction was devastating: 'He was incredibly racist . . . He came to check out that Erik wasn't Māori.'[9]

ANS MEANWHILE BEGAN TO contend with her new situation. In the 1960s being an 'unmarried mother' was seen as both a personal moral failure and a threat to the institution of the nuclear family,[10] such was the opprobrium that many young women gave up their newborns for adoption rather than bring down shame on themselves and their families. In the years that followed, Erik became her companion as much as her son. She insisted he call her Ans rather than Mum.[11]

Now there were two of them, securing an income was more pressing than ever, and thankfully, despite the controversy over *Washday at the Pa*, the editors of *Te Ao Hou* continued to provide Ans with work, a clear signal that they were not worried about employing the woman who had taken those controversial photographs in Ruatōria. In fact, 1965 proved to be one of her busiest years yet, with her photographs appearing in three of the four editions of *Te Ao Hou*.

However, the March edition — the first for the year — featured a review of *Washday at the Pa* by P. J. Ruha. The first review by a Māori writer, it began by acknowledging Ans' 'fine photography', with the subjects 'artistically portrayed'. Then the review got down to business. 'One wonders if the author really understands the background of Maori life, necessary for sympathetic and understanding treatment of such subjects . . .' There followed measured criticism of the 'stove' photo, then: '*Washday at the Pa* was published in the first place as a primary school bulletin for standards two to five. Children of this age-group do not usually note the artistic value of photography. They accept what they see and read as the truth.' The faint implication left

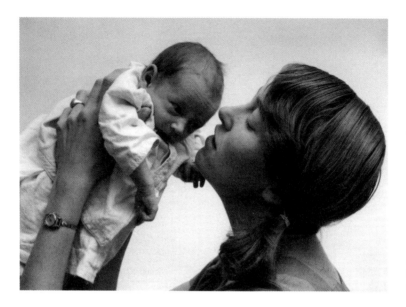

Ans Westra with her son Erik, Karori, Wellington, 1965.

hanging was that Ans' images did not quite reach the threshold of truth.

The review then took issue with the use of the word 'pā' in the title, which it described as a 'misnomer'.[12] Others, too, had argued that it was the wrong word. A pā referred to a pre-contact fortified Māori village, and in using this word Ans was further alienating the community in the photographs from contemporary mainstream society.

It was far from a damning review, but it did reiterate some of the key concerns for many Māori. Ans had never doubted the documentary quality of her images in *Washday at the Pa*, but at some point she decided that in future she would confine contributions to images, and avoid supplying text.

In the winter of 1965 *Te Ao Hou* published a story about a Rātana gathering at Te Rere a Kāpuni, the waterfall at the foot of Taranaki Maunga where the founder of the Rātana movement was said to have received inspiration and insight, and which subsequently was regarded by his followers as a sacred location. The journey to Te Rere a Kāpuni inspired Ans to take a very different approach from her last coverage of a Rātana event.

Shortly before his death (in 1939), Rātana had predicted that in 1965 there would be a mass gathering at this site. Widespread curiosity about this prophecy led to its fulfilment, and up to 10,000 people descended on Te Rere a Kāpuni in April,[13] among them the heavily pregnant Ans Westra. There was space for only four images to accompany the article, and Ans gave the selection a great deal of thought. One image in particular stands out for its almost biblical aura: a crowd gathered along the riverbed below the waterfall.[14] Many are in their finest clothes, while a few are wading barefoot. There are people standing with heads bowed and hands clasped in a state of deep reverence. The source of their inspiration — the waterfall itself — is not in the frame; Ans' focus was on the reactions of the devotees.

At first it seems possible that most of the people who thronged to the site were curious onlookers, keen to see whether the prophet's prediction would come to pass, but Ans' viewpoint, atop an adjacent promontory, makes it difficult to escape the impression that the viewer is peering down into a bush-lined valley inside a temple of nature.

For its September edition, *Te Ao Hou* asked Ans to photograph sculptural works by the artist Arnold Wilson, a modernist who believed that conventional Māori wood carving had almost reached the end of the line in terms of creative options, becoming a form of mimicry. 'Maori relief work has been thrashed, and to my mind is not "living". It is time now to see the possibilities in a different environment, and thus to make the works "live" again,' Wilson stated.[15]

Ans photographed four stylised pou whenua — carved posts traditionally used to delineate boundaries or to serve as a warning that the surrounding area was tapu — which had been temporarily placed in Wilson's garden. All four were stylistically different and Ans was given the freedom to photograph them as she chose.

She lowered the angle of the camera, creating the effect of the pou whenua almost looking down at the viewer, and thus possessing some authority. These totemic figures have an ancient history extending back millennia in Polynesia and some semblance of their status is conveyed in

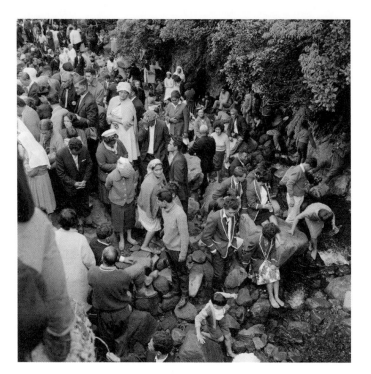

A Rātana gathering at Te Rere a Kāpuni, the waterfall at the foot of Taranaki Maunga, from *Te Ao Hou*, June 1965.

A photograph of pou whenua carved by the artist Arnold Wilson (Ngāi Tūhoe, Te Arawa), photographed in Kawakawa in 1963 and published in *Te Ao Hou* in September 1965.

Ans' photographs. But the depiction is not entirely reverential because three children appear in the images, playing with the pou whenua. Suddenly the scene is made dynamic, the stern faces of the carvings contrasted with the smiling faces of the children, and the pou whenua rooted in the ground while the children run around freely. The balancing act is skilfully managed; neither the children nor the pou whenua appear subservient.

As always, Ans played with themes of movement, life, culture, tradition, modernity, mortality, but without becoming prescriptive. The viewer was encouraged to consider the elements of the photographs and come to their own assessment.

———

WHILE SHE CONTINUED TO get steady commissions from *Te Ao Hou*, Ans always had an eye out for other opportunities. Now with a child to take care of, her earnings from her disparate jobs was often insufficient to cover basic living costs. Around this time she was commissioned to take photographs for a 56-page booklet to be called *Tamariki: Our Children Today*, published by the Maori Education Foundation, with text by Katerina Mataira.[16] This would be the first time Ans had collaborated with a Māori writer in a stand-alone publication.

The work's purpose was to prepare children to become familiar with books as they started primary school. As they worked on the project Ans and Katerina Mataira soon struck up a friendship. 'We were both expecting at the same time — she already had two daughters and was expecting another baby. This beautiful woman married to a physical education teacher — Julian Mataira.' Ans recognised Katerina as a person with whom she had 'an immediate understanding', and regarded it as crucial that she was able to 'add . . . the Māori voice'.[17]

Reviewing *Tamariki: Our Children Today*, the Māori academic Merimeri Penfold praised the book, observing that the particular combination of photographs and text worked well to emphasise the importance of the home

as a place of learning.[18] The widespread acceptance of this work, absent the commotion that had followed publication of Washday at the Pa, confirmed to Ans what she may already have suspected — that a partnership with Māori was essential when entering the Māori world. There would always be those who insisted that Pākehā had no place photographing Māori, and their voices would become more forceful over time, but Ans understood the complexity of the world, and the importance of the work she was doing, and was not derailed by this view.

ANS STILL HARBOURED A desire to publish a book of her own, an adult book about Māori, and had some years before had preliminary discussions with the publisher A. H. & A. W. Reed.[19] She had thousands of photographs, but first she needed to find a Māori author who could provide a text that would suit the images she wanted to publish. She approached a few people to gauge their interest and assess their suitability. 'I even thought of [novelist and teacher] Sylvia Ashton-Warner,' she said later, but was talked out of that idea by another novelist, Noel Hilliard, who warned, 'No, she's all over the place.'[20] Another possibility was Merimeri Penfold, but she was too busy. In the end, Ans settled on James Ritchie, a Pākehā academic who had a deep interest in the Māori world and was a fluent speaker of te reo. The two had met briefly in Wellington. As it happened, Ritchie had been approached by Reed's with a similar suggestion, so the planets seemed to be aligning.[21]

Around this time Ans moved out of central Wellington to a cottage she bought with financial help from her mother in the fast-growing suburb of Karori.[22] In the late summer of 1965 she bundled up all the paraphernalia of her work and her new baby and moved into a house on Makara Road, a place she thought would be more suitable for raising Erik. James Ritchie was living just three houses away, but was in the process of shifting to Hamilton to take up a position as a professor of psychology at Waikato University.

The early stages of the collaboration between the two was clumsy. They

knew each other in a cursory sense but had little mutual understanding, and the book's concept was still vague and unformed. Ans found the initial stages challenging, trying to match groups of photos to Ritchie's text: 'In some cases I was successful and it worked.' But not always. 'I was having a real struggle, and Jim [Ritchie] paid me the compliment, "You haven't got the trained mind", which I didn't. I had natural instinct but not a trained mind as such.'[23]

But they ploughed on, and by mid-1965 the book was nearly completed and given the eponymous title *Maori*.[24] Ans got some sense of the possible reaction by a portion of New Zealand readers when she showed some proofs to Kiriwai Hilliard, wife of Noel Hilliard, who said, 'You've seen a lot of dirty Māori.'[25] Ans considered this a consequence of the way Māori had typically been represented in glossy tourism photography in the past — the ultimate commodification of the culture.

A year before *Maori* was scheduled to appear, Reed's had published a much smaller photographic book called *Rebecca and the Maoris* by Gregory Riethmaier.[26] A German migrant who was a generation older than Ans, Riethmaier worked for the National Publicity Studios, a branch of the Department of Internal Affairs established after the war to supply photographs for government departments and other state agencies for a variety of purposes. A lot of its work in the early years had been producing promotional images for the tourism sector.[27]

A review of *Rebecca and the Maoris* described it as dealing with 'a lively, pretty Maori girl who lives in Rotorua'. In addition to 'portraying the warmth and every-day variety of normal Maori life', the book 'adequately covered the "sights" of the location'.[28] Ans found the work 'a little patronising',[29] and it may well have inadvertently served as a guide to what to avoid as she finalised her images for *Maori*. *Rebecca and the Maoris* was a salve that assured readers that Māori remained content in hermetically sealed cultural bubbles like Rotorua. They may have been, if not poor, then poorer than their Pākehā compatriots, but they were happy and satisfied. Urbanisation? Cultural dislocation? Racism? Twelve-hour factory shifts? Not in Rieth-

maier's book. Ans and Ritchie, on the other hand, were assembling a starker montage that was more likely to challenge readers.

The publishers were fully aware of this and, as publication neared, their trepidation mounted. Could this end up being another *Washday at the Pa*? Consequently, publication of *Maori* was delayed for two further years, until Reed's was more confident the work would be favourably received.[30]

By June 1965, life seemed good for Ans. Her new book was almost complete, she was enjoying steady work, she had recently moved to a new house with a new baby, and her photographic output was increasing in both volume and variety. The controversy over *Washday* was largely in the past, and her network of friends and associates was growing, especially among the creative community. Then suddenly she announced that she was going to return to the Netherlands for an undetermined period.

It seems a combination of things prompted this decision, not all of which were mentioned publicly. One was to do with family. 'I just wanted Erik to meet his grandmother, and my mother was utterly delighted with him. He was rather a beautiful, friendly little baby boy. So yes, and I thought those early months with the baby it was good to have somewhere to stay.' There was a hint here of another issue: the impact on her career of having to care for a child.

Impatient to leave, but aware of some loose ends on the *Maori* project, she decided to do the final image selection and printing (from a set of 800 photographs) in the Netherlands. 'My mother had this big kitchen. I took my enlarger with me, [and] developing trays, and I finished the prints for *Maori* in Holland.'[31] Even when she was at her mother's, she only managed to work on the photographs while Erik was asleep. Once again, she drew on the formative exhibition she had seen in Amsterdam as a student. 'I based the sequencing of my pictures on the *Family of Man* exhibition. I would collect a whole lot of pictures together and see what would work. I did most of my own layout from that.'[32]

The comparative freedom she had in selecting and sequencing the photographs stemmed from an early discussion she had had with Reed's.

When they first approached her about the project she had replied, 'Yes, but I don't like your book design. I want to have input into it.' Reed's agreed. To make sure of getting what she wanted, she said, 'I printed all the photos to size so that [Reed's] couldn't change the layout. I was determined they wouldn't mess around with it.'[33] She was satisfied with the book's final production, particularly in hindsight when she compared *Maori* with some of her later works in which editors and designers had greater input.[34]

ANS HAD NOT SOLD her house in New Zealand, but it seemed she had no immediate plans to return. Living with her mother 'certainly made it easier', when it came to raising Erik, but she still needed to make a living. In a step away from photography she began to assemble 'shells and bits of driftwood' to make craft items. 'There were very good shops in Holland where you could buy glass beads and wholesale [goods], and Mother sold what I'd made. She had a separate box on the counter, and each time one of my bits was sold I would get the money. I managed to furnish my whole house [in New Zealand] with my little jewellery making.'[35]

As artistic as this undertaking became, it was not photography, and Ans' passion for that medium had not dimmed. She decided on an extensive journey through Europe to find fresh subject matter. Money was short, so she entered PhotoPrize Amsterdam, a competition that would give her both publicity and prize money if she were successful. She soon discovered, though, that aesthetic preferences in Europe differed from those she had cultivated in New Zealand: 'I entered a series of photographs . . . but because I had not followed the education in Europe . . . [someone else] scooped the prize. My series . . . didn't even get hung on the walls [of the Stedelijk Museum].' She quizzed the judges but 'got nowhere'.[36] She could see her style was different. The winners' works 'were much more trendy than [mine]. My photographs were just too straight . . . it was just because I'd developed my own style here [in New Zealand]. I found what I could do best. So I didn't

really find my way again in Holland, probably because I'd started off here, been too far away from it.'[37] This small dose of artistic failure amplified her financial uncertainties, and her funds, which had been meagre to start off with, began to dwindle further.

In 1967, while Ans was still trying to find her feet back in the Netherlands, *Maori* was finally published in New Zealand. It was no orphan publication but rather the latest example of a Pākehā (many of them recent immigrants)[38] photographing Māori subjects. Theo Schoon, another Dutch photographer, had arrived in New Zealand in 1939, aged 24, and had gone on to photograph Māori carvings, tā moko and kōwhaiwhai in the late 1940s and early 1950s. Hester Carsten (also from the Netherlands) provided photographs of Māori subjects for *Landfall*, the country's pre-eminent art and literary journal, in the 1950s.[39] Photographs by Swiss national Pius Blank had appeared in a 1963 children's book by Lesley Powell: *Turi: The Story of a Little Boy*.[40]

However, although there was some semblance of documentary work in the output of each of these photographers, with minimal staging, they fitted more easily with the plethora of romanticised images depicting Māori in korowai, leaning against carved whare, looking wistfully into the distance — occupying, in other words, some Pākehā idea of an authentic indigenous setting. It was almost as if Māori were inherited antiques put on display in the nation's china cabinet.

Ans believed her own images to be far more authentic. She and Ritchie were trying to set the record straight, depicting Māori in contemporary New Zealand as they saw them, and not in some stylised colonial tableau. *Maori* would be the firm corrective to all that vapid imagery, and would recast the way in which Māori were depicted in photographs.

In a perfectly composed photobook, the text and images appear as a symbiotic whole, perhaps with an occasional tension evident over which of these two constituent elements dominates. In *Maori*, the tension was fuelled by the contrast between Ritchie's academically informed text and Ans' more intuitive approach to the photography. The visual content tended to predominate, in part because Ans had compiled the final sequence of

images while in the Netherlands, denying Ritchie any close collaboration. She was quite clear that she wanted her photographs to be able to stand alone, without the need for text to clarify their meaning.⁴¹

Maori began with 17 pages of text, opening with a resolute conviction about the triumph of the West.

> The Western way of life has spread all over the world. Only where other peoples live in areas of little economic interest have they escaped its impact. So it is only in deep jungle places, in the northern tundras, in isolated areas in rugged mountains, or in remote islands that anthropologists may now seek out and record what remains of the extraordinary variety of the ways in which men once fashioned their lives.⁴²

As far as scene-setters went, this was pretty clear. With Ans' first photographs not coming for another 16 pages, readers were being primed to see images portraying a group on the margins of the contemporary world — caught in a balancing act of traditionalism and modernity, trying 'to weave the broken strands of the old way into a new mantle . . . to revive the old tradition, to show that it still has meaning'.⁴³

The ensuing pages contained a mixture of history and anthropology as Ritchie surveyed Māori society from its origins right through to the present day. From there, the book traced the sequence of life, starting with a chapter on childhood, followed by one on 'Growing Up', then progressing through maturity, family life, social interaction and death. Death was not the end, though. Ritchie concluded the book with his interpretation of the state of Māori society in the mid-1960s and his prognosis for the future: 'Most Maoris now live in two worlds and move easily between them. The Maori world itself is in one sense closing . . . Some Maoris now have little identification with Maori ways. They have migrated psychologically as well as physically to the Pakeha world.'

All was not lost, though, as Ritchie set out a compromise solution. Some

traditional elements of the culture would survive, but only those that could be accommodated in modern New Zealand society.[44] Ritchie's approach resonated with ideas about the sociology of modernisation, which was a popular field of analysis among academics at this time, prescribing ideas about how non-Western communities could (and even ought to) transition into more Westernised forms of living.[45]

The precise extent to which Ans agreed with Ritchie's summation is unknown, but it is fair to conclude that in general terms she was sympathetic with his assessment.

Midway through the opening chapter on childhood came the first section of Ans' photographs — 33 of them — arranged in an idiosyncratic montage. However, ahead of any photos there was a small surprise. The first image was of a portion of a painting by Para Matchitt: *Te wehenga o Rangi rāua ko Papa*, depicting part of the Māori creation myth. After this concession to indigeneity (almost a stamp of cultural authority), the opening collection of photographs appeared, beginning with another surprise: a close-up photo of a smiling child — in colour.

There were two reasons for Ans' use of colour here. Although she had immersed herself in the artistic possibilities of monochromatic photography, and had a preference for that form, throughout her career she repeatedly made small inroads into colour. She spoke of her 'sense for colour', which she described as a 'gift from birth'. The other reason *Maori* included some colour photographs was commercial. The publisher had told her: '"No Māori will buy a book of black and white photographs." . . . They had their rules and so I had to have x number of pictures in colour . . . I did them basically as an afterthought.'[46]

All but one of the remaining images in this section were black and white. To herald the theme of childhood, Ans began with a photograph of a priest christening a baby. For all the talk in the work to this point about the traditional Māori world, here was a ritual that drew on an imported tradition. But Ans was asking the viewer immediately to consider this more closely. The child is Māori, as is the priest, which raises the question of whose tradition this is. Should the tradition be sealed off entirely from

outside influences? Was this image not encapsulating the transition that Māori society was in, as described by Ritchie?

On the very next page there was a hint of return. Once again photographing from a low angle, Ans portrayed a mother carrying a child on her back, wrapped in a blanket or shawl. The image filled the entire page. There is nothing overtly European in the picture, but at the same time it is saved from appearing like a colonial-era image by the fact that the garment is not a conventional korowai, and by an absence of carvings or any other visual references to locate the scene in a 'traditional' setting.

The juxtapositions continued. On the facing page was a photograph of a young Māori couple with a baby, but they were wearing contemporary clothing, and the man was holding the baby. Māori traditionalism was placed side by side with Māori modernism as Ans revealed the growing diversity of Māori society at this time.

This section on children was supplemented by at least one photograph that Ans had taken during her visit to Ruatōria, but which had not made the final selection for *Washday at the Pa*. The children are playing with their father on the living-room floor. Perhaps because she was conscious of how the *Washday* photographs had been received, this time Ans included enough of the surrounds to indicate that the setting was one of relative prosperity. The room has new carpet, new furniture and an electric heater.

After 'Childhood' came 'Growing Up', in which Ritchie avoided sinking into the swamp of anthropological theory by going to the other extreme, providing a lightweight assessment of the challenges Māori youth faced growing up in what was fundamentally a non-Māori environment. Parts of his analysis were sympathetic, but elsewhere he seemed to get caught up in generalisations that (for modern readers at least) come across as unsophisticated stereotyping. When trying to convey the importance of collectivism in Māori culture, he resorted to a catalogue of typecast traits:

> The fun of young Maori people is the fun of participation, of shared activity, of the sports team, the impromptu band, the more

A christening at Okahu Bay, 1963, published in *Maori*, written by James Ritchie, in 1967.

A teacher and children at Parikino School, 1963, published in *Maori*.

> organised rhythm group, the action song team or haka party, the feast at a hui, waiting on the tables, sending plates of food down a human chain, going off hunting in the bush with a mate, hanging around the dance hall, or just standing.[47]

Ans seems to have paid little heed to Ritchie's reductionism, and the connection between images and text in this section was minimal. In fact, for all of Ritchie's emphasis on community, around a quarter of the images were of individuals.

As the reader progressed further into *Maori*, Ans provided a succession of images highlighting those places where ripples from the traditional Māori world lapped against the shores of modern, urban New Zealand. The text next to the images was generally made up of snippets (mainly whakataukī, poems and so forth) from Māori writers in tightly knit combinations of pictures and words.

One example of this is a passage quoted from the great Ngāti Porou politician and Māori leader Sir Apirana Ngata, which implored Māori youth to grow up 'according to the pattern of your day and age', with their 'hands grasping the arts of the Pakeha for your worldly well-being' while they ensured that their hearts were 'ever mindful of the treasures of your forbears'.

Ans translated this sentiment in various ways in this section, but one photograph in particular caught the sometimes bewildering reality of living in two worlds. It shows a teacher and a student in a classroom. The scene has a cold, almost sterile atmosphere, with gleaming surfaces, stark light emanating from the windows, and the absence of any decorative features at all, making the two people in the room seem more encased than accommodated. There is little of Ngata's 'worldly well-being' evident. Instead, the student stares directly at the camera, fingers interlocked in a tight clasp, his face seemingly whittled into an image of uncertainty.

The teacher has his back to the camera. We don't know who or what the teacher is looking at, but there is no doubt that this is a location where

the 'arts of the Pakeha' are being imparted. The student is the recipient, but in a setting that is culturally arid, reflecting nothing of his own background. The effect is amplified by Ans' extraordinary use of natural lighting effects. In that classroom, Ans succeeded in capturing the architecture of despair brought about by cultural alienation. As hard as he might try, it is difficult to imagine this student remaining 'ever mindful of the treasures of [his] forbears' in such an austere environment.

'ON THE EDGE OF *Maturity*' was the title given to the next section of *Maori*, which focused on Māori aged roughly from their late teens to their late twenties. This was the generation whose members Ritchie described as knowing they were 'part of an older and firmer heritage than that of any other social group in the country', having 'grown up either in a Maori community or at least not more than one generation removed from the experience of such a community'.[48] It was a group that by the 1960s was split by experience and geography. Those who remained 'back home' continued with life in much the same way that their parents had. Those who migrated to the cities had confronted 'the sense of stimulation, of delight, of danger . . . Suddenly their world of experience exploded in their faces to include all kinds of people, of situations, of moralities, which they would never have before encountered.'[49]

This was a field rich with possibilities for Ans — maybe too rich. It was a big ask, given the constraints of space. The photograph she selected to open this section was of a youth staring blankly out into a street on a rainy day. We can see the youth's head in profile, along with his shoulders, through a shop's corner display window. This has the effect of obscuring his almost silhouetted outline, while simultaneously projecting reflections of the traffic and buildings on the window.

This virtuosic composition demands contemplation. The material world is shown up here for the surface-only value it possesses, along with its

Wairoa, 1963 (above), and Wellington, 1960, published in *Maori*.

capacity to distract and elude. The bright lights of the urban Promised Land are exposed as just superficial glare. Above all, the viewer is drawn to the solemn stillness of the subject's face, which conveys a sense of overpowering loneliness and concentrated gloom.

Not all is overcast with despondency, however. Images of dancing, sport, friends, music-making and cultural performances crowd the following pages. A vibrant urban rhythm exists for Māori in the cities, but Ans' shrewd perception drops a note of caution right in the middle of this pool of good-time scenes, and the warning sends ripples throughout the photographs in this section.

The scene in question is outside what appears to be a public bar. On the left, leaning against the white walls, are four Māori youth. As the viewer's eyes move across the photograph — over a yawning space of empty footpath — they land on a pair of women walking past, evidently oblivious to the stares directed at them by these young men. The separation — of space and gender — could not be more confronting. It is another of those images where the viewer imagines the differing intent of the parties, and the unresolved tension that lingers as a result.

In what was to be the central pillar of *Maori* — 'A New Family' — Ans went right off-script. Ritchie had patiently pieced together the features that he felt constituted Māori whānau at that time, but Ans took an entirely different route, portraying the family, in all its ethnic and structurally diverse shapes and configurations, as the heroic essence of humanity. The forms might have varied but not the function. The influence of the *Family of Man* exhibition was most evident in this part of the book.

The scenes of people at work, study or play incorporated the hardship some families faced (including a photograph from *Washday at the Pa*), along with the diversity of activities and settings where families functioned. But what few visual references there were to traditional Māori culture were insufficient to subsume the emphasis on the modernity. There was even a piece of sly humour thrown in, with a young Māori (nuclear) family looking through a shop window, with the sign 'Smith & Browns' hanging above

them. Perhaps a bit too obvious, but if it kindled a moment of reflection for viewers, then it was worth it.

From 'A New Family', *Maori* moved to 'Hui', which was used in a broader sense to include traditional gatherings of various forms. Again, Ans selected scenes that emphasised a variety of activities and groups of people. In an inspired decision, on facing pages in this section she managed to cram 15 photographs of two men engaged in a passionate conversation. Hands are held up, fingers are jabbed, arms are crossed, eyes are widened, brows are furrowed as seemingly the entire gambit of conversational display is put on show. The effect is practically filmic.

Maori had now just about come full circle, with the section 'Tangi'. This portion of the book dealt with various Māori dimensions of death. Ritchie recalled in some detail his own experiences in attending tangi, and the ways that he believed Māori responded to death. In the traditional setting, he suggested that 'death in the Maori world is rarely . . . personally catastrophic or disruptive', but noted that '[m]any Maoris in cities are now buried in the Pakeha manner with little or no opportunity provided for tangi. On such occasions there is a bleak and hopeless feeling, a new sadness, that what should be done cannot be done.'[50]

In her collection of images for this section of the book, Ans dwelt mainly on the way culture was used to mediate emotional reactions to the passing of loved ones. Death is the invisible presence in these photographs, meaning her attention was fixed on how people react to death, both personally and culturally. For all their desire and effort to fit into the Pākehā world, death draws many Māori back to the consoling rituals of their culture, and this collection of photographs embodied the essence of the processes of mourning, grieving and sharing that lay at the core of traditional tangihanga.

Everywhere, Ans made sure to incorporate the iconography of that cultural process. There were images of elderly women wearing kawakawa wreaths as their heads were slumped in grief. There were scenes of the respectful advance of people approaching the casket lying in state at a marae. There were depictions of individuals addressing the dead, honouring them

Tūrangawaewae marae, Ngāruawāhia, 1963 (above), and Rātana pā, Whanganui, 1964, published in *Maori*.

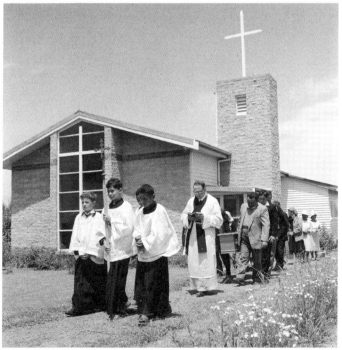

Putiki marae, Whanganui (above), and Te Kaha, 1963, published in *Maori*.

in oratory. There was a photograph of mourners eating at a table heavily laden with food, where eating was part of the process of lifting the tapu from the event. And there was the slow procession of women — clad in black coats and shawls — touching the tombstone of the departed.

The traditional ways had not remained stagnant, however. In one photograph a cortège winds its way out of a modernist church. A large crucifix at the top of the picture presides over this procession, led by a Pākehā priest and four Māori altar boys. Yet there is no apparent disjunction anywhere. Imported rites had long since been grafted onto indigenous ones, and the two were now inseparable.

Maori ended with a brief postscript in which Ritchie drew together the various strands of the preceding content. He summed up the nature of modernisation and urbanisation for Māori, and the challenge it posed: 'Within Maori society itself there is a new awakening to a new dawn. Its light is hard and strong, bleaching that which is feeble or inessential in present day Maori life, subjecting its most treasured activities to a new scrutiny.'[51]

There was space for just one photograph to accompany this closing section, and Ans selected an image of a kuia with a moko kauae (chin tattoo) and a young girl, both staring at some distant point as though gazing towards the future — a future that is unknown but not necessarily unsettling.

———

MAORI WAS AN IMPORTANT accomplishment. It was a handsome hardback, well designed with assistance from graphic designer Gordon Walters (who was married to Margaret Orbell), and utilising rotogravure printing, a type of intaglio process. It has been described as 'perhaps the finest New Zealand photographic book of the sixties'.[52]

Ans' motive for participating in this project was clear. 'I did the book mainly because in those days we felt the Māori were a dying people,' she said later. She did not mean this literally, in the way of the extinction narrative

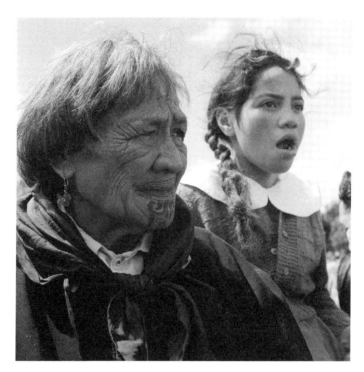

Tūrangawaewae marae,
Ngāruawāhia, 1962–63,
published in *Maori*.

of the end of the nineteenth century, but rather that 'through marrying and integration, it would just happen naturally that the Māori would disappear. And nobody was documenting their culture. I've so often found that things vanish very quickly . . . so it is that [need to] pinpoint history.'[53] With 211 of her images included, *Maori* was her first substantial opportunity to do so.

Readers at the time found *Maori* revelatory. One review noted: 'Westra's photographs show that there is in New Zealand a very real Maori world — a world in which the Pakeha is not normally present.' The quality of the reproductions was praised: the 'matt finish of the photographic plates and the use of matt light grey paper for the text enable one to enjoy the book without having to wear dark glasses'.[54]

Ans had finally published a fully fledged book, a landmark work. In the face of her increasingly futile struggle to establish a photographic career in the Netherlands, this achievement propelled her thinking about returning to New Zealand. But her wanderlust was irrepressible, and she was not quite done with travelling:

> With the proceeds of the first sale of *Maori* I bought . . . a brand-new Volkswagen with an opening roof. I ordered it from the factory in Germany and had the driving on the right-hand side, and I had Erik in a little car seat sitting in the passenger seat . . . [We went] to the North of Holland, wandering about, sleeping in the car together. That was a bit hazardous because people would [see two of us asleep and] think that we were a couple and they would bang on the roof of the car. [Or] the police said, 'No you can't camp there.'[55]

Most of the images she took at this time were in colour, and were, in general, compositionally unremarkable — resembling holiday snapshots rather than the carefully conceived works she made for publication. It was almost as though she could flick a switch and became a casual holiday photographer when she wanted to.

Despite travelling with him, there were signs that Ans wanted breaks away from Erik. At one stage she planned to send him away to boarding school. She had her eye on Summerhill, the alternative school in Suffolk, England, founded by Alexander Sutherland Neill. At times she left Erik with her mother to go off on her own around Europe taking photographs. These little traces of maternal ambivalence were an interesting contrast to her lifelong interest in children as a subject for her photography.

ANS DID PRODUCE ONE publication while in the Netherlands. *Children of Holland*, whose text was by Ingeborg Brown, featured photographs taken over the three years she lived in the country. Yet even this venture had a New Zealand connection — it was a commission from the School Publications Branch, and was published in Wellington.[56]

The photographs in *Children of Holland* were, by Ans' standards, fairly pedestrian images, but in a few cases she clearly invested a greater degree of artistic energy. A scene of a pair of horses pulling a cart along a rural road draws on a compositional style popular from the seventeenth to the early nineteenth century in European art; it is as if Ans were bringing this antique scene to life in a form of anti-modernism.[57]

Another pastiche of an earlier photographic style appeared in her image of a young girl, 'Riemke', standing with a suitcase inside the Haarlem Railway Station. From evoking rural landscape paintings, Ans had now shifted styles to a type of mid-century humanism. The scene was an act of documenting everyday life for illustrative purposes, but it also possessed a distinct aesthetic that connected it with other European (particularly French) humanist photographers whose works had been in vogue in the 1940s and 1950s. Ans sometimes became a bit of a stylistic magpie — taking the shiniest examples of other photographic movements, and incorporating them into her own works.[58]

Children of Holland was published in 1969 and featured photographs Ans Westra took during the three years she lived in the Netherlands.

'Riemke', standing in the Haarlem Railway Station, from *Children of Holland*.

This image had a noticeable poignancy. It was as though, through this photograph, Ans was reconstructing a memory of the experiences of a decade or two earlier — the time where she was growing up in the Netherlands. This style of work, which had dominated newspapers and magazines prior to the arrival of television in the 1960s,[59] had gone into decline by this time, but she consciously employed its aesthetic both to broaden her own stylistic repertoire and as a veiled homage to an earlier time in her life. The image also succeeded as a form of metaphysical challenge to the viewer.

The American documentary photographer Dorothea Lange, renowned for her images of the Depression and who was a significant influence on Ans' work,[60] conveyed this best when she wrote: 'The great photographer first asks, then answers, two questions. "Is that my world? What, if not, has that world to do with mine?"'[61]

In a very direct way, these two questions defined Ans' entire photographic career, and even her sense of herself and where she felt she belonged.

7. The Country I Live In

On 28 October 1969 the passenger liner *Iberia* sailed into the Waitematā Harbour with Ans and Erik Westra on board. They had been away just over four years. During the leisurely voyage back to New Zealand, with numerous stop-offs along the way, Ans had to face the fact that her attempt to settle back in the Netherlands had foundered, and to consider how she would reassemble her life and career in New Zealand. She occupied some of her time on the voyage considering ideas for a new book. She had come to realise that books, unlike feature articles or school bulletins, gave her the opportunity to include hundreds of her photographs, and to create a narrative in so doing. *Maori* had given her impetus to continue in this direction, but she needed a suitable topic.

During a short stay in Australia, on the final leg of the voyage, inspiration struck. She'd seen a book called *The Australians*, with photographs by Robert B. Goodman, and conceived of a volume called *The New Zealanders*, 'but that didn't feel good as a title'. She started considering the possibility of travelling around New Zealand, 'from top to bottom [in] different seasons', taking photographs of locations and people along the way.[1] The concept at this stage lacked form, structure and detail, but the seed was beginning to germinate in her mind.

Once settled back in Wellington, she put out feelers while starting to consider the logistics of such a project. Naturally all that travelling would take time and money. No publisher would pay for this, so in 1970 Ans applied

for funding from the Queen Elizabeth II Arts Council. She wanted, she explained in her application, to create 'a comprehensive photographic essay on contemporary New Zealand life', which would be 'a personal response to the people and their environment', resulting in 'a historic social document of life in New Zealand in the 70s for future generations'.[2]

She was awarded $500 (around $9000 in today's money), which would come close to paying for her food and petrol, and this was all the impetus she needed.[3] She had no accommodation costs — she slept in her car, a lifelong habit.

One of the potential publishers she talked to was Alister Taylor, then an editor at Reed's who was looking for a suitable project to launch his new independent publishing business. They discussed possible subject matter and approaches. Both wanted a project with real potency — something above the middle-brow, coffee-table book that *Maori* had become. Eventually, all their discussion and planning led to *Notes on the Country I Live In*, which was published in 1972.[4]

Ans immediately threw herself into taking the photographs and assembling them in a rough order, even before an author had been chosen to provide the accompanying text. It was left to Taylor to find this person, and he eventually settled on poet James K. Baxter — an interesting choice, and perhaps not an ideal one. Baxter's lengthy essay meandered through various streams of thought, only occasionally referencing some of Ans' photographs.

'Ans Westra shows us the children of two cultures,' he wrote. 'The pakeha people of New Zealand work and drink and argue and play sports and get married and go to the races and watch TV in a strenuously activist and money-making culture that is still struggling to understand itself.' As for their indigenous counterparts, Baxter explained in an equally generalised way that '[t]he Maori people of today are in a somewhat different situation. They can take three roads, none of them easy — the road that will lead them to become brown pakehas, the road of illegal social conflict, or the overgrown track that leads back to the broken pas.'

And how did Ans' work fit into this cultural crossroad? Baxter insisted that she was 'the visual poet of the poor . . . Perhaps . . . [she] is making a delicate and implicit comment on the perpetuation in New Zealand of a class structure that most New Zealanders would fiercely claim to be non-existent . . . I value this element of social comment in her work.'[5]

Baxter's text reduced Ans photographs to serving a polemic role and most of his commentaries on individual photographs missed the point of what Ans was trying to achieve. For Baxter, Ans' images were not works of social documentary, let alone art photography, but rather they served an essentially political function.

This was not what Ans had wanted or expected: 'What he wrote initially I didn't want, because he did more or less a review of the book telling us what was in the pictures. I didn't want that — I wanted more of a story.' She made excuses for the poet, pointing out that he was distracted because the community he had established near Whanganui was under great stress. 'James K. was very much at [a] low [at this time] . . . everything had sort of not worked out, the commune in Jerusalem . . . So that was quite a gloomy story.'[6]

She met Taylor, hoping he would agree to find an alternative author for the work, but he was reluctant to discard Baxter completely, despite sympathising with Ans' concerns. Taylor had just published *Bullshit and Jellybeans*,[7] by another counterculture figure, Tim Shadbolt, an outspoken student activist who had acquired notoriety for leading protests against the Vietnam War. The book's rejection by A. H. & A. W. Reed had prompted Taylor to go out on his own as a publisher. Taylor told Ans, 'Tim is on a high; [I'll] ask him to write the counter story.' Taylor's plan was that Ans' photographs would now be accompanied by two sets of text — one by Baxter and the other by Shadbolt.[8]

Ans was not worried about any reputational risk caused by being associated with authors who were outliers in New Zealand society; all she cared about was that justice was done to her photographs. However, the rest of the book's production was fraught for her. She became frustrated that two authors were now working on independent texts, and also with some

of Taylor's production methods: 'Alister worked with double-page spreads, and people around the office would [vote on] whether they liked the page or not. So it became a book done by committee — which I didn't enjoy.' She consoled herself that certain photographs she had insisted be included in the book were kept in.⁹

Alister Taylor clearly believed that having three reasonably high-profile contributors to the book would be a recipe for commercial success. Commenting on the publication later, John B. Turner did not mince his words. Despite the importance of the images in the work, especially the depiction of elements of New Zealand's counterculture, which were seldom photographed for publication, in Turner's opinion *Notes on the Country I Live In* 'was just a pot-boiler that Alister actually stuffed up . . . He compromised it a lot.'¹⁰

Ans was not entirely happy with how it had gone but she did not voice her objections too strongly. She was in the process of rebuilding her career and wanted to avoid stepping on anyone's toes. And she realised that she had become pigeonholed as 'very much a photographer of Māori, and that in itself was not much in demand'. 'Breaking through that barrier of being [seen to] just . . . photograph Māori' was part of her motivation for creating *Notes on the Country I Live In*. 'I've got plenty of white people in there, and specifically the cover, [which has] so many different nationalities . . . I did have to re-establish myself here and that wasn't easy.'¹¹

———

READERS MUST HAVE BEEN struck by the pugnacious photograph on the cover of *Notes on the Country I Live In*. It was tightly enough cropped to deny the reader any clues as to the setting, but the setting was never the issue anyway. It shows a middle-aged woman, mouth clenched, lips thinned, jaw jutting forward, eyes deep set and glaring through a pair of cats-eye glasses, dressed in a heavy coat with fur collar and a matching fur hat. She seems like a joyless throwback to the 1950s, curiously out of place in a society that had since undergone sexual and social revolutions. Hovering in the background

Wellington, 1971, from *Notes on the Country I Live In*, published in 1972 and Ans Westra's first major work not focused on Māori. This image was cropped and flipped for the cover of the book.

Upper Hutt, 1971, from *Notes on the Country I Live In*.

of the image was a smattering of unremarkable-looking young adults who provided a backdrop of ordinariness for the extraordinary individual who dominated the foreground.

The image's generation gap is used to embody two very different outlooks on life; the dichotomy between repressed and liberated, dour and lively, and conservative and progressive is stark. The old New Zealand is giving way to the new, and the former, epitomised by this matriarchal figure, does not seem at all happy about it. The book's title is thus ambiguous: 'New Zealand' is not depicted as a uniform and neatly packaged entity, but something broader, less definable, in some cases fragmented, and perhaps even unstable.

What the book's cover made immediately clear was that this was by Ans Westra, whose name featured directly under the title, while those of Baxter and Shadbolt were in a smaller font at the bottom. Despite the reputation and notoriety of both authors, the quality of the photography gave the book its substance, which Taylor believed was its main selling point.

When certain sorts of creative people look ahead, they see the next peak they wish to ascend: the motivation is always to produce something better than they have previously accomplished. It is a form of self-competition, but also often with an eye to public recognition. In some cases, a more venal search for recognition puts public acclaim ahead of artistic accomplishment. Ans was certainly not part of the fawning, fame-seeking, fashion-following carnival of some aspects of the professional art world. She did constantly seek new artistic summits to conquer, but less for popular acclaim than as part of a life-long competition with herself. Every new project she began had to exceed everything she had done before.

Maori had been a definite career peak, and *Notes on the Country I Live In,* with its images encompassing more of the country's character than any of her previous works, could have topped this. However, the book's production values were underwhelming. Its 125 A5-sized pages in a paperback edition hardly matched the physical grandeur of *Maori,* which had almost double the number of pages, a larger format, a superior layout and better image reproduction.

And *Notes* was a book of three distinct parts — two unconnected essays and a selection of photographs that the text scarcely addressed. Baxter's essay (the longer of the two) dwelt on his life in Jerusalem and his distaste for cities, and included a poem before ending with a meditation on the state of the nation:

> When I think of my country, I think of the cloud of pain that presses down on the spirits of her people. She has not yet come to understand herself. Perhaps some of the young, in their heavy tribulations, may be able to become her eyes. When the people have learnt to share their possessions freely, they may then be able to say from their hearts the Maori blessing — 'Kia tau te rangimarie' — 'May peace be strong among us!'[12]

Shadbolt's brief and meandering narrative made a generic criticism of 'war, racism, greed and pollution'.[13]

And yet, despite all that, *Notes on the Country I Live In* was still a seminal work of New Zealand documentary photography and an important milestone in Ans' career. Few other works in the twentieth century portrayed such an idiosyncratic representation of the breadth of New Zealand society, and, in doing so, it left a distinct documentary record.

In assembling the 130-odd photographs for the book, the challenge for Ans had been to document a sample of subjects that gave an impression of the breadth of the country's inhabitants, but not so much breadth that their 'New Zealandness' could not be grasped. The obvious categories of ethnicity, gender and age were easy, but beyond that she wanted to convey an assortment of attitudes, prejudices, outlooks and apprehensions. In this small publication, Ans decided to represent 'types' of people, chosen on the basis of the way in which readers might react to them.

Those pictured would be unnamed and unknown to the reader, their primary purpose being to act as a sort of cypher, conveying elements of the New Zealand experience that would be interpreted according to the viewers'

own outlook. Her intention was clear: 'I wanted it to be intimate, a book that people would leaf through and gradually the images would work on them.'[14] It was an ambition she masterfully achieved.

Fifty years on, some of these images carry a nostalgic tone. Anti-Vietnam War protests and Golden Kiwi lottery tickets may not have the same resonance for younger viewers, but a quintessentially New Zealand spirit and character still pervades them. The enormous diversity of subjects somehow coalesces to convey an extraordinary unity of national character.

One thing missing entirely from *Notes on the Country I Live In* is an idealisation of the nation. This was certainly not a book tourists would buy as a memento. Ans was presenting New Zealand society as she saw it, and many of the images are imbued with the characteristic Westra sense of transition or loss of an earlier way of life.

For much of her work with Māori, urbanisation had been the dominant motif — the traditional indigenous world was being subjected to the forces of Western modernity. Ans found a similar type of transition occurring more broadly in wider New Zealand society, but here she used age as the axis. In very general terms (she was careful not to labour the point), older subjects were cast as conservative figures while younger subjects were seen as allied to the period's counterculture. The cumulative effect gave the impression that the 'old' New Zealand was in retreat, and in its place a new generation with different values and aspirations was emerging.

But just when readers might have begun to detect this pattern, the photographer would puncture the predictability. After a succession of photographs of middle-aged or elderly conservative people going about their middle-aged or elderly conservative activities, she inserted an image of an older woman holding an anti-Vietnam War placard. In a small autobiographical hint as to Ans' own sympathies, the woman is clutching a camera.

This gave Ans a further opportunity to play with ideas about who is watching whom, and the notion of the photographer being photographed.[15] Watching the watchers was a theme Ans returned to throughout her work.

Not everyone, though, appreciated her subtle organisational style. An anonymous reviewer for the *Press* informed the newspaper's readers:

> [T]he pictures do not follow a consistent theme and to some degree suffer the limitation that all books of this kind can be in danger of suffering. The photographs are random observations of New Zealand life with little attempt to break the sameness which frequently restricts books of photographs. A more imaginative approach in some of the photographic work and layout might have given the book the variety that it needs.[16]

In fact the arrangement of the photographs was never 'random', but if a critic missed the finer points of the form and composition of Ans' photographs, then there was a chance that casual readers would also.

In some photographs Ans focused primarily on creating art. A vivid example is the image of wood-chopping at the Trentham A&P Show in Upper Hutt in 1971, which portrays two men, axes in hand, hacking at perpendicular logs. The angle ensures that both men's faces are obscured: instead the viewer's attention is drawn to the men's movements. There is a clear appreciation of the aesthetics of the body, as the axemen turn, fold and swing at their targets. Into this very male, agricultural activity, Ans injected a sense of graceful rhythm. The camera angle creates an almost disorienting effect, the two men balancing on planks as they hack away at the logs, set against a background of sky. Wood-chopping was a mainstay of A&P shows, and Ans subverted this male sport into a form of choreography.

Notes on the Country I Live In was Ans' first major work not focused on Māori, and she had to work at producing the required level of ethnic diversity. 'The publisher was sort of listing how many white people, how many coloured people were in the pictures and my New Zealand was still very much occupied by Māori,' she said. In the end, 'there was still an awful lot of darker skinned people there in the pictures, Māori or otherwise'.[17]

ANS' SHIFT AWAY FROM a Māori focus for her subject matter coincided with the erosion of her privileged — almost exclusive — status as a Pākehā operating in this field. Her work photographing Māori had been groundbreaking in the 1960s, but the monopoly she had enjoyed could hardly endure indefinitely. It was only a matter of time before other photographers turned their cameras on this area.

One of those who, from the late 1960s, began to wade into the pond Ans had previously occupied alone was also a woman, also an immigrant, and also prodigiously talented: Marti Friedlander. Eight years older than Ans, Friedlander had received a formal education in photography at the Camberwell College of Arts in London, and in the ensuing decades this distinction between the professional and the amateur became a wedge that inserted itself between the two women. The relationship was never cordial.

In other circumstances, things could have turned out differently. There was plenty of room in the pantheon of New Zealand photography for both of them to exhibit their photographic prowess, but any chance of close camaraderie was practically extinguished by the chain of events that led to Friedlander's first major foray into photographing Māori.

Moko: Maori Tattooing in the Twentieth Century, with photography by Marti Friedlander and text by the historian Michael King, was published by Alister Taylor in 1972. The two had started planning the book around 1968,[18] while Ans was in the Netherlands. Ans recalled that a year later, shortly after she had returned to New Zealand, King approached her to say that he was 'thinking of doing some . . . documentation of kuia with moko. "You have quite a number of them in your book *Maori* — where did they live?"' he apparently asked. Ans 'gave him all the details and he said, "We'll go, and we'll have a tour, and you can photograph for me."'

It was the sort of project that would have been perfect for Ans, and she had all the contacts. However, the opportunity did not blossom, at least not for her: 'I heard no more from Michael King until quite a bit later I bumped into him . . . and I said, "What happened about those photos that we were

going to do?" And he said, "Oh, I've already got somebody else to do them. You were saying you needed a bit of time to organise a babysitter. Sorry."'[19]

The episode was described much later by Friedlander's biographer as 'a breakdown in communication',[20] but Ans was extremely upset. She felt that King had been underhand in approaching her for contact information. 'I was really angry because he picked my brain, he was going to come back as soon as he was ready.'[21] Friedlander's work was very different to Ans', and Ans felt they were very different people, even if outwardly they probably seemed like two peas in the same female, immigrant-photographer pod.

Years later, during an embassy function at which both she and Marti Friedlander were present, Ans noted that Friedlander 'was sort of demonstrating [her camera technique] and actually she got quite a nice picture of me'. When both women were being photographed by art curator Ron Bronson he apparently jokingly said to Ans: '"I've got to do Marti first, she's older. She'll die before you."' Looking back on that episode in 2022, Ans joked: 'And she has obliged.'[22]

INTO THE MASS OF anonymous faces and semi-recognisable places that featured in *Notes on the Country I Live In*, Ans slipped a sliver of autobiography: a photograph of two men sitting side by side playing guitars. Only a handful of people would have realised that the Pākehā guitar player was Barry Crump. Old flames died hard, and Ans' affection for the father of her first child continued to smoulder long after Crump had moved on (and on).

Her motive in getting back in touch at this stage was to get him to admit that he was Erik's biological father. He agreed, 'though under duress', as she put it. He had been saying, she said, 'Oh well, she's had other boyfriends' as a way of dodging paternity, but he eventually conceded that he was Erik's father. But there was a catch: 'The proviso was that I wouldn't ask for any financial support,' said Ans.[23] From that time onwards, although her feelings for Crump never subsided entirely, she barely saw him again.

The Country I Live In 133

Coromandel, 1971, from *Notes on the Country I Live In*. Barry Crump is at left.

Around 1969 Ans, Erik and Crump had met at a rock concert. When Crump saw Erik, according to Ans, 'he turned around and said to one of his mates, "This is my son." And Erik's standing there all proud as anything. He'd finally found his father . . . [H]e knew [when we were in Holland] that his father was a writer [who] lived in this funny place on the other side of the world.'[24]

It was a happier ending than it might otherwise have been, given Crump's capricious nature, but it was an ending nonetheless. Ans and Barry stayed together for the next few days, and as she left, he said to her, 'Any holiday if you want to work, send [Erik] over.' Erik was enthusiastic about having his father in his life, and wrote a Christmas wish list, which simply stated: 'For Christmas I'm asking Father Christmas for Barry to come.' Ans sent this to Crump, who apparently responded, '[A]hh, they are trying to fleece me. No,

it's not convenient to send your child.' Ans was infuriated: '*Your* child — never *my* child. These men. That's the last [time] I ever saw Barry.'

A quarter of a century later, in July 1996, Ans was moving into her house in Lower Hutt. With practically nothing yet unpacked, the first evening she went to the supermarket to buy some food. As she entered, she saw a headline on the newspaper stand. Crump had died.[25]

———

AFTER *NOTES ON THE COUNTRY I LIVE IN* failed to have quite the impact Ans had hoped for, she was once again on the lookout for a new project. Another Alister Taylor book, *Down Under the Plum Trees*, fell into her lap.[26] *Down Under the Plum Trees* was ground-breaking in its content and ambition, openly surveying sexual activities and relationships, and broaching topics such as masturbation, rape, abortion and same-sex attraction in a way that no book published in the country had ever done. This was at a time when homosexual acts were still illegal, and when being an 'unmarried mother' still carried the twin stigmas of immorality and social delinquency.[27] Taylor outlined the gist of the content to Ans, who gave no apparent thought to any potential for controversy. All she saw was another channel for her photography.

It was aimed at teenagers, and Ans saw this as an opportunity to connect with a new audience. 'I felt I was too distant from people,' she said later.[28] It would give her 'a chance to learn how people function, how people operate, how their relationships work'.[29]

It would also pay the bills. Not that photography — or publishing — would ever make her rich. She received modest royalties (sometimes with an advance paid) for her own books, and a fee per image when she supplied photos for other people's books.

When news about the book's imminent publication broke, the reaction was swift and savage. In December 1976, just as the work was being readied for release, the chair of the Indecent Publications Tribunal imposed an

interim restriction that prevented it from being sold or otherwise distributed until the tribunal had ruled on an application by the Secretary for Justice alleging indecency.

A representative of the Secretary for Justice argued before the tribunal that *Down Under the Plum Trees* was 'an affront to the commonly-accepted standards of decency',[30] while a series of witnesses — including a schoolteacher, a priest, a doctor and a psychologist — spoke in support of the book. Then what had looked to be a relatively straightforward matter of establishing whether the book crossed the threshold of 'common decency' took a twist, with a parent claiming that a photo of their child that featured in the work had been taken without consent. The image had been taken by a photographer for the *Dominion* newspaper, and not by Ans, but she and Taylor were now anxious because there were other photos in the book that had been obtained without specific written consent.

The power of the state was breathing down her neck, and she was facing the possibility of even worse. There was a risk here of reputational damage worse than she had endured with *Washday at the Pa*.[31]

In March 1977 the book was officially ruled indecent, and banned for readers under the age of 18, except with parental or professional permission. One bookshop was fined $1100 just for putting it on display,[32] while the issue of unconsented photographs of minors in the book made its way through the courts.[33] In the end, Alister Taylor avoided prosecution because the book's ostensible purpose was to provide health education.

Ans' brief had been to contribute some but by no means all of the photographs for the book. Robin Morrison, another prominent photographer, also provided images. Both of them worked for a fee.[34] This commission was fundamentally different from anything she had done before. Instead of blending into the background, going almost unnoticed, now she was required to photograph a couple having sex while standing only a metre or two away. She fronted up to it without flinching: 'The young couple in there, they'd been an item and okay, [they were] obliged to have intercourse for the camera . . . I grasped my moments, I clicked the shutter. That's the

only way I can work and okay, it became difficult me photographing people, people became more aware.'[35] Her primary concern was that the couple was aware of her, and were thus not as spontaneous or unguarded as they otherwise might have been.

The photographs of naked people had their faces cropped off (for the sake of anonymity), and were black and white, rendering them almost like biological specimens. The book also included a brief discussion of traditional Māori birth practices for which Ans used a photograph she had taken previously of a kuia with some children around her in an outside setting, which seemed incongruous with all the other images.[36]

Down Under the Plum Trees dealt also with the emotional issues associated with sex. In a section about relationship break-ups the text read: 'Of course it's hard for you when the one you love walks out, when the phone doesn't ring. When they're there with you all your dreams come true, but when they leave you're broken hearted, alone, a loser.'[37] To accompany this passage, Ans took an image of a young woman wearing fashionable clothes, her hair elaborately tied, sitting forlornly on a kitchen floor, slumped against a cupboard. Her despondency is palpable, and Ans accentuated that piteous feeling by angling her camera to look down at her subject from above. From this to photos of sexual intercourse, and contraceptive devices to a dizzying montage of photographs of breasts occupying a full page: Ans capably shifted focus as required. It was just another paying job.

Outwardly, Ans remained equally untroubled by the subsequent commotion over the book, although her partner at the time, John van Hulst, a fellow immigrant from the Netherlands, worried that it might signal the end of her career.[38] It was one of the few occasions in which her photography became a source of domestic disagreement. In hindsight, she accepted that she should have turned down the invitation to be involved in *Down Under the Plum Trees*. 'John was very much against me getting involved,' she admitted, 'but I took the job as a bit of a challenge. But as it worked out, it was a bit silly to drop off the baby on him [John] and go out and photograph sex acts . . . He was very upset because he was very anti the whole thing.'[39]

The Country I Live In 137

Melville, 1974, from *Down Under the Plum Trees*, published by Alister Taylor in 1976.

To make matters worse, the fee barely made the effort worthwhile, especially when she had to 'fight like anything' to get it out of Taylor.

When the book was finally released she was in the South Island on a commission from the Department of Education for a publication on the geography of Southland.[40] The fracas over *Down Under the Plum Trees* barely registered.

IN 1972 ANS HAD her first ever exhibition at Barry Lett Galleries, a dealer gallery in Auckland that specialised in contemporary art. It was a failure. '[We] didn't sell anything, it wasn't the best beginning. Actually, it was very much a question of whether photography was art, or was acceptable as art.'[41]

The experience and careers of photographers in Europe and the United States had long since answered these questions in the photographers' favour, but the New Zealand setting was slightly different, and it forced Ans into existentialist corners. Her lack of income was beginning to bite, as Erik reflected later:

> One thing I clearly remember growing up is how little money we had . . . We could go hunting for mushrooms in the fields, we'd often go picking blackberries, she made many of our clothes or bought them second hand, and she would make the most of whatever food she had. I remember, for example, always having to sniff the milk before using it because it might have gone off, or scraping the mould off cheese or jam before using it. We hardly ever threw anything away.[42]

Later the same year Ans' works featured in an exhibition by seven New Zealand photographers at the Waikato Art Gallery, then at the Robert McDougall Art Gallery in Christchurch. Each photographer was allotted space for up to five photographs, all of which had to have been taken in the preceding 18 months, and which were available for sale. The publicity described Ans as 'the best known' among the contributors, with some of her previous 'well-received books' cited as evidence of her status.[43]

Also in 1972 her work was exhibited in the Dowse Art Gallery (later the Dowse Art Museum) in Lower Hutt. As a newcomer to exhibiting she had to adjust to the sometimes improvised nature of such undertakings. Recalling her early exhibitions, she described how she 'put photos on boards and tried to exhibit them cheaply without framing costs, and hung them myself. It gave me a chance to exhibit work that hadn't been published before. I had such a big body of work by now.'[44]

Once again there were no sales, but Ans insisted that income was not the only consideration. 'I chose to exhibit to seek a response to photographs which had a personal meaning to me. The chance to have such an exhibition

was an incentive to put a selection of my favourite images together — it gave me something to work for.' It was a chance for her to dip her toe into the pool of public reaction and test the response.

In July 1973, a more substantial exhibition of Ans' work was mounted in Christchurch when 30 of her photographs, taken during the previous decade, were displayed in the Mezzanine Gallery at the Canterbury Society of Arts building on Gloucester Street. The main drawcard was a series of images from *Washday at the Pa*.[45] Once more, though, the exhibition received only modest public attention, and convinced Ans that exhibiting her work was going to be a slow way to fortify her career.

IN THE MIDST OF raising Erik, travelling around the country for various photographic projects (some of which ended up never seeing the light of day), and accepting practically any paid commission that came her way, in the early 1970s Ans had begun another relationship.

Since her brief and volatile encounter with Crump she had buried herself in her work and her son, but now another impulse was rising to the surface. 'I had my little boy; he was eight years old. I was beginning to feel I would like some more babies — I was going on in my thirties.' Her biological clock drove Ans once again into relationship territory. She and John van Hulst had two children: Lisa (born in 1973) and Jacob (born three years later). Unlike Erik, who had his mother's surname, his half-siblings took their father's.

Ans had met van Hulst, a phototypesetter who ran his own business, in Wellington through a mutual friend, the German-born photographer Hubert Sieben, who said to her in a mercenary manner, 'Here is your meal ticket . . . Make him a good meal, cook him a steak and have it just right and you've got him.'

She followed his advice but on the evening in question, just as she put the meal on the table, 'Erik, who had just been rolled into some sheep dung

by the neighbours' kids, needed attention first. I think John probably never got over that fact.' In fact, the two were not well matched. Although Ans liked John's sense of humour, 'There was no real understanding,' she said. 'He never trusted me. He made me tell lies for him as well.' So, as it turned out, 'he didn't turn out to be a very good meal ticket'.[46]

They stayed together for seven years, and part of the reason Ans believed that their relationship did not last longer was that they were unevenly yoked. Van Hulst came from the south of the Netherlands, where the Catholic influence was much stronger than in the more Protestant north. According to Ans, for Dutch Catholics at this time, '[f]amily, babies is what you aimed for, not adventure. [It] was adventurous enough for the family to have migrated. His older brother and one sister came here first.'[47]

Van Hulst had previously been married to a 'good old English Catholic woman' but they had no children, Ans said. His motive in establishing a relationship with Ans appeared to be their common desire to have children, but, she said, 'He actually wanted quite a number more, but I stopped at two, once he had his boy three years after Lisa.'[48] Jacob was born in 1976, when Ans was 40 years old.

John was 'a good father to the children . . . [but] not to Erik,' she said. 'He couldn't cope with Erik. Erik was too different. I can't even explain it.' Apparently, when Erik was eight, John said, 'At age eight [my] grandfather was working in the cigar factory.' Ans thought, 'What had that got to do with my baby at primary school?', John said, '"I can't love him", and that's basically what it boiled down to.'[49]

She claimed much later that van Hulst had little understanding of and even less respect for her profession: 'He called it "the hobby the family couldn't afford".'[50] But perhaps her recollections had calcified over the decades. She did not mention, for example, that he had offered a helping hand with her career at various times, such as phototypesetting for a number of early editions of *New Zealand Photography* in which her images were published,[51] as well as attending to household duties when she was away on some assignment or other, and playing a prominent parenting role

when Ans was tied up with an assignment, in an era where comparatively few fathers took on such responsibilities to this extent.

Ans believed that envy was the root of the problem in the relationship. John was trained as a typesetter, whereas Ans had no formal training in her career. Yet her so-called amateurism seemed to be towering over his profession. Even when the two went out to photograph local scenes, Ans noticed a sense of competition. 'I have an ability to see composition and [know intuitively that] it's right, whereas . . . [John] would be standing next to me with his camera on the tripod and a ruler, having to measure it up. It's a different way of working. He had to have a Rolleiflex, he had to have the single-lens Rolleiflex I was working with.'[52]

Half a century later, episodes that signalled the decline of the relationship surfaced quickly in Ans' memory. Once the two of them were driving to a caravan they kept in Greytown in the Wairarapa (about 60 kilometres north-east of Wellington). Along the way, Ans wanted to stop at a few locations so that she could take photographs as part of a commission from Magnum Photos, which was developing a library of images of New Zealand. John didn't want to keep stopping and there was a disagreement.[53]

On another occasion Ans had to photograph a Greek Orthodox priest at a Sunday-morning service and asked John to look after Lisa for a few hours. He said, 'Oh no, no, I can't do that because I'm having an insurance agent come to talk about insurance for staff.' So Ans 'had Lisa locked in the Volkswagen in a little plastic raincoat'.

A further fracture in the relationship occurred when John was offered a teaching job in Australia but turned it down because, according to Ans, 'he reckoned that he couldn't trust me to look after *his* children properly'.[54] From the time he turned down the Australian job offer, the relationship seemed irretrievable.

Unsurprisingly, the children's own recollections of their father differed, and Ans admitted as much, aware that they said their father 'supported and lov[ed] them. I also had to keep on working and make enough money for Lisa's school fees.' Ans was also paying the mortgage. John was happy to

rent. 'Typically Dutch idea,' she said dismissively. 'You don't need to own a house, you can always rent.'[55]

It cannot have been easy for John. Ans was still in love with Barry Crump and he knew it. She believed this lay behind John's problems with Erik.[56]

Perhaps she had a knack for choosing the wrong partners, but Ans also bore some responsibility for the perhaps unrealistic expectations she placed on them. Ans' ideal family was a vague abstraction rooted in a notion of 'being natural'. It was almost an intuitive recipe for managing a family, and she did not offer any specifics when asked. Someone pointed out to her that in one of her collections there were 'an awful lot of pictures of fathers, and fathers with children, and this must be because I didn't have fathers to my children who worked in a way I wanted them to — in a more natural way with children. These fathers had their preconceived ideas, but these were outside what I wanted.'[57] What she did want, however, was not spelt out.

———

BY 1972, IT WAS plain that the sun was setting on James K. Baxter's dream for his commune in Jerusalem. He had previously argued self-referentially that a poet 'should remain as a cell of good living in a corrupt society and . . . by writing and example attempt to change it'.[58] However, society proved not to be that obliging, and pressure from various directions was causing the props that held up his community to collapse.

Ans had known Baxter since the 1960s. When she was preparing *Washday at the Pa* he would come to her house and she would spread out her photographs and ideas for the book's layout for them to discuss. And when money (invariably) got tight for either of them, the other would help wherever they could. 'He was also a postie, just before I did the postie spell,'[59] she said. In the mid-1960s these were not the only two substantial figures in the country's arts scene who delivered mail to support themselves financially.

Their association deepened when Baxter invited Ans to a Catholic student camp at Lake Karāpiro in 1972. Baxter, who had immersed himself in

Catholicism, was leading a Mass one Sunday when Ans got out her camera ('he was doing his big thing, he was throwing himself on the ground and talking to the nuns'). She also documented a more sombre Baxter reading a lesson to a congregation in St Joseph's Catholic Church. The images she made here were among those she intended for *Notes on the Country I Live In*. One photograph captured something of the dichotomy of Baxter's popularity. Many people sought him out and stayed for various periods at his commune, but few were deeply invested in the unorthodox spiritual direction in which he was heading. This particular image suggested as much. Ans sat in a pew at the rear of the church (with Erik by her side) and moved her camera around, pointing it in different directions until it framed the scene she wanted.

The resulting photograph was a study of religiosity and light. The image is dominated by the white walls and ceilings of the church's interior and the altar, itself a stark white in the light from the adjacent windows. Far from the embracing aura of white that had become a cliché in religious art, this white is lifeless and cold. Along the bottom of the photograph is the counterbalance provided by the backs of rows of dark timber pews, with the right of the picture dominated by the out-of-focus end of the pew closest to her camera, a soft dark blur that contrasts with the sharp whites.

Baxter is standing at the lectern, modestly dressed, hands clasped, and looking down at the Bible from which he is reading. His long hair, draping beard and gaunt physique convey a John the Baptist-type impression. Above his right shoulder is a standard Catholic statue of Christ with a Sacred Heart. The comparison between the two is sacrilegious.

Baxter's public image was at its height at this time, and his fame attracted followers. But when it came to his take on Catholicism and religious consciousness, the numbers told a different story, as this image conveys. Apart from Ans and Erik, only the priest and one other person are shown sitting in the congregation. This scene, in which the crowds have abandoned Baxter, foreshadowed the collapse of his community, and his own imminent demise.

Ans was not as cynical as to dismiss Baxter the way others had — as some mildly manipulative leader of a Catholic-inspired cult. 'I can't say he was a

James K. Baxter reading a lesson to a congregation in St Joseph's Catholic Church, Hiruhārama Jerusalem, in 1972.

fraud because he wasn't,' was her verdict. However, she also acknowledged problems with Baxter's heavy use of drugs — 'mostly marijuana' — and how, like some other cult leaders in this era, he encouraged the use of drugs to help get people 'to a place where [they] could actually find themselves'.[60] For all his sacred ambition, Ans could see that Baxter was all too human, and possessed the frailties and shortcomings that went with that.

On 22 October 1972 James K. Baxter had a massive heart attack and died, aged 46, in Auckland. Four days later a Requiem Mass was held for him in the city, after which his body was taken to Whanganui, and from there, along the remote country road to Jerusalem.[61] Ans went straight there and, as soon as she arrived, began to move around the other mourners who were assembling to pay their respects. Although she was there to express her grief at losing a friend, she instinctively wanted also to document the proceedings.

On this occasion, though, her instinct to photograph the funeral, including the body in the coffin, blinded her to the sensitivities of others. 'I wouldn't have done that on my own initiative but the photographer for the *Evening Post* went in and I followed, so I made the mistake.'[62]

Baxter's son, John, was outraged but another drama soon distracted attention. 'When they lowered the coffin,' Ans recalled, 'they put him the wrong way around first. He didn't want to walk to the South Pole, he wanted to go north, and they had to raise it again and lift it and turn it, and here was Hone [Tūwhare] reciting a poem, making up a poem in his head. That's one of the good photos.'[63]

DURING THIS PROFESSIONALLY productive but personally tumultuous period Ans completed the children's book *We Live by a Lake*, with text by Noel Hilliard.[64] The idea for the book dated back to the mid-1960s, when Hilliard was impressed by the images in *Washday at the Pa* (and possibly by the publicity the work had brought its creator). The two bounced ideas between them over the following years, waiting for a time when they could both commit to it. Hilliard had a rough storyline in mind, along with a location, and he even had thoughts about some of the children who could feature in the work. He favoured a commercial publisher rather than the Department of Education, probably partly because he envisaged a grander format than officialdom would have sanctioned.

We Live by a Lake was a partially stylised account of Hilliard's own three children — Moana, Harvey and Hinemoa. As much as this book was created for popular consumption, it was also a personal memento for Hilliard and his wife, Kiriwai. For Ans, it was an opportunity to return to her favourite subject matter: children.

The setting was the central North Island town of Mangakino, where Hilliard had worked as a teacher.[65] Mangakino was originally envisaged to be a temporary settlement, created to accommodate workers employed in the

nearby hydroelectric power schemes in the 1950s. However, it survived the departure of the workforce and by the 1970s was a much smaller and slightly more run-down town on the banks of the Waikato River (which at this location widened enough to be identified as a lake). However, little trace of dereliction is evident in the book. Rather, the setting is cast as a rural idyll, in keeping with a great deal of children's literature which, for much of the twentieth century, idealised the 'wide open spaces' where children were free from the constraints of suburbia, and could roam free, finding fun and adventure in the countryside.[66]

Yes, it was a romanticised view of rural New Zealand, and yes, it was served to readers as a confection of childhood experiences, but that was partly the point. For Ans, it was a chance to photograph children without having to document themes such as urbanisation, poverty, rural decline or race relations. *We Live by a Lake* aimed to capture the joyous revelry and innocence of childhood, without any superimposed meanings or lessons.

Ans aimed her camera where the range and pace of the children's activities seemed relentless. There are photos of them climbing trees, fingering through a bush looking for raspberries, collecting stones and flowers to construct a fairy garden, making facial 'tattoos' from pieces of charcoal, discovering a pond hidden under a tree, and having sword fights with pieces of wood. Activity is everything, and the momentum carries the reader along.

Then abruptly, after 15 monochrome photographs of the children in energetic play, Ans threw a dramatic pause into the score, with a full-colour photograph that bleeds to the edges of the page. It is a placid scene of the children in the lake, the only movement evident being some faint ripples around them. This turned out to be the end of the first movement, and the next 12 pages are dominated by photographs of the vast industrial apparatus of the power station and the dam that fed it. The children who appear in some of these images are dwarfed by the huge scale of their surrounds.

Ans included several photographs of the power station. In terms of subject matter, this was a striking departure from her normal preferences, yet she seemed to relish coming to grips visually with this muscular machine

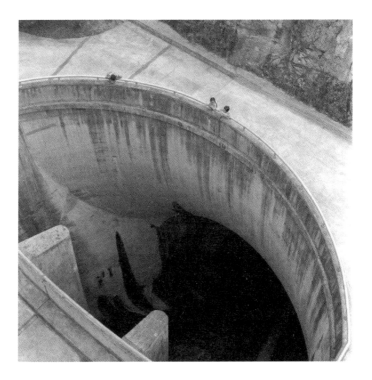

We Live by a Lake, written by Noel Hilliard and published in 1972, was set in the central North Island town of Mangakino.

aesthetic. The images conveyed the dynamics of power — industrial metamorphosising into electrical. Engineers, it turned out, could create art, and Ans captured some of the highlights of their creations. Bulging steel girders, vast slabs of cast concrete and all the massive machinery of electricity generation dwarfed the children to such an extent that in one instance Hilliard had to provide a caption to tell the reader where the children were in the picture.

The most dramatic and even terrifying of all the photographs was of Moana, Harvey and Hinemoa leaning over the lip of the dam at the point where the water entered into the turbines. They are peering into a gaping abyss. From the angle that Ans took this shot, this section of the dam appears like an open mouth — an industrial behemoth in every sense.

Then, just as abruptly as this scene-change had commenced, it was over.

The rest of the book was devoted to images of the children playing in the shallows of the river, and exploring the terrain along its banks. But there are two small twists at the end. The penultimate photograph was taken at night. At its very centre is the white glow of an electric lantern. The children hover over this light, their faces partially lit up by it. Beyond them, the light falls away immediately into complete darkness — in fact most of the photograph is completely black, giving the up-lit faces an almost spectral appearance.

The final photograph is of one of the children reflected in the river. The water is not quite settled enough to make out which child it is, and a few reeds and bits of debris obscure the reflection further. The viewer is invited to reconstruct the image of the child based on these clues. There is no accompanying text. The more obvious image to finish the book might have been the night-time one on the previous page, but Ans was never one for a conventional ending. Instead she used the final photograph to anticipate another day of activity.

Her ability to fine-tune the arrangement of her photographs in larger works enabled her to control the pace and direction of the narrative — in this case even more so than Hilliard's text. Part of her expertise was to ensure that the reader's imagination was constantly being engaged, often challenged, and occasionally even caught off-guard.[67] She was not inclined to contrive effects simply because she was capable of them, and nor was there anything ponderous in her approach. Instead, over a series of images she used the techniques of scene-setting, composition, lighting and subject selection to control the movement of the narrative, to direct the anticipation of the reader for what might come next, and to contribute to the atmosphere of the locations being depicted.

Although *We Live by a Lake* was a children's book, it received the attention of one of the emerging titans of Māori literature, Witi Ihimaera, who reviewed the work in 1974 and described the experience of reading it as 'like looking through a childhood photograph album'. While he was full of praise for the photographs and text, he was critical of some of the production elements. 'Reproduction of the photographs is a little too grey and grainy,' he

From *We Live by a Lake*.

noted, 'making them look sometimes as if they've been taken on an overcast day, and the layout could have been more imaginative — for instance the visual effect of the photograph of the three children looking into the dam's big dark tunnel could have been increased if it had been "bled" to the top of the page.'[68] He was right about the print quality, a problem Ans frequently faced when publishers cut costs to make a book financially viable.

WHEN WE LIVE BY A LAKE hit bookshops, it had been 15 years since Ans had arrived in New Zealand, and yet, apart from the brief eruption of publicity surrounding *Washday at the Pa* in 1964, she was hardly widely known in the country's art scene, or even as a documentary photographer. Was she taken less seriously because she primarily photographed children?

Having her own children certainly affected her career. Ans did not regard motherhood as an impediment to her work, but it did restrict her mobility, particularly when her children started school. She couldn't simply hop into her Volkswagen and drive for hours to a remote location where she might stay for several weeks. But whenever possible, she travelled in the North Island in particular, sometimes looking for new material to photograph, but just as often catching up with old acquaintances, many of them Māori whom she had met on one assignment or another. She recalled one example of how, in the early 1960s, she had been travelling 'from tangi to tangi with old ladies in the back of the car. It just happened, natural.'[69]

When *Maori* was published, Ans was told by a few readers that one image was of Sophie Kaa, 'who claimed to be one of the remaining full-blooded Māori on the East Coast. She was tilling her garden and I photographed her, put her photo in the book.' One of Kaa's neighbours saw the image and immediately ran up to her, saying, 'You're in the book. Sophie, you're in the book! You should have had your good frock on!' Kaa was pleased to have been photographed as she was, and shared Ans' preference for natural as opposed to contrived.

A self-portrait at National Park, 1963.

Ans Westra and her daughter Lisa picking peas in Te Horo in 1974, photographed by John van Hulst.

A kind of friendship grew between the two, and one Christmas when Ans' children were still small she took them to meet Kaa at her home in Tikitiki. Ans wanted to camp on the nearby beach, but Kaa said it was not safe and invited them to camp near her house. 'So okay,' Ans recollected, 'we camped on the front lawn and tiptoed to her bathroom, being slightly terrified because we heard Sophie say to her nephew, "I'm just so sick of those Pākehā in the house." But it was natural . . . she was one to really speak her mind. She wasn't taking any nonsense from anyone.'[70] Despite these minor cross-cultural adjustments, Ans looked forward to such trips, and usually took her children with her.

In the final year of her life Ans spoke of her aspirations for her children. 'I've always wanted my children to get to a level of happiness with what they're doing, where they're at in life, and that hasn't changed. I still wish that for them. I don't think they ought to be scared of grasping life with both hands and their opportunities opening out, but it's harder to maintain that.'[71]

However, she admitted that although she had been keen to be a mother — or, more precisely, 'to experience childbirth' — she did not have a strong maternal instinct. Of course she cared for her children, but the relationship could probably best be described as unconventional, because she was an unconventional person.

8. Close to Home

By 1970 the New Zealand photography 'scene', in the parlance of the time, was still in its embryonic phase, but there was a growing commitment among serious photographers in Wellington to convene with a view to exploring what they could do to expand their art. It was a small congregation to start off with, but it more than compensated for its meagre membership and austere circumstances with enthusiasm for the possibilities of promoting its work to a wider audience in the city.

It was an eclectic and unnamed group, made up of individuals bound by a common interest. John B. Turner and Desmond Kelly led discussion groups and organised screenings of documentaries that dealt with new photography trends in Europe and the US.[1] Turner described the organisation's aim as 'helping identify, encourage, stimulate, challenge and meet the needs of the growing number of independent-minded photographers with something worth saying about life in New Zealand'.[2]

Turner had first come across Ans in 1965 through a mutual acquaintance, Colin Broadley, an actor and artist.[3] He remembered the encounter because when they met at her home, he had noticed a pile of rejected prints that turned out to be from *Washday at the Pa*, which he rescued and took back home to study.[4] Turner described Ans as 'open, well-read and unpretentious',[5] and over the following decades he would be one of her strongest advocates.

The group's newsletter, *Photographic Art & History*, first appeared in 1970, and within a year was being edited by Bruce Weatherall, along with

Turner and Kelly.⁶ In the third edition there was a brief article on Ans, followed by a selection of her photographs spread over four pages. The editor represented Ans as a 'Concerned Photographer', distinguishing her from those who merely dabbled in photography as a pastime, and also those who worked solely to depict beauty. Ans brought some sort of social conscience to her craft, and was 'committed . . . to the depiction of life and people'. She was also described as 'one of New Zealand's few successful free-lance photographers'.

Bruce Weatherall, the article's author, was particularly interested in Ans' technique:

> The 35mm camera is usually cited as the proper tool for the 'slice of life' photographer, but most of Ans' work in this field has been done with a twin-lens reflex, her second Rollei which she got seven or eight years ago and which is still going strong in spite of the thousands of photographs and the impact of a policeman's fist at a political demonstration earlier this year. . . . Westra is a photographer very conscious of the importance of print quality. When we were discussing photographs for the newsletter, she pointed to one which looked pretty good to me and said: 'You might like to use that one, but I'd have to make a better print; that one's not very good.'⁷

The newsletter itself was hardly the epitome of quality reproduction, but this extract reinforces the extent to which Ans was committed to publication quality. While some photographers might become infatuated with their compositional accomplishments, Ans always maintained an emphasis on the mechanics and the standards of photographic reproduction in addition to the artistic ambition of her work. She was aware of the collaborative relationship between the photographer and the audience, and appreciated that the quality of the image was an important intermediary.

Photographic Art & History became *New Zealand Photography* and then in 1974, emerged as *Photo-Forum* magazine (which was soon contracted to

PhotoForum). PhotoForum was also the new name of the group that had been gathering in Wellington for the past four years. It now had around 30 members and was committed to promoting 'fine photography' through exhibitions, workshops and lectures.[8] In 1974 a branch began in Auckland. The group's emphasis was on the sort of photography that fitted into that somewhat neglected gap between the slick commercial work done for newspapers and magazines and amateur photography,[9] which was mainly a means of preserving memories.

Ans was an enthusiastic supporter and a frequent presence at PhotoForum meetings and events, especially in summer when she taught photography part-time. Gil Hanly was one of her students. In one of the workshops Ans facilitated in 1974 she was described by the Swiss-born photographer Max Oettli as providing 'a solid counterbalance to Simon Buis [a fellow photographer], who was an unreconstructed alpha male'. According to Oettli, when Ans and Buis taught together, 'the sparks really flew — in both English and Dutch — and it resulted in a quite productive workshop'.[10]

Ans served as president of the Wellington branch of PhotoForum for several years. One of the attractions of the group for her was as a sort of cloister for those who understood the very individualistic nature of their craft. 'Photographers are essentially loners,' she noted, and she regarded it as critical to have an organisation that catered to loners, as paradoxical as that sounds.[11]

Funds were thin on the ground, and sponsorship non-existent in the early days, so exhibitions were mounted in whatever public spaces could be found. Her first PhotoForum show was in a former toilet block on Cambridge Terrace. 'We had an exhibition in . . . the Taj Mahal,'[12] she reflected with a mirthless smile. The building, dating from 1928, had originally been a public toilet but by 1971 was being used as a workshop for actors. Still, an exhibition was an exhibition, and it was through such determined efforts that photographers such as Ans inched ahead in developing their public profile.

Such exhibitions served other purposes, too. They cultivated a friendly rivalry between photographers, and encouraged them to focus on what

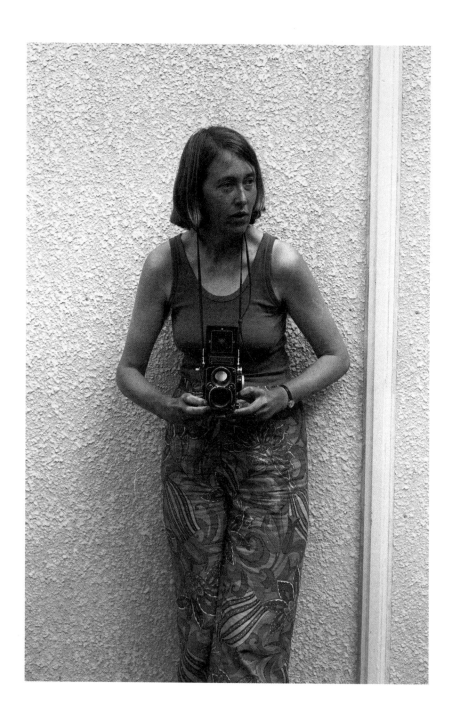

Ans Westra photographed by Max Oettli in 1973.

made their work distinct. They were also an opportunity to test the public's reaction to their work. There was even a slight advantage to exhibiting in such a modest setting: anyone who came to see a show in a cramped, converted, run-down public toilet did so out of genuine interest (and possibly curiosity). PhotoForum was strictly committed to art for art's sake.

Ans remained a member of PhotoForum for the rest of her life, but lamented later that '[a] lot of the big-name photographers we have nowadays don't . . . belong'. As late as 2018 she was still exhibiting with PhotoForum, and using the opportunity to display some of her more experimental works.[13] She felt loyalty to an institution that had been such an important part of her professional development, but she also appreciated that the process of exhibiting was crucial for cultivating her art, and for maintaining an artistic dialogue with the public. No matter how good she thought a photograph was, it was the viewers who were the final arbiters.

Life at home for Ans was difficult as her relationship with John van Hulst — her longest relationship to date — descended from bliss to burden. She felt constantly undermined as he queried her motives for exhibiting her work, accusing her of being on an extended ego trip. That first PhotoForum exhibition, as modest as it was, offered her just the sort of feedback and encouragement she needed. Through her fellow PhotoForum members — especially Turner and Weatherall — she found the one thing that was absent at home: 'support'.[14] Photography offered her consolation, and she gratefully accepted it.

For artists in New Zealand in the 1970s — particularly in the medium of photography, which was still finding its feet among the big boys of the artistic genres — mounting an exhibition was expensive and time-consuming. It was anything but glamorous. The upfront costs and weeks spent selecting and preparing the works for display often outweighed any financial reward. And for all the intense preparation, there was no guarantee that the crowds would come, or, if they did, that they would remember the work after the exhibition was over. There was always another exhibition and another new artist just around the corner vying for attention.[15]

Yet exhibitions were important. They signalled significance, they enabled an artist's work to be judged in the context of their peers, they could foreshadow trends and, at their most effective, they were the consummation of the artist's intention and the viewer's expectation. Artists such as Ans were keen to exhibit just about anywhere there was a chance of an audience.

In 1975 she was offered the opportunity to contribute to *The Active Eye: Contemporary New Zealand Photography*, an exhibition that would begin at the Manawatu Art Gallery in Palmerston North and then tour to 11 other locations. But with around 50 photographers included (including Marti Friedlander, Gary Baigent, Robin Morrison and Max Oettli), standing out from the crowd would be a challenge.

PhotoForum collaborated with the Manawatu Art Gallery in staging the exhibition, with the assistance of a grant from the Queen Elizabeth II Arts Council and some funding from Kodak. It was organised by Dutch-born art historian Luit Bieringa, with the exhibitors chosen by the curator and art writer Gordon Brown, and photographers Tom Hutchins and John B. Turner. The organisers sought the works of as broad a range of photographers as possible. Initially, individual photographers were approached by the organisers and asked to contribute samples of their work, but when volunteers were exhausted, an 'open call' was put out to anyone who wished to be included. Brown, Hutchins and Turner then worked through the entrants and culled those they felt were not a fit.[16]

The exhibition comprised 104 photographs and reached audiences no previous photographic exhibition in the country had ever got to.[17] The moral tone of a few of its photographs — in particular two images of transgender people by Fiona Clark — attracted the censorious eyes of some. Ironically, it was the text accompanying Clark's photographs that seemed to cause the most concern. It read: 'we are real people, & can fuck everything and everyone, enjoying life & having a ball. Aren't you furious, you hung up closet queens.'[18] In a society where, a quarter of a century later, there were over a hundred complaints to the Advertising Standards Authority over the use of the word 'bugger' in an advertisement (spoken by Barry Crump),[19]

it was unsurprising that this would be seen by many as unacceptable.

From early August 1975, the exhibition was due to run for a month at the Robert McDougall Art Gallery in Christchurch. It was billed as containing works 'by New Zealand's foremost serious photographers . . . [including] Ans Westra',[20] but the controversy over Clark's photographs saw them withdrawn from show in that venue. In Auckland, the Auckland Art Gallery director was told by the police the gallery faced prosecution under the Indecent Publications Act if Clark's two images were not withdrawn. Then director Ernest Smith opted to cancel the exhibition instead. 'The gallery has taken this stand because in the first instance the works concerned are not considered by the staff to be indecent and it did not seem fair to withdraw two works on threat of action by the police,' he said.[21]

Eventually the tour was cut short due to the controversy.[22] Ans' contributions were described as 'a sympathetic exposé' of social commentary',[23] but the outrage over Clark's photographs largely overshadowed the efforts of the exhibition's organisers and contributors.

BY THE MID-1970S ANS was shifting away from her previously strong focus on documenting Māori and searching for a new niche to occupy. Her attraction to photographing Māori had not diminished, but there was no money in it. The realisation hit home after she tried to sell a close-up image of a Māori woman in the early 1970s: 'I had a decent-sized print which I was trying to sell in the display case of the camera shop where I worked, and nobody bought it. Nobody would put photos of people on their wall if they were not their own family members. So [the] . . . portrait never sold.' The shop was owned by well-established Wellington photographer Ronald Woolf, who had 'a big display window [with] beautiful scenic pictures that people would buy'.[24]

She also sensed a bit of a chill wind blowing in some Māori settings. Her former M.O. of arriving at a venue, taking photographs and then publishing

them was meeting with a degree of resistance. It was not so much personal, as a feeling among some communities that they wanted more control when it came to people photographing their members. Occasionally the resistance was voiced openly, as in the case of an episode that occurred during the 1975 Land March.

The march set of from Te Hāpua, in the Far North, in September and reached Wellington a month later, as Parliament was passing the Treaty of Waitangi Act.[25] The march, organised by Te Roopu o te Matakite and led by the revered kuia Whina Cooper, was designed to draw attention to the ongoing alienation of Māori land, and the state of the nation's race relations more generally.[26] For some of the participants, especially those urban Māori who had experienced a degree of cultural alienation since moving to the cities, this was the right cause at the right time. Having documented aspects of Māori urbanisation since the late 1950s, Ans was also sympathetic to the cause, and eager to capture this historic expression of indigenous solidarity.

'They had a kind of sit-in at the end,' she recounted. 'They [didn't leave] Parliament grounds, and in the evenings they had gatherings where they discussed the day's events. I wanted permission to carry on photographing.' She put in a request to the protest organisers, and someone suggested she should pay for the right, as she would be profiting from the pictures she took. She told them, 'Well, actually I'm getting less than the office cleaner,' to which a voice from the group responded, only half-jokingly, 'You should have stayed with cleaning.'

It was a potentially awkward moment, but Ans took the comment in good humour and resisted any urge to argue. As it turned out, the situation eventually ripened in her favour: 'When [the protesters] were finally arrested and carried away from the grounds they came to me — could they have [some] photographs to carry on the protest? And my pictures ended up on many a pole in Wellington City.'[27]

TO DATE ANS' OBVIOUS preference had been to photograph people, but she was not averse to focusing her lens on the built environment. In 1976 she contributed to a book with an underlying theme of a specific urban space. The idea for *Wellington: City Alive*[8] emerged from the publisher Whitcoulls, which had approached Noel Hilliard with a rough concept that involved a strong visual component. Hilliard immediately thought of Ans as a photographer for the work, but told the publisher that her preference was for photographing people. Whitcoulls agreed to Ans nonetheless, with the only stipulation being that some of the photographs would have to be in colour — a compromise she was more than happy to accept.

The two began preparing the book, with Ans supporting herself financially during this period by working part-time at PhotoForum as a photography instructor and selling (disappointingly few) photographs in various galleries. To build a stock of photographs for the book, Ans spent more than a year wandering around Wellington, day and night, traversing the city's peaks and troughs — both geographical and social — to assemble a visual depiction of what she regarded as its soul. She aimed to produce documentary photography at its most profound: representative, expansive in its scope; familiar to locals yet resonating with outsiders; and giving context and meaning to the scenes portrayed.

Her fieldwork was as much in the realm of the imagination as it was among the buildings and people of the city. This was to be an exploration of the urban wilderness, similar to the way in which, in the previous century, artists had documented the country's fauna and flora. But it was also more than that. Ans' careful selection of images for the book would be an attempt to show some of the ingredients and conditions that made Wellington the unique city it was.

The book's captions were tucked away at the end of the book, forcing the reader to be guided by the various visual cues in the images themselves to interpret what they were seeing. It helped that Ans had become so adept at entering spaces in an unobtrusive way. Years of experience had made her method almost instinctive by this stage, and meant she could observe

scenes without anyone being aware or affected by her presence. She worked very much on impulse. When she saw some potential in a scene she would take a series of photographs, often positioning herself slightly differently between shots, in order to capture the moment in a way that conveyed the effect it had on her.

She amassed thousands of photographs, then spent a further year reducing that number down to the final 138, finally sorting them into the sequence she felt would create the greatest effect. This book was more substantial than her previous publications, and the subject matter — the city where she lived — was a more defined focus. She had to work to avoid repetition, while at the same time also steering away from any temptation to accentuate variety for its own sake. She and Hilliard divided the work into broad themes — 'Spirits Modern and Ancient', 'Weekday', 'Weeknight', 'Weekend' and 'Haere Ra' — and worked to link them all together.

If ever there was a photographic book that distilled the moods of the nation's capital, then *Wellington: City Alive* was it. With the outward appearance and heft of a coffee-table book, it held within the covers a far more complex collage of the city, incorporating samples of its splendour along with images of destitution and squalor, and importantly, the scenes of everyday life that lay between these two extremes.

Deciding on the opening image was always a complex consideration. In some ways that photograph would be a scene-setter, establishing the tone for the rest of the book. Anything too specific might leave viewers struggling to get a sense of the scope of the images that would follow, but any sort of generic city panorama would lack Ans' trademark intimacy. Should the opening image focus more on the built environment or people or some combination? Perhaps a mosaic would do the trick? Get the mix right, and it would strike a resounding note of familiarity with readers straight away. But there was a risk that if the arrangement was not quite right, the result could be discordant, derailing her commitment to directing her lens at all that was idiosyncratic, rough and raw.

She finally settled on a black-and-white photo she captioned 'Facing

Wellington, 1974, from *Wellington: City Alive*, written by Noel Hilliard and published in 1976.

the weather at the corner of Lambton Quay and Bowen Street'. All that was missing from this description was the fact that it was raining. It was a masterstroke. The key to its success lay in the brilliance of its composition, and in Ans' ability to transfer the generally glum mood of the scene onto a page. Despite the heavily overcast day, she had taken advantage of available lighting contrasts to show office buildings in pallid shades of grey set against an anaemic cloudy sky. The bottom of the scene is dominated by the glossy black of the wet road. Against this gloomy foreground an assortment of individuals stand in a thin line waiting to cross the road. For all their variety — men and women, young and old, shoppers and workers — they all look united in a wish to be anywhere but there.

Such city scenes play out dozens of times a day, but the experience for the viewer is visceral. This was Ans Westra at her best — taking familiar and

even banal elements and moulding them into something exceptional.

The cast of characters in this pageant of Wellington was broad. She strove to enrich the impression of the city, rather than merely sustain curiosity in it. She counterpointed contrasts to achieve this effect. Some were explicit within single images, such as Santa Claus standing next to Wellington's mayor, or the demolition of a Victorian building with a new office block towering above it. She used the juxtaposition of images on facing pages to striking effect. In one example, of two homeless people, one lies on a park bench under a building, while the other looks over him with an expression of concern. The next photograph, also set in a park, shows a group of young people wearing kaftans and dancing.

A construction worker standing on a girder and grappling with a rope is matched with five men at the Wellington Railway Station, all seemingly looking at him. Except that they are not — they are in a different location. Through such techniques, Ans toyed with playful connections between images. The image of a man in flared jeans who is painting a picture on the wall of a striptease club in Vivian Street sits opposite one of a sign at a Cuba Street market advertising flared jeans. A shirtless man struggling to mow a steep, overgrown lawn sits beside an almost surreal image of a horse standing on the footpath outside a house, tied to a fence and with nowhere to graze.

Wellington: City Alive showed that Ans was still evolving as a photographer. She had tackled cityscapes with the same curiosity she brought to human subjects, hoping to prompt an emotional reaction from viewers.

There were 50 colour photos in the book, and two examples will suffice to demonstrate how quickly she mastered its use. One showed a group of dancers backstage. A rack of colourful outfits sets the scene, and in front of this three scantily clad women are dressing for the evening. It is only the foreground of this photograph, however, that is in focus. It shows a dressing table covered with the make-up items the women have applied to their faces. By controlling the focus in this way, Ans allowed the cloud of background colour to accentuate the atmosphere.

Wellington, 1974, from *Wellington: City Alive*.

A similar technique is at work in 'Wet night, Courtenay Place'. The centre of the scene is dominated by the street. Ans held her camera close to ground level, positioning it so the kerb, the line of shop canopies, the row of streetlights and the overhead trolley-bus lines all converge into a hazy vanishing point in the distance. A dazzling mix of coloured lights reflects on the wet road. It is the early hours of the morning and the focus is on two individuals in a long stretch of otherwise empty footpath. The scene is desolate — cold, wet and inhospitable, the shops closed, buses stopped for the night, and the streets a wasteland.

Noel Hilliard's text did not follow the photographs directly, but in this section of the book ('Weeknight') he opted for a journalistic prose style.[29] His taut summaries of an evening in central Wellington dwelt almost exclusively on grim events, devoid of glamour, and Ans' photographs conveyed a corresponding aura of moral vacuity. For all the bright hopes, bright lipstick and bright lights, there was barely anything authentically attractive.

For all the introspection and occasional cynicism in *Wellington: City Alive*, the work ends on a positive note, with Ans' optimistic images of the city at play according with Hilliard's text: 'Who knows, people may even find time to think about politics or religion or philosophy, or the meaning and purpose of existence. Who knows, they might even find time to think about each other for a moment.'[30]

During the more than two years it took to assemble this substantial book, Ans managed to find time to devote to a few smaller projects that promised some much-needed income. Among these were half a dozen books for children, published by Price Milburn,[31] established in 1957 by two couples, Jim and Barbara Milburn and Hugh and Beverley Price. All four had an interest in children's education, and produced works that effectively competed with those being published by the Department of Education at the time. But Price Milburn also found a strong market overseas for its works.[32]

These commissions were timely, because Ans' longstanding collaboration with the Department of Education was winding down. One of

the final works she produced for School Publications came out in 1975 — a Māori-language book for school children with text by Tūroa Royal.³³

———

ON 4 DECEMBER 1976, Ans' second son, Jacob, was born. His parents' relationship had long since been drained of any strong affection, and the two remained together because both regarded separation as a slightly less attractive option. It finally came in 1980.

Towards the end of 1976, a heavily pregnant Ans had been interviewed by a journalist for the *Listener* who described her as professionally 'bored . . . working with models is not her thing'. Ans was quoted as saying, 'At one time I thought I could go away from all commitments and keep moving. But now I realise that is not possible. I would just become a recording machine and dry up.'³⁴

In order to maintain her career she had become adept at organising her time. While Erik was at school she would go out with Lisa, photographing subjects, then return home, do the various household duties, and when the children were in bed she would go to her home darkroom and work. She tried to make the best use of whatever free moment she could find, but of course a third child made it all much more of a challenge. There were compromises. Dinner could be served at any time, from late afternoon to after nine at night.

Jacob remembered his mother 'scrambling out of the darkroom to make dinner', oblivious to how long her hungry children had been waiting for their meal.³⁵ They never went without, but there was a frugality to their lives at this time, and an unpredictability.

It would have saved her hours each night had she had her films processed in one of the several professional developers' labs in Wellington, but she regarded this process as too important to hand over. 'It is exciting to actually see what you can do with the negative. Right from the beginning I wanted to do my own processing — have a hand in how you compose and

what kind of atmosphere you give in the print. It was important to have all that under control, to do it my way.'[36]

As she felt family life, suburban life — 'I've never lived in suburbia, it's something I'm not part of' — closing in on her, and the 'simpler lifestyle' of the previous decade slipping away,[37] her artistic expression was her escape. Photography offered her order, purpose, activity, intellectual challenges and the chance to flourish creatively. Sustaining this vocation was crucial.

9. The Thick of It

Patterns in history are often plainly evident when looked at with hindsight, and can lead to a false sense of inevitability about the course of events. Certainly, when it comes to the lives of individuals, patterns might only be apparent in retrospect. In reality, people grapple with the uncertainty of the present and the unpredictability of the future.

Being a freelance photographer made the outlook even more obscure, and what made it even more challenging for Ans was that there were so few others in the field whose careers she could emulate. Instead she relied on intuition, pursuing personal interests and experimentation. Her temperament was a key ingredient. Instead of dwelling obsessively on setbacks she would shift her attention to something else. She was disinclined to nurse grudges, and shared a trait common to many successful creative people — a refusal to cling to past accomplishments. Ans' attention — literally up to the last days of her life — was always directed to the next idea, the next project, the next opportunity to exercise her talent.[1]

In the second half of the 1970s such opportunities looked to be on the wane. Ans' career did not quite go into hibernation, but it was certainly creatively quiet while two of her three children were under five. In 1977 she was appointed to the judging panel for the New Zealand Academy of Fine Arts' exhibition *Ex Camera*, but that was a one-off job.

Around 1978 she contributed to another half-dozen children's books, mostly for Reed's, which kept her occupied but offered little in the way of

aesthetic challenge.[2] On the contrary, publishers sometimes obliged her to rein in any experimentation, leaving her feeling her work was little more than ornamentation. She even recycled earlier photos on occasion.

There were, however, projects that sparked more interest. In 1978 PhotoForum invited her to contribute images for a calendar that would showcase the works of several of the country's leading photographers. Ans sifted through innumerable options, finally settling on a handful that she regarded as some of her best work, but none was selected. 'That sort of thing hurts more with personal work then with the main bulk of my work,' she admitted.[3] It also bewildered her, and momentarily led her to question her career.

In the background was her intermittent frustration that family life was incompatible with her career. Someone once asked her in an interview whether having Erik with her was a good ice-breaker for opening up conversations with photographic subjects, and her response was curt. 'No,' she said. 'He was more of a nuisance most of the time. I had to make sure he stayed out of the photographs. He had the strictest instructions that when the camera was pointed one way, he had to be in the other direction.'[4]

Erik acknowledged that Ans could be 'a challenging parent, and in some ways, we were not good enough for her', but in general, he said, she was affectionate towards her children. Erik had fond memories of his early childhood, noting that 'in the early days . . . there were only the two of us doing these things . . . We were almost more like friends than parent–child in a way.' Of their travels he said:

> I was quite happy to do it in a way. I was an independent child. I remember playing in the back of the Volkswagen when we were going around visiting people. I didn't [appreciate] at the time how incredibly lucky we were in a way . . . It was a very unusual upbringing, I suppose, but because it was [all I knew], I didn't really think about it too much at the time.[5]

BUT NOW THAT SHE was unable to travel, Ans began to invest herself more heavily in exhibitions. Most were group shows, which did not carry quite the same prestige as a solo show, but they were a way to select her best work and position it in the context of the work of her counterparts.

In the five years following the publication of *Wellington: City Alive* Ans had work in the group shows *17 Wellington Photographers* at the National Art Gallery in 1978; *Collection 80* at PhotoForum Gallery in Wellington in 1980; and *Opening Show* at the Wellington City Art Gallery in 1980. In 1980 she also had a solo show in Auckland: *A Private View — Take Two: Photographs by Ans Westra*, in the newly opened Real Pictures Gallery.

A Private View was a revised version of an exhibition of the same name that she had assembled four years earlier, and received significant critical acclaim. Reviewer Desmond Kelly was enthusiastic, writing: 'There are some photographers who have the power to make you examine the ordinary again, to appreciate how unique it can be . . . Ans Westra does this with the people of the New Zealand city.' Her exhibition presented 'versatility of technique and a wide range of subject matter', with images that revealed 'a consistent clarity and lack of pretension'.

> Visually, Westra's pictures are deceptively simple. Some will view them as beautifully printed snapshots, some as philosophical statements. A woman at a Trentham racecourse for instance sits cornered against a block wall. Empty beer cans and bottles cover every inch of the table in front of her and cap the top of the wall above her. It's a bit of a laugh at a New Zealand scene, but the longer one looks the less so it becomes. The woman looks so lonely and the scene represents such a solid consumption of beer. Might not alcohol really create more barriers than sociability? Suddenly the picture is not funny.[6]

After something of a hiatus during the previous four years, 1980 turned out to be a time of prolific exhibiting and it also (finally) heralded a return

to travelling around the country. Although no detailed records of her excursions to various locations of interest have survived from this period, it is possible partially to reconstruct her movements based on her skeletal notes about the photographs she took in the first 18 months of the decade.

The sequence is not entirely chronological, but the places she ventured give a good indication of the breadth of her journeying. In April 1980 she was in the West Auckland suburb of Glen Eden, taking a series of photographs of the opening of Hoani Waititi marae (3 kilometres from the house she lived in with her father when she first arrived in New Zealand nearly a quarter of a century earlier). An 'urban marae', a pan-tribal institution, Ans found plenty to explore here.[7]

A month later she was back in Wellington for the opening of Pipitea marae on 31 May. This was another marae where all iwi affiliations (and non-Māori) were welcome, based on the idea that 'current constructs of iwi identity are, in part, attributed to processes of retribalisation' after the Second World War. But Pipitea had taken that notion further, becoming 'one of the first pan-Māori groups to call themselves an iwi . . . Ngāti Pōneke'.[8] Ans had developed an early affinity with Pipitea — it was where she had her te reo lessons and absorbed some aspects of Māori culture.

Later she looked back fondly on her involvement with Ngāti Pōneke. 'It's lovely that I can be in the supermarket here and somebody will come running to me, "You're Ans, aren't you? Remember Ngāti Pōneke days? Oh, you wouldn't know who I am." And I say, "Yeah, I know you are Jeanie or you're Dallas." "Oh, you have a good memory!"'[9] The bonds she developed with some of those in Ngāti Pōneke were just as enduring as those she formed with members of PhotoForum, and they continued to strengthen through her ongoing involvement in photographing at particular marae over the years.

Some time in the first half of 1980 Ans also travelled to Gisborne and Ruatōria. The purpose of this visit is not known, but perhaps she was accumulating another set of images for a future publication. Was she looking at something along the lines of *Maori*, published 15 years earlier? The range,

subject choice and composition of the images she took at this time suggests this possibility.

Ans was also finding interesting material closer to home. There were rich pickings if you knew where to look, and she certainly did. A small series of photographs she took at Belmont School, in Lower Hutt, contained some of her most intimate images of children. The photographs were all taken outside, and reflected a school with an ethnically diverse mix of students. One image in particular that highlighted Ans' exquisite artistic sensibilities was of a small boy who is sitting on the concrete, taking his socks off and with his gumboots next to him. The photograph was taken almost at ground level, so the classroom to the left implied a vanishing point immediately behind the child. Other background details — a netball hoop, trees on the boundary, a remote outline of hills in the distance — were kept slightly out of focus so the viewer was drawn to the subject, whose face is a study of concentration.

One of Ans' most evocative sets of photographs of children was of two of Lisa and Jacob, taken on a patch of long grass on a hill overlooking suburban Wellington on a fine day in 1980. Compositionally, they were not as deliberate or detailed as many of her other photographs of children, but in a way that was the point. Ans wanted maximum spontaneity and one other ingredient: a sense of relationship.

Some of the images from this session were self-portraits — one of the most difficult forms for a photographer to master. She positioned the camera, set the timer, and then 'imagine[d] herself on the other side of the lens'.[10] It sounds mechanical, with little opportunity for the photographer to control the image being taken, but in fact Ans mastered this technique and produced works of great sensitivity on this occasion.

The pictures she took that day are airy, bright and bucolic. The family are in either playful or restful poses on the pastoral slopes, with the camera positioned so that the scenes are shot through long, straggling blades of grass, framing an internal harmony. In one of the photographs Ans has Jacob on her lap. As he stares in the direction of the view she has her arms around

Ans' children
Lisa and Jacob,
Wellington, 1980.

him and her lips pressed against his forehead. The viewer is left in no doubt that whatever the challenging circumstances Ans might have been enduring professionally, personally or psychologically, for that sunlit afternoon she felt undiluted affection for her children.

BY 1980 A WAVE of political unrest was building in the country. There were issues that had remained repressed and unresolved for generations, and the nation was also confronting new challenges. The status of Māori in New Zealand society, which Ans had been documenting since the late 1950s, was becoming more contested, with some activist groups demanding greater opportunities for Māori to exercise their cultural agency in an environment that they increasingly found to be racist, or at the very least unsympathetic.

The 'March for Mana', in March and April 1980, was one manifestation of this sentiment. The small protest of around 100 people, initiated by members of Ngāti Pōneke, was photographed by Ans as it made its way through Porirua on its way to the Tūrangawewae marae in Ngāruawāhia, where its participants would congregate with others for a convention that Easter.

One of the march leaders, the Reverend Manu Pohio, said that its purpose 'was to promote the real meaning of mana — the spiritual dimension'. The movement aimed to publicise concerns about the social, economic and moral climate in which many Māori found themselves, and also served as 'a plea to Maori leaders to turn their people back to God'.[11] In one photograph Ans caught a moment when the protesters look almost to be marching in time. It was the poise rather than the politics that interested her professionally.

Ans' photographs showed some of the subtle changes that were occurring in the world of urban Māori. The women walking in front of the men captured in one particular scene, although by no means a first, highlighted the rise of Māori women as protest leaders during this period.

Another visible development reflected in some of these images was the revolution in clothing worn by Māori women. In Ans' works from the early 1960s most of the Māori women were dressed conservatively, but one of the women photographed in 1980 is wearing a T-shirt, shorts, knee-high socks and sports shoes. This is part of the tension in this photograph: between the return to more traditional Māori values promoted by the march organisers, and the modernised, Westernised appearance of some of the protesters themselves. Ans passed no judgement on this juxtaposition, but simply offered it to viewers for consideration.

In April 1980 also a deeper political rumbling began following the announcement that the South African national rugby team, the Springboks, would tour New Zealand the following year. South Africa's black population was still living under the heavy burden of the apartheid system, and internationally various forms of boycotts had been applied to the South African state to pressure it to abandon its racist regime.[12]

A photograph from a series taken at Belmont School in Lower Hutt in 1980.

The 'March for Mana' protest in March and April 1980. Initiated by members of Ngāti Pōneke, it urged Māori leaders to 'turn their people back to God'.

Ans was on hand to photograph the protests that took place in the wake of the announcement. She was familiar with photographing protest and, as testament to the degree of trust the Wellington protesters had in her, she was invited to attend a planning session. She listened as the protest leaders warned people that they may face a range of consequences, including imprisonment. She knew this was unlikely to be her fate, as she would be there to record the event rather than participate, but there was no guarantee that she would not get caught up in the mayhem.

Whatever her own political beliefs, she was committed to documenting the protests in a dispassionate way. She was eager to examine the sentiments and emotions of the protagonists. 'I don't . . . photograph in the way that press people photograph,' she explained. 'They look at the actual event and the big picture. I look at more how people experience it.'[13]

Sometimes, though, events made a decision for her. On one Wellington march, she approached a row of police facing off with a row of protesters. 'The police actually threw me among the demonstrators, so that sorted out where my sympathies [were],' she later said half-jokingly. Of course she found it impossible to remain completely impartial. 'I'm not out there to wave banners. If the photos can do some good, that's a bonus then,' was how she summarised where her loyalties lay.[14]

IN JANUARY 1981 ANS was back on the road, heading north. Auckland and Waitangi were among her stated destinations, but she would leave the selection of other locations to closer to the time, relying on intuition to direct her. It was precisely in such haphazardness that Ans seemed able to capture authenticity and spontaneity.

The first stage of this photographic odyssey was around Northland, and two images in particular from this period rank highly in her corpus. One is of a mother cradling a baby wrapped in a towel in her arms, while the other features two workmen preparing to lay concrete on a footpath. One

is smoking a pipe, and the other is wearing a top hat. Both photos show the way Ans was capable of generating a form of visual poetry from an everyday scene.

By the beginning of February she was at Waitangi, taking a series of photographs which, although they are undated, are most likely of people at Te Tii marae preparing for Waitangi Day. From there she drove to Kaikohe, which was then enjoying a degree of relative prosperity. Ans' photographs of the town were almost all taken on Broadway, Kaikohe's main street. At first glance they seemed to be a continuation of her work on Māori urbanisation, but there was a subtle difference: most of Kaikohe's population was Māori, making for a specifically indigenous form of urbanisation.

The New Zealand Polynesian Festival at the Avondale Racecourse in Auckland between 6 and 8 February offered another opportunity for Ans to accumulate images for use in an as-yet-unspecified project. One of the (admittedly faint) indications that she was possibly preparing a book or exhibition based on this busy period was that some of the sets of images she was collecting seem to fall naturally into sequences.

She took the opportunity to visit Auckland suburbs with a high proportion of Māori and Pasifika residents. At Ōrākei, Ngāti Whātua heartland, she photographed some children playing in Kitemoana Street. Unlike many of her photographs of children from earlier in her career, though, Ans now chose to admit a lot more of the surrounds in her compositions, almost as if she was increasing the degree of the urban backdrop as a mirror of the process of increasing urbanisation, as one of the images from Kitemoana Street, of a small child sitting on the kerb, reveals.

Once again, she took this photo at a low angle, but in a departure from another of her established techniques, the subject is looking directly at the camera. The background of state houses, some parked cars and an otherwise deserted streetscape vies for attention with the child as the primary subject of the photograph, mainly because of how small he is in comparison. It can be seen as a picture of a street scene with a child in it, or as a photograph of a child surrounded by a street scene.

Ans acknowledged that being in the right place at the right time helped a great deal when it came to capturing moods and feelings in her photography: 'I try to go deeper, build more of a body of work that has got a meaning, that has got a story in it, even in the individual image.' But it was not always straightforward. 'Sometimes, I might exhaust my subject by trying to dig too deep and staying around too long by not being satisfied with the first image, by trying to get more and more and more, so it helps to have an eye for it, and to have that quick reaction.' She discovered early in her career that instinct, combined with 'a bit of luck', was crucial to create the sorts of images she regarded as worthwhile.[15]

In March she was back in her car, this time travelling to the Wairarapa town of Masterton for the centennial celebrations of wharenui Ngā Tau e Waru at Te Oreore marae, on 22 March 1981. In April she set about developing,

Auckland, 1982.

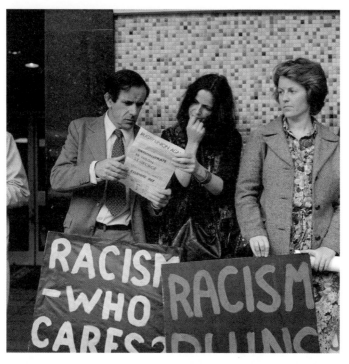
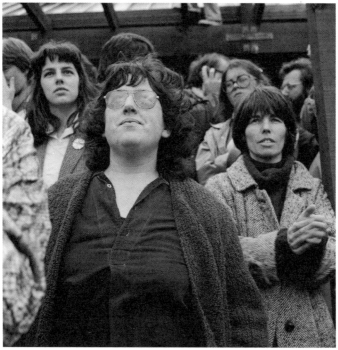

Springbok tour protesters in Wellington, 1980–81.

cataloguing and storing the photographs that she had been taking since the beginning of the year.

But publishers were not queuing up to incorporate all these images into books, a matter of simmering concern. She wrote to one close friend in April that she needed a job 'that brings in money *now*', and that the 'awful reality' was that she was falling behind on her financial commitments to the point where she was struggling to feed the family.[16] 'This year, payments seem to be cut back,' she wrote to John B. Turner in June 1981. 'I have totally nothing going except some silly family portraits.'[17]

———

PRACTICALLY EVERYONE IN THE country was politicised to some extent by the South African rugby tour of 1981. No other issue had divided the country to such a degree. For a few years in particular, everyone was categorised as either 'pro-tour' or 'anti-tour', and hardly anything else seemed to matter. But, as she had so frequently in the past, and despite admitting that she sympathised with the protesters, Ans was able to elevate herself professionally above partisan issues and focus her attention on the human experience.

One episode from the aftermath of a protest very much reflected this attitude: 'There was one arrest, but also what I thought was hilarious, ten o'clock in the morning, here came a van, morning tea for the police. I thought, "Well, we're human on both sides," you know. And I photographed that.'[18]

It would not be going too far to say that, in a sense, Ans' greatest ideological commitment — and the one through which all her other views were refracted — was to document human experience and emotion. She did not yield to the temptation to seek out the most dramatic, the most dynamic, or the most dangerous scenes to photograph. Her artistic curiosity instead often lay more in banal events. This was epitomised in an image she took of three anti-tour protesters in Boulcott Street, Wellington, in April 1980.

These three were middle-class, approaching middle age, and appeared

indistinguishable from any other pedestrians on Wellington streets that day. They were modestly dressed (the male is wearing a suit and tie) and two of them were studying a leaflet while the third is staring blankly at something out of frame. In fact the only clue that these are protesters are the placards leaning against their legs. It is almost the antithesis of the popular perception of activists at the time, and perhaps that was Ans' intention: an act of visual subversion against a group of supposed subverters.

Nothing in 1980 had presaged the violence of the hundreds of protests around the country the following year. Ans' photographs were all taken in Wellington, but she avoided (either by chance or design) entering into the thick of the clashes between demonstrators and police, and so did not photograph the charging, throwing, hitting, yelling, bruising and bleeding that occurred at a protest near the Wellington Public Library.[19]

One of the images she took during this time was a close-up of about half a dozen people, some of whom are smiling and possibly listening to a speaker (who is out of view), while others are looking vaguely in different directions. Were it not for the title, there would be no way of knowing that this was a demonstration. Once again, Ans was subtly challenging the common perceptions in 1981 of who protesters were. Images such as this one remain rare examples documenting a softer face of the protest movement at a time when the focus of public interest was on the more ferocious aspects of the encounters on the streets.

Even when Ans got closer to the confrontational edge, her temperament drew her away from lingering in order to witness any violence. This may seem counterintuitive for a documentary photographer but it makes some sense. Very few of her photographs were preoccupied with the visually spectacular. If anything, such scenes detracted from her preference to portray the (emotional) experience of everyday life. This was where her curiosity lay, and where she felt her artistic and documentary skills were most effectively deployed.

She could not escape entirely the growing levels of aggression, but in those situations she would compose a scene that allowed viewers to consider

events in a different way, avoiding the mainstream perspective. It was a fine balance. 'You have your sympathies of course . . . you do get involved. I try not to, I tried to also be aware of what's happening on the other side and how they feel, because it's all part of being human.'[20] Her refusal to be dragged into tribal allegiances, and to seek an underlying humanity beneath all the fury, is what made her photographs of this time so distinct.

Following the tour, two books featuring Ans' images — the curator Athol McCredie's *The Tour* and the activist Tom Newnham's *By Batons and Barbed Wire* — were released.[21] Both were compilations of pictures taken by some of the country's better-known photographers. All were in black and white, and the emphasis in both was to draw attention to the human experience of the protests (from both sides) at a time when the issue had become increasingly depersonalised and polarised.

Newnham's book used 10 of Ans' photographs, relatively small and often on the same page as pictures by several other photographers. McCredie's *The Tour* contained only two of Ans' photographs, both important images, taken at a protest in Wellington on 20 August 1981. The first was more compositionally coherent. Ans had bisected the scene to show a protester on the left cowering, his back towards the camera, a small shed behind him and a policeman with a dog on the right of the picture, standing in front of a house and lunging at the protester. The two people are separated by head-high coils of barbed wire in the foreground.

The scene is brutal, the aggression overt, but it is a clash reduced to just two people. There is no mass of protesters or thick blue line of police — just two New Zealanders, bound by location and separated over an issue. Change a few details and it could have been a sectarian scene in Northern Ireland, or a civil rights clash in the United States. The common lament of the time — 'We never thought this sort of thing could happen in New Zealand' — could easily have been the caption for this photograph.

The second image of Ans' in the book looks at the protest aftermath. The scene is of children playing with the debris of the demonstrations. Helmets, improvised shields and placards have become objects of play rather

than tools of protest. It is a deeply subversive image and open to a number of interpretations. Even though Ans was sympathetic to the demonstrators, there is almost a hint of her mocking them here.

ALSO IN 1981 ANS successfully applied for an Arts Council grant of $5000 towards another project that involved photographs of Māori.[22] Her draft notes for the application sketched out how she saw this planned work in the context of her career to date and explained why she regarded it as important. 'After a time gap of almost 20 years,' she wrote, 'I want to do a further photographic study of the Maori people . . . A comparison between the situation today and 20 years ago would provide valuable resource material.' She revealed that although there was a publisher who was interested, they were only prepared to produce 'a condensed small-scale book', whereas Ans (of course) wanted a larger work that would do justice to her photographs.

'Even if the resulting publication cannot be of a large size,' she went on, 'the quality could still be vastly improved [and] my resulting negative file could prove as valuable historically as my material of the 60s.' She ended: 'My negatives are part of the country's heritage and a suitable home (Turnbull Library?) shall eventually have to be found for them. I feel that I am, through my past record, uniquely placed to do this work and could contribute through my photographs to a greater racial harmony in New Zealand.'[23]

The lines between documenting history and being a part of that history were becoming slightly blurred in this appraisal, and that was entirely as it ought to have been. Having laboured in the field for two decades, and worked continuously for longer than most of her contemporaries, with a greater output and with intimate cultural access that was denied other photographers, Ans Westra understood clearly the value of her work. This was no example of inflated self-regard; Ans was presenting her honest view of her achievements. And if it did come across to some as an unrepentant boast, well, it was a right she had earned.

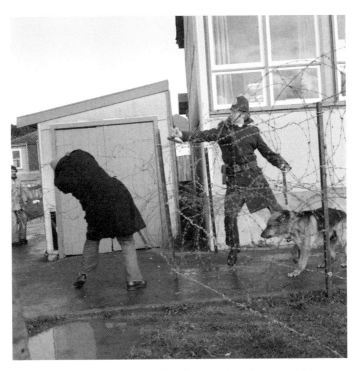

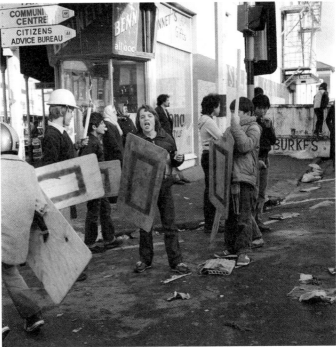

Photographs published in *The Tour*, by Athol McCredie, in 1981.

IN 1982, WHICH WAS to be an auspicious year, the Alexander Turnbull Library in Wellington (a division of the National Library of New Zealand) established an archive for Ans' work in recognition of the importance of her photography to the nation, culturally and socially. It encompassed photographic negatives, proof sheets, enlargements and later digital files, and eventually spanned her photographic career from 1959 to 2013.

Ans' motive in collaborating in the establishment of this archive was, outwardly anyway, more pragmatic. There were young children in the house, and she was fearful that they might accidentally start a fire and destroy her life's work. A library seemed a much safer and more permanent option to store the collection.[24] Of course the status of having an archive in the nation's foremost library devoted to one's work was something she would have appreciated, even if it was not in her nature to boast of such things.

But above all, Ans saw this archive as her gift to the country. It was her way of ensuring that all the people she had photographed could now see themselves, and download these images. A facility was added to the library website by which people could contribute details about individual photographs, so that over time, more information would accumulate about the people and places depicted in the images.

As of 2023, the library had amassed 1423 black-and-white original photographic prints (on roughly 120 proof sheets), 117 individual black-and-white original photographic prints, 10,560 black-and-white original negatives, 58,236 electronic scans of black-and-white original negatives, and 18,916 electronic scans of original colour negatives and transparency strips.[25] The size of the collection was staggering, although it represented just 30 per cent of her total work, estimated at 300,000 photographs. However, the main point was that here was an unequalled manifestation of New Zealand society, in its multitudinous forms — from clerics and drag queens, to gang members, office workers, the affluent, the destitute, and a rich range of cultures and ethnicities. No other body of work came close.

———

A SMALLER BUT STILL important milestone was reached in 1982, when Ans was permitted to photograph a meeting of the Māori Women's Welfare League, held in the Legislative Council Chamber at Parliament. The body that had been the most vociferous in its criticism of *Washday at the Pa* in 1964 now welcomed her presence. It was hard to know who was redeeming whom, but it represented a symbolic end to the enmity of 18 years earlier. Another accomplishment that year was Ans' contribution to the *Three Photographers* exhibition, which toured around parts of the country.[26]

In around 1982 also Ans revived her association with Katerina Mataira when the two began to work on the book *Whaiora: The Pursuit of Life*.[27] Ans had first collaborated with Mataira on the 1971 children's book *Te Motopaika (The Motorbike)*,[28] one of the earliest children's books written in te reo Māori for mass circulation in schools, and an early step in Mataira's life-long mission to promote the language.[29]

Te Motopaika had featured one of Mataira's daughters — 'They were sort of acting out,' as Ans described it. For one of the scenes Ans envisaged for the book, the daughter would ride as a pillion passenger on a motorbike. 'I had a Volkswagen with an open roof, and I was photographing while Katerina was driving. We had this young man who tried to tip her daughter into the river . . . And then . . . they career into a cow, they have an accident, and they spend the night under a bridge.'[30]

Ans viewed Mataira as a supporter from the Māori world, noting that Mataira had 'apologised for the stance of the Māori Women's Welfare League on *Washday*, having it banned. She apologised on their behalf.' Whether Mataira had the authority to apologise on behalf of the League is not certain, but Ans felt redeemed. She trusted Mataira implicitly. 'To allow a person that close into your life,' she reflected, 'you've got to have an area of understanding', and that is what she felt they had.[31]

Over the previous two years Ans had accumulated a substantial number of new photographs of Māori, and over coffee at her house with Mataira one day, she took out a sample of them to show her friend. Should they work together on another book? Ans wondered.

Mataira immediately saw the possibilities for a text she could write to accompany a selection of these images. Ans was delighted because, as she put it, 'I wanted the Māori mind.'[32] This was a revealing statement. Two decades earlier she would have given little if any thought to this aspect, but now she had a greater appreciation of the fact that someone from the culture would be best placed to provide the words to synchronise with her images. It was a sign of a maturing of her approach, and her enduring concern for authenticity.

Whaiora: The Pursuit of Life, as the book came to be called, followed 'that sequence that follows the line of *Family of Man*. You start with the birth, the young person, gradually towards old age and funeral.'[33] This was what had informed the selection and ordering of images in *Maori*[34] and to a lesser extent in *Wellington: City Alive*.

However, whereas James Ritchie had been happy to write text to accompany the photographic narrative that Ans constructed, working with Mataira was different, because her prose partner had her own firm ideas. Mataira shuffled through Ans' shortlisted photos for the book and approved of most of them, but not all. She paused when she saw a picture of some gang members that Ans had taken recently, then firmly told her, 'No, I can't have that in the book I publish, that I'm involved with.'[35]

Such robust discussion might be expected in a creative collaboration, where both parties have their individual perspectives and a compromise is eventually reached. But for Ans this was a first. She had never produced a book with someone who expressed such forthright views on the selection of photographs. Picking and arranging the images was her territory, her area of expertise.

The photograph Mataira objected to was of a group of gang members in Cuba Mall, in Wellington, looking at a woman. Ans conceded that it was the sort of picture that was 'very easy to read wrong, because the girl has got a dress you can actually look through, you see the outlines of her body'. However, she pointed out, the woman was related to one of the gang members. 'She's talking to a family member, but at the same time you can

Mongrel Mob members at a gathering in Porirua in 1982.

think, oh, she's just a gang moll. Easily wrong.'[36] Perhaps too easily wrong.

Mataira was adamant that the photograph be excluded from the book, and it was. The matter was settled, but although Ans did not say so directly, it is hard not to get the sense that she felt this represented an attempt to sanitise. However, she was enough of a pragmatist to know which battles were worth fighting, and rationalised the decision by reminding herself that she 'would get paid per picture published'.[37]

ANS DIDN'T STOP PHOTOGRAPHING gang members. She had spent the Easter of 1982 in Porirua, where a Mongrel Mob gang convention was being held. She drove to the location, approached the first gang members she

saw and asked them if it was all right if she took some photographs of the convention. They agreed, and she set to work.

One memorable image was of a gang member opening a bottle of beer with his teeth. She later joked that she was disappointed he had not offered her a drink. Shortly after the beer bottle display she came across a European man standing among some of the other gang members: 'He was in his late thirties I would say, [and] he [made] a beeline for me. "You're only here to be laid," he said. "No thank you." [He was] trying to lure me into the house, and I didn't go for it.'

Overall, it was a successful visit professionally: 'Ultimately I shot through quite a few rolls of film, and one [gang member] said, "Haven't you got enough pictures by now?" And I said, "Yes thank you," and I walked out, but I didn't turn my back on them.' She was not frightened, but she was cautious. 'You get a feel [for] what's safe and what isn't.'[38]

Gangs were people on the periphery of society, but part of society nonetheless, and Ans was curious to get a better sense of a group that was generally condemned. If, at first, she saw some novelty in the subject matter, that soon disappeared, leaving her with a sense of ambivalence. 'Black Power were very keen on images of themselves, and they came to see their [photographic] proofs and they ordered some. And what annoyed me, I was a solo parent and when they walked out they stuck a stick into my milk bottle [lid] so I couldn't use it anymore.' She described her relationship with gangs as 'chequered', but overall, she concluded, 'the good far outweigh the bad memories'.[39]

Much later in life her view was more sanguine: 'You see their vulnerability. I see it when I'm taking the picture. Gang members are parents, and if they are lucky enough to have some children around, that's part of their way of living. And their values might not be mine, but you don't judge it. You accept it.'[40] After all, she herself occupied a space outside the boundaries of 'normal' society.

Ans' friend Desmond Kelly admired her overtly covert means of obtaining images of marginal members of society, which, he said, almost

no other photographer in the country at the time seemed able to emulate to quite the same degree, or with anywhere near the same apparent ease. He once watched her taking images of a group of gang members in a bar. 'She started way off, then gradually moved forward, forward, forward, and there came a moment when one of the bikies clocked her. He looked at her. She was still looking down into her camera — not at him eye to eye, not as aggressive as 35 millimetres — and he just ignored her. Now, if that had been me, he would have said, "Piss off." But there was something about her spirit, stature and manner that was non-threatening, and all those things added up to her being accepted.'[41]

Obtaining consent from a person being photographed was not a big issue in the 1960s or 1970s, but by the 1980s it was. When Ans was working on *Whaiora*, Mataira insisted that everybody who featured in the book should be approached for permission. While many people at the time probably regarded this as only fair, for Ans it was a headache. 'I started with the old lady who was leading an action song in Parliament grounds, and she said, "No, you can't use that, I look fat."' Some protesters Ans was photographing wanted a fee in return for their permission. Ans informed them that in many cases she made no money from her photographs. She found herself working in an increasingly challenging environment.[42]

Ans felt that this 'empowering' of photographic subjects was evidence of a deterioration of society. 'I had a lovely photo of this woman running [on the] Petone foreshore . . . she was running, and [her] child was on the wall. I had a really good photo of her, but she heard the shutter click so she made me delete it. She insisted I had invaded her private space.' Ans promised not to use the photo, but 'when I saw what she made me take out I was annoyed'.[43]

———

ANS COMPLETED ASSEMBLING HER photographs for *Whaiora* by the end of 1984, and publication was planned for the following year. Witi Ihimaera had supplied a foreword in which he offered a perceptive critique

of the use of unsolicited photographs, particularly when the subjects were indigenous people. He described standing at the traffic lights in an Auckland street on one occasion when a tourist bus drove by, with its occupants taking photographs of the people outside, including himself.

> The incident lasted only a few seconds but I have never forgotten it. I have never felt so exposed in all my life. Or angered. Or saddened. I stumbled around the corner and was physically ill at this unwarranted, unasked for, and unpermitted intrusion on my life. On that day I learnt about the camera as a voyeur, as a taker of life — and of Maori as object.[44]

This was a dimension of photography of which many non-Māori may not even have been aware of at the time, and so was a welcome corrective to the view that when it came to taking photographs, it was open season for any subject.

Was this a veiled missive directed at Ans? Ihimaera noted that in her photography 'there has been no manipulation nor any overt interpretation. She has continued to hold the mirror to Maori life.' At the same time, though, he did not shy away from identifying some of the cross-cultural challenges that had emerged in Ans' work with Māori, and offered a succinct assessment:

> Ans, in fact, has had a love affair with the Maori culture ever since she arrived in Aotearoa back in 1957, and her persistence with it is the trait by which her own integrity must ultimately be judged. A lesser person, burnt by Maori criticism, could well have made the choice not to face the flames again. But Ans has done so again and again and, in doing so, I consider she has redeemed the earlier explorations of *Washday* by giving us a continuing and unfolding photographic history of the iwi Maori.

He then concluded with a forceful endorsement of the significance of Ans' growing body of work, describing her as continuing 'to give us a pictorial

whakapapa of our lives, a genealogy which charts the ever-changing destiny of the Maori'.[45]

Ihimaera's finely turned verdict on Ans' approach to photographing Māori was gracious, but at the same time penetrating. This was no fawning prelude to the images contained in *Whaiora*, but an impassioned plea for readers to consider how Māori might feel about having their photographs 'taken' (in every sense of the word), often without their consent. Ihimaera managed to shed light on an indigenous perspective in a way that was illuminating rather than blinding. Even the most recalcitrant Pākehā could not help but have their understanding of the Māori world increased.

Whaiora consisted of 143 photographs, all black and white, and mostly taken over the preceding five years. Ans was generally happy, but her perfectionism later made her look on some images less fondly than others. One example was of a boy jumping in the air. Although the composition was flawless, the staging apparently was not. 'It's a little artificial for me,' she later told an interviewer, 'but only because I was there of course and the situation comes back to me . . . He was reacting to being photographed and he was showing off. . . . Technically it's right, but actually it means very little to me and I'm very sorry they put it on the dedication page. That's my little gripe with the publishers.'[46]

Mataira's text was much more innovative than that of any of the previous photography books to which Ans had contributed. There was no linear narrative but rather Mataira's impression of particular scenes. Her text was taut, analytical, sometimes poetic and occasionally dark. For the photograph of a sculptor finishing a creation for Taputeranga marae in Wellington, Mataira wrote: 'Cold heartless stone/ Let me give you life/ Let me hear the pulse/ of locked cries beating.'[47] This was typical of her captions — generally avoiding literal description in favour of interpretation.

Alongside photos depicting aspects of urbanisation, the sustained tone of despondency in Mataira's text at times undermined the ambiguity apparent in Ans' photographs. One scene, for example, depicted a young Māori male seated in Aotea Square in Auckland. The expression on his

face can be interpreted a number of ways, but Mataira narrowed down the options, writing: 'City of lights/ City of stone/ I love you . . . / And I hate you/ I should go home/ to my turangawaewae.'[48]

On the opposing page a young Māori woman faced the picture of the man. She was sitting outside a marae in Whanganui and had a similarly ambivalent look on her face. It was one of Ans' finely tuned juxtapositions, capable of multiple interpretations, but in Mataira's text it was reduced to a binary narrative of urban dislocation and rural loss for Māori. The caption for the photograph of the woman read: 'This is the place/ Where the old people lived/ No one here now/ Only the wind/ And the whispers in the whare.'[49]

In speculating on the photographs, Mataira inadvertently restricted their interpretation by the reader. In one image of a young girl resting on a bus, she suggested that the child was dreaming about things she could not afford to buy, and in another image, of a child whispering in a woman's ear, Mataira's caption was: 'Guess what I bought Dad for Christmas?'[50] Most of the photographs, however, appeared only with the details of where and when they were taken, and without any directive text.

Ans' approach to choosing the photographs for the book had been to pay most attention to the implied relationships or connections between people. 'When I'm photographing,' she explained, 'I really prefer them [the subjects] to be interacting with other people. In *Whaiora* . . . there's two people that are out in the pā, there was a whole dialogue that was expressed in language and in hand movements, and I love being a fly on the wall.'[51] She saw her best works as those that encouraged viewers to exercise their imaginations.

There is a line for all creative people between refining a technique and becoming repetitive or formulaic in their work. Structurally, *Whaiora* seemed to be walking a tightrope in this regard — the similarities to *Maori* are too obvious to ignore: the narrative arc from birth to death; the themes of urbanisation, cultural adjustment and dislocation. But the two books were separated by two decades, and much had changed over that time. Ans' photographs in *Whaiora* explore these changes, which is partly what makes the work so important from a documentary perspective.

Whanganui, 1979 (above), and Tūrangi, 1982, from *Whaiora: The Pursuit of Life*, with Katerina Mataira, published in 1985.

Hikurangi, 1982, from *Whaiora: The Pursuit of Life*.

There is also more of a political tinge to her work in this book, which features anti-Springbok tour protests, a trade union demonstration and protests on Waitangi Day. Urban discontent is just as prominent as urban domesticity. In some images her increasing technical sophistication is evident. One comes towards the end of the book: an image of an 80-year-old woman hunched over a patch of soil in Hikurangi, harvesting potatoes. The photograph does not glamorise her task as any sort of example of wholesome rusticism in a location of pastoral splendour. This is a scene of toil (especially given the age of the kuia). The background is the remote, hilly hinterland common throughout much of the North Island, while the foreground appears more parched than luscious. And as the woman holds a spade in her left hand, her right hand lunges into the dusty earth to excavate the potatoes.

There is more than a passing similarity here with the work of one

of Ans' compatriots. In Vincent van Gogh's *Peasant Woman Digging Up Potatoes*, the pose of the subject, the placement of the hands and even some of the foreground landscape looks remarkably similar. Was it a subliminal influence, or did Ans consciously decide to mimic van Gogh's work as a homage? Either way, it was an echo of a compositional style that had slipped out of fashion by the 1980s in the world of 'serious' art photography, but chasing trends was of no interest whatsoever to Ans.

She was in a protracted process of refining her own style. 'I know my work is not avant garde in any way,' she readily conceded. 'My view of people is, as they say, definitely a feminine one and perhaps very gentle. It doesn't break any new ground and for that reason I find it hard to be met with excitement overseas.' To which she added, with prescience, 'I think my photographs will have their value in history . . . In a hundred years' time people will treasure the photographs.'[52]

If there was one element missing in some of the images in *Whaiora* it was spontaneity. The days of surreptitiously photographing people unawares had largely passed, and prior permission had to be sought, meaning some pictures have a slightly staged or contrived appearance, and a degree of vitality is lost.

Ans was, however, very disappointed with the quality of the publication. 'When I saw it, when I had the first copy in my hands, I felt it had been very under-inked, it wasn't the real black and I was very upset about it . . . Somebody [had] look[ed] at the proofs and had okayed them and I had no comeback . . . I was terribly upset.'[53]

Erik remembered seeing his mother in tears as she leafed through *Whaiora*.[54] Lawrence McDonald described the photographs in the work as 'the least well reproduced and printed of any in Westra's books', observing that they had 'a weak tonal range, [were] lacking in her usual sharp chiaroscuro contrasts, and residing in a middling grey zone'.[55] One expert even wrote to the publisher, Allen & Unwin, describing the reproduction as 'quite tragic' and betraying 'less than adequate quality control'.[56]

In the years after the publication of *Whaiora*, contact between Ans and Katerina Mataira fell away. The two were each preoccupied with their own

spheres of activity, and their paths only occasionally crossed. Ans remembered the last time she saw Mataira, in 2006. 'That was after her book [*Rehua*] was launched in Auckland at a writers' festival. Here was Katerina next to me and she said the family have insisted that she have her modest moko . . . she had cancer diagnosed not long after and I never saw her again.'[57] *Whaiora* remains a rare example from that decade of Māori and Pākehā collaborating on a depiction of contemporary Māori society. The book eventually passed into relative obscurity, but an assessment of the significance of Ans' photography more generally was made around this time by John B. Turner.

It 'informed and shaped my vision of this country', he said, and was a 'part of our collective memory to a remarkable degree'. He then put her work in a broader context:

> Her predominantly black & white photographs have permeated our national consciousness as genuine, truthful, and lasting documents to the rare degree achieved in the United States by such photographers as Dorothea Lange and Robert Frank, in France by Henri Cartier-Bresson and Robert Doisneau, and in Great Britain by Bill Brandt.[58]

Then, glancing back two decades, Turner asserted that *Maori* was 'perhaps the finest New Zealand photographic book of the sixties'. This was a strong endorsement of the significance of Ans' contribution to New Zealand's photography.

———

WITH HER WORK ON *Whaiora* completed, Ans took time to reinvigorate other branches of her career. In October 1985 she mounted a solo exhibition at Exposures Gallery in Wellington, titled *Retrospective IV: Maori Today* (following on from *Retrospective III: Demonstration Decade*, seven months earlier, and *Retrospective II: Early 70s*, in 1984).[59] The following month

there was a more substantial exhibition that also incorporated works by Les Cleveland and John Pascoe. *Witness to Change* was billed as works by 'the first generation of contemporary social documentary photographers in New Zealand' and consisted of images taken between 1940 and 1965. Organised by PhotoForum and the Wellington City Art Gallery, it was curated by Janet Bayly and Athol McCredie, who published a substantial book to accompany the exhibition. Over the next two years it toured the country, giving prolonged public exposure to the three photographers and raising the profile of art photography.[60]

Artist and critic Pat Unger reviewed the Christchurch show, emphasising how the photographs 'rejected a vision of New Zealand as a colonial rerun of England's "green and pleasant land" for what they saw as a more visually truthful description'. The increasingly worn narrative of the country's prosperity and idealised race relations was dispelled by the many images that depicted New Zealand as 'a place for the uneasy game of urban versus rural', and, in the case of Ans' contribution, by showing 'the lives of Maoris, their community life, and the results of cultural dislocation'. However, there was some criticism of Ans' images:

> [While the prints as] studies . . . have appeal, [they fail] to capture more . . . The essence of Maoriness is spiritual, and documentation fails to show that. No one would expect the soul of Catholicism or Protestant history in a series of black and white photographs, but she, with her middle-class logic, hoped to do just that for Maoritanga, the way of the Maori.[61]

This observation presumed Ans' intentions, misunderstood her social background and prescribed a particular way of revealing spirituality that may not have been detected by Pat Unger but certainly was by others.[62]

Inevitably, given the period covered by the works on show, there was a hint of nostalgia about *Witness to Change*. For some viewers it was like flicking through an old photo album: a reminder of how things used to be.

But the nostalgic effect was enhanced in the case of Ans' work. The scenes of Māori she submitted had been taken when the nation's sense of its identity was less strongly developed, and when depictions of Māori were often paternalistic if not patronising (or worse). The 1961 Hunn Report had anticipated 'improvements [for Māori] as coming about principally through implementation of the assimilationist vision'.[63]

Nearly three decades later, much had changed. The new generation of Māori were predominantly urban-born, Māori living standards and educational attainment were on the rise, and Māori society was beginning to unfetter itself from Pākehā expectations. The assimilationist dream was long gone. A renaissance in arts, education and social leadership rejuvenated and fortified Māori society, and refashioned what urbanisation had once threatened to disfigure. Māori language revitalisation, the work of the Waitangi Tribunal, the proliferation of urban marae and the rapid growth in cultural festivals were all indications of a society that was no longer struggling to adapt, and instead was much more certain about itself, and more resurgent in its ambitions. And critically, these developments were all the product of Māori agency, rather than any Pākehā intervention.

In some respects, *Whaiora* marked a turning point. Ans had borne witness to change, but so much of what had first captivated her about the country's indigenous population was by now gone. That more carefree time in her career, when her unobtrusive, fly-on-the-wall approach had enabled her to capture so many candid scenes, was also on its way out.

She began to think she was reaching the end of projects with a heavy Māori focus. When asked shortly after the publication of *Whaiora* whether she intended to continue documenting aspects of the country's indigenous people, her response was ambivalent: 'We'll have to see where we go.'[64]

A year later her position seemed to be firming: 'I will take no more pictures of Maoris unless I am asked,' she told a journalist. 'They say I have a Pakeha mind, that I can never have a Maori mind. It's true.'[65]

10. Retrospection

By the mid-1980s, Ans' body of work totalled roughly 100,000 photographs. This massive collection was not confined to one physical location, and had grown beyond the control of its creator. Indeed, it was so great as to be practically unmanageable by curators, save for attaching a reference number to each image, and then interring it in some archival tomb.

However, Ans had a prodigious memory that extended deep into these collections. Her ability to locate particular photographs in her vast mental filing cabinet, and pluck them out for a particular project, was a saving grace.

One of the things that worked against her in exhibitions of her work was that exhibitions thrived on the oxygen of novelty, whereas viewers attending an Ans Westra exhibition had a reasonably good idea of what to expect even before walking in the door. She was largely self-taught, and although she occasionally took inspiration from the works of others, her style was the product of decades of experimentation and self-reflection. Hers was a more insular approach, and the evolution of her style was little influenced by changes in technique, style, subject matter, technology, fashion and all the other variables that fuelled the world of photographic art. What changes were evident by the 1980s were comparatively slight, and had accrued very slowly over decades.

Putting her work on public display — where viewers (and critics) could pass judgement on them — was a challenge for Ans, personally and

professionally. A few of her exhibitions at this time were regarded by some as exercises in artistic recycling. However, she was still working on new projects.

In March 1986 she took up the challenge laid down by the organisers of the Commonwealth Photography Award to take photographs for a period of one week commencing on 10 March (Commonwealth Day). Her initial thought on learning of the competition was: 'I can't take part because New Zealand is such a quiet country. I wish I could travel to somewhere exciting.'[1] As it turned out, though, it was the distinct quietness of so many of the scenes, along with the play on Māori–Pākehā interactions, that she eventually felt could make a worthwhile entry.

The loosely defined theme was 'Life in the Commonwealth', the objective 'to create a collection of photographic images of the Commonwealth today which had outstanding artistic and photographic merit'. Ans settled on the idea of photographing mostly elderly people, eventually narrowing down her final portfolio to six images. There were 120 entrants from around the Pacific (and a thousand throughout the Commonwealth), and in May the judges announced that Ans had won the regional competition.[2] Her entry had been the unanimous choice of the judges for the Pacific category.[3] Judges also noted 'the near absence of indigenous photographers' in the competition.[4]

Ans' images appeared in *Pictures of Everyday Life*, the book of the winning entries published by the Commonwealth Institute. One exemplified Ans' mastery of the humanist approach to photography. It was of two young men (one Māori, one Pākehā) leaning against a wall, looking in different directions.[5] From this image it is possible to draw various meanings that hinge on ideas about difference: different ethnicities, different perspectives on the world, the different directions each is heading in, different clothing, and even the different sides of the same wall that they are standing against. This appealed to the judges' interest in the uneven material, cultural and aesthetic aspects of people's lives.[6]

Her tightly contained scenes of real life were, as was her wont, an aesthetic of the ordinary. A matriarch of the mundane? That would be too

simplistic an appellation. Ans was an explorer of the human condition who composed her discoveries in such a way that viewers were driven to examine her images and determine their meaning for themselves. Throughout her career, she had maintained her appetite for the authentic, and for finding meaning in the prosaic. The fact that her images resonated with international judges meant that she was producing works of artistic and documentary photography that had broad appeal.

Another of the competition photographs had been taken in a Wellington nursing home, where obtaining permission to photograph — especially people who might not have the presence of mind to give their consent — was particularly challenging. However, Ans' gentle determination won the day and she was eventually invited to an institution where she could get to work photographing people.

She arrived at the nursing home just after breakfast and began walking around unobtrusively, stopping every now and then in some corner to observe without being observed. What she saw was a scene that played out in such institutions across the world: recently fed elderly residents slumped in cushioned chairs, gazing at a television. Ans felt this vindicated her decision to use this setting to take pictures: 'Often we try to hide away what's happening to our own people. So that's sort of justification for trying to record it.'

Her initial encounter epitomised the subtlety of her approach. She noticed an elderly man walking past her and 'had the feeling that he wasn't very happy about me being there'. Then she noticed that he had a relationship with the elderly woman he sat down next to. Ans' intuition guided her from this point. 'I very gently moved in and he accepted me then, and even held my hands as well. He hadn't been in the home very long and seemed to have appointed himself [the woman's] protector. If she left the room he would follow.'[7]

Once Ans had formed an understanding of the relationships between the various individuals in the room, she was able to position herself and take photographs in a way that focused on their personal connections.

Wellington, 1986, from *Pictures of Everyday Life: The People, Places and Cultures of the Commonwealth*, published in 1987.

THE £1000 PRIZE MONEY from the award enabled a rare indulgence: some overseas travel. She spent 23 days in the Philippines between September and October 1986. The choice of destination had been quite spontaneous: she had recently visited her father in Brisbane, and it was from there the exoticism of the Philippines began to beckon. Its proximity to Australia, along with the allure of unfamiliar landscapes, cultures and ethnicities, was enough to convince her.

She could not afford to go for long, but she was also curious to see how she would get on traversing and photographing an entirely new location under comparatively severe time constraints. She had ruled out China and Papua New Guinea as possibilities (she felt she could not do justice to either place in just a few weeks), and Australia itself did not inspire her, apart from the interior, which again would require more time than she had available.

Ans was not especially well prepared for this expedition into the unknown, which in a way echoed the slightly naïve approach she had always taken to her photography. 'I knew almost totally nothing [about] the Philippines before I went,' she said, but she regarded this as an advantage, 'because you can soak it up, you're much more open minded in a way.'[8]

Shortly after unpacking at the hostel that would be her base for the first leg of her journey, Ans was approached by a local Catholic clergyman who asked whether she was a missionary. She told him she was a photographer, to which he responded, 'Well, perhaps a photographer with a mission.'[9] The comment amused her, but also made her slightly conscious of the need to be more aware of her appearance if she wanted to remain unobtrusive while photographing.

Ans travelled and photographed extensively through the Philippines in the short time she was there. She even managed to undertake two small commissions, one for a UNICEF project, and the other for the External Aid Division of New Zealand's Ministry of Foreign Affairs.[10]

Yet, for all the differences that confronted her in the Philippines, most of the images she took seemed to conform to the approach she had developed over the the decades. Infant–mother pictures, an all-time favourite, were

given another outing in Ans' Philippines photographs, which were a series of depictions of culture and people composed around what was by now a very familiar trope. The choice of subject matter, the framing of scenes, the angles used, the control of light and the composition of background elements showed few if any signs of having altered since some of her work in rural New Zealand as far back as the 1960s.

The work confirmed that she had established a stylistic archetype, which allowed her to convey the mood, atmosphere and human dynamics of a scene in her own very persuasive way, but which also confined her. Viewers wanting to see a radically new or different approach were out of luck.

A year after her return from the Philippines, Ans selected 30 of the photographs for an exhibition to tour New Zealand university campuses. The New Zealand Students' Art Council helped organised the exhibition, and chose the title *People Power: 'Freedom' in the Philippines* to reflect their activist sentiment.[11] This title, along with one of Ans' photographs of an impoverished rural Philippines settlement, with dilapidated huts teetering on stilts above the muddy ground, appeared on the cover of the Auckland University Students' Association magazine *Craccum* in September 1987.

Interviewed by the magazine, Ans gave a candid interpretation of the political situation in the country. She ascribed the mounting nationalism among the communities she visited to a reaction against US influence:

> [I]t is certainly the beginning of trying to go back to what they were, but they've lost so much of it — they've got to find out about their roots, their origin as a people . . . people have got to a point where they can see there's all this Americanism, which didn't do them any good, and now they're fighting to go back.[12]

It is difficult to read this without being reminded of Ans' impressions about Māori and the corrosive effects of Western culture. The experiences of indigenous societies were to an extent transposable in her mind, and this perception helped to drive the sorts of photographs she took in both

locations. For all that she found it 'an advantage not to have preconceived ideas about what I'm photographing but just to observe and draw conclusions from that', she told *Craccum*, certain social and cultural preconceptions were undeniably guiding her photography by this time, and the particular sort of visual drama in some of her works reinforced these.

By the 1980s Ans — and her work — were becoming more political. There had been glimpses of it in the past — most recently during the Springbok tour in 1981 — but her 1987 *Craccum* interview revealed a shift from observation to intervention when it came to certain issues. Suddenly she was articulating ideas in a way that she had never really done publicly before. She told journalist Janet Cole:

> [T]he one thing I felt very strongly about when I was there was that the population increase has got to come down and whether we

A photo from Ans Westra's time in the Philippines, exhibited in *People Power: 'Freedom' in the Philippines* in 1987.

> need to put pressure on the Philippines from the outside . . . I think that's probably the only way to make it no longer acceptable to just have babies and so we have to fight a lot of ignorance and a lot of attitudes. . . . [A]s a starting point it would have to be no longer acceptable that there is no form of birth control because well, 3% population increase means that an already over populated area will be doubly populated in 33 years so we'll have to support double that number of people . . . this is something possibly the West can put pressure on, can change the motivation of the Catholic Church . . . because they think that's what their mission is rather than looking after the poor . . . that whole attitude is wrong.

Ans concluded with a barely veiled reference to herself: 'There are very few that dare to be different and dare to speak up for the people, dare to help the people.'[13] She had marked out where she stood on certain social issues, and it had taken a visit to a much poorer country than her own for her to voice these concerns openly.

THE BRIEF PHILIPPINES TRIP changed things. Her outlook on the world was recalibrated. The documentary photographer whose images veered frequently into the territory of art photography was now being tempted towards political photography.

There was only so much she could do for the Philippines while living in New Zealand, so her first openly political project — a photographic polemic she conceived in 1986 — was based at home. The title for this planned work was 'Peaceful Islands', and the root of its inspiration was the government's recent ban on nuclear-powered or -armed ships visiting New Zealand. This prohibition, imposed by the country's ebullient prime minister, David Lange, had motivated Ans to the point where her photography became inseparable from politics. In the anti-nuclear stance she saw more than just populist

sloganeering — there was something fundamentally righteous in the ban, and she was eager to deploy the arsenal of her talents to support it.

Ans was drawn to this particular area of political activity because it was an issue of existential magnitude. The ideological tussles between left and right mattered considerably less to her than the moral imperative to steer clear of the nuclear arms race — especially with the fear of nuclear obliteration that was baked into the world's consciousness in this era. Ans felt that she had to do her bit in this time of slow-burning crisis, and her contribution would be a book of images that she hoped would serve as an impassioned visual plea to prevent the country being destroyed in a man-made apocalypse.

Her mind raced ahead, selecting photographs and envisaging possibilities for their arrangement in this prospective paean for peace. The small matter of who would publish the result was left to one side.

She and John B. Turner wrote a brief proposal that was sent to potential contributors, notable New Zealanders, who were invited to submit 'a short essay on New Zealand position at this time in history, especially in regards to its nuclear free stance and its hopes for the future'. These essays would be 500–800 words long, and prospective writers were advised that 'As the book at this point has no publisher, remunerations have to be settled when the idea has taken a more definite form. I hope that this will not defer [sic] you from contributing.'[14]

As the polite rejection letters arrived in Ans' letterbox, her list of alternative contributors grew. She would jot down names of the notable (and not so notable) on scraps of paper as they occurred to her.[15] Publishers appeared to be as unenthused as writers about 'Peaceful Islands', and the rejection letters suggested that the market for such a work was limited.[16] Though not abandoning the project, Ans began to toy with other possibilities for books with working titles such as 'High Country', 'Samoan', 'Beach Diary' and 'Book with Hone'.[17] None of these eventuated, but they point to Ans' yearning to produce another substantial publication.

Then in August 1986, there was a glimmer of hope. The New Zealand

publisher at Penguin Books, Geoff Walker, visited Ans at her home to discuss a possible format for 'Peaceful Islands'. His suggestions were constructive, but Ans admitted to feeling 'a bit lost' about the whole thing.[18] Every piece of advice she received seemed to be at odds with how she imagined the project. When she showed little enthusiasm for making the sorts of changes Walker proposed, Penguin informed her in October that they were 'no longer interested' in the book.[19]

In the meantime (and somewhat awkwardly), a few of those invited to write essays for the book — including economist Brian Easton, director of the Auckland Institute of Technology John Hinchcliff, race relations conciliator Walter Hirsh and the academic and former MP Marilyn Waring — had submitted draft texts. They were consigned to a manila folder in the thickets of Ans' paperwork. An application to the Arts Council in 1992 for $9000 to complete the work was unsuccessful.[20] 'Peaceful Islands' was left marooned.

Ans had set aside most of her various projects to travel to London in 1987 to receive her award from the Commonwealth Institute. While in the Northern Hemisphere she took the opportunity to visit the Netherlands and also New York, where she had intended to stay longer and take more photographs, but she was running out of money and the stay was cut short.[21] On her return, she was struck by what was happening in the political realm. The Labour government, under finance minister Roger Douglas, was busy restructuring large numbers of government services into 'state-owned enterprises', with market forces being unleashed and permitted to drive a near-obsessive liberalisation, rationalisation and drive for efficiency.[22]

Some of the fabric of New Zealand society quickly began to unravel. One small but not insignificant sign of 'Rogernomics', as these reforms became known, was the closure of 'uneconomic' post offices, deemed a burden on the taxpayer,[23] ignoring the fact that for many, particularly smaller communities, such services were central to people's lives.[24]

As policy began to unfold into practice, a historically astute librarian from the Alexander Turnbull Library (ATL) realised the need to memorialise some of these community facilities in photographs before the reforming

Waimamaku (above) and Cambridge, 1988, from a series commissioned by the Alexander Turnbull Library to document public facilities. They were eventually exhibited in *Within Memory* at the National Library gallery in Wellington in 2006.

scythe began swinging. In 1988 the ATL commissioned eight 'professional photographers', one of whom was Ans.[25] She contributed two images to this collection: 'Children at post office counter with savings bank passbook'; and 'Posting mail at Waimamaku Post Office'. These photographs documented what many people at the time would have regarded as something utterly mundane; it was only later that their value became clear. In 2006 the images were put on show in the *Within Memory* exhibition at the National Library gallery.[26] Collectively, the photographs were a lament for a New Zealand that had been familiar to those of Ans' generation, but which, like so much else at this time, was subsiding rapidly into the past.

In 1988 Ans was elected president of PhotoForum Wellington — and re-elected in each of the following three years. She was now in her early fifties, and finding it even harder to support herself financially. In a sparsely peopled country, where popular tastes were still slightly more 'agricultural' than in other developed nations, there were lean pickings for a photographer inclined to operate in niche subject areas. However, opportunities did present themselves, and from the late 1980s to the early 1990s Ans devoted herself to two principal areas of activity: the 'bread-and-butter' work of a photography tutor, delivering classes to community groups around the country, and exhibiting her work whenever she could. They were mostly group exhibitions, but she did have one solo exhibition: *Portrait of the Hutt*, in 1991. This was the culmination of a six-month residency at the Dowse Art Museum in Lower Hutt during 1988 and 1989.[27]

New Zealand art galleries were then emerging from being 'bastions of tradition and symbols of enduring values for whom change was not going to come easily', as photography curator Athol McCredie has described it.[28] The Dowse was a leader in this respect, and by the 1980s it had developed a reputation internationally for staging innovative, occasionally even 'quirky' exhibitions, and for its community focus. In *Portrait of the Hutt* local viewers would see their community on display — and perhaps even catch a glimpse of themselves.

Ans knew the area well, which added an intimacy to many of her

images. In searching for subjects for this work, she would keep an eye on community noticeboards to find out about special events, and hang out in shopping malls, where 'people tend to linger'.[29]

The residency and the ensuing exhibition were funded by an Arts Council grant and the Lower Hutt City Council. The idea had come from James Mack, director of the Dowse from 1981 to 1988,[30] whom Ans held in high esteem: 'He just had really helpful, inspirational ideas. He gave me a free hand. I could photograph what I like but at the same time he loved the area . . . and he was just a great one to go back to with pictures and discuss them.' She spent hours with Mack poring over proof sheets,[31] but just as Ans' residency was about to begin, Mack left the Dowse, primarily for health reasons, and she felt that his successor, while encouraging, did not share Mack's intense interest in her work.

Nevertheless, the residency was a lifeline. '[M]y children were growing up, they needed to get university fees,' she explained. (She was earning around $9000 year when the average yearly wage in the country was around $20,000).[32] 'A residency was a great way of actually being paid a salary to be an artist.'[33] Interestingly, by now, Ans was referring to herself as an artist, whereas up until the 1980s she had tended to identify as a photographer, sometimes a documentary photographer. She also earned some additional income from the Dowse by running photography classes (including specialised workshops for children, sponsored by Kodak).[34]

The collection Ans produced during her residency represented a skilled act of documentary photography, but it also revealed how she saw the ordinary, and what specific elements and compositional arrangements she sought out to depict it. When Ans felt that the effect would be heightened by doing so, a few of the images were staged.

One such picture is of a man with his granddaughter waiting for a pizza in Patrick Street, Petone. The photo came about through a contact Ans had with a local retirement village where the grandfather was living. They organised for her to visit the man in his room, and then follow him as he was out and about. More than 30 years later, when Ans was shown this

photograph, a rush of details bubbled to the surface of her memories. She recalled how the granddaughter had brought the old man flowers, and how, based on the books he owned, Ans suspected that he was a widower.

She also remembered how, after she was invited into his room, she had a sense that she had broken through the barrier of his private world. 'You can't just walk into a house and start photographing,' she said. 'You've got to be invited, you've got to ask permission.' Permission was the necessary prelude to obtaining the images she was seeing in her mind's eye. 'Here they're quite relaxed, although I think he's wearing a hat because he's being photographed. That's not accidental. He's sitting there ready to be photographed with his tie and his hat. And the granddaughter is there.'[35] What Ans was after was a sense of relationship and closeness between individuals, the elderly man and his granddaughter.

When it came to portraying intimacy, composition was crucial, as one extraordinary photograph from this exhibition illustrated. The scene is of a mother with her child on a seesaw in the park in Judd Crescent in the Lower Hutt suburb of Naenae. The mother on one end of the seesaw looks joyously at her young child elevated at the other end. Ans positioned herself in a way that the two seesaws cross in the centre of the image, the background dominated by a steep row of hills that upset the symmetry of the scene.

The composition was then made slightly vertiginous by Ans' decision to accentuate the slope of the ground at the park. The viewer can immediately see the mother–child bond, but is left feeling ambivalent about the visual discordance throughout the photograph.

Attentiveness to her own aesthetic instincts always trumped adherence to any particular style or fashion. Her most precious asset was her irrepressible independence. She was committed to exploring the human condition, to uncovering the truthfulness of people. Her reluctance to countenance different artistic approaches may have been limiting in some instances, but the narrowness of her palette of artistic techniques forced her to make the most use of those methods she did rely on, pushing them to extremities of effectiveness that few other photographers ever reached.

Retrospection 215

IN 2022 ANS ATTENDED a retrospective exhibition of these Lower Hutt works, and as she moved — each slow shuffling step cautiously made — she would angle her head in the direction of these artefacts from her photographic past, and pass comment on some of them, providing a potted survey of fragments of her career in the process. The most obvious change in the intervening three decades had been the advent of digital photography. Ans had been using digital cameras by this stage for several years, and had eventually become accustomed to the ease of the technology to the point where she could not imagine returning to film.

'Although [film has] a certain quality that I miss . . . it's not practical. It's marvellous to have that many images available and just go for it, be not restricted. It used to be 12 pictures on the roll and then I had to change film. That's such a different way of working.'[36] There were other advantages, too.

A photo from
Portrait of the Hutt,
Dowse Art Museum,
Lower Hutt, 1991.

With conventional film, she found herself 'always having to protect my film canisters', meaning that in some humid regions, 'I had to store my films in dry tea'.[37]

She did return to her Rolleiflex occasionally, though, for certain jobs. Desmond Kelly was hugely impressed by her mastery of the apparatus. 'Her technique with that two-and-a-quarter [inch] camera was impeccable. I think she knew as much about her camera as Henri Cartier-Bresson knew about 35-millimetres. She knew her camera backwards. She could do the settings without looking. She knew her weapon very well indeed . . . She was a craftswoman with that camera.'[38]

Digital photography did not change her approach, however. She accumulated those images in Lower Hutt by 'just quietly going around snipping my pictures. Not being aggressive or arresting . . . I think I still have the same vision. If it works then you don't change it . . . It's still very much the same way of working which has been consistent right from the very beginning when I started taking photographs.' What had changed in those 30 years was her confidence in her ability to get what she was after: 'My style, my voice has probably strengthened, and I don't think anybody can now teach me anything very much. I just go along with what I know and feel secure in.'[39]

She had shaken off any doubts about her lack of formal training:

> I found my own style quite early on and stuck with it. I knew that I had something that I wanted to stay with and be consistent. So that sort of came from pretty much the first pictures I took. I worked out what worked for me so why have second thoughts and copy somebody else's style? There's no need for that.

She said this in a tone of triumph. Experience had been her tutor and when it came to the source of her inspiration, she still harked back to the genesis of her career: 'I did look at examples in the *Family of Man* exhibition which . . . sort of fitted in with what suited me. So from there on it was just

going forward really. Going straight forward. Finding a documentary style that was as honest and as active as I could possibly be.'[40]

However, possessing a style that seemed impervious to evolutionary change was not necessarily seen as a good thing. Athol McCredie highlighted this stylistic rigidity when considering who to include in his 2019 book *The New Photography: New Zealand's First-Generation Contemporary Photographers*.[41] McCredie deliberated before selecting Ans' work for inclusion. Not only was she half a generation older than the others, but she also had an 'older style' which was humanist, and placed a priority on subject matter over other artistic considerations.

As McCredie later put it: 'I don't think she pushed any boundaries in terms of photographic approach, stylistic approach, formal approach, artistic approach. It was more she pushed boundaries ... of subject matter and that business of persistence.' Even by the 1970s her photographic style was becoming dated, but she was consistently (and persistently) producing a type of photography that no one else in the country was. She retained that ability to capture a gesture, an expression or a sentiment that effectively transcended any 'outdatedness' in her style.[42]

THE *PORTRAIT OF THE HUTT* exhibition became a finalist in the 1989 Montana-Lindauer Art Awards run by the Auckland Society of Arts,[43] and the following year Ans was shortlisted for the United-Sarjeant Art Award. Then in 1991 she was nominated by the Wellington branch of PhotoForum for the Henri Cartier-Bresson Prize in Paris, for which nominees had to have built up a significant body of work, primarily in the field of documentary photography, and had to be supported by a gallery, museum, curator or photographic organisation.

Another accolade, though more modest, followed that same year, when her images were selected for a 1992 calendar depicting scenes from the Lower Hutt suburb of Petone.[44] The calendar's cover image is a good example

of Ans' humour at work. It is a picture of two elderly women chatting on a suburban street. One of the women has her hand resting on a road sign that reads 'AURORA ST. Early Settlers Ship'. The barque *Aurora* was the first ship that brought British settlers to Petone, arriving in January 1840. The positioning of the sign, right above the heads of these elderly women, implied that they were part of this group — almost like a meme before the meme age.

―――

ON 5 JUNE 1990, Aucklanders were invited to attend the opening of *Pictures from the Big 'A'*, an exhibition featuring photographs of the city by Miles Hargest, Christopher Matthews, Paul McCredie, Stuart Page and Ans Westra. It ran for six weeks in the Rare Books Room of the Auckland Public Library.

However, there was a problem for Ans because the Auckland Public Library was insisting on retained possession of the negatives of any photographs that were included. No doubt this was part of some arcane regulation, but it had not happened to Ans before and she was unhappy. Her negatives were the base metal of her photographic alchemy, as well as being an archive of her work. She sometimes reused images in new projects, and the prospect that some of these negatives would be placed beyond her control was very difficult for her.

She initially discussed the issue with library staff by phone, and, based on that conversation, understood that she would retain ownership of the negatives. However, she later discovered that there had been a misunderstanding: the library wished to own the negatives outright. She rang them again to clarify her position. Three months before the exhibition was due to open, the library wrote to Ans, responding in a tone that was slightly more forthright than Ans expected: 'I am very concerned that you may wish to retain some of the negatives,' the letter read. 'As the library has funded the period of photography in Auckland, I do not see that you can arbitrarily decide that some of the images are yours and not the library's.'

Ans was urged to reconsider her stance and to surrender the negatives, with a promise that they would always be available to her to use if she needed them.⁴⁵

Ans replied, reiterating that she did not want to break up the body of her work by giving some of it to the library, especially as she feared that once she surrendered these images, there was a risk that they would 'disappear'. She told Paul McCredie, a fellow photographer who was involved in organising the exhibition, 'I am very fed up with the attitude of your employers.' She apologised for the fact that he was bearing the brunt of her frustration.⁴⁶

Eventually, as the opening date for the exhibition neared, Ans relented, and 12 of her photographs were put on display.

Meanwhile, in the early months of 1991, planning was under way for a 10-day international photography symposium to be hosted by the University of Canterbury's Department of Continuing Education. Organisers had high ambitions when it came to prospective speakers — both international and local. 'It is important to have a good panel of New Zealanders to fly the flag,' the committee recorded, and accordingly it drew up an extensive list of the country's photographers, from which the final group of local speakers could be selected.⁴⁷

One name, however, was conspicuous by its absence. When Ans found that she was missing from consideration — even from the longlist — she immediately wrote to the symposium's organisers, complaining that the event 'ignores the existence of "art" photographers'. She asked whether those planning the event were even aware of the existence of PhotoForum, which she suggested could become involved, but with the proviso that 'we would in no way want to become party to a purely commercial venture of no benefit to New Zealand's creative photography'.⁴⁸

Fair enough, perhaps, to question the organisers' failure to consider her participation, but Ans' response put her offside with some members of the photographic community. It was another display of uncharacteristically confrontational behaviour, hard on the heels of her outspoken disagreement with Auckland Library.

ANS' CAREER WAS PROGRESSING steadily (if not lucratively) by the beginning of the 1990s. She was keeping busy and feeling 'inspired' at the prospect of exploring new forms as well as topics for her photography.[49] The inventory of her success was strong and growing, but beneath the surface, all was not well. Her previously tranquil disposition — critical for enabling her to blend into the background and remain unobtrusive in her work — was beginning to fray at the edges.

The volatility of her recent dealings with the Auckland Library and the organisers of the Christchurch symposium was the initial outward sign that all was not as it should be. At times, Ans' creative impulses ran riot, with so many ideas surging at such great speed through her mind that she could not keep up with them all. In these moments she was elated, but this euphoric state did not last. As it inevitably waned, her mood sagged, and then deepened further into a much darker cavity of depression. During these periods her appetite diminished, she would feel tired, find it difficult to concentrate, suffer from erratic sleep, and feel incapable of pleasure or satisfaction.

On 25 June 1991 she was admitted to the psychiatric unit at Wellington Hospital. According to the clinical notes, her family had become increasingly anxious about her sleeplessness, 'excesses in activity', and erratic spending in the preceding several days.[50] 'She had also been irritative of late,' the psychiatric registrar noted, 'having arguments with family members. She had herself noted that she had been making more mistakes lately, for example driving through red lights or against a one-way street',[51] and at one stage announced that she believed that her car could drive itself.[52] She was also failing to attend to some basic daily tasks, such as paying bills, which soon began to accumulate.

The tipping point — for those close to her as well as Ans herself — came the night before she was admitted. During that evening 'she had undergone a marked change of experiencing her thoughts as accelerated and out of control, receiving messages from things around her merging with others and noticing foreign thoughts in her mind. There were flashes of visual images endowed with revelation-like quality which she, a highly

accomplished photographer, experienced with great fascination.'[53]

The psychiatrist's subsequent detailed assessment lifted the lid on many aspects of Ans' life. In the few years leading up to her admission she was said to have lived 'in a somewhat lonely world from which she found it difficult to relate her feelings and internal conflicts to others'.[54] Erik recalled one Christmas, prior to her hospital admission, 'when she basically gave back all our Christmas presents, and said, "I didn't want any of this stuff, you can have it back." And she was very hostile to us . . . She basically had a breakdown.'[55] In 1989 she had tripped and broken her wrist, which had temporarily halted her ability to take photographs, and around the same time she had bought a house, putting her in greater debt and dragging her into a legal dispute with the previous owner.

Of course her troubled childhood was laid open for examination. There was the loneliness, and a feeling of being an outsider because she was so much taller than her peers. There was her distant relationship with her father, the sexual abuse by her stepfather, and the trauma of forcing her mother to leave her stepfather. Then there was the lingering regret about not having completed a university degree, and the resentment that her father, in the psychiatrist's words, had 'enticed her to New Zealand, falsely promising to bring her back, but later upon arrival, told Ans that this had been to spite her mother'.

It transpired during Ans' sessions with the psychiatrist that her father had undergone electroconvulsive therapy in Auckland in 1956.[56] No reason was specified, but typically this was used at the time as a treatment for depression and other forms of mental illness.[57]

As the layers of her public persona were peeled away, a clearer image of the private Ans emerged. Her famed ability to 'get on' with people from all sorts of backgrounds masked 'a general lack of trust', which had affected her ability to get closer to people, along with her 'fear of expecting too much from relationships and getting let down'. The psychiatrist recorded that there was a 'sense of uneasiness about her', and that although she was 'both intelligent and rational', she sometimes struggled to focus on a particular

topic for too long and also exhibited traits of paranoia and egocentric behaviour, in addition to depressive episodes.[58]

In addition, there was her abiding disappointment over the breakdown of her relationship with John van Hulst, who had accused her of being responsible for everything that was wrong with his life. In this, Ans identified herself as the victim, and she appeared unable to come to terms with the possibility that more than one party may have contributed to the relationship coming to an end.

At first Ans found the psychiatric ward 'intimidating', and feared that she would lose her 'creative potential' if she were to be confined there for too long.[59] But she acclimatised more quickly than she had expected. She chatted to other patients, occasionally writing down in her notebook comments they made that interested her,[60] and even managed to photograph some of the others in her ward, with a view to publishing a book on the topic.[61] Even in this alien environment, Ans' curiosity about people came to the fore, her mind always eyeing up the world around her in photographic terms.

It was not just the medical professionals who were making notes about Ans' internment. She herself had paper and pen within reach at all times, and she recorded thoughts as they came to her mind. When a doctor described her as having the potential to be 'a very dangerous patient', Ans wrote down this comment, followed by the exclamation 'Shit!' Other notes appeared to be random thoughts fired directly from mind to paper, such as 'There is no madness — only difference', and 'This pen flows easier, so I shall use it to defend myself from here on!' Once she had begun to adjust to the setting, she wrote that this was her 'first little holiday from sanity'.[62]

Soon enough she began producing a series of observations over many pages that she titled 'Portrait of my breakdown'. There were criticisms of the 'butch nurse', the Milo that was too sweet, and even suggestions on improving the hospital parking. Her biggest concern was how long she would have to be there. 'Don't leave me too long in here,' she pleaded to a future reader. 'I am so scared of going mad!!! Don't they see what is happening to me??' This apprehension descended into hopelessness: 'I could have escaped.

But where to? Perhaps somewhere where no one cares about me and I care about no one. Is that an image of hell?' The random thoughts continued:

'This thought scares me: I want to stop time.'

'Inside at least, there is always someone awake.'

'I feel I have written my life away. But that is not so.'

'Is all madness total reason?'

'Does it really matter if I die in the next minute? Other people have died in their sleep. That really is an easy death.'[63]

Ans was eventually diagnosed with bipolar disorder and hypomania.[64] After about a week she was unofficially discharged from hospital and into the care of her half-sister Yvonne, who, along with Ans' children, looked after her as she steadily recovered. Her illness remained under control, and in 1999 her psychiatrist told her it would probably not be necessary to have any further consultations, but that the service was still open to her if she felt the need.[65]

―――

HER NEW-FOUND EQUANIMITY, however, was to face a severe challenge in 1993. She was invited in December 1992 by the Suffrage Centennial Year Trust 'to present a folio of photographs depicting women in the cultural sector in New Zealand'. The Ministry for Culture and Heritage approached Ans directly and she sensed that she was the preferred candidate. The letter stated that 'the approach taken will be a documentary one', and that '[i]f you already have photographs that fit within the theme defined, these may be included in the folio'. Ans was invited to submit a written proposal along with a small selection of prints illustrating her ideas, with the fee to be negotiated in due course.[66]

Patiently and methodically, Ans began to conceptualise what a portfolio on this topic might look like. The deadline was April 1993, and the ministry's chief executive wrote in March, noting that the deadline was just five weeks away. This letter also mentioned that 16 photographers had been

approached,[67] but Ans continued to believe she was the favourite for this prestigious (and potentially lucrative) assignment.

She duly submitted her application, and two weeks after the deadline was devastated to hear that she had failed.[68] The implication Ans took from the bureaucratic rejection letter was that her art and documentary abilities were not judged to be at the requisite standard. She was furious, and promptly wrote to one of the judges — John Leuthart (the Visual Arts Manager of the Queen Elizabeth II Arts Council) — giving full vent to her displeasure:

> I hereby wish to express my dismay at the selection of Denise Burt for the photographic commission for the Ministry of Cultural Affairs. The stated outcome of the project was to gift to the nation a collection of creative works by an *eminent* New Zealand woman photographer. In selecting a relative newcomer over and above photographers of some renown . . . shows a shallowness of judgment.

Ans reminded Leuthart that she had '30 years of experience of precisely the kind of photography required', something she noted that the successful applicant did not. She then went on to complain that for a project involving women photographers commemorating a major event in women's history, having male judges 'was obviously not the best way to go about it'. This indignant epistle ended with a shot fired at the winning applicant: 'I can only hope that Denise Burt will now become an eminent photographer of the future, warranting the investment you have made in her.'[69]

Leuthart's commendably balanced reply acknowledged Ans' 'significant contribution . . . to photography and the wider understanding of New Zealand culture',[70] but in Ans' mind the reputational damage had already been done, and no amount of placatory text could remedy that.

DURING HER RESIDENCY AT the Dowse in 1988 and 1989 Ans had come into contact with educationalist Kelvin Smythe. Throughout his career as teacher, headmaster, lecturer and school inspector,[71] Smythe styled himself as a bit of an outsider — a member of the counterculture who was working 'within the system' in order to change it. Ans had met Smythe in Hamilton, where he was attempting to establish a teachers' collective through which he hoped new teaching methods and innovative material could be shared among the country's more progressive educators.

He had also begun work on a publication similar to the *School Journal*, which he hoped to distribute to primary schools throughout New Zealand. Momentarily flush with money and optimism from a redundancy payout, he began to look for collaborators. He told Ans he was not happy with the way School Publications was being run — that it had become too commercial and focused on export. He wanted to produce more New Zealand-centred publications, reminiscent of *Washday at the Pa*.

Ans of course was thrilled:

> His idea was really great because I would go and spend a day or however long it took with a family, build a story and when I had enough pictures . . . I would print these photographs up and he would take them to the people and get their background, what was actually happening. This is a much easier way of working than having story first and having to follow a story. Everything [then] has to be right; I'm more tied down.[72]

The idea blossomed into three works: *Families of New Zealand: Tenga of Waikuta* (1992), *Sarah of the Valley* (1993) and *Christmas at the Cape* (1994). Sarah was Pākehā, 'living up in the Whanganui River, one of the arms of the river, and there was a long drive, and you go through about seven gates that say "Fair Weather Road Only"'.

Tenga of Waikuta was cut from a similar cloth to *Washday at the Pa* and followed the daily activities of a child in a Māori household. However,

Māori urbanisation had been under way for nearly half a century by now, and the everyday existence of those in urban settings closely resembled that of everyone else in the country, meaning any cultural differences tended to be less conspicuous.

Whether intentionally or otherwise, Ans compensated for the somewhat mundane interior photographs of the whānau with some remarkable exterior landscape images. Backgrounds had always been an important compositional element in her work, but *Tenga of Waikuta* includes a handful of images where the attention is firmly on the landscape, with any people in the scenes confined to a small part of the photograph. One of these images was of 'an old house that no one lives in now' — 'a special house with lots of memories'.[73] The image has a foreground of long, unkempt grass, partially illuminated by the low-level sunlight. The house itself is abandoned and decaying, with a few tall trees punctuating a clear sky. Everything looks bedraggled, rugged, twisted and tattered. The house itself (thanks to a hint in the accompanying text) has taken on a melancholic appearance. It was where memories were once created, but they are now disappearing.

Ans' rendition of this scene plays strongly to the readers' imaginations, encouraging them to see this derelict building as a remnant of a way of living, a leaking repository of recollections of the past. Was this one of the casualties of urbanisation? The photograph poses the rhetorical question.

Another, more complex depiction of the area's landscape features two people, and represented another reach into a more artistic approach to the images in the booklet. Tenga and a friend are playing haupoi (sometimes known as Māori hockey) but the image is dominated by two cabbage trees rising from the flat field, stark and almost skeletal against the cloudless sky. These two trees are a sort of botanical counterpoint to the two boys playing in the foreground.

Landscape photography was not an area for which Ans was known, but here she was continuing PhotoForum's longstanding crusade to have photography taken as seriously as any other contemporary art medium. These images may not have been in keeping with the latest trends in art

Photos from *Families of New Zealand: Tenga of Waikuta*, with Kelvin Smythe, published in 1992.

photography, but they were able to evoke feelings in viewers about the rural world. 'At this stage of my career,' Ans wrote in the early 1990s, 'I feel the need to explore new directions in my creative work . . . I have become inspired by the potential of photographing landscape . . . The way people have left their mark, have shaped their environment to suit their needs or have simply used up and abandoned, is worthy of documentation.'

Her interest in Māori as a subject for her photography had not diminished, but she did admit that continuing to work in that field 'at present feels inappropriate for an outsider'.[74] Landscapes offered no such challenges.

Although her reputation had been built on photographs she had taken of people, she conceded that at times she went through phases when she chose completely different subject matter. It was not because she received commissions for it, but simply because her interest in something out of the ordinary for her took hold of her imagination, and drew her towards it.

IN 1993 ANS MOVED to Whanganui to become artist-in-residence at the Sarjeant Gallery,[75] living in the renovated 1853 house, Tylee Cottage. Her plan was to document the transition that Whanganui was experiencing, and its effect on the existing character of the area.[76] Although she was reprising this theme of change, Whanganui was a fresh location in which to fossick around, and the residency proved to be a productive time. The resulting exhibition — *Wanganui Seen* — comprised almost 160 photographs, most of them taken in the preceding few months.

Something about Whanganui resonated with Ans, and she thought about moving there permanently at the end of her residency. 'It has a good museum, a good art gallery, and the polytechnic, which is very good, and brings young artists here.' It was also sufficiently close to Wellington, and surrounded by what she regarded as a 'beautiful landscape'.[77] With her children now older and more independent, this was a chance to look to recapture

the narcotic effect of dialogue between photographer and new surrounds.

Her physical move echoed her shift from people to landscapes as the objects of her photography. In 1985 she had met the internationally renowned Austrian-American photojournalist Ernst Haas, who was touring New Zealand. He had stressed to her the importance of using 35-millimetre film for larger outdoor scenes, and she soon realised, 'Yeah, well, he's got a point for landscape specifically.' Ans had already wanted to 'push the sides out and have more of a wide view'.[78]

There was no sudden cut-off, though, where she thought she would cast aside people for places. People remained her abiding interest, but from as early as the mid-1980s she began contemplating landscape photography as an additional realm.

The first substantive results were exhibited in August 1998 at Wellington's Christopher Moore Gallery (although all the images had been taken between 1991 and 1993). *Ans Westra's Landscape* comprised 23 photographs (some colour, some black and white) depicting various locations throughout the country, with each work listed for sale for between $960 and $1100.

The inspiration of one of the nation's greatest landscape photographers, Robin Morrison (who had died five years earlier), was unmistakable in these works, but the artistic standard of Ans' images was more irregular. Two photographs of derelict farm sheds in the Whanganui region were strongly reminiscent of Morrison's scenes of old, abandoned rural buildings, but without the corresponding compositional strength or sense of aching loss. If Morrison's photographs in this subject area were a heartfelt lament for the loss of an earlier New Zealand, Ans' were more of a condolence card — similar sentiments but expressed at a greater emotional distance.

However, while these early landscape images were aesthetically still works-in-progress, Ans' documentary skills were as formidable as ever, as could be seen in her 1998 exhibition, *Worship*, at the Dowse.[79] Sacred spaces (churches, marae, cemeteries and urupā) had long been features in her work, but towards the end of the 1990s she took an interest in buildings and their inhabitants, particularly in the Lower Hutt area (including her

1996 documentary project 'Life Around the Churches').⁸⁰ It was a subject area riddled with contrasts: the profundity of religious ecstasy amid dreary suburbia; the gatherings of small religious communities within larger geographical communities; the amorphous sense of spirituality amid the hard edges of church architecture; and that greatest of tensions — temporal bodies gathering to nurture their eternal souls.

Ans obtained permission before entering each of these churches, and was respectful of the fact that she was photographing people in intimate situations. However, she was not prepared for her encounter with a minister from a local Baptist church, in which a potential clash between piety and profanity threatened her freedom to exhibit her photographs. The minister noticed that she had taken some pictures of children in Sunday school, and warned her that 'when these pictures are exhibited people will come and stand in front of them and masturbate'.

This had never occurred to Ans. She considered the photographs she had taken that day to be particularly good, and devoid of any sexual element whatsoever. Her response was to offer the minister the chance to look at each of the images before they were added to the exhibition, and decide whether he was happy about their inclusion. The compromise rankled with Ans' sense of artistic integrity — she regarded the whole business as 'bizarre'. That was until staff at the Dowse informed her that the minister worked part-time at the gallery and had witnessed the behaviour of some visitors when looking at images of children . . .

During her Whanganui residency Ans decided one day to visit Pipiriki — a two-hour drive north, and a place she had last visited 30 years earlier — to take photographs of people and the landscape. She held fond memories of Pipiriki, and reached her destination just as a hui was winding up at the marae. She got out of her car, put the camera around her neck and walked to the gate at the entrance to the marae, where a few people were seated on the ground drinking beer. She told them why she was there, and one of them said, 'Oh, there's still some people cleaning up on the marae — you can go over there and take some photos.'

Ans walked in to the wharenui and began to take a few images from roughly the same spot as she had stood in the last time she was there. This time, though, the reception was less welcoming. 'A lady came rushing up and said, "What do you think you are doing?"' She led Ans over to 'the big man there', who said, '"Well, you can't just come in, just walk onto the marae and take photos. You have to ask permission first." And I said, "Well, who should I ask?" And he said, "Any of the houses around here . . ." I had asked the people at the gate, but I didn't want to stand my ground on that . . . I was severely told off for just walking in and photographing.'[81] Ans felt so hurt by this encounter that for the rest of her Whanganui residency she avoided the area.

As she grew older, her tolerance of obstructive behaviour diminished. In one case, when a member of the public voiced an objection to her taking photographs, she responded, 'Now come on, this is my city, my footpaths, you can't tell me that I can't walk there.' Generally, she tried to remain civil. 'When I get accosted by somebody,' she conceded, 'I can't actually bite back.' But sometimes this resolve was tested to breaking point. The family of her friend and neighbour, the barrister Greg King, gave Ans permission to take photographs at his funeral after King committed suicide in November 2012. But on the day a church official told her, 'No, you've got to sit down. You can't walk around.'

Initially Ans turned the other cheek and left, returning just as the coffin was being carried out of the church. As she readied her camera to take a photograph, the same official again insisted that she was not allowed to take photos. Ans explained who she was, to which the official snarled, 'Yes, I know who you are.' In that moment, Ans' approach changed. 'I got angry, and I said, "You know nothing." And all the people said to me, "Well, these are God's steps. I'm not trespassing."'[82]

Ans sometimes thought she had become a sort of tall poppy whom some saw as ripe for cutting down. Such was the price, she felt, of a successful career.

THE WHANGANUI RESIDENCY represented an alignment of many of her wishes: time to work on taking photographs without life's normal interruptions, a new location to explore, a modicum of financial security, and the prospect of exhibitions.

But in October 1993 she made the startling announcement that she intended to leave the country in June the following year, and that after some travel she would return to the Netherlands, where she would spend her remaining years.

It sounded as though she was exhausted with New Zealand. 'I feel I have served my time here,' she told a reporter for the *Evening Post*. 'I have ... done everything I want to do here and I want to have new horizons, look at other people.'[83] Another reason was the growing insistence of some that it was inappropriate for Pākehā to photograph any aspect of Māori and their culture. 'She took it very hard,' her sister Yvonne recalled. 'She felt she wasn't appreciated or valued for her work.'[84]

Ans wanted to escape this form of artistic suffocation — to get into a car and drive to different countries, to 'be a gypsy', as she described it. Her plan was to visit China, Mongolia and Russia before settling in the Netherlands, where she anticipated starting work on a collection of photographs of 'an outsider's view of Holland'.

However, she hadn't forgotten about 'Peaceful Islands', which had been lying in a literary coma for years. Before departing New Zealand, Ans was determined to complete the work, which she saw as her 'parting gift' to the country. She told the *Evening Post* that proceeds from the sale of the (eventual) book would go to the Māori Women's Welfare League.[85] As the work remained half-drafted and dormant, not everyone shared her optimism.

And indeed, 'Peaceful Islands' lay unfinished when, at the end of June 1994, Ans boarded a flight to Singapore. From there she flew to Hong Kong and then Beijing, where she began the month-long trans-Mongolian railway tour, concluding with stays in Moscow and St Petersburg.[86] Shortly after reaching the Netherlands she learned of her father's death in Brisbane. She

was not unaffected by the news, but her grief was tempered by the fact that they had long since been estranged, having exchanged just a few letters over the previous decade.

Instinct, frustration and a feeling of longing had drawn Ans back to the country of her birth. She was Dutch by birth, language and culture, but she had also become a New Zealander. The two identities were indivisible yet clearly competing elements in her mind. Ans had never gone out of her way to disguise her nationality, or to conform to the expectations of whichever society she found herself living in. But now, approaching 60, she was struggling to decide where the rest of her life ought to play out — where she would feel most at ease with herself.

She spent less than a year in the Netherlands this time before deciding her future lay in New Zealand. The Netherlands was the country of her upbringing, but the number of family and friends who remained had dwindled. Professionally, she was an outsider, with relatively few contacts in the Dutch photography community, and there were fewer opportunities for the sorts of publications and exhibitions she had been involved with in New Zealand. The prospect of starting again must have been daunting. She had not sold her house before she left New Zealand, so the option to return was always there. Deep down, she probably knew she would return to New Zealand at some point. Her departure had been an act of escapism, not abandonment.

But what would she be returning to? She felt her career had stalled, and that if she picked up where she left off it would merely offer her more of the same. Nevertheless, after much weighing up of pros and cons, she packed up her belongings and flew back to New Zealand in 1995.

Shortly after arriving back she decided on a personal pilgrimage, retracing the steps she had trod 30 years earlier when taking photographs for *Washday at the Pa*. She first settled back home in Wellington, taking stock of her life and scraping together a small amount of money from various jobs. Then, throughout 1997 and 1998, Ans travelled to Auckland, Bay of Plenty, Murupara, Rotorua, Napier and Hastings, tracking down people she

had photographed all those years ago. She announced that May 1999 would be the month that she would take pictures of the available original family members who featured in *Washday*. The date was symbolic to her, being 35 years (a number she double-underlined in her notes) since she had taken the original images. She was completing a cycle in her life.

Financially, the undertaking was disastrous. She gave out a total of $1500 in koha to the family members she photographed, and other costs approached $10,000. A grant covered some of this expenditure, but the act of reconnection had never been about making money. It was a chance for Ans to relive an encounter with 'the real New Zealand' that she vividly remembered, and a way to revive her enthusiasm for the country she had nearly abandoned. In some notes she drafted along the way she gave every indication that she was back to doing what gave her the most satisfaction: 'Each family was marvellous to photograph. They understood my way of working, remembered it in fact from our first encounter. So they let me be and gave me an insight into their lives.'[87]

AND WHILE ANS WAS reacquainting herself with the country, the apparatus of state recognition and honours had begun (arguably belatedly) to clank into action for her. In the 1998 Queen's Birthday Honours list, Ans Westra was appointed a Companion of the New Zealand Order of Merit (CNZM) for services to photography. Nine years later she became an Arts Foundation Icon — an honour given to only 20 living artists in recognition of their lifetime achievements and significance, and then in May 2015 she received an honorary doctorate from Massey University for her contribution to the country's visual culture.

Ans was appreciative of these awards, but she had her own take, as always. Regarding the CNZM, she commented that 'because I was never English . . . it could have meant more. It was . . . a great recognition, but more of the work itself than of me as a person.' She was pleased nonetheless,

and sent her mother a small version of the award, saying that 'she probably was more impressed than I was'. Ans saw herself having 'reached a certain level and that was recognised and that was honoured. People that helped on the way, they're also honoured as a consequence. Their efforts had been worthwhile to get me there.'[88]

When it came to the Arts Foundation Icon Award, her reaction was more liverish. When she learned of the award, it 'sort of almost annoyed me because there was no monetary attachment so I couldn't step back and go down a few steps of the ladder and get something substantial. It was purely the mana it vested in the award. People recognised your work as of international standard.' The honorary doctorate, by contrast, was something she cherished, for the validation it gave her professionally and for the recognition it afforded her. 'I'd never been to university and didn't achieve that status so just to get it awarded was a great honour, a great personal honour, not just because of my personality but because of the work that I'd done.'[89]

While honours in recognition of Ans' work accumulated, she was keen to avoid any implication that these were end-of-career acknowledgements — some sort of living obituary. She busied herself at home, padding around her piles of paperwork and considering what new prospects might lie scattered somewhere on her overcrowded floor.

Practically no one involved in any creative enterprise devises some master strategy along which their career will comfortably and predictably travel. Financial constraints, the erratic nature of inspiration, various 'real life' demands and the involvement of others all militate against that fleeting storm of creativity that initially seems so certain to succeed. Ans' career was peppered with projects at various stages of completion. Some came from deep within her imagination, while others were suggested by outsiders.

One of the latter sort arose in 1992, when a newly established organisation called Inter-View Photo Agency wrote offering Ans 'exclusive publication access for your work'. The letter had been printed in bulk, with a blank space for the recipient's name.[90] It was clearly a fishing expedition, but Ans nibbled at the bait, phoning the firm to see what they had in mind. The

idea they proposed was a book on New Zealand photography, provisionally titled 'Five Photographers'. The others to be included were Bruce Connew, Anne Noble and Laurence Aberhart, along with Jenner Zimmermann (who happened to be one of the founders of Inter-View Photo Agency).[91]

Connew, Aberhart, Noble and Ans met to discuss the project, and shortly afterwards wrote to Zimmerman to express their 'common concern' that his work did not 'sit comfortably with the work of the other four participants'.[92]

Zimmermann's response seemed to them defensive. He told them the agency was already in the process of organising an alternative book, with contributions from photographers 'of at least equal importance'.[93]

Ans had taken very little part in the discussions thus far, but when Aberhart showed her Zimmermann's letter she wrote to him herself. She acknowledged that the rift could probably not be bridged, but went on to suggest that he had 'tried to step amongst a bunch of very dedicated artists ... [without understanding] what they are doing'.[94] Privately, she was more forthright. She wrote a note to Aberhart, calling the group's original letter 'courageous — brilliant', and observing, '[The] least said the better about J.Z.'s reply.'[95]

Other projects stalled simply because of inertia, or because the alignment of forces to make them happen could not be achieved. The book 'Ans Westra's World' was one example. It had been planned for release in 1999, and would have included a broad sweep of Ans' images dating back to the early 1960s. There had been a tentative expression of interest from a publisher who later withdrew, sensing some commercial risk.

Sometimes, circumstances entirely beyond Ans' control hobbled opportunities. Such was the case with the exhibition *Mudpool Modernism: Modernism and Tourism in Rotorua*, held in the Rotorua Museum of Art and History in 2000,[96] and in which it was planned that some of Ans' photographs would feature.[97] However, at the eleventh hour Ans was advised that one of the other contributors to the exhibition had threatened to pull their work if the organisers proceeded with their plan to reduce the size of the catalogue. 'In order to keep with the length required for publication,' the

letter to Ans continued, 'I have cut all references to tourism in the catalogue essay entirely . . . these changes mean that all reference to your work has been dropped from the publication.' While some of her images still appeared in the exhibition, there would be 'no record of this in written form'.[98]

'Celebrating Life: A Hutt Documentary' was another project that blazed brightly in Ans' mind, but soon faded. This was to be an exhibition accompanied by a book, but it did not materialise beyond a rough outline.

Two other book ideas that never eventuated give a glimpse of how she saw and understood aspects of the world around her. The first of these was a proposed work on immigrants to the country. 'The uprooting of people from their origins brings a variety of reactions,' she suggested in her proposal. 'Some cling to their remembered lifestyles, even reviving old customs to give a sense of identity perhaps needed more here. Others get absorbed into the country's fabric very quickly making the most of new found freedoms.' In keeping with her established technique, she hoped to identify certain immigrant families and follow their lives over a period of time.[99] However, no publisher interest was forthcoming.

Ans gave the working title 'Changing Times in New Zealand' to another book she conceived, in 1992, which she hoped would be complete in time for the millennium celebrations at the close of the decade. This was by far her most ambitious proposal — a publication to which other New Zealand photographers would also contribute, and that might contain in excess of 300 images. Her intention was to create a detailed documentary time capsule of the country.

Unsurprisingly, the sheer scale of the project frightened even the most accommodating of publishers. The photography would take place over five years, with Ans estimating that the cost to get the work to the stage where it was ready for submission to the publisher would be in the vicinity of $100,000. She concluded her proposal with a dip into philosophy as a means of emphasising the significance of the planned book. 'If it is true,' she informed what by this stage must have been an incredulous publisher, 'that the unexamined life is of little value, then it behoves us to examine

our lives as we live them — for our own benefit and for that of future generations. If we do not create our own history/historical record, can our descendants' pasts be said to have existed?'[100] The project found no takers.

Some projects never advanced beyond half a page of scribbled lines. Scattered through her home were manila folders titled 'Thoughts!' and 'Ideas!!!'. One was for a book titled 'The Plastic Society', which would depict the lives of the country's rich.

———

IN 1996 SHE WAS sorting through a pile of documents when she came across an invitation from artist Diane Halstead, a lecturer in photography at Otago Polytechnic, to accept an artist-in-residence role the following year, including a stipend of up to $5000 and the use of a studio.[101] When the invitation had first arrived, she had been keen initially, but she felt overwhelmed by the bureaucracy of her life at the time and could not face the lengthy and convoluted process of completing applications for funding on top of everything else. Inevitably, details occasionally slipped through her fingers, including in this instance, submitting her application for the position.

Twelve months after receiving Halstead's letter, Ans got in touch about the position and managed to negotiate a reduced residency of three weeks for a fee of $3000.[102] There were four requirements: using the polytechnic's facilities, 'experiment[ing] freely with the medium', 'act[ing] as a role model for students', and assembling 'several portfolios from current colour work', with the intention that they be exhibited at the polytechnic's art school and then added to its art collection.[103]

The emphasis on colour photography was in response to a statement in Ans' application: 'Recently I have begun to work in colour, but as I have no colour printing equipment or little experience, I have found that I have no control over the final outcome of my prints and many of the subtle interpretations needed to give the work its full aesthetic richness are lost when they are handled by a commercial printer.' She hoped that

this residency would enable her to improve her colour skills through using the excellent equipment at the polytechnic. She admitted that when it came to photographing the natural world she was finding black and white inadequate, and that as she began working with colour, it 'became an integral part of ... [her] work'. 'I ... react with my personality rather than my intellect,' she informed those considering her application.[104]

She finally took up the residency in 1998. Although short (it eventually lasted for two months), she saw it as a chance to launch her into the world of colour photography. At an age when others might have looked to consolidate their comfortable status as the matriarch of their medium, Ans was poised to delve into new ways of representing the world around her.

11. Broken Ends

It is an industry built on seduction, where carnality is king, and where desire is cast as a kitsch commercial aesthetic. And because it was still popularly regarded in some quarters at the turn of the twenty-first century as salacious and outside the realm of 'normal' life, the sex industry was grist to Ans' mill.

The exhibition *Behind the Curtain: Photographs of the Sex Industry by Ans Westra*, which opened at the Manawatu Art Gallery in 2000, consisted of 38 black-and-white photographs taken by hanging around in the back rooms of brothels and striptease clubs in Auckland and Hamilton, talking to the women and observing the mood. Backstage from the pantomime of sex was a side of the industry few on the outside ever got to see, and it was far removed from anything even remotely erotic.

The sex workers in this nocturnal world looked bored and despondent. Several images showed women getting dressed for the night, their faces showing their real feelings in the moments before they applied their fake enthusiasm. The scenes Ans photographed were described by one reviewer as 'prosaic' and 'banal'.[1]

'I was actually trying to be helpful in a political issue,' Ans explained in the catalogue, 'because they were trying to [achieve] decriminalisation of the sex industry through Parliament.' Equally, though, she wanted to look at why people were drawn to work in the sex industry; she found that many were in the industry as a means of survival.[2] They were reluctant, solemn-

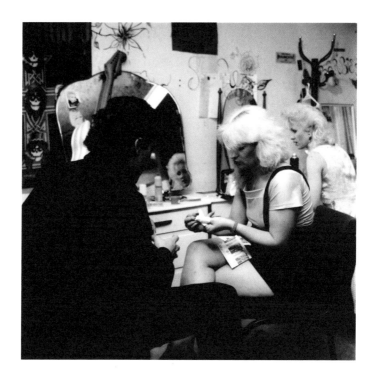

The exhibition *Behind the Curtain: Photographs of the Sex Industry by Ans Westra*, first shown in 2000, consisted of 38 black-and-white photographs taken in the back rooms of brothels and striptease clubs in Auckland and Hamilton.

faced participants in a business which required them to submit to male lasciviousness to make a living. Any distaste Ans felt was implicitly directed at those who led the demand, not those who through circumstance were more or less forced to yield to it.

Behind the Curtain represented a return to form for Ans. After dabbling in colour, and experimenting with landscapes, here was a visual study in black and white of the human condition that drew on her exceptional ability to render emotions, attitudes and atmosphere in images. No other New Zealand photographer could communicate sadness in sombre settings as acutely.

BY NOW ANS WESTRA had been taking photographs of New Zealand and its inhabitants for 43 years and many of her roughly quarter of a million images had acquired historical significance. Her corpus now spanned two generations. It made some sense, then, to organise an exhibition to showcase the chronological breadth of her art.

Rotorua Visits 1963–2000 was one manifestation of this concept. The exhibition, curated by and held at the Rotorua Museum of Art and History in 2000, charted images taken by Ans in her many visits to the city over nearly four decades. The older photographs on show were not only snapshots of the past; collectively, they also offered a slice of history.[3] There was no accompanying catalogue — the images did all the heavy lifting.

As always, Ans had no specific narrative in mind when taking her images. She simply represented what she saw: Rotorua's complex and evolving identity, the 'awkwardness of . . . cultural encounter', opaque notions of cultural authenticity, and the ambiguity of Rotorua as a tourist town.[4]

With the support of many of the country's leading figures in photography, and under the direction and curation of Luit Bieringa, Lawrence McDonald and Neil Pardington (among others),[5] a major retrospective exhibition of Ans' work toured in 2003. This was followed the next year by a book — *Handboek: Ans Westra Photographs*,[6] and then in 2006 by Bieringa's documentary, *Ans Westra: Private Journey/Public Signposts*. The book was a substantial statement about Ans' contribution to the visual anatomy of the country since the late 1950s, and included texts by nine writers and around 250 photographs. The choice of title for this exhibition-book-film juggernaut was an obvious evocation of Ans' Dutch heritage: 'handbook' or 'guide'.

The idea for a major retrospective went back as far as 1979, when John B. Turner, then teaching photography at Elam School of Fine Arts, had identified the value of condensing Ans' repertoire in a way that would represent her art, her skill and her contribution to the way in which New Zealanders saw themselves. But the usual barricades of institutional inertia and insufficient funding prevented the idea from advancing beyond its

conceptual stage. The publication of *Witness to Change* in 1985 had served as a prompt to reconsider. A retrospective would not be comprehensive (how could it be, given the scale of her output?), but it could be representative. *Handboek* became the high-water mark among exhibitions of Ans' work, its organisers combing through 48,000 negatives in their selection process.[7]

Ans had little involvement, apart from the film, but even then she 'starred' in it rather than controlled its content. She trusted people like the writer and academic Lawrence McDonald, John B. Turner and Luit Bieringa, and felt they understood what she was trying to achieve artistically. McDonald contributed two essays, the first of which looks at how best to characterise, identify and define Ans' work. He homed in on her professionalism, her patience, her productivity, her many publications, and the fact that she had become a participant in many of the scenes depicted in her images through her particular approach to her work. McDonald also considered the scale of her output, writing that beneath the 'impressive body of published work, like the submerged part of an iceberg, is a huge archive of negatives and contact sheets . . . an image reservoir, the largest collection by an individual photographer held at Turnbull Pictures, which is still being filled'. It was an archive that 'has the potential to continue making statements within projects yet to be conceived. Like the lexicon of language itself, it is too large to be grasped by any one curatorial and monographic project.'[8]

Turner's essay addressed the genesis of Ans' career and its remarkable trajectory; Gavin Hipkins explored her nimble-footed traverse through the tricky terrain of the nation's identity; writer and curator Kyla McFarlane traced the conceptual lineage of Ans' photography to the ideas of universalism in *The Family of Man*; art historian Damian Skinner surveyed the ways in which Ans assembled an outsider's view of Māori society in the 1960s; and writer and artist Cushla Parekowhai provided a recent oral history of Parikino, a location where Ans had previously photographed.

The closing essay, by curator and writer Christina Barton, insightfully and judiciously addressed the role of the documentary photographer,

reminding readers that no photograph could be socially or culturally neutral and thus 'objective'. Rather than being a medium to communicate truth, photography could more accurately be described as a tool of ideology.[9] The underlying subjectivity did not necessarily detract from the value of photography, but it needed to be remembered.

The sequence of photographs in *Handboek* was broadly chronological and spanned the period 1959–2004. However, because no attempt was made to demarcate eras or artistic phases, frequently topics seem to run together. *Handboek* presents readers with a full visual opera, with solo performances and choruses all contributing to the overall effect. It made it abundantly clear that Ans functioned like metaphorical blotting paper, soaking up every drop of real life before her camera. The result was an epic 'culturescape' of the country, warts and all. What constituted New Zealand's distinct identity? This was Ans Westra's unique and idiosyncratic answer.

Many of *Handboek*'s images would have been familiar to those interested in her work, but the texts, which constituted almost half the book, finally gave Ans the serious consideration and recognition she deserved. Poet Hone Tūwhare contributed a mihimihi:

> Ans' photographs evoke in me an admiration for the quiet, but effortless depiction — in the pictorial sense, of the human and social impact of New Zealanders, in the quiet, but nonetheless emphatic sense of ease, the sense of belonging, and being at one in the social and tribal sense of 'being at home', entirely.

Tūwhare had captured an important aspect of how Ans portrayed New Zealandness, going on to suggest that the power of her photographs lay in what they could contribute to that sense of identity: 'Ans' works are seedlings of a quiet joy, of hope; and smartening up, the human sense of: Hey Mate! You're me!'[10] Tūwhare could see through the patches of social and cultural friction in the country to a brighter future, and placed Ans' photography as a guide along that route.

Ans reminisced later about visiting Tūwhare at his modest cottage at Kākā Point, on the blustery South Otago coast, to discuss the book and his contribution to it. He produced the mihimihi and she bridled at his original final line, which she regarded as being 'too militant . . . you know, raised fist . . . I didn't like the last line.' Tūwhare was adamant that it be kept, and made it clear to Ans that it was not her decision. Two stubborn personalities collided, and neither would back down. In the end Ans had the last word, removing the final line at typesetting stage.[11] She said Tūwhare subsequently forgave her.

The *Handboek* exhibition opened at the National Library gallery in Wellington on 14 August 2004. In its media release a year earlier the library had described it as being 'designed to offer viewers the unique experience of walking through a giant family photo album' that would include 'a snapshot of New Zealand children of all ethnicities, whom Westra loved to photograph, blissfully unaware of the political issues raging above their heads'. The exhibition was pitched very much at the general viewing public — curious Saturday-afternoon visitors who might be lured into a rare trip to a gallery. Ans was given voice in this promotional material, urging viewers to 'value what is here — the landscape, the lifestyle', and to try to avoid being 'like everyone else'.[12]

The exhibition indeed proved popular. In addition to photographs, many of the publications that featured Ans' works were on display, right back to early editions of *Te Ao Hou*, and of course *Washday at the Pa*. Groups such as the Correspondence School held team meetings in the midst of the exhibition, and there were resources designed for visiting school children. The exhibition was filmed for television and even proved popular with tourists, serving as an impressionistic summary of five decades of popular New Zealand culture.[13]

'Honesty' was a favourite noun among reviewers. As one reviewer pointed out, 'This was no Tourism Board view of New Zealand but rather one that echoed that slight embarrassment you have when you have to concede that the photograph of you really is how you look.' This was clearly a lot of

the appeal of these photographs: it was a form 'of documentary photography as a way of knowing ourselves' as we really seemed to be.[14]

THE DOCUMENTARY *ANS WESTRA: Private Journeys/Public Signposts*, was the first film Jan and Luit Bieringa had ever made. With the backing of Television New Zealand and the funding agency New Zealand On Air, Luit set to work with an able crew consisting of his wife, Jan, New Zealand Film Archive founder Jonathan Dennis, film editor John Irwin and filmmaker Gaylene Preston as a consultant.[15] Bieringa's lack of film experience was more than compensated for by his close understanding of the art scene in New Zealand — he was the director of the Manawatu Art Gallery from 1971 to 1979, and of the National Art Gallery for the following two decades.

The documentary screened at the 2006 Wellington International Film Festival, and an edited version was shown on television shortly afterwards. It was a highly accomplished piece of work that scrutinised Ans' life and career closely but in a way that never felt intrusive, in part no doubt because Ans was extremely candid about her life. Together with the book and the exhibition, the film marked a significant advance in the promotion of Ans' work, and in the degree of its public and critical recognition.

Having reached the age of 70, it would have been easy, and perhaps even tempting, for Ans to look on the three-pronged offering as a fitting punctuation point with which to end her professional career. Posterity had been ably served by *Handboek*. Was it time to hang up the Rolleiflex and glide into retirement?

While the crowds were flocking to the *Handboek* exhibition in Wellington, one visitor noticed Ans out of the corner of their eye. There she was, standing outside the National Library gallery, her body in that familiar shape arched over her camera, busy taking photographs. If anything, the monumental success of *Handboek* had invigorated her. She wasn't done yet. As she said in Bieringa's film:

> I can't help being captured by photography. I'm a gatherer. I collect images — my vision of that particular moment. Photography holds the power to capture a moment in time — a record of things happening that will stand as witness. It's my personal diary, it's my personal story . . . I'm documenting my personal journey. I photograph what interests me, what captures my attention, so it can never be the whole story, it can never stand for the complete truth. It can only be my version of it really.[16]

Ans Westra's story evidently had some way to run, and she was on the lookout for new material . . .

WHILE THE *HANDBOEK* EXHIBITION was winding down in 2005, a small new exhibition of Ans' work, titled *To the Pleasure Garden*, opened in Auckland.[17] This retrospective incorporated a selection of photographs taken over the previous 44 years. The reference to pleasure gardens evoked the eighteenth-century English notion of a colourful urban arcadia designed for strolling around.[18] Several photographs in the exhibition nod to this theme: a close-up of a flowering magnolia tree against a rich blue sky; a hydrangea heavily laden with faded pink blooms.

The use of colour was still rare for her — she had taken a set of photographs earlier in the year for the band Fat Freddy's Drop in her trademark black-and-white format. Just before the exhibition's opening, she explained that she had decided on the exhibition's title 'before the pictures came into existence . . . So it dictated a new direction in my work.' She was moved by 'the sheer pleasure that nature can bring to those willing to listen. And what photography is capable of. How colours affect each other on film and what is pleasing to the eye . . . This work has been healing for my soul and a good counterbalance to my documentation of human life.'[19]

By now Ans had embraced digital reproduction and found her pictures,

enlarged for the exhibition, 'overwhelming in their size and feel and texture'. 'You almost float into them . . . and of course the colours evoke different moods.' She regarded this project as 'fun', and it was clearly also revelatory in terms of the potential of colour.[20]

One floral photograph from the six in the exhibition stood out for its experimental qualities. 'The Pleasure Garden III' was a close-up image of a camellia bush, but this was no literal depiction but rather an impressionistic one. Almost the entire image is out of focus. The background is a haze of pink flowers and white sunlight that are barely distinguishable, but identifiable in light of the camellia leaves in the foreground, which themselves are not entirely in focus, but clear enough. The lack of focus is exaggerated in some parts of the photograph, giving a sense of depth and also dragging the viewer's eye back and forth as they scan the visual clues. Within this lush botanical haze, one twig protrudes in sharp focus on the far left of the image. It is bathed in the pink reflection of the surrounding blossoms.

Ans then slipped into a more familiar mode for a diptych she called 'Trees — Winter Paraparas'. 'After photographing nature for its colour,' she explained, 'I wanted the challenge to record in black and white. Suddenly I had to think in the abstract. Form and composition dominated. What I was looking at were the bones of the tree, showing winter.'[21]

Two photographs were a study in natural form. The first portrayed some bare, drooping branches, set against an indistinct grey sky, and the second was of a row of these leafless trees, with a range of light-grey hills and a paler grey sky behind them. These old trees, with their weather-worn trunks, gaunt limbs and broken branches, were emblematic of the passage of time, and drew on picturesque tropes of the splendour of the nature-ravaged world. They were not among Ans' greatest compositions by any measure, but their importance lay in the way they revealed her testing new categories of subject.

To the Pleasure Garden included work going back to 1961. The decades since had given Ans an opportunity to reflect on these photos, and she included a few observations in the exhibition booklet. About an image of

two men photographed outside the wharekai at Ngāruawāhia in 1963 she wrote, 'Now you cannot photograph on this marae. I have to stay outside the gates with my camera.'

Elsewhere she conceded that in 1963, when taking photographs for *Washday at the Pa*, she had been 'unaware of how Māori wanted to be seen'.[22] There was an innocence to these fragmentary reflections. She was not excusing or defending her past approaches but simply acknowledging that society's temperament had shifted since. It is almost as though she were an outsider looking in on her own life — perhaps naïvely, but definitely dispassionately.

———

From the series *To the Pleasure Garden*, 2005.

Parapara, 2005,
from *To the
Pleasure Garden*.

HANDBOEK HAD RAISED ANS' profile considerably, and a growing band of academics, critics and journalists was eager to interview her. There were invitations to attend gallery functions and speak at various events, including openings of her own exhibitions here and there. She disliked speaking in public, and where possible opted for discussions and interviews about her work. Most such occasions were polite and convivial, and Ans was happy to participate, but in 2007 an invitation came that she'd much rather have avoided, but felt she could not. She was invited to be part of a panel discussion hosted by the New Zealand Festival of the Arts, held in Wellington, along with photographer Marti Friedlander.[23]

Ans was 71 and Friedlander 79 — both in the autumn of their careers. Despite the fact that each had been photographing New Zealand and its inhabitants for around half a century, extraordinarily, this would be the first time they had met in person.

Ans respected some aspects of Friedlander's craft, but she felt that some of her photographs of individuals were too contrived in their composition and artificial in their staging, in contrast to her own 'natural' approach.[24] Ans was also aware that Friedlander was seen as a 'professional' photographer, while she herself still dragged around the label 'amateur', based on her 'untrained' background. She had never quite managed to free herself from the perceived taint.

It is remarkable that these two forces of the tightly knit New Zealand photography community had not encountered each other directly before. 'They were radically different personalities,' recalled Lawrence McDonald, who had been selected to chair the festival panel, and he immediately felt the tension between them. Just before the event got under way, McDonald asked Ans about the speaking order, and where on the stage she wished to sit. 'I don't mind what order I speak in or where I sit, as long as I'm as far away from *that* woman as possible, she told him.'[25]

In an unexpected turn of events, Friedlander announced that she wanted to photograph Ans at that meeting. Ans accepted with both civility

and extreme reluctance. Was this a gesture of rapprochement, or a case of one attempting to outfox the other? The photograph offers no definitive answer. In his 2020 book about Friedlander, art historian Leonard Bell wrote that Ans did 'not look like an adversary in this portrait',[26] but that seems a generous assessment. Ans' typically joyous face is reduced to a clench-lipped grin. An attempt to gather a smile never quite succeeds. Her eyes look penetratingly down the lens, giving the sense that her forbearance is about to run out. It is an uncomfortable image to look at. Possibly unintentionally, Friedlander captured what Ans herself was renowned for achieving: a candid moment.

———

IT WAS INEVITABLE, GIVEN the volume of her output, that Ans would come across examples of her work being used in books and magazines and on television without her permission — and without due remuneration. In 1983 she was surprised to see one of her photographs pop up in the promotional material for a television documentary on Whina Cooper — cropped and reproduced without any authorisation from her at all.

Earlier in her career she may have been inclined to turn the other cheek, seeing it as a form of recognition of her work, but by these latter stages she was more aware of the need to protect her intellectual property. But asserting rights retrospectively was no simple matter, as she discovered when she took action against the producers of the documentary. 'I took them to court because it was my copyright,' she said, but they countered that Ans had signed an authorisation for her pictures to be used 'for promotional purposes'. Ans eventually proved that she had not given permission for that particular photograph to be used, achieving what she felt was a moral victory. 'I didn't get much out of that one, but I thought it was worth bringing the case.'[27]

On another occasion she discovered a portion of a photograph she had taken of Kiri Te Kanawa in an edition of the *New Zealand Listener* — again,

without her consent, and without any payment being offered.[28] Although this time she took no action, her resolve stiffened about better managing the use of her work.

A somewhat more unusual situation arose in 2019, when a box of photos taken at the time of the Springbok tour in 1981, in which there were a number of Ans Westra prints, came up for auction. She contacted the auction house to say she had not given her prints to anyone.[29] The items were withdrawn from the auction, but the episode further emphasised to Ans the mounting need to sort out the administrative side of her work.

These issues were clearly signalling to Ans that the business of photography, with the attendant concerns about rights, royalties, distribution, cataloguing and marketing, had grown to the point where she was no longer able to manage it herself. Gone were the days when a single letter from the Department of Education would suffice as a promise of income and subsequent protection of her works. The world of photography had become more complex, and the internet exponentially increased the opportunities for unauthorised use. Some sort of organisational and protective measures needed to be put in place, though exactly what they should be was still unclear to her.

―――――

ONE INDICATION OF THE success of *Handboek* was its international reach. A selection of photographs from it (mainly those depicting Māori) formed the basis of a touring exhibition which, fittingly, had its final show at Volkenkunde, the Museum for Ethnic Art in Ans' hometown of Leiden, in 2006. She travelled to the Netherlands with the exhibition, and gave a series of talks to enthusiastic audiences. On the exhibition's opening day, David Alsop, a New Zealand lawyer and keen art collector who was working in Amsterdam at the time, attended the talk and they chatted briefly afterwards.

When Alsop returned to New Zealand the following year he founded {Suite} Gallery, and through the network of the Wellington art scene, crossed

paths again with Ans when she turned up at the gallery one day with two prints taken during the Springbok tour that were looking for a buyer.[30] Alsop agreed to put them up for sale. The prints sold quickly, and a relationship of mutual respect between the artist and the gallery owner began to blossom.

Alsop soon organised a small exhibition of Ans' works — just six photographs — which again attracted public interest and buyers. The volume may have been small, but there was an unmistakable upsurge in enthusiasm for Ans' photography. When Alsop visited Ans, and saw parts of her enormous collection, he 'realised early on that she had no record-keeping, no cataloguing, and that she was going to need support'.[31] His response was to begin a process of categorising and cataloguing Ans' work — a daunting process. Alsop also conceived the idea of republishing *Washday at the Pa*, in 2011, which was to prove by far the biggest boost to her career in this period.

In 2012 Alsop dedicated the final few months of his temporary satellite gallery on Wellington's Oriental Parade exclusively to Ans' works, and later that year the pair established Suite Tirohanga Limited — named for her house — to act as the manager of Ans' print archive and copyright.

Two years later Ans gifted ownership of her negatives to the Alexander Turnbull Library, and at the same time Suite Tirohanga, with the assistance of the National Library and specialist technicians, began the massive project of cataloguing and digitising her black-and-white negatives.[32] Unlimited online access to Ans' archive is now available via the National Library website; images are catalogued by location and date, with additional information about the events, activities and people in the images noted where known.

Still on the lookout for new ways to promote Ans' work, Alsop then took the unusual step of creating a 'living museum' devoted to her career. It immediately proved popular, not just to buyers but also to a growing number of people who were discovering Ans' photography for the first time. Arts administrator and writer Malcolm Burgess, writing in *Art New Zealand*, examined the distinction between a museum and a gallery, observing that the former 'has an air of authority and finality to it, [while] the other a more

dynamic interplay, full of possibility, and suggesting the active involvement of the artist'.[33] By establishing the museum in the floor above {Suite} Gallery on Wellington's Cuba Street, Alsop gently fused these two categories of spaces. The museum contained samples of books she had contributed to, along with posters, items from her house and samples of her work.

'She would love it,' Alsop recalled, 'and people would be glad just to have an audience with her.'[34] It seemed that finally Ans was beginning to enjoy not just the art that she produced but also the popular acclaim it deserved.

With Ans clear of the enormous burden of her archive, she was free to test new areas of photography. She had already made a start on that, with a somewhat surprising foray into photographs of souvenir toys. Outwardly, it looked as if she was wading into an ocean of kitsch, but she had it all thought out. She decided to shoot the collection in colour because the toys she selected, especially the dolls, were brightly coloured.[35]

It was quite a conceptual leap from high-minded images of cultures in transition. Almost by accident she had begun to notice things to which she had previously given little thought: 'I started looking at the souvenir market, how we portray ourselves to the world, collecting things people sell for souvenirs. It is representation in a more playful way.'[36] Playful was the key adjective. The resulting series of images, exhibited under the quixotic title *Toy-Land* (sometimes *Toyland*), revealed something of Ans' underrated sense of humour.

The humour operated on several levels, starting with her decision to make these some of the largest photos she had ever put on display — *Maori Doll 1*, for example, measured 1470 x 1240 millimetres — despite their being among the smallest objects she had ever photographed. The joke rolled on. With this particular photograph she also discovered a way to bypass the increasingly restrictive rules about photographing Māori. The work served as a mild rebuke to those who had denounced her right to do so.

Peter Shaw's gallery notes for the exhibition gave some background. 'Bought in op shops or at car boot sales, the tiny figures that are her subjects . . . attracted that photographer on many levels, not least because she found

them amusing and slightly shocking. They fall into that familiar category of souvenir which appropriates the distinct features of Maori identity . . . in order somehow to convey a humorous message about New Zealand national identity.'

Ans 'directed her camera in such a way as to uncover tensions rather than to confirm comfortable stereotypes', and she viewed these souvenirs 'with an ironic eye, one that is both critical and amused'.[37] She was taking examples of commonplace cultural appropriation, and undermining any offence they might cause via irony and humour.

The *New Zealand Herald*'s art critic, T. J. McNamara, was restrained in his assessment of *Toy-Land*. Although acknowledging its 'brilliance', he considered that it did not quite strike the ideal balance between thought, technique and emotion. He appreciated the technical excellence of the photographs but found that their significant scale could produce 'uncomfortable' results. One example he cited was a picture of a sheep wearing a tīpare (a traditionally styled headband), a piupiu (a waistband with traditional motifs) and a plastic tiki. McNamara felt that this image was only saved from 'complete insensitivity' by the dark, slightly ominous carving of a Māori ancestor in the background.

However, this was not 'horrid irony', as the critic described it.[38] Rather, Ans was depicting both ends of a spectrum — from the culturally inappropriate debris produced for the tourist market at one extreme to something more considered, serious and authentic at the other end. She did not create any of these items, rather she was representing them in ways that engaged viewers not just aesthetically, but also culturally and socially. In particular, the photographs magnified, in every respect, the absurdity of the way the country and it peoples were portrayed in such souvenirs.

The joke was also on Ans. Possibly in an effort to offset any accusation of cultural offence, Ans included an image called 'Dutch Doll', a crude rendition of a stereotypical Dutch woman, with a vase of fake tulips in the background. The artist was having a joke at everyone's expense, including her own, at a time when humour in the cultural realm was in short supply.

These images were part of an experiment in taking a more contemporary approach to her work. In the twilight of her career, she was perhaps finally becoming aware of a need to remain artistically relevant by evolving stylistically. But for all the visceral appeal of the saturated colour and overall spectacle of *Toy-Land*, these photographs were nowhere close to her best work. She never returned to them.

———

'Dutch Doll', from the *Toy-Land* series, 2004.

SINCE THE TIME OF the first Pākehā settlement in the country, the boundaries of New Zealand identity have been porous. Food, fashion, cultures, languages, beliefs and, of course, genes from many places have flowed into the nation's sense of itself. From the beginning of the twenty-first century in particular, immigrants of many flavours, including refugees, have made the country's major urban areas increasingly cosmopolitan. The emergence of sizeable minority communities around her kindled that sense of the Other that had initially drawn Ans to photographing Māori half a century earlier.

Her next major project, the 2009 book *The Crescent Moon: The Asian Face of Islam in New Zealand* (with accompanying text by Adrienne Jansen) was a return to her signature technique of photographing people. The book was commissioned by the Asia New Zealand Foundation.

Auckland, 1998, from *The Crescent Moon: The Asian Face of Islam in New Zealand*, with text by Adrienne Jansen and commissioned by the Asia New Zealand Foundation.

The allure of the subject matter to Ans was obvious, and there was also a timeliness about the work. In the aftermath of the terrorist attacks on the Twin Towers in New York there had been a 'questioning lens . . . focussed on Islam', the book's introduction stated, and many of the subjects who were photographed and interviewed for the book wished to 'share their stories . . . to reorient this perspective, to start a conversation with their own voices and in their own words'.[39] The book thus served as 'a gentle intervention against Islamophobia'.[40]

It had been a long time since Ans had collaborated on this type of publication — *Whaiora* had been published 24 years earlier. Here she was stepping into a different political, social and cultural environment in a country that was indisputably more complex than it had been in 1985. *The Crescent Moon* turned out to be no reprise of Ans' earlier formula, where she would spend months sorting through hundreds or even thousands of photographs, then sequencing her selection to make a seamless visual progression. Asian Muslims living in New Zealand were not bound by a single culture or ethnicity, but by the more nebulous ties of a shared religious faith. The amorphous nature of the group she was committed to documenting emerged as an insurmountable obstacle to Ans' preferred approach and drained the book of her customary symphonic artistic arrangement.

The result was a work in which almost all the photographs ended up being marooned with a facing page of accompanying text but practically no sense of thematic flow, no overarching narrative and no interplay between images.

Her age may also have contributed to the more aesthetically subdued collection of photographs in *The Crescent Moon*. At 73 she was unavoidably wearier than the 28-year-old who had worked on *Maori*, or the 38-year-old who trudged the city to compile *Wellington: City Alive*. There was also less spontaneity in the *Crescent Moon* photos. Several were staged, or the subjects were looking straight down the lens of her camera or obviously aware that they were being photographed. When asked at the time about the process of taking photographs for this work, she noted that the subjects 'often had

great reservations about [being spontaneous] and would only pose'.[41]

In a first for a book of Ans' photos, the book's text, carefully composed, highly insightful and empathetic, featured as the main component, and the images were in more of a supporting role. However, one classic trait of the images in *The Crescent Moon* will make them more valuable over time: her incorporation of so much background material served to fix the period in which the photographs were taken. The style of an electric fan, the shape of a computer screen, the choices of clothing, the type of camera being used by one subject, the products and layout inside a shop — all these visual cues confined the images to a particular period, and in succeeding decades their documentary value will continue to be enhanced. A patina of nostalgia will also inevitably coat these photographs. Ans jokingly referred to this practice as 'random composition'.[42]

The release of the book was followed by a touring exhibition to various locations around the country, built around Ans' photographs. The photos were then consigned to storage, but they were to undergo a revival more than a decade later, occasioned by tragic events.

On 15 March 2019 a lone gunman massacred 51 people and injured 40 more in attacks on two mosques in Christchurch. New Zealanders were shocked by the barbarity and extent of the attack on the country's Muslim community. There was no template to guide a reaction to such a slaughter, and in the days, weeks and months that followed, individuals and institutions expressed their grief and repulsion at the killings in various ways.

Four months later, when the rawness and immediate shock of the massacre had begun to subside, Rhonda Bunyan, director of the Percy Thomson Gallery in the Taranaki town of Stratford (and herself an accomplished professional photographer), recalled the exhibition of *The Crescent Moon* and thought it would be timely to resurrect it. It would serve as a form of remembrance, and a means of providing solace for some.[43]

And so it was that Ans' photographs of members of New Zealand's Asian Muslim community took on a new role, their original documentary function now subsumed by events. The complete ordinariness of so many

of the scenes depicted a naïve belief in New Zealand as a place of sanctuary. These were a group of new New Zealanders with expectations of a brighter future, but that future, for many, now lay in tatters. The reprised exhibition became a way of curating and channelling grief, and ultimately, of directing at least some viewers towards a sense of resilience.[44]

ANS' NEXT BOOK PROJECT was *Nga Tau Ki Muri: Our Future*, produced by {Suite} in 2013. The brief was to provide 'an awareness of what we've changed and lost within our short history'.[45] Ans was back on the road, driving incessantly around the country, a mattress in the back of her station wagon. She loved the sense of freedom this gave her. 'When you are staying in hotels,' she explained, 'you are in a very artificial environment, you stay in that very touristy group, and it doesn't feel like home.'[46] Her car was very much her second home.

It was a melancholy theme, and the majority of images in *Nga Tau Ki Muri* did not feature people. Rather, they depicted mostly environmental scenes that showed some sign of human agency — a tyre half submerged in a muddy foreshore, a single crucifix-mounted grave enveloped by native forest, a farm where tree clearance has led to hillside erosion.[47] Her concern for the degradation of the landscape was emerging as an important cause, and she felt she could help advance the cause through her work:

> I'm trying to show how we have robbed the land, emptied it out — how much damage people have done in New Zealand, how overpopulating the world has not been a good thing . . . I wanted to say, 'Look, the fact that you own the land doesn't give you the right to do what you like with it or to alter it. We should be guardians.' But it's very difficult — human beings are very greedy, they're not easily satisfied.[48]

From *Nga Tau Ki Muri: Our Future*, produced by {Suite} in 2013.

She was adamant she did not want to include 'pretty pictures' of landscapes because such images meant nothing in terms of how a landscape affected people, other than in a very narrow aesthetic sense.[49] Her photographs appeared without captions, left to speak for themselves.

All the photographs were in colour, which was still comparatively new for Ans. 'It took a long time to go from black and white to colour,' she said, 'and have the colours in the right places where they actually contributed to composition. Black and white was just light and shade and it's what you respond to more easily. But [although] I've managed to work in colour . . . well, I still call it a monster.'[50] The images in *Nga Tau Ki Muri* confirm that by the 2010s Ans had harnessed the monster, if not tamed it entirely. The landscapes contain a range of colours that are the hallmark of popular scenic photographs but without their cloying beautification.

Ans' mastery of arranging images produced a narrative of its own that ran throughout the work. The sequence of photographs reveals the mounting impacts of humans on nature, but in a manner that is always subtle and that does not make the images subservient to the message. It was the sort of fine balancing act Ans had refined through decades of experience — a gift she had of effecting a slow build through a succession of scenes.

Photographs of rotting fenceposts, crumbling concrete, the carcass of a rusting car give way to images of land subdivision, forests being cleared, roads being extended and humans expanding relentlessly and unthinkingly, obliterating nature.

Throughout this carefully assembled photographic fabric, Ans wove a dark thread. The theme of death pervades *Nga Tau Ki Muri*, with several of the images — crucifixes, cemeteries, felled trees and various dead animals — alluding to mortality. Among much else, the motifs of death serve to remind the reader that humans necessarily have a short lease on their surrounds, and that not even the greatest incursions into nature will be permanent.

One of the more intriguing motifs appears in the photograph of a pou whenua (a traditional Māori carved wooden post) next to what looks like an overgrown park, with the view of the post itself slightly obscured by

stalky weeds in the foreground.⁵¹ The pou whenua has an air of Ozymandias about it — a lifeless trunk in a state of decay, mounted in a wasteland. Ans accentuated various levels of tension in this image — between humans and nature, past and present, temporary and permanent, indigenous and introduced, living and dead — and thrust these before the viewers' eyes, almost demanding that they pause to consider these weighty issues.

The book concluded with a short text by the then Green Party leader, Russel Norman, in which he anguished over the ongoing encroachment of pastureland into the nation's wilderness. He ended on a more positive tone, however, writing about his dream of 'healing the land . . . healing ourselves . . . [and] living here as if it were forever'.⁵²

The final photo in the book needed to encompass the book's theme, and Ans put a good deal of thought into its selection. In the background, two headlands (one on either side) protrude into a harbour. One is bush-clad, while the other is topped with houses: the pristine and the despoiled staring at each other across the sea, which opens up to occupy the entire middle ground of the picture. In the foreground, sprouting from a patch of grass, is a pōhutukawa sapling protected by netting, a hint that nature's regeneration will need a helping hand for some time.

This image is more subdued than some others in the book — it is no dramatic final flourish, but rather a succinct, reflective suggestion that perhaps the environmental mistakes of the past might be redeemed. One reviewer described the book as showing 'the other face of Janus', noting that Ans had presented a 'catalogue of our environmental sins' based on 'our propensity to scatter the detritus of our consumer lives about the landscape, and our belief in the onward march of technological progress even if its presence rudely impacts on nature'.⁵³

IN THE 16 YEARS since Ans had first conceived of 'Peaceful Islands', the book that never was, two of the planned contributors — Hone Tūwhare

and David Lange — had died. Ans' response to the deaths of those she knew was heartfelt and empathetic, but also reflected a degree of resignation to its inevitability. When Noel Hilliard's wife, Kiriwai, died in 1990, Ans had observed how Noel was 'unbelievably lonely'. She had seen him standing outside a shop in Cuba Mall 'weeping'. Yet she had decided not to approach him directly.[54] Noel died six years later, and Ans attended to a few of his affairs in the immediate aftermath.

Tūwhare's death in 2008 was another reminder to Ans that, one by one, the people who had contributed to the architecture of her own life were falling away. She and Hone had been friends since the winter of 1964, when Ans had been despatched to take a portrait of the poet for the cover of the September edition of *Te Ao Hou*.[55] When she visited him in the early 2000s she noticed that he was not eating much, and was spending more time hunched around the fireplace, trying to stay warm.[56] Her friendship with Tūwhare was one of the few in her life that was close and enduring, and her inclusion in *Nga Tau Ki Muri* of two of his poems was her way of honouring her friend.

One of the poems, entitled 'Friend', was a eulogy for the state of the environment, but it is also an expression of a deep and enduring friendship:

> Allow me to mend the broken ends
> of shared days:
> but I wanted to say
> that the tree we climbed
> that gave food and drink
> to youthful dreams, is no more . . .
>
> Friend, in this drear
> dreamless time I clasp
> your hand if only for reassurance
> that all our jewelled fantasies were
> real and wore splendid rags . . .[57]

The poet Hone Tūwhare (Ngāpuhi), photographed in 1963.

Midway through *Nga Tau Ki Muri* another ghost was summoned in the form of three sentences written by Lange back in 1987. This pithy contribution, with its rejoicing in the country's diversity, was a prescription for a future where there was 'contentment among people and empathy with the sea and landscape'.[58] Lange had died in 2005, and Ans included a postscript in

Nga Tau Ki Muri to Lange's words, noting that this text by the former prime minister was part of what would have been the introduction to 'Peaceful Islands'. She wrote with regret: 'I could not get enough of those in power to commit to a vision, hence this book never saw the light of day.'[59] She did, however, graft some of the ideas from 'Peaceful Islands' onto her work in *Nga Tau Ki Muri*.

In 2013, the same year that *Nga Tau Ki Muri: Our Future* was published, Alsop conceived of an exhibition involving Ans travelling to five North Island locations — Ruatōria, Rūātoki, Rotorua, Kaitāia and Whanganui — and to Invercargill in the South Island and Rakiura/Stewart Island, with a collection of images she had taken in those towns 50 years earlier.[60]

Ans appreciated that she herself was an integral part of the tour — 'Well, I'm the main exhibit,' she joked.[61] She enjoyed the opportunity to reconnect with people and places from her past, and the exhibition served as a history lesson for generations born since she had photographed in these locations. For some, it was a chance to see images of youthful relatives whom they had only known as elderly.[62]

The title of the exhibition, *Full Circle*, contained a notion of closing the circle, or completing the loop. Looked at in this light, the event acquired an air of finality, as though it represented the final chapter in Ans' career. Certainly her ageing body was imposing physical limitations — the weight of her cameras made it difficult for her to take photographs for a sustained period. But her prodigious ability to select and sequence images remained undiminished, and this contributed to the success of further exhibitions. The lack of fresh content was becoming apparent, and her photographic style had even acquired something of the novelty of a museum artefact, and yet something in the country's cultural retina continued to register the significance of Ans Westra's work, and exhibition attendance numbers continued to grow.

THE FINAL EXHIBITION OF her work during her lifetime was another retrospective, which opened on 23 April 2022, coordinated by David Alsop. *Ans Westra Photographs: After Handboek* consisted of 80 of Ans' most accomplished photographs displayed in the Māpuna Kabinet Art Gallery in the small Manawatū town of Foxton. Luit Bieringa (who died two months after the exhibition's opening) wrote that he was pleased to 'see part of that collection of works come to life again, for yet another generation of admirers — in an art gallery with both a Dutch and Māori name'. It was, as he concluded, 'a fitting tribute to Ans' work'.[63] Although it was just a small sample of the vast reservoir of Ans' work, the exhibition did serve in some ways as a final summation of her career.

Ans herself, meanwhile, was (as ever) ploughing new pastures, photographing the 23-day occupation of Parliament grounds in early 2022 by protesters representing a mosaic of interests who were united against the government's Covid vaccine and mandate policies. For Ans, it was almost like the old days — the spirit of the Land March or the Springbok tour protests returning to possess the disgruntled and unsettled, and urging them into action.

One Cabinet minister described those gathered at the protest as 'a river of filth',[64] but Ans was, initially at least, more open-minded in her assessment of their motives and methods. She managed to capture a few scenes, but her plans to join in on the periphery of the protest began to unravel as the atmosphere became increasingly hostile. Ans began to feel that there were too many groups with very disparate aims, and that as the protest dragged on, those on the political extremes increasingly appeared to be taking centre stage.[65] What could have been an intriguing photographic study was abandoned as the protest lost its way.

Ans struggled with the Covid-19 pandemic and being 'locked down' at home for extended periods. She described it as 'never-ending', and it left her feeling despondent about the country. 'It's certainly changed the nation's feeling, its character,' she observed.

> We're more suspicious, we're more frightened, easily frightened.
> Less openly, brazenly, 'she'll be right' . . . You know, the attitude
> that nothing will hurt us — we've lost that. We found a real fear
> of life ending, of dying, of the world ending. We're now more and
> more inclined to be hiding, to be shielding ourselves . . . There are
> many unpleasant elements now. Much more so than when we had
> that easy-going attitude.⁶⁶

How would young Ans have felt had she arrived for the first time in New Zealand in 2022? Would she want to stay, or turn around and go elsewhere? Her response was ambivalent:

> I may now prefer to go to a place where there's less trying to
> become rich and international, [the] same [as] the rest of the world.
> I think we've been trying too hard to lose our different identity
> and now we don't really know where we're at, what makes a New
> Zealander, what makes them stand out, makes them different. And
> they have so many good qualities we seem to not value so much
> now. There was a generosity, there was an openness . . . it's been
> a very good, very welcoming place but I still miss Europe in many
> ways. Just the diversity, the closeness, togetherness of people.⁶⁷

This could be read as a lament of an elderly person discovering that those long-standing, granite-like familiarities on which they built their perceptions of the world have turned out to have the permanence of vapours. But there was more here than regret over the passing of the 'good old days'. The changes Ans perceived altered the dialogue between photographer and subject on which she had built her career. And as the confrontation between the rump of protesters outside Parliament and the police hurtled towards its ugly conclusion, Ans was forced to confront the possibility of her own artistic bathos.

It was not that she saw herself as a spent force. She still wished to give visual form to her experiences through the vocabulary of photography.

The challenge for her was that as the culture seemed to be altering, so too were the opportunities for her unique approach to mediating meaning and emotion between image and viewer.

At the end of her life, Ans became almost fixated on producing one last great photographic book. She had a title — 'To Be a Child' — and her initial inspiration was a 1958 book by the American photographer Wayne Miller. Children were uncontaminated by the world, and possessed the same innocent qualities she had captured on film when she first acquired a camera. As she put it, 'If I can get that book done on childhood . . . that's to me a crucial book. It spans my whole career.'[68]

The idea had come to her as far back as the 1960s, when a nurse who was flatting with Ans had a baby. One day the baby was lying in its pram outside on a sunny day, and as Ans looked at him she wondered 'what the world is like from his viewpoint . . . And that was the beginning very much of the whole project on 'To Be a Child' . . . That was the beginning of it really, the germ of it. I just need to be allowed to do this book . . .'[69]

But although the project lingered on her mental horizon during the last few months of her life, by early 2023 she knew this work would never materialise. Ans' description of the moment of capturing images could equally apply to life: 'Yes. It passes very quickly. If you're not ready, if you're not set up, then you've missed it. You've got to be quick.'[70]

Departure

'I'll see you again soon.' These were my final words to Ans, and as they left my mouth I noticed that she was averting her gaze, as if she knew something I did not. Age had nearly finished its work on her. Her smile had been reduced to a crumpled grin, the rims of her eyelids looked red and sore, her face was sagging and pallid, and her hair hung lifelessly. Slouched in her armchair, she seemed ill at ease.

'I suspect she's stopped taking her medicine,' David Alsop told me as we drove away. Neither of us said anything further. Four days later, on Sunday 26 February 2023, Alsop phoned to let me know that Ans had died. Jacob had discovered her body that morning after the family reported getting no response to their calls.

―――

ANS WESTRA'S CAREER WAS rare for its longevity. Most photographers are forced for economic reasons to have a day job, but Ans was prepared to live on a shoestring budget and endure financial privations for most of her life in order to support her vocation.[1] She was driven by her conviction about the importance and consequence of photography: 'Because the photograph is there as a lasting document, it will be an image in people's minds, working on their sub-conscious, and it will possibly bring about a longing . . .

Ans Westra, photographed by Yvonne Westra at Lyall Bay in 2017.

Ans Westra and David Alsop outside Ans' Lower Hutt home in 2020, photographed by Joseph Kelly.

I like that aspect of photography — to be able to influence people — to contribute a little bit anyway.'[2]

She believed that photographers are granted a power to preserve images from a place that no longer exists except in people's memories. And over 60 years her images built a picture of a culture, giving younger viewers in particular a sense of what the country was like in an earlier age. These images can then be grafted onto their own impression of what it means to be a New Zealander. In this way, Ans probably accomplished as much as any other individual in the country's history when it came to constructing a vision of New Zealand's identity. And, as Desmond Kelly put it, 'The country is richer for it.'[3]

———

DURING HER SHORT STAY in hospital in 1991, when she was tackling mental health issues, Ans reflected on what was most important to her. Her mind's eye eventually settled on a tombstone she had once seen, which simply had 'Mother' carved on it. 'So beautiful,' she said. 'It stands for all mothers. That is all I want to be known as — mother to Erik, Lisa and Jacob. But kids — they walk over your heart and leave you. I have my photography as compensation for what — life, living itself?'[4]

In this moment of despair over the present and uncertainty over the future, she wavered about the purpose of her life's work. But within a few months she was back at work, planning publications, projects and exhibitions, propelled by her simple manifesto: 'I can't . . . disappear until I've documented as much as possible.'[5]

Notes

Abbreviations
AW: Ans Westra
HM: Hugo Manson
PM: Paul Moon

ARRIVAL

1. AW interviewed by PM (22 February 2023). Unless otherwise indicated, all quotes from AW in this chapter are from this interview.
2. D. Alsop interviewed by PM, Auckland (20 December 2022).
3. J. B. Turner in L. Bieringa, *Ans Westra: Private Journeys/Public Signposts*, television documentary (2006).
4. Yvonne Westra interviewed by PM (26 July 2023).

1. ORIGINS

1. AW interviewed by HM (5 February 2022).
2. Ibid.
3. M. Horn, 'The great depression: past and present', *Journal of Canadian Studies* 11, no. 1 (1976): 41–50.
4. AW interviewed by HM (5 February 2022).
5. J. L. Foray, 'The "Clean Wehrmacht" in the German-occupied Netherlands, 1940–45', *Journal of Contemporary History* 45, no. 4 (2010): 768–87.
6. AW interviewed by HM (5 February 2022).
7. Ibid.
8. AW interviewed by PM (22 February 2023).
9. W. Veraart, 'Two rounds of postwar restitution and dignity restoration in the Netherlands and France', *Law & Social Inquiry* 41, no. 4 (2016): 956–72.
10. AW interviewed by HM (5 February 2022).
11. Ibid.
12. AW in L. Bieringa, *Ans Westra: Private Journeys/Public Signposts*, television documentary (2006).

13	AW interviewed by HM (5 February 2022).
14	AW in Bieringa, *Private Journeys/Public Signposts*.
15	AW interviewed by HM (5 February 2022).
16	AW in Bieringa, *Private Journeys/Public Signposts*.
17	J. B. Turner, email with PM (1 August 2023).
18	Ibid.
19	AW interviewed by HM (5 February 2022).
20	AW interviewed by PM (22 February 2023).
21	AW interviewed by HM (5 February 2022).

2. THE FAMILY OF MAN

1	A. Hall, 'The rise of blame and recreancy in the United Kingdom: A cultural, political and scientific autopsy of the North Sea flood of 1953', *Environment and History* 17, no. 3 (2011): 379–408.
2	Industrieschool voor Miesjes, Rotterdam, Akte van Bekwaamheid vor Nijverheidsonderwijs Ns, 21 June 1957, translation (NZ Department of Internal Affairs), 30 October 1958.
3	AW interviewed by HM (5 February 2022).
4	E. Steichen and C. Sandburg, *The Family of Man* (New York: Museum of Modern Art, 1955); E. J. Sandeen, 'The international reception of *The Family of Man*', *History of Photography* 29, no. 4 (2005): 344–55; B. Morgan, 'The theme show: A contemporary exhibition technique', *Aperture* 3, no. 2 (1955): 24–27.
5	B. Jay, '*The Family of Man*: A reappraisal of the greatest exhibition of all time', *Insight, Bristol Workshops in Photography* 1 (1989), 2.
6	J. Bayly, 'Ans Westra: Finding a "place" in New Zealand', in J. Bayly and A. McCredie (eds), *Witness to Change: Life in New Zealand: John Pascoe, Les Cleveland, Ans Westra: Photographs 1940–1965* (Wellington: PhotoForum, 1985), 67.
7	AW interviewed by HM (5 February 2022).
8	J. van der Keuken, *Wij Zijn 17* (Bussum: van Dishoeck, 1955).
9	AW in L. Bieringa, *Ans Westra: Private Journeys/Public Signposts*, television documentary (2006).
10	AW in D. Skinner, 'The eye of an outsider: a conversation with Ans Westra', *Art New Zealand* 100 (Spring 2001): 94–100.
11	J. Hartog and R. Winkelmann, 'Comparing migrants to non-migrants: The case of Dutch migration to New Zealand', *Journal of Population Economics* 16, no. 4 (2003): 683–705; A. Comello, 'That's a different story: Comparing letters and oral accounts of Dutch immigrants in New Zealand', *The History of the Family* 17, no. 2 (2012): 178–98.

12 Passenger lists 1839–1973, Archives NZ, Wellington; FHL microfilms 004459813; 004508775.
13 AW interviewed by HM (21 February 2022).
14 Ibid.
15 Ibid.
16 C. Bell, '"Not really beautiful, but iconic": New Zealand's Crown Lynn ceramics', *Journal of Design History* 25, no. 4 (2012): 414–26; V. R. Monk, *Crown Lynn: A New Zealand Icon* (Auckland: Penguin Books, 2006).
17 AW interviewed by HM (5 February 2022).
18 S. Manchester, 'Collection: The secondary market for applied arts', *Journal of Australian Ceramics* 52, no. 1 (2013): 116–18.
19 AW interviewed by HM (21 February 2022).
20 AW in Bayly, 'Finding a "place" in New Zealand', 67.
21 A. P. Wood, 'Kees Hos: Printmaker, gallerist, teacher, war hero', *EyeContact* (23 December 2015).
22 Bayly, 'Finding a "place" in New Zealand', 66.
23 AW interviewed by HM (21 February 2022).
24 AW interviewed by HM (5 February 2022).
25 Ibid.
26 Ibid.

3. THE AO HOU: THE NEW WORLD

1 A. McCredie (ed.), *The New Photography: New Zealand's First-Generation Contemporary Photographers* (Wellington: Te Papa Press, 2019), 169.
2 M. A. Chan, 'Dawn and *Te Ao Hou*: Popular perspectives on assimilation and integration, 1950s–1960s', BA Hons dissertation (University of Otago, Dunedin, 2008), 1–22; A. T-P. Somerville, '*Te Ao Hou*', in M. Williams (ed.), *A History of New Zealand Literature* (Cambridge: Cambridge University Press, 2016), 182–94.
3 *Te Ao Hou* 1 (Winter 1952): 1.
4 AW in D. Skinner, 'The eye of an outsider: A conversation with Ans Westra', *Art New Zealand* 100 (Spring 2001): 94.
5 Ibid., 96.
6 AW in McCredie, *The New Photography*, 169.
7 AW interviewed by HM (5 February 2022).
8 B. E. G. Mason (ed.), 'Brief notices', in *Te Ao Hou: The New World* 32 (September 1960).
9 AW interviewed by HM (5 February 2022).
10 Ibid.
11 J. B. Turner, email with PM (1 August 2023).

12 F. Barnes, 'Pictorialism, photography and colonial culture 1880–1940', *New Zealand Journal of History* 47, no. 2 (2013): 136–56; B. Labrum, 'Not on our street: New urban spaces of interracial intimacy in 1950s and 1960s New Zealand', *Journal of New Zealand Studies* 14 (2013): 67–86.
13 J. B. Turner in L. McDonald (ed.), *Handboek: Ans Westra Photographs* (Wellington: Blair Wakefield Exhibitions, 2004), 21.
14 AW interviewed by HM (5 February 2022).
15 AW in McCredie, *The New Photography*, 169.
16 AW in L. Bieringa, *Ans Westra: Private Journeys/Public Signposts*, television documentary (2006).
17 J. B. Turner, email with PM (1 August 2023).
18 U. Price, *An Essay on the Picturesque, As Compared with the Sublime and the Beautiful* (London: J. Robson, 1794); W. Gilpin, *Three Essays on Picturesque Beauty* (London: R. Blamire, 1792); H. F. Clark, 'The sense of beauty in the 18th, 19th and 20th centuries: Aesthetic values in English landscape appreciation', *Landscape Architecture* 47, no. 4 (1957): 465–69.
19 L. Cleveland, *The Silent Land* (Christchurch: The Caxton Press, 1966); J. Bayly, 'Ans Westra: Finding a "place" in New Zealand', in J. Bayly and A. McCredie (eds), *Witness to Change: Life in New Zealand: John Pascoe, Les Cleveland, Ans Westra: Photographs 1940–1965* (Wellington: PhotoForum, 1985), 67–83.
20 AW interviewed by S. Black, 28 March 1979, annotated by J. B. Turner, Ans Westra Archive, CA000621/2, Te Papa Archives.
21 Ibid.
22 D. Kelly interviewed by PM (12 July 2023).
23 Bayly, 'Finding a "place" in New Zealand', 66.
24 AW in McCredie, *The New Photography*, 169.
25 AW in Bieringa, *Private Journeys/Public Signposts*.
26 J. B. Turner, email with PM (1 August 2023).
27 AW in Bieringa, *Private Journeys/Public Signposts*.
28 Arts Committee of the Festival of Wellington, *Industrial Design Exhibition 1961 Booklet* (Wellington: Standard Press Ltd, 1961); C. Thompson, 'Modernizing for trade: Institutionalizing design promotion in New Zealand, 1958–1967', *Journal of Design History* 24, no. 3 (2011): 223–39.
29 AW interviewed by HM (20 February 2022).
30 Ibid.
31 A. Ballara, *Te Kīngitanga: The People of the Māori King Movement* (Auckland: Auckland University Press, 1996).
32 AW interviewed by S. Black, 28 March 1979.
33 Ibid.

34 'Annual celebrations at Ngaruawahia', *Te Ao Hou* 41 (December 1962).
35 D. Kelly interviewed by PM (12 July 2023).
36 AW interviewed by HM (20 February 2022).
37 AW interviewed by S. Black (28 March 1979).
38 Ibid.
39 S. Ivey, 'Focusing on the female gaze: Women as photographers and heroines', BA thesis (Florida International University, 2019), 11.
40 C. Griffen, 'Towards an urban social history for New Zealand', *New Zealand Journal of History* 20, no. 2 (1986): 111–31.
41 AW in Bayly, 'Finding a "place" in New Zealand', 71.
42 J. B. Turner, email with PM (1 August 2023).
43 Z. Dirse, 'Gender in cinematography: Female gaze (eye) behind the camera', *Journal of Research in Gender Studies* 3, no. 1 (2013): 15–29; A. Cohen, 'Speaking of the "female gaze"', *The Nation* (22 September 2017).
44 Ivey, 'Focusing on the female gaze', 5.
45 AW interviewed by HM (7 May 2022).
46 Ibid.
47 Ibid.
48 AW interviewed by HM (20 March 2022).
49 J. Phillips, 'Māori and royal visits, 1869–2015: From Rotorua to Waitangi', *Royal Studies Journal* 5, no. 1 (2018): 34–54.
50 AW in S. Stephenson, 'Cry, the beloved country', *North & South* (June 2013): 74.
51 AW interviewed by HM (20 February 2022).
52 'Passion play at Hastings', *Te Ao Hou* 39 (June 1962).
53 J. Maguire, 'Depicting the macabre: The lasting influence of German Expressionism on photography', MA thesis (University of Huddersfield, 2020).
54 'T. W. Ratana and the Ratana Church', *Te Ao Hou* 42 (March 1963); J. J. Mol, 'The religious affiliations of the New Zealand Maoris', *Oceania* 35, no. 2 (1964): 136–43.
55 AW interviewed by HM (21 February 2022).
56 A. Newman, 'The religious beliefs, rituals and values of the Ringatū Church', MA thesis (Massey University, Palmerston North, 1986).
57 J. Binney, 'Myth and explanation in the Ringatū tradition: Some aspects of the leadership of Te Kooti Arikirangi Te Turuki and Rua Kēnana Hepetipa', *Journal of the Polynesian Society* 93, no. 4 (1984): 345–98.
58 AW interviewed by HM (5 February 2022).
59 AW interviewed by HM (20 March 2022).
60 AW interviewed by HM (6 March 2022).

61 'Auckland's Community Centre', *Te Ao Hou* 40 (September 1962); J. Metge, *A New Maori Migration: Rural and Urban Relations in Northern New Zealand* (Melbourne: Melbourne University Press, 1964).
62 *Te Ao Hou* 40 (September 1962): 25.
63 'M.M.W.L. Garden Party', *Te Ao Hou* 39 (June 1962).
64 AW interviewed by HM (7 May 2022).
65 AW, 'Para Matchitt: Painter and sculptor', *Te Ao Hou* 45 (December 1963).
66 J. M. Wheoki, 'Art's histories in Aotearoa New Zealand', *Journal of Art Historiography* 4 (2011): 11.

4. THE FRIENDLY ISLANDS

1 J. Cook, *A Voyage Towards the South Pole, and Round the World. Performed in His Majesty's Ships the* Resolution *and* Adventure, *in the Years 1772, 1773, 1774, and 1775* (London: W. Strahan and T. Cadell, 1777), 18.
2 AW, *Viliami of the Friendly Islands, Bulletin for Schools* (Wellington: Government Printer, 1964).
3 Archives NZ, Passenger lists 1839–1973, Wellington; FHL microfilm 004459813.
4 AW interviewed by HM (6 March 2022).
5 AW in D. Skinner, 'The eye of an outsider: A conversation with Ans Westra', *Art New Zealand* 100 (Spring 2001): 97.
6 A. McCredie, 'Pictures on a page: Towards a history of the photobook in New Zealand', *Back Story Journal of New Zealand Art, Media & Design History* 5 (2018): 5.
7 AW interviewed by HM (6 March 2022).
8 Ibid.
9 AW interviewed by HM (20 March 2022).
10 AW, *Viliami of the Friendly Islands*.
11 Ibid.
12 Ibid.
13 G. McMaster, J. Lum and K. McCormick, 'The entangled gaze: Indigenous and European views of each other', *Ab-Original: Journal of Indigenous Studies and First Nations and First Peoples' Cultures* 2, no. 2 (2018): 125–40.
14 AW interviewed by HM (6 March 2022).
15 AW, 'Children of Fiji', *School Journal* 2, no. 3 (1964).
16 K. Fischer, *The Imperial Gaze: Native American, African American, and Colonial Women in European Eyes* (Oxford: Blackwell Publishers, 2002); S. Stevenson, 'The empire looks back: Subverting the imperial gaze', *History of Photography* 35, no. 2 (2011): 142–56.
17 M. Amoamo, 'Māori tourism: The representation of images', *AlterNative: An International Journal of Indigenous Peoples* 3, no. 1 (2006): 72.

18 J. Bayly, 'Ans Westra: Finding a "place" in New Zealand', in J. Bayly and A. McCredie (eds), *Witness to Change: Life in New Zealand: John Pascoe, Les Cleveland, Ans Westra: Photographs 1940–1965* (Wellington: PhotoForum, 1985), 68.

19 J. Stenhouse, '"A disappearing race before we came here": Doctor Alfred Kingcome Newman, the dying Maori and Victorian scientific racism', *New Zealand Journal of History* 30, no. 2 (1996): 124–40.

20 AW in Bayly, 'Finding a "place" in New Zealand', 68.

5. WHITEWASH?

1 P. Moon, *A Draught of the South Land: Mapping New Zealand from Tasman to Cook* (Cambridge: The Lutterworth Press, 2023), 19.

2 R. Welten, 'Paul Gauguin and the complexity of the primitivist gaze', *Journal of Art Historiography* 12 (2015): 1–13; P. Lafuente, 'Art and the foreigner's gaze: A report on contemporary Arab representations', *Afterall: A Journal of Art, Context and Enquiry* 15 (2007): 12–23.

3 C. McCarthy, 'The rules of (Maori) art: Bourdieu's cultural sociology and Maori visitors in New Zealand museums', *Journal of Sociology* 49, nos 2–3 (2013): 173–93; N. Eaton, 'Nostalgia for the exotic: Creating an imperial art in London, 1750–1793', *Eighteenth-Century Studies* (2006): 227–50; B. Van Haute, 'African tourist art as tradition and product of the postcolonial exotic', *International Journal of African Renaissance Studies* 3, no. 2 (2008): 21–38; J. MacKenzie, *Orientalism: History, Theory and the Arts* (Manchester: Manchester University Press, 1995); J. Hackforth-Jones and M. Roberts (eds), *Edges of Empire: Orientalism and Visual Culture* (Hoboken: John Wiley & Sons, 2008); C. Barton, 'Rethinking "'Headlands"', *Afterall: A Journal of Art, Context and Enquiry* 39 (2015): 101–10.

4 AW interviewed by HM (6 March 2022).

5 Ibid.

6 AW interviewed by HM (21 February 2022).

7 AW in D. Skinner, 'The eye of an outsider: A conversation with Ans Westra', *Art New Zealand* 100 (Spring 2001): 99.

8 AW in A. McCredie (ed.), *The New Photography: New Zealand's First-Generation Contemporary Photographers* (Wellington: Te Papa Press, 2019), 170.

9 J. Bayly, 'Ans Westra: Finding a "place" in New Zealand', in J. Bayly and A. McCredie (eds), *Witness to Change: Life in New Zealand: John Pascoe, Les Cleveland, Ans Westra: Photographs 1940–1965* (Wellington: PhotoForum, 1985), 68.

10 R. Boyask, J. C. McPhail, B. Kaur and K. O'Connell, 'Democracy at work in and through experimental schooling', *Discourse: Studies in the Cultural Politics of Education* 29, no. 1 (2008): 25–27.

11 AW, *Washday at the Pa*, Bulletin for Schools (Wellington: Department of Education, 1964).
12 AW and M. Amery, *Washday at the Pa* (Wellington: {Suite} Publishing, 2011), 36.
13 B. Brookes, 'Nostalgia for "innocent homely pleasures": The 1964 New Zealand controversy over *Washday at the Pa*', *Gender & History* 9, no. 2 (1997): 246; N. Frost, *New York Times* (8 March 2023).
14 *Press* (23 July 1964), 6.
15 D. S. Walsh, 'Inter-ethnic relations in New Zealand: A recent controversy', *Journal of the Polynesian Society* 73, no. 3 (1964): 340; P. Heyward and E. Fitzpatrick, 'Speaking to the ghost: An autoethnographic journey with Elwyn', *Educational Philosophy and Theory* 48, no. 7 (2016): 703.
16 *Press* (30 July 1964), 1.
17 *Press* (4 August 1964), 8.
18 Director, School Publications Branch (18 August 1964), John B. Turner Archive, RC2016/1, Auckland Art Gallery.
19 A. Kinsella to Dominion Secretary, Maori Women's Welfare League (7 August 1964), John B. Turner Archive, RC2016/1, Auckland Art Gallery.
20 J. Melser in B. McDonnell, '*Washday at the Pa* (1964): History of a controversy', *Journal of NZ & Pacific Studies* 1, no. 2 (2013): 137.
21 *Press* (4 August 1964), 1.
22 Ibid.
23 *Press* (11 August 1964), 14.
24 *Press* (14 August 1964), 3.
25 AW interviewed by HM (21 February 2022).
26 W. Main and J. B. Turner, *New Zealand Photography from the 1840s to the Present* (Auckland: PhotoForum, 1993), 53.
27 *Press* (14 August 1964), 3.
28 *Press* (31 August 1964), 3.
29 AW interviewed by HM (20 March 2022).
30 T. O'Regan in *NZ Woman's Weekly* (4 November 1985): 77.
31 J. K. Baxter in N. Pardington and R. Leonard, 'No good going to bed with cold feet: Ans Westra's *Washday at the Pa* and the debate surrounding it', *Photofile* (Spring 1988): 13.
32 AW in ibid.
33 AW and Amery, *Washday at the Pa* (2011).
34 AW in Pardington and Leonard, 'No good going to bed with cold feet', 14.
35 Pardington and Leonard, 17.
36 M. Belgrave, 'The politics of Maori history in an age of protest', *Journal of New Zealand & Pacific Studies* 2, no. 2 (2014): 143.

37	D. Skinner, 'The eye of an outsider: A conversation with Ans Westra', *Art New Zealand* 100 (Spring 2001): 94, 100.
38	B. Barclay, *Our Own Image: A Story of a Māori Filmmaker* (Minnesota: University of Minnesota Press, 2015), 1–14.
39	R. Panoho, 'The harakeke — no place for the bellbird to sing: Western colonization of Maori art in Aotearoa', *Cultural Studies* 9, no. 1 (1995): 17.
40	AW interviewed by HM (20 March 2022).
41	J. Te Kani in *Gisborne Herald* (3 November 2011), 5.
42	AW interviewed by HM (20 March 2022).
43	AW interviewed by HM (6 March 2022).
44	AW interviewed by HM (21 February 2022).
45	AW and Amery, *Washday at the Pa* (2011), 40.
46	AW in Skinner, 'The eye of an outsider', 98.
47	AW interviewed by HM (5 February 2022).
48	Ibid.

6. GOOD KEEN MEN

1	AW interviewed by HM (6 March 2022).
2	Ibid.
3	Ibid.
4	Ibid.
5	Ibid.
6	Ibid.
7	AW interviewed by HM (6 March 2022).
8	Y. Westra interviewed by PM (26 July 2023).
9	AW interviewed by HM (6 March 2022).
10	A. Else, '"The need is ever present": The Motherhood of Man movement and stranger adoption in New Zealand', *New Zealand Journal of History* 23, no. 1 (1989): 47–67; G. R. Palmer, 'Birth mothers: Adoption in New Zealand and the social control of women, 1881–1985', MA thesis (University of Canterbury, Christchurch, 1991), 8, 11, 13, 86.
11	Y. Westra interviewed by PM (26 July 2023); E. Westra email with PM (26 July 2023).
12	P. J. Ruha, '*Washday at the Pa*', *Te Ao Hou* 50 (March 1965): 58.
13	P. H. de Bres, 'Memoir No. 37: Religion in Atene: Religious association and the urban Maori', *Journal of the Polynesian Society* 79, no. 3 (1970): 20–21; *Press* (6 January 1965), 3.
14	'Ratana pilgrimage to Te Rere a Kapuni', *Te Ao Hou* 51 (June 1965): 35.
15	'The sculpture of Arnold Wilson', *Te Ao Hou* 52 (September 1965): 32.

16 AW and K. Mataira, *Tamariki: Our Children Today* (Wellington: Maori Education Foundation, 1965).
17 AW interviewed by HM (21 February 2022).
18 M. Penfold, 'Reviewed work: *Tamariki: Our Children Today* by Katerina Mataira and Ans Westra', in *Journal of the Polynesian Society* 76, no. 1 (March 1967): 112.
19 AW interviewed by HM (21 February 2022).
20 AW interviewed by HM (20 March 2022).
21 L. McDonald, 'Camera Antipode: Ans Westra: Photography as a form of ethnographic and historical writing', PhD thesis (Massey University, Palmerston North, 2011), 109.
22 *Evening Post* (6 December 1972).
23 AW interviewed by HM (20 February 2022).
24 AW and J. Ritchie, *Maori* (Wellington: A. H. & A. W. Reed, 1967).
25 AW interviewed by HM (20 February 2022).
26 G. Riethmaier, *Rebecca and the Maoris* (Wellington: A. H. & A. W. Reed, 1964).
27 E. McAvoy, 'Basement biopsies', *Landfall* 238 (2019): 64–72.
28 M. Orbell, 'Rebecca and the Maoris', *Te Ao Hou* 52 (September 1965): 58.
29 AW in D. Skinner, 'The eye of an outsider: A conversation with Ans Westra', *Art New Zealand* 100 (Spring 2001): 100.
30 McDonald, 'Camera Antipode', 109.
31 AW interviewed by HM (6 March 2022).
32 AW in Skinner, 'The eye of an outsider', 100.
33 AW in A. McCredie (ed.), *The New Photography: New Zealand's First-Generation Contemporary Photographers* (Wellington: Te Papa Press, 2019), 170.
34 AW in L. Bieringa, *Ans Westra: Private Journeys/Public Signposts*, television documentary (2006).
35 AW interviewed by HM (6 March 2022).
36 Ibid.
37 AW in Skinner, 'The eye of an outsider', 97.
38 D. Dekker, 'Communicating via the camera', *Evening Post* (3 July 1976); L. Bell, *Marti Friedlander: Portraits of the Artists* (Auckland: Auckland University Press, 2020), 48.
39 H. Carsten, 'Four Maori studies by Hester Carsten', *Landfall* 5, no. 3 (September 1951): 208–09; 'Maori studies by Hester Carsten', *Landfall* 6, no. 4 (December 1952): 288–89; 'Meeting house at Ruatahuna', *Landfall* 11, no. 1 (March 1957): 33–34.
40 L. C. Powell and P. Blank, *Turi: The Story of a Little Boy* (London: Angus & Robertson, 1963).
41 AW interviewed by HM (21 February 2022).
42 AW and Ritchie, 7.
43 Ibid., 7.
44 Ibid., 225.

45 As examples, see D. Lerner, *The Passing of Traditional Society: Modernizing the Middle East* (New York: Free Press, 1958); B. F. Hoselitz, *Sociological Aspects of Economic Growth* (New York: Free Press, 1960); D. C. McClelland, *The Achieving Society* (New York: Free Press, 1961); T. Parsons, 'Evolutionary universals in society', *American Sociological Review* 29 (1964): 339–357.

46 AW interviewed by HM (21 February 2022).

47 AW and Ritchie, *Maori*, 58.

48 Ibid., 78.

49 Ibid., 80–81.

50 Ibid., 206–07.

51 Ibid., 225.

52 W. Main and J. B. Turner, *New Zealand Photography from the 1840s to the Present* (Auckland: PhotoForum, 1993), 53.

53 AW in McCredie, *The New Photography*, 170.

54 D. S. Walsh, 'Review', *Journal of the Polynesian Society* 79, no. 4 (1970): 450.

55 AW interviewed by HM (6 March 2022).

56 I. Brown and AW, *Children of Holland* (Wellington: School Publications Branch, 1969).

57 A. Stott, 'Dutch utopia: Paintings by antimodern American artists of the nineteenth century', *Smithsonian Studies in American Art* 3, no. 2 (1989): 47.

58 AW, application to W. Eugene Smith Grant in Humanistic Photography (c. 1993).

59 N. L. Vestberg, 'Photography as cultural memory: Imag(in)ing France in the 1950s', *Journal of Romance Studies* 5, no. 2 (2005): 75.

60 D. Kelly interviewed by PM (12 July 2023).

61 D. Lange, 'Photographing the familiar', *Aperture* 1, no. 2 (1952): 4.

7. THE COUNTRY I LIVE IN

1 AW interviewed by HM (5 February 2022).

2 AW, Application for Arts Council Award, cited in L. McDonald, 'Camera Antipode: Ans Westra: Photography as a form of ethnographic and historical writing', PhD thesis (Massey University, Palmerston North, 2011), 158.

3 AW in L. Bieringa, *Ans Westra: Private Journeys/Public Signposts*, television documentary (2006); Alister Taylor, Memorandum of Agreement with Anna Jacoba Westra (August 1972).

4 AW, *Notes on the Country I Live In* (Wellington: A. Taylor, 1972).

5 J. K. Baxter, 'The country and the people', draft essay, family collection, 1–2.

6 AW interviewed by HM (5 February 2022).

7 M. Simpson, 'Radical spaces: New Zealand's resistance bookshops, 1969–1977', MA thesis (Victoria University of Wellington, 2007), 111.

8 AW interviewed by HM (5 February 2022).
9 AW in McCredie (ed.), *The New Photography: New Zealand's First-Generation Contemporary Photographers* (Wellington: Te Papa Press, 2019), 171.
10 J. B. Turner in Bieringa, *Private Journeys/Public Signposts*.
11 AW interviewed by HM (21 February 2022).
12 J. K. Baxter in AW, *Notes*, 8.
13 T. Shadbolt in AW, *Notes*, 12.
14 AW in McCredie, *The New Photography*, 171.
15 McDonald, 'Camera Antipode', 163–64.
16 *Press* (13 January 1973).
17 AW interviewed by HM (7 May 2022).
18 M. Friedlander, Photographs of kuia i mokotia (tattooed Maori women), National Library, PAColl-9977-7.
19 AW interviewed by HM (6 March 2022).
20 L. Bell, *Marti Friedlander: Portraits of the Artists* (Auckland: Auckland University Press, 2020), 288.
21 AW interviewed by HM (6 March 2022).
22 Ibid.
23 Ibid.
24 AW interviewed by HM (20 March 2022).
25 AW interviewed by HM (6 March 2022).
26 F. Tuohy and M. Murphy, *Down Under the Plum Trees* (Martinborough: Alister Taylor, 1976).
27 M. Haenga-Collins and A. Gibbs, '"Walking between worlds": The experiences of New Zealand Māori cross-cultural adoptees', *Adoption & Fostering* 39, no. 1 (2015): 64.
28 AW interviewed by HM (21 February 2022).
29 AW in Bieringa, *Private Journeys/Public Signposts*.
30 *Press* (23 February 1977), 3.
31 Ibid.
32 H. Smyth, *Rocking the Cradle: Contraception, Sex and Politics in New Zealand* (Wellington: Steele Roberts, 2000), 169.
33 *Taylor v. Beere*, Court of Appeal (CA 38/80), Cooke, Richardson, Somers, JJ. (19 March 1982), *Auckland University Law Review* 4, no. 3 (1982): 326.
34 Tuohy and Murphy, *Down Under the Plum Trees*, 285.
35 AW interviewed by HM (22 March 2022).
36 Tuohy and Murphy, *Down Under the Plum Trees*, 93.
37 Ibid., 199.
38 AW interviewed by HM (22 March 2022).
39 AW interviewed by HM (20 March 2022).

40 AW interviewed by HM (5 February 2022).
41 AW in Skinner, 'The eye of an outsider', 95–96.
42 E. Westra interviewed by PM (13 July 2023).
43 *Press* (16 May 1972).
44 AW in McCredie, *The New Photography*, 173.
45 *Press* (24 July 1973).
46 AW interviewed by HM (20 March 2022).
47 Ibid.
48 Ibid.
49 Ibid.
50 Ibid.
51 N. Seja, *PhotoForum at 40: Counterculture, Clusters, and Debate in New Zealand* (Auckland: Rim Books, 2014), 126.
52 AW interviewed by HM (20 March 2022).
53 Ibid.
54 Ibid.
55 Ibid.
56 Ibid.
57 Ibid.
58 J. K. Baxter in F. McKay (ed.), *James K. Baxter as Critic* (Auckland: Heinemann Educational Books, 1978), 11, cited in D. Brown, 'James K. Baxter: The identification of the "Poet" and the authority of the "Prophet"', *Journal of New Zealand Literature* 13 (1995): 136.
59 AW interviewed by HM (6 March 2022).
60 Ibid.
61 *Press* (25 October 1972).
62 McDonald, 'Camera Antipode', 175–76.
63 AW interviewed by HM (6 March 2022).
64 AW and N. Hilliard, *We Live by a Lake* (Auckland: Heinemann, 1972); Heinemann Ltd, Memorandum of Agreement with Ans Westra and Noel Hilliard (25 November 1971).
65 *Press* (4 May 1963).
66 J. Owain, 'Country childhood stories', in P. Cloke and J. Little (eds), *Contested Countryside Cultures* (London: Routledge, 1997), 158–79.
67 McDonald, 'Camera Antipode', 177.
68 W. Ihimaera, '*We Live by a Lake*', *Te Ao Hou* 75 (March 1974): 60.
69 AW interviewed by HM (21 February 2022).
70 AW interviewed by HM (20 March 2022).
71 AW interviewed by HM (7 May 2022).

8. CLOSE TO HOME

1. A. McCredie (ed.), *The New Photography: New Zealand's First-Generation Contemporary Photographers* (Wellington: Te Papa Press, 2019); AW interviewed by HM (6 March 2022).
2. J. B. Turner, 'PhotoForum: A personal reminiscence', in N. Seja, *PhotoForum at 40: Counterculture, Clusters, and Debate in New Zealand* (Auckland: Rim Books, 2014), 37.
3. J. B. Turner, diary entry, c. January 1965, in 'Good Luck John' (Wellington, 1985), 57; C. Broadley, Wellington Centre Gallery, exhibition catalogue (1965), National Library, ref. ArtEph-65-B.
4. J. B. Turner to PM (24 April 2023).
5. J. B. Turner in L. McDonald (ed.), *Handboek: Ans Westra Photographs* (Wellington: Blair Wakefield Exhibitions, 2004), 25.
6. *Photographic Art & History* 4 (March 1971).
7. B. Weatherall, 'Ans Westra: Concerned photographer', in *Photographic Art & History* 3 (October 1970): 8; Seja, *PhotoForum at 40*, 17.
8. 'Exhibition celebrates new PhotoForum website', *The Big Idea: Te Ariā Nui* (23 January 2008).
9. M. Oettli, 'They say you want a revolution', *Landfall* 231 (2016): 191–94.
10. M. Oettli in Seja, *PhotoForum at 40*, 210.
11. AW interviewed by HM (6 March 2022).
12. Ibid.
13. 'PhotoForum Members' Show 2018' (11 April–6 May 2018), Studio 514, Auckland.
14. AW interviewed by HM (20 March 2022).
15. G. Simmel, 'On art exhibitions', *Theory, Culture & Society* 32, no. 1 (2015): 87–92.
16. Manawatu Art Gallery, *The Active Eye: Contemporary New Zealand Photography* (Palmerston North: Manawatu Art Gallery, 1975).
17. Seja, *PhotoForum at 40*, 262.
18. P. Wells, 'Incandescent moment: Fiona Clark's "Go Girl"', *Art New Zealand* 106 (Autumn 2003).
19. C. Doherty, A. Berwick and R. McGregor, 'Swearing in class: Institutional morality in dispute', *Linguistics and Education* 48 (2018): 1–9.
20. Robert McDougall Art Gallery, *The Active Eye* (1975), Exhibition 145, Christchurch.
21. *Press* (4 March 1976).
22. *Taranaki Herald* (11 January 1975); *Northern Advocate* (26 April 1976).
23. *Press* (19 August 1975).
24. AW interviewed by HM (6 March 2022).
25. Land March itinerary, ANZ, ref: AAMK 869 W3074 Box 684/d 19/1/774 Part 1.
26. R. Walker, *Ka Whaiwhai Tonu Matou: Struggle Without End* (Auckland: Penguin, 1990), 212; A. Harris, *Hīkoi: Forty Years of Māori Protest* (Wellington: Huia, 2004), 71–72.
27. AW interviewed by HM (20 March 2022).

28 AW and N. Hilliard, *Wellington: City Alive* (Christchurch: Whitcoulls, 1976); Whitcombe & Tombs, Memorandum of Agreement with Ans Westra and Noel Hilliard (28 December 1973).
29 Ibid., 77–83.
30 Ibid., 97.
31 AW and P. Cape: *Down at the Garage* (Wellington: Price Milburn, 1974); *Brian Helps at the Shop* (Wellington: Price Milburn, 1974); *Brian and the Bus* (Wellington: Price Milburn, 1974); *Everyone Collects Rubbish* (Wellington: Price Milburn, 1974); AW and B. Murison, *Jane* (Wellington: Price Milburn, 1975); AW and M. Renwick, *Richard* (Wellington: Price Milburn, 1977).
32 L. Wevers, 'Reading and literacy', in L. Wevers (ed.), *Book and Print in New Zealand: A Guide to Print Culture in Aotearoa* (Wellington: Victoria University Press, 1997), 212–18.
33 AW and T. Royal, *Te Tautoko 3: Te Hararei* (Wellington: Department of Education, 1975); S. Green, School Publications Branch, Memorandum for Miss Ans Westra (8 June 1972).
34 Frances Parkin, *New Zealand Listener* (11 December 1976).
35 J. van Hulst interviewed by PM (25 July 2023).
36 AW in L. Bieringa, *Ans Westra: Private Journeys/Public Signposts*, television documentary (2006).
37 Frances Parkin, *New Zealand Listener* (11 December 1976).

9. THE THICK OF IT

1 AW interviewed by PM (22 February 2023).
2 AW and M. Renwick, *John Goes to School* (Wellington: A. H. & A. W. Reed, 1978); *The Stevens Family* (Wellington: Reed Education, 1978); *Keep Healthy* (Wellington: Reed Education, 1978); *Safety First* (Wellington: Reed Education, 1978); *The Helpers* (Wellington: Reed Education, 1978); AW and J. Horton, *On the Way to Reading* (Wellington: Department of Education, 1978); A. H. & A. W. Reed Ltd, Memorandum of Agreement with Ans Westra (May 1975); A. H. & A. W. Reed Ltd, Memorandum of Agreement with Ans Westra and Margery Elizabeth Renwick (June 1976).
3 AW interviewed by S. Black (28 March 1979), annotated by J. B. Turner, Ans Westra Archive, CA000621/2, Te Papa Archives.
4 Ibid.
5 E. Westra interviewed by PM (13 July 2023).
6 D. Kelly, review of *A Private View: An Exhibition by Ans Westra*, Taj Mahal Gallery, Wellington, September 1976, *PhotoForum* (December 1976/January 1977): 14.
7 J. Reidy, 'Looking after ourselves', in F. MacDonald and R. Kerr (eds), *West: The History of Waitakere* (Auckland: Random House, 2009), 157–78;

M. Kelderman, 'Te Whare Wānanga o Hoani Waititi Marae', MA thesis (Unitec, Auckland, 2014), 51.

8 J. Avery, 'Māori performing arts and the weaving together of local, national and international communities', MA thesis (Te Kōkī New Zealand School of Music, Wellington, 2015), 7; H. M. Mead, *Tikanga Māori: Living by Māori Values* (Wellington: Huia, 2003), 224.

9 AW interviewed by HM (20 March 2022).

10 I. Loewenberg, 'Reflections on self-portraiture in photography', *Feminist Studies* 25, no. 2 (1999): 400.

11 *Press* (8 March 1980).

12 M. Keech and B. Houlihan, 'Sport and the end of Apartheid', *The Round Table* 88, no. 349 (1999): 109–21.

13 AW in L. Bieringa, *Ans Westra: Private Journeys/Public Signposts*, television documentary (2006).

14 Ibid.

15 Ibid.

16 AW to J. B. Turner (18 April 1981), John B. Turner Archive, RC2016/1, Auckland Art Gallery.

17 AW to J. B. Turner (9 June 1981), John B. Turner Archive, RC2016/1, Auckland Art Gallery.

18 AW interviewed by HM (6 March 2022).

19 *New Zealand Herald* (24 May 2008).

20 AW in J. Saker, 'City interview: Ans Westra', *Wellington City Magazine* (April 1986): 27.

21 A. McCredie, *The Tour: Photographs* (Wellington: Thames Publications, 1981); T. Newnham, *By Batons and Barbed Wire: A Response to the 1981 Springbok Tour of New Zealand* (Auckland: Real Pictures Ltd, 1981).

22 M. Volkering to AW (2 April 1982), Ans Westra Archive, CA000621/3, Te Papa Archives.

23 AW, draft notes for Whaiora project (c. 1982), Ans Westra Archive, CA000617/2, Te Papa Archives.

24 AW in Bieringa, *Private Journeys/Pubic Signposts*.

25 Alexander Turnbull Library, National Library of New Zealand, 'Westra, Ans, 1936–2023: Photographs', ref: PA-Group-00941.

26 L. McDonald, 'Camera Antipode: Ans Westra: Photography as a form of ethnographic and historical writing', PhD thesis (Massey University, Palmerston North, 2011), 263.

27 AW and K. Mataira, *Whaiora: The Pursuit of Life* (Wellington: Allen & Unwin/Port Nicholson Press/National Art Gallery of New Zealand, 1985).

28 AW and K. Mataira, *Te Motopaika* (Wellington: Department of Education, 1971); J. R. Gillespie, School Publications Branch, Memorandum for Miss Ans Westra (22 December 1970).

29 *New Zealand Herald* (16 July 2011).

30 AW interviewed by HM (21 February 2022).
31 Ibid.
32 Ibid.
33 AW interviewed by HM (6 March 2022).
34 AW in D. Skinner, 'The eye of an outsider: A conversation with Ans Westra', *Art New Zealand* 100 (Spring 2001): 100.
35 AW interviewed by HM (6 March 2022).
36 Ibid.
37 Ibid.
38 AW interviewed by HM (20 March 2022).
39 Ibid.
40 AW interviewed by PM (22 February 2023).
41 D. Kelly interviewed by PM (12 July 2023).
42 AW in McCredie (ed.), *The New Photography: New Zealand's First-Generation Contemporary Photographers* (Wellington: Te Papa Press, 2019), 173.
43 AW interviewed by HM (20 February 2022).
44 W. Ihimaera, foreword in AW and K. Mataira, *Whaiora: The Pursuit of Life* (Wellington: Allen & Unwin/Port Nicholson Press/National Art Gallery of New Zealand, 1985), 5.
45 Ibid., 7.
46 AW in Saker, 'City interview: Ans Westra', 21.
47 Mataira in AW and K. Mataira, *Whaiora*, 75.
48 Ibid., 62.
49 Ibid., 63.
50 Ibid., 44–45.
51 AW interviewed by HM (6 March 2022).
52 AW in Saker, 'City interview: Ans Westra', 28.
53 AW interviewed by HM (21 February 2022).
54 E. Westra interviewed by PM (13 July 2023).
55 McDonald, 'Camera Antipode', 191.
56 M. Beaumont in ibid., 191.
57 AW interviewed by HM (21 February 2022).
58 J. B. Turner, 'Ans Westra', MS notes, c. 1987.
59 Exposures Gallery, *Retrospective II: Early 70s* (1–20 October 1984); *Retrospective III: Demonstration Decade* (4–23 March 1985); *Restrospective IV: Maori Today* (1–19 October 1985); Posters advertising exhibitions of photographers, photographs and photography (1985), National Library, Folder 1, ref: Eph-C-PHOTO-EXHIBITION-1985-1.
60 *Press* (27 November 1985).
61 P. Unger in *Press* (18 March 1987).

62 G. Simmel, 'The aesthetic significance of the face', in H. H. Wolff (ed.), *Georg Simmel, 1858–1918* (Columbus: Ohio State University, 1959), 278; McDonald, 'Camera Antipode', 145; S. Tamihana, 'Review of *Whaiora*', *Broadsheet* (April 1986): 44.
63 R. S. Hill, *Māori and State: Crown–Māori Relations in New Zealand/Aotearoa, 1950–2000* (Wellington: Victoria University Press, 2009), 90.
64 AW in Saker, 'City interview: Ans Westra', 25.
65 AW in *New Zealand Woman's Weekly* (29 June 1987), 12.

10. RETROSPECTION

1 *New Zealand Herald* (6 December 1986).
2 *Press* (28 May 1986).
3 D. Dallimore to AW (6 June 1986), Ans Westra Archive, CA000621/10, Te Papa Archives.
4 H. Ennis, 'Pacific', in N. Goodman and S. Hall (eds), *Pictures of Everyday Life: The People, Places and Cultures of the Commonwealth* (Surrey: Comedia Publishing Group, 1987), 157.
5 Goodman and Hall, *Pictures of Everyday Life*, 76, 77.
6 S. Hall, 'Essay one: The mirror of the lens', in Goodman and Hall, *Pictures of Everyday Life*, 15.
7 AW in *New Zealand Herald* (6 December 1986).
8 AW in J. Cole, 'People Power: "Freedom" Philippines', *Craccum* (21 September 1987): 10.
9 AW in *New Zealand Woman's Weekly* (29 June 1987), 11.
10 L. McDonald, 'Camera Antipode: Ans Westra: Photography as a form of ethnographic and historical writing', PhD thesis (Massey University, Palmerston North, 2011), 203.
11 New Zealand Students' Arts Council, *People Power: 'Freedom' in the Philippines: Photographs by Ans Westra*, Victoria University of Wellington Library, 1988.
12 AW in Cole, 'People Power', 11.
13 Ibid.
14 AW, J. B. Turner, 'Proposed book project: Peaceful Islands', n.d., unpublished, family collection.
15 AW, notes, Ans Westra Archive, CA000617/2, Te Papa Archives.
16 J. Connor to AW (4 July 1989); P. Wagemaker to AW (16 February 1996), Ans Westra Archive, CA000617/2, Te Papa Archives.
17 Ans Westra Archive, CA000617/2, Te Papa Archives.
18 AW to J. B. Turner (12 August 1986), John B. Turner Archive, RC2016/1, Auckland Art Gallery.
19 AW to J. B. Turner (29 October 1986), John B. Turner Archive, RC2016/1, Auckland Art Gallery.

20 R. Keay to D. Brasell (2 September 1993), Ans Westra Archive, CA000617/2, Te Papa Archives.
21 AW in *New Zealand Woman's Weekly* (29 June 1987), 12.
22 J. R. Peet, 'Comparative policy analysis: Neoliberalising New Zealand', *New Zealand Geographer* 68, no. 3 (2012): 151–67.
23 E. Pawson and G. Scott, 'The regional consequences of economic restructuring: The West Coast, New Zealand (1984–1991)', *Journal of Rural Studies* 8, no. 4 (1992): 373–86.
24 C. B. McKirdy, 'Falling branches, dying roots? Bank branch closure in small towns', BA (Hons) thesis (University of Otago, Dunedin, 2000), 15.
25 AW, 'Post Office Documentary Project Photographs', 1988, National Library, ref. PAColl-1299.
26 National Library gallery, *Within Memory*, National Library Galley (2006) National Library, ref. PAColl-1301-05.
27 J. Mack to AW (30 September 1988).
28 A. McCredie, 'Going Public: New Zealand art museums in the 1970s', MA thesis (Massey University, Palmerston North, 1999), 59.
29 *Western News* (17 June 1991).
30 D. Luoni, 'Museum leadership in practice: A New Zealand case study', MA thesis (Victoria University of Wellington, 2011), 36.
31 AW interviewed by HM (21 April 2022).
32 AW in J. Saker, 'City interview: Ans Westra', *Wellington City Magazine* (April 1986): 20.
33 AW interviewed by HM (21 April 2022).
34 K. M. Goody to N. Anderson (27 January 1989).
35 AW interviewed by HM (21 April 2022).
36 AW interviewed by HM (7 May 2022).
37 M. Burgess, 'Full circle: Putting Ans Westra in the picture', *Art New Zealand* 160 (Summer 2016/2017): 81.
38 D. Kelly interviewed by PM (12 July 2023).
39 AW interviewed by HM (7 May 2022).
40 Ibid.
41 A. McCredie (ed.), *The New Photography: New Zealand's First-Generation Contemporary Photographers* (Wellington: Te Papa Press, 2019).
42 A. McCredie interviewed by PM (16 June 2023).
43 *Broadsheet* 171 (September 1989): 41.
44 AW and P. Maunder, *Te Ao Hurihuri: The Moving World — A Year in the Life of Pito-One*, Calendar 1992', National Library, ref. Eph-C-CALENDAR-1992.
45 P. McCredie to AW (9 March 1990), Ans Westra Archive, CA000621/3, Te Papa Archives.
46 AW to P. McCredie (20 March 1990), Ans Westra Archive, CA000621/3, Te Papa Archives.

47 Minutes of meeting of planning committee for New Zealand's first International Symposium of Photography held in the Department of Continuing Education, University of Canterbury (1 March 1991).
48 AW to P. Harper (8 April 1991).
49 AW, 'Details of the work to be undertaken etc' (c. 1990), family collection.
50 L. van Hulst interviewed by PM (24 July 2023).
51 S. Bantz to E. Geiringer (19 July 1991).
52 Y. Westra interviewed by PM (26 July 2023).
53 S. Bantz to E. Geiringer (19 July 1991).
54 Ibid.
55 E. Westra interviewed by PM (13 July 2023).
56 S. Bantz to E. Geiringer (19 July 1991).
57 S. H. Lisanby, 'Electroconvulsive therapy for depression', *New England Journal of Medicine* 357, no. 19 (2007): 1939–45; C. Loo, N. Katalinic, P. B. Mitchell and B. Greenberg, 'Physical treatments for bipolar disorder: A review of electroconvulsive therapy, stereotactic surgery and other brain stimulation techniques', *Journal of Affective Disorders* 132, nos 1–2 (2011): 1–13.
58 S. Bantz to E. Geiringer (19 July 1991).
59 Ibid.
60 AW, 'Some plans!', notebook (1991), Ans Westra Archive, CA000621, Te Papa Archives.
61 S. Bantz to E. Geiringer (19 July 1991).
62 AW, notes (July 1991), family collection.
63 AW, 'Portrait of my breakdown', notes (July 1991), family collection.
64 G. Mellsop to C. Shand (21 December 1992).
65 C. Barapatre to AW (7 January 1999).
66 Ministry for Culture and Heritage to AW (4 December 1992), Ans Westra Archive, CA000621/1, Te Papa Archives.
67 S. Trotter to AW (24 March 1993), Ans Westra Archive, CA000621/1, Te Papa Archives.
68 S. Ingram to AW (11 May 1993), Ans Westra Archive, CA000621/1, Te Papa Archives.
69 AW to J. Leuthart (May 1993), Ans Westra Archive, CA000621/1, Te Papa Archives.
70 L. Leuthart to AW (26 May 1993), Ans Westra Archive, CA000621/1, Te Papa Archives.
71 C. Riddle, *Waikato Times* (27 October 2018).
72 AW interviewed by HM (20 March 2022).
73 AW and K. Smythe, *Families of New Zealand: Tenga of Waikuta* (Hamilton: Developmental Publications, 1992), 4.
74 AW, 'Details of the work to be undertaken etc', (c. 1990), family collection.
75 J. Leuthart to B. Milbank (2 November 1992); B. Milbank to AW (24 April 1992).
76 AW in *New Zealand Listener* (3 February 1996), 38.
77 Ibid.

78 AW interviewed by HM (20 March 2022).
79 McDonald, 'Camera Antipode', 261.
80 AW, Curriculum Vitae, Lower Hutt (1999), family collection.
81 AW interviewed by P. Ireland, 28 October 1995, Ans Westra Archive, CA000621/1, Te Papa Archives.
82 AW interviewed by HM (6 March 2022).
83 *Evening Post* (20 October 1993).
84 Y. Westra interviewed by PM (26 July 2023).
85 *Evening Post* (20 October 1993).
86 Sun Travel itinerary prepared for Ans Westra, 25 May 1994, Ans Westra Archive, CA000621/7, Te Papa Archives.
87 AW, personal notes, 1999, family collection.
88 AW interviewed by HM (7 May 2022).
89 Ibid.
90 J. Zimmermann and A. Somerville-Shaw to AW (January 1992).
91 J. Zimmermann to AW (27 February 1992).
92 B. Connew, L. Aberhart, A. Noble and AW to J. Zimmermann (6 March 1992).
93 J. Zimmermann to L. Aberhart (23 March 1992).
94 AW to J. Zimmermann (31 March 1992).
95 AW to L. Aberhart (c. March 1992).
96 D. Skinner, *Mudpool Modernism: Modernism and Tourism in Rotorua* (Rotorua: Friends of Rotorua Museum of Art and History, 2000).
97 D. Skinner to AW (2 October 2000).
98 D. Skinner to AW (c. 20 October 2000).
99 AW, book proposal: 'To document New Zealand's new immigrant population' (c. 1990s), Ans Westra Archive, CA000621/7, Te Papa Archives.
100 AW, book proposal: 'Changing times in New Zealand' (1992), Ans Westra Archive, CA000621/7, Te Papa Archives.
101 D. Halstead to AW (8 July 1996).
102 AW to L. Godman (13 July 1997).
103 L. Godman to AW (30 July 1997).
104 AW, 'Visiting research scholar proposal to research and development committee, Otago Polytechnic' (9 July 1996), family collection.

11. BROKEN ENDS

1 T. Cardy, *Dominion Post* (4 November 2011).
2 AW in City Gallery Wellington, *Behind the Curtain: Photographs of the Sex Industry by Ans Westra* (City Gallery Wellington, 2001).

3 V. R. Schwartz, 'Walter Benjamin for historians', review essay, *American Historical Review* 106, no. 5 (December 2001): 1721–43.
4 D. Skinner, 'Viva Roto-Vegas! Ans Westra and Mark Adams in Rotorua', *Art New Zealand* 98 (2001): 63.
5 H. Frances, 'Humanity found', *Urbis* (Autumn 2005): 86.
6 L. McDonald interviewed by PM (22 June 2023).
7 J. Bayly, 'Ans Westra in the realm of textual re-construction(s)', *Landfall* 209 (2005): 115.
8 L. McDonald in L. McDonald (ed.), *Handboek: Ans Westra Photographs* (Wellington: Blair Wakefield Exhibitions, 2004), 18.
9 C. Barton in ibid., 93.
10 H. Tūwhare in ibid., 7.
11 AW interviewed by HM (20 March 2022).
12 National Library, Ans Westra exhibition media release (5 June 2003).
13 L. Alcock, 'Westra a big hit in Wellington', in *NewsNotes* (1 October 2004), National Library, Wellington.
14 S. Rowe, 'Handboek: Ans Westra Photographs', *Hutt News* (10 August 2004); *Capital Times* (22 September 2004).
15 *New Zealand Herald* (10 August 2006).
16 AW in L. Bieringa, *Ans Westra: Private Journeys/Public Signposts*, television documentary (2006).
17 FHE Galleries, *Ans Westra: To the Pleasure Garden* (2005), FHE Galleries, Auckland.
18 J. Conlin, 'Vauxhall on the boulevard: Pleasure gardens in London and Paris, 1764–1784', *Urban History* 35, no. 1 (2008): 24–47.
19 AW in FHE Galleries, *Ans Westra*, 4.
20 AW in *Private Journeys/Public Signposts*.
21 AW in FHE Galleries, *Ans Westra*, 5.
22 Ibid., 10.
23 L. Bell, *Marti Friedlander: Portraits of the Artists* (Auckland: Auckland University Press, 2020), 288.
24 AW interviewed by HM (6 March 2022).
25 AW, according to L. McDonald, interviewed by PM (22 June 2023).
26 Bell, *Marti Friedlander*, 288.
27 AW interviewed by HM (6 March 2022).
28 Ibid.
29 AW interviewed by HM (20 March 2022).
30 M. Amery (producer), *Curators of Cuba: {Suite} Gallery with Ans Westra* (2020), Wellington Independent Arts Trust.
31 D. Alsop interviewed by PM (24 July 2023).

32 M. Burgess, 'Full circle: Putting Ans Westra in the picture', *Art New Zealand* 160 (Summer 2016/2017): 80–81.
33 Ibid., 80.
34 D. Alsop interviewed by PM (24 July 2023).
35 Burgess, 'Full circle', 80–81.
36 E. Westra interviewed by PM (13 July 2023).
37 AW in Ans Westra's *Toyland (Again)* media release (24 January 2019), {Suite}, Wellington.
38 P. Shaw, 'FHE Galleries presents *Toy-Land* Ans Westra' (2008), FHE Galleries, Auckland.
39 T. J. McNamara, *New Zealand Herald* (10 April 2008).
40 A. M. Gabe in AW and A. Jansen, *The Crescent Moon: The Asian Face of Islam in New Zealand* (Wellington: Asia New Zealand Foundation, 2009), 10.
41 N. Seja, *PhotoForum at 40: Counterculture, Clusters, and Debate in New Zealand* (Auckland: Rim Books, 2014), 86.
42 N. Bhandari, 'New Zealand book lets Asian Muslims tell their own stories', *Inter Press Service* (17 March 2009).
43 AW interviewed by PM (22 February 2023).
44 *Stratford Press* (12 August 2019); *Taranaki Daily News* (6 August 2019).
45 W. Bowler, 'An exhibition on resilience for a time of grief', in N. Thompson and G. R. Cox (eds), *Promoting Resilience: Responding to Adversity, Vulnerability, and Loss* (New York: Routledge, 2019), 203–08.
46 AW in S. Stephenson, 'Cry, the beloved country', *North & South* (June 2013): 74.
47 D. Christie with AW, BFM interview (Auckland, 20 March 2005).
48 AW et al., *Nga Tau Ki Muri: Our Future* (Wellington: {Suite} Publishing, 2013), 19, 31, 87.
49 AW interviewed by HM (20 March 2022).
50 AW in Bieringa, *Private Journeys/Public Signposts*.
51 AW interviewed by HM (20 March 2022).
52 AW et al., *Nga Tau Ki Muri*, 40.
53 R. Norman in ibid., 159.
54 A. Cocker, 'Janus' other face', *New Zealand Review of Books* 103 (Spring 2013).
55 AW interviewed by HM (6 March 2022).
56 AW, 'Hone Tuwhare: Poet', *Te Ao Hou* 48 (September 1964), cover image; Bieringa, *Private Journeys/Public Signposts*.
57 AW interviewed by HM (20 March 2022).
58 H. Tūwhare, 'Friend', in AW et al., *Nga Tau Ki Muri*, 29.
59 D. Lange in AW et al., *Nga Tau Ki Muri*, 55.
60 AW in AW et al., *Nga Tau Ki Muri*, 55.
61 *Rotorua Daily Post* (21 February 2013).
62 AW in TNVZ, 'Ans Westra's *Full Circle* exhibition returns to rural NZ', *Marae* (2013).
63 Burgess, 'Full circle', 80.

64 L. Bieringa in A. van der Boon, 'Through the lens of Ans Westra: Modern Aotearoa in the making', media release, *Dutch Connections* (8 April 2023).
65 M. Wood, *Northland Age* (24 February 2022).
66 AW interviewed by HM (6 March 2022).
67 AW interviewed by HM (7 May 2022).
68 Ibid.
69 AW interviewed by HM (20 February 2022).
70 Ibid.
71 AW interviewed by HM (7 May 2022).

DEPARTURE

1 A. McCredie interviewed by PM (16 June 2023).
2 AW in J. Bayly, 'Ans Westra: Finding a "place" in New Zealand', in J. Bayly and A. McCredie (eds), *Witness to Change: Life in New Zealand: John Pascoe, Les Cleveland, Ans Westra: Photographs 1940–1965* (Wellington: PhotoForum, 1985), 71.
3 D. Kelly interviewed by PM (12 July 2023).
4 AW, 'Portrait of my breakdown', notes (July 1991), family collection.
5 AW interviewed by HM (21 February 2022).

Bibliography

INTERVIEWS AND CORRESPONDENCE WITH AUTHOR

David Alsop, interview, 20 December 2022, 22 February, 24 July, 3 August 2023.
David Alsop, email correspondence, 7 March, 4 April 2023.
Desmond Kelly, interview, 12 July 2023.
Desmond Kelly, email correspondence, 28 June 2023.
Athol McCredie, interview, 16 June 2023.
Lawrence McDonald, interview, 22 June 2023.
John B. Turner, email correspondence, 20–25 April, 29 May, 1–3 June, 29 June, 1 August 2023.
John van Hulst, interview, 24–25 July 2023.
Ans Westra, interview, 22 February 2023.
Erik Westra, interview, 13 July 2023.
Erik Westra, email correspondence, 13 July, 26 July 2023.
Yvonne Westra, interview, 26 July 2023.
Simon Woolf, interview, 4 March 2023.

OTHER INTERVIEW TRANSCRIPTS

D. Christie, BFM interview with AW, Auckland, 20 March 2005.
AW interviewed by S. Black, 28 March 1979, annotated by J. B. Turner, Ans Westra Archive, CA000621/2, Te Papa Archives.
AW interviewed by P. Ireland, 28 October 1995, Ans Westra Archive, CA000621/1, Te Papa Archives.
AW interviewed by H. Manson, 5 February, 20 February, 21 February, 6 March, 20 March, 21 April, 7 May 2022, family collection.

ARCHIVES

A collection held by the family contains much unsorted paperwork retrieved from Ans Westra's house after her death.
Alexander Turnbull Library, National Library of New Zealand, 'Westra, Ans, 1936–2023: Photographs', ref: PA-Group-00941.

Ans Westra Archive, Te Papa Archives, contains AW letters, notes, diagrams of proposed book layouts, roadmaps, travel itineraries and sundry other materials.
Land March itinerary, Archives NZ, ref: AAMK 869 W3074 Box 684/d 19/1/774 Part 1.
Passenger lists 1839–1973, Archives NZ, Wellington; FHL microfilms 004459813; 004508775.

BOOKS AND CHAPTERS

Where Ans Westra contributed to a multi-authored work, her surname is listed first to make her contributions easier to locate.

Arts Committee of the Festival of Wellington, *Industrial Design Exhibition 1961 Booklet*.
Ballara, A. *Te Kīngitanga: The People of the Māori King Movement*. Auckland: Auckland University Press, 1996.
Barclay, B. *Our Own Image: A Story of a Māori Filmmaker*. Minnesota: University of Minnesota Press, 2015.
Bayly, J. 'Ans Westra: Finding a "place" in New Zealand'. In J. Bayly and A. McCredie (eds), *Witness to Change: Life in New Zealand: John Pascoe, Les Cleveland, Ans Westra: Photographs 1940–1965*. Wellington: PhotoForum, 1985.
Behdad, A. and L. Gartlan (eds). *Photography's Orientalism: New Essays on Colonial Representation*. Los Angeles: Getty Publications, 2013.
Bell, L. *Marti Friedlander: Portraits of the Artists*. Auckland: Auckland University Press, 2020.
Bogre, M. *Documentary Photography Reconsidered: History, Theory and Practice*. Oxford: Routledge, 2020.
Bowler, W. 'An exhibition on resilience for a time of grief'. In N. Thompson and G. R. Cox (eds), *Promoting Resilience: Responding to Adversity, Vulnerability, and Loss*. New York: Routledge, 2019.
Braudy, L. and M. Cohen, M. (eds). *Film Theory and Criticism: Introductory Readings*. New York: Oxford University Press, 1999.
Brown, D. *The Whare on Exhibition*. Wellington: Victoria University Press, 2004.
Cleveland, L. *The Silent Land*. Christchurch: The Caxton Press, 1966.
Cloke, P. and J. Little (eds). *Contested Countryside Cultures*. London: Routledge, 1997.
Colberg, J. *Understanding Photobooks: The Form and Content of the Photographic Book*. New York: Routledge, 2017.
Cook, J. *A Voyage Towards the South Pole, and Round the World. Performed in His Majesty's Ships the* Resolution *and* Adventure, *in the Years 1772, 1773, 1774, and 1775*. London: W. Strahan and T. Cadell, 1777.
Darwin, E. *The Temple of Nature, Or, The Origin of Society*. London: J. Johnson, 1803.
Eklund, D. 'Art and photography: 1990s to the present'. In *Heilbrunn Timeline of Art History*. New York: Metropolitan Museum of Art, 2004.

Fischer, K. *The Imperial Gaze: Native American, African American, and Colonial Women in European Eyes.* Oxford: Blackwell Publishers, 2002.

Gilpin, W. *Three Essays on Picturesque Beauty.* London: R. Blamire, 1792.

Golding, A. (trans.). Ovid, *Metamorphoses.* London: De La More Press, 1902.

Goodman, N. and S. Hall (eds). *Pictures of Everyday Life: The People, Places and Cultures of the Commonwealth.* Surrey: Comedia Publishing Group, 1987.

Green, D. G. *From Welfare State to Civil Society.* Wellington: New Zealand Business Roundtable, 1996.

Hackforth-Jones, J. and M. Roberts (eds). *Edges of Empire: Orientalism and Visual Culture.* Hoboken: John Wiley & Sons, 2008.

Harris, A. *Hīkoi: Forty Years of Māori Protest.* Wellington: Huia, 2004.

Hill, R. S. *Māori and State: Crown–Māori Relations in New Zealand/Aotearoa, 1950–2000.* Wellington: Victoria University Press, 2009.

Hori. *The Half-Jar.* Auckland: Sporting Life Publications, 1962.

Hoselitz, B. F. *Sociological Aspects of Economic Growth.* New York: Free Press, 1960.

King, M. *Moko: Maori Tattooing in the Twentieth Century.* Wellington: Alister Taylor, 1972.

Lerner, D. *The Passing of Traditional Society: Modernizing the Middle East.* New York: Free Press, 1958.

MacDonald, F. and R. Kerr (eds). *West: The History of Waitakere.* Auckland: Random House, 2009.

MacKenzie, J. *Orientalism: History, Theory and the Arts.* Manchester: Manchester University Press, 1995.

Main, W., and J. B. Turner. *New Zealand Photography from the 1840s to the Present.* Auckland: PhotoForum, 1993.

McClelland, D. C. *The Achieving Society.* New York: Free Press, 1961.

McCredie, A. *The New Photography: New Zealand's First-Generation Contemporary Photographers.* Wellington: Te Papa Press, 2019.

McCredie, A. *The Tour: Photographs.* Wellington: Thames Publications, 1981.

McDonald, L. (ed.). *Handboek: Ans Westra Photographs.* Wellington: Blair Wakefield Exhibitions, 2004.

McKay, F. (ed.). *James K. Baxter as Critic.* Auckland: Heinemann Educational Books, 1978.

Mead, H. M. *Tikanga Māori: Living by Māori Values.* Wellington: Huia, 2003.

Metge, J. *A New Maori Migration: Rural and Urban Relations in Northern New Zealand.* Melbourne: Melbourne University Press, 1964.

Miller, W. *The World is young.* New York: Ridge Press, 1958.

Monk, V. R. *Crown Lynn: A New Zealand Icon.* Auckland: Penguin Books, 2006.

Moon, P. *A Draught of the South Land: Mapping New Zealand from Tasman to Cook.* Cambridge: The Lutterworth Press, 2023.

Newnham, T. *By Batons and Barbed Wire: A Response to the 1981 Springbok Tour of New Zealand*. Auckland: Real Pictures, 1981.

Newton, J. *The Double Rainbow: James K. Baxter, Ngāti Hau and the Jerusalem Commune*. Wellington: Victoria University Press, 2009.

Powell, L. C., and P. Blank. *Turi: The Story of a Little Boy*. London: Angus & Robertson, 1963.

Price, U. *An Essay on the Picturesque, As Compared with the Sublime and the Beautiful*. London: J. Robson, 1794.

Reidy, J. 'Looking after ourselves'. In F. MacDonald and R. Kerr (eds), *West: The History of Waitakere*. Auckland: Random House, 2009.

Riethmaier, G. *Rebecca and the Maoris*. Wellington: A. H. & A. W. Reed, 1964.

Robertson, W. *The History of the Discovery and Settlement of America*. New York: J. & J. Harper, 1831.

Rugg, J., and M. Sedgwick (eds). *Issues in Curating Contemporary Art and Performance*. Bristol: Intellect Books, 2007.

Schama, S. *Landscape and Memory*. New York: Vintage Books, 1996.

Seja, N. *PhotoForum at 40: Counterculture, Clusters, and Debate in New Zealand*. Auckland: Rim Books, 2014.

Skinner, D. *Mudpool Modernism: Modernism and Tourism in Rotorua*. Rotorua: Friends of Rotorua Museum of Art and History, 2000.

Smith, A., and L. Wevers (eds). *On Display: New Essays in Cultural Studies*. Wellington: Victoria University Press, 2004.

Smyth, H. *Rocking the Cradle: Contraception, Sex and Politics in New Zealand*. Wellington: Steele Roberts, 2000.

Somerville, A. T-P. 'Te Ao Hou'. In M. Williams (ed.), *A History of New Zealand Literature*. Cambridge: Cambridge University Press, 2016.

Steichen, E., and C. Sandburg. *The Family of Man*. New York: Museum of Modern Art, 1955.

Thompson, N., and G. R. Cox (eds). *Promoting Resilience: Responding to Adversity, Vulnerability, and Loss*. New York: Routledge, 2019.

Tuohy, F. and M. Murphy. *Down Under the Plum Trees*. Martinborough: Alister Taylor, 1976.

Turner, J. B. *Three New Zealand Photographers: Gary Baigent, Richard Collins, John Fields: A Survey Exhibition of Contemporary New Zealand Photographs*. Auckland: Auckland City Art Gallery, 1973.

van der Keuken, J. *Wij Zijn 17*. Bussum: van Dishoeck, 1955.

Walker, R. *Ka Whaiwhai Tonu Matou: Struggle Without End*. Auckland: Penguin Books, 1990.

AW. 'Children of Fiji'. *School Journal* 2, no. 3 (1964).

AW. *Viliami of the Friendly Islands*. Bulletin for Schools. Wellington: Department of Education, 1964.

AW. *Washday at the Pa*. Bulletin for Schools. Wellington: Department of Education, 1964.

AW et al. *Ngā Tau Ki Muri: Our Future*. Wellington: {Suite} Publishing, 2013.

AW. *Notes on the Country I Live In*. Martinborough: Alister Taylor, 1972.

AW and M. Amery. *Washday at the Pa*. Wellington: {Suite} Publishing, 2011.
AW and I. Brown. *Children of Holland*. Wellington: School Publications Branch, 1969.
AW and P. Cape. *Brian and the Bus*. Wellington: Price Milburn, 1974.
AW and P. Cape. *Brian Helps at the Shop*. Wellington: Price Milburn, 1974.
AW and P. Cape. *Down at the Garage*. Wellington: Price Milburn, 1974.
AW and P. Cape. *Everyone Collects Rubbish*. Wellington: Price Milburn, 1974.
AW and N. Hilliard. *We Live by a Lake*. Auckland: Heinemann, 1972.
AW and N. Hilliard. *Wellington: City Alive*. Christchurch: Whitcoulls, 1976.
AW and J. Horton. *On the Way to Reading*. Wellington: Department of Education, 1978.
AW and A. Jansen. *The Crescent Moon: The Asian Face of Islam in New Zealand*. Wellington: Asia New Zealand Foundation, 2009.
AW and K. Mataira. *Te Motopaika*. Wellington: Department of Education, 1971.
AW and K. Mataira. *Tamariki: Our Children Today*. Wellington: Maori Education Foundation, 1965.
AW and K. Mataira. *Whaiora: The Pursuit of Life*. Wellington: Allen & Unwin/Port Nicholson Press/National Art Gallery of New Zealand, 1985.
AW and B. Murison. *Jane*. Wellington: Price Milburn, 1975.
AW and M. Renwick. *John Goes to School*. Wellington: A. H. & A. W. Reed, 1978.
AW and M. Renwick. *Keep Healthy*. Wellington: Reed Education, 1978.
AW and M. Renwick. *Richard*. Wellington: Price Milburn, 1977.
AW and M. Renwick. *Safety First*. Wellington: Reed Education, 1978.
AW and M. Renwick. *The Helpers*. Wellington: Reed Education, 1978.
AW and M. Renwick. *The Stevens Family*. Wellington: Reed Education, 1978.
AW and J. Ritchie. *Maori*. Wellington: A. H. & A. W. Reed, 1967.
AW and T. Royal. *Te Tautoko 3: Te Hararei*. Wellington: Department of Education, 1975.
AW and K. Smythe. *Families of New Zealand: Tenga of Waikuta*. Hamilton: Developmental Publications, 1992.
AW and K. Smythe. *Sarah of the Valley*. Hamilton: Developmental Publications, 1993.
Wevers, L. (ed.). *Book and Print in New Zealand: A Guide to Print Culture in Aotearoa*. Wellington: Victoria University Press, 1997.
Williams, M. (ed.). *A History of New Zealand Literature*. Cambridge: Cambridge University Press, 2016.
Wolff, H. H. (ed.). *Georg Simmel, 1858–1918*. Columbus: Ohio State University, 1959.
Woolf, V. *Granite and Rainbow: Essays by Virginia Woolf*. New York: Harcourt, Brace and Co, 1958.

JOURNAL AND MEDIA ARTICLES

Alacovska, A. and D. Kärreman. 'Tormented selves: The social imaginary of the tortured artist and the identity work of creative workers'. *Organization Studies* 44, no. 6 (2023): 961–85.

Amoamo, M. 'Māori tourism: The representation of images'. *AlterNative: An International Journal of Indigenous Peoples* 3, no. 1 (2006): 68–87.

Barnes, F. 'Pictorialism, photography and colonial culture, 1880–1940'. *New Zealand Journal of History* 47, no. 2 (2013): 136–56.

Barton, C. 'Rethinking "Headlands"'. *Afterall: A Journal of Art, Context and Enquiry* 39 (2015): 101–10.

Batchen, G. 'The naming of photography: "A mass of metaphor"'. *History of Photography* 17, no. 1 (1993): 22–32.

Behdad, A. 'Mediated visions: Early photography of the Middle East and Orientalist network'. *History of Photography* 41, no. 4 (2017): 362–75.

Belgrave, M. 'The politics of Maori history in an age of protest'. *Journal of New Zealand & Pacific Studies* 2, no. 2 (2014): 139–56.

Bell, C. '"Not really beautiful, but iconic": New Zealand's Crown Lynn ceramics'. *Journal of Design History* 25, no. 4 (2012): 414–26.

Bhandari, N. 'New Zealand book lets Asian Muslims tell their own stories'. *Inter Press Service*, 17 March 2009.

Binney, J. 'Myth and explanation in the Ringatū tradition: Some aspects of the leadership of Te Kooti Arikirangi Te Turuki and Rua Kēnana Hepetipa'. *Journal of the Polynesian Society* 93, no. 4 (1984): 345–98.

Boyask, R., J. C. McPhail, B. Kaur and K. O'Connell. 'Democracy at work in and through experimental schooling' . *Discourse: Studies in the Cultural Politics of Education* 29, no. 1 (2008): 19–34.

Brickell, C. 'Sex education, homosexuality, and social contestation in 1970s New Zealand'. *Sex Education* 7, no. 4 (2007): 387–406.

Brookes, B. 'Nostalgia for "innocent homely pleasures": The 1964 New Zealand controversy over *Washday at the Pa*'. *Gender & History* 9, no. 2 (1997): 242–61.

Brown, D. 'James K. Baxter: The identification of the "Poet" and the authority of the "Prophet"'. *Journal of New Zealand Literature* 13 (1995): 133–42.

Brown, D. B. 'Gothic cathedrals from Romanticism to Modernism: Images and ideas'. *Tate Papers* 23 (2020): 1–10.

Burgess, M. 'Full circle: Putting Ans Westra in the picture'. *Art New Zealand* 160 (Summer 2016/2017): 79–81.

Carroll, N. 'The ontology of mass art'. *Journal of Aesthetics and Art Criticism* 55, no. 2 (1997): 187–99.

Carsten, H. 'Four Maori studies by Hester Carsten'. *Landfall* 5, no. 3 (September 1951): 208–09.

Carsten, H. 'Maori studies by Hester Carsten'. *Landfall* 6, no. 4 (December 1952): 288–89.

Carsten, H. 'Meeting house at Ruatahuna'. *Landfall* 11, no. 1 (March 1957): 33–34.

Clark, C. E. 'Capturing the moment, picturing history: Photographs of the liberation of Paris'. *American Historical Review* 121, no. 3 (2016): 824–60.

Clark, H. F. 'The sense of beauty in the 18th, 19th and 20th centuries: Aesthetic values in English landscape appreciation'. *Landscape Architecture* 47, no. 4 (1957).

Cocker, A. 'Janus' other face'. *NZ Review of Books* 103 (Spring 2013).

Cohen, A. 'Speaking of the "female gaze"'. *The Nation* (22 September 2017).

Comello, A., 'That's a different story: Comparing letters and oral accounts of Dutch immigrants in New Zealand'. *The History of the Family* 17, no. 2 (2012): 178–98.

Conlin, J. 'Vauxhall on the boulevard: Pleasure gardens in London and Paris, 1764–1784'. *Urban History* 35, no. 1 (2008): 24–47.

de Almeida, D. B. L. 'Toys as texts: Towards a multimodal framework to toys' semiotics'. *Trabalhos em Linguística Aplicada* 59 (2021): 2102–22.

de Bres, P. H. 'Memoir no. 37: Religion in Atene: Religious association and the urban Maori'. *Journal of the Polynesian Society* 79, no. 3 (1970): 1–50.

Dekker, D. 'Communicating via the camera'. *Evening Post*, 3 July 1976.

Demeritt, D. 'The nature of metaphors in cultural geography and environmental history'. *Progress in Human Geography* 18, no. 2 (1994): 163–85.

Dirse, Z. 'Gender in cinematography: Female gaze (eye) behind the camera'. *Journal of Research in Gender Studies* 3, no. 1 (2013): 15–29.

Doherty, C., A. Berwick and R. McGregor. 'Swearing in class: Institutional morality in dispute'. *Linguistics and Education* 48 (2018): 1–9.

Eaton, N. 'Nostalgia for the exotic: Creating an imperial art in London, 1750–1793'. *Eighteenth-Century Studies* (2006): 227–50.

Else, A. '"The need is ever present": The Motherhood of Man movement and stranger adoption in New Zealand'. *New Zealand Journal of History* 23, no. 1 (1989): 47–67.

Foray, J. L. 'The "Clean Wehrmacht" in the German-occupied Netherlands, 1940–45'. *Journal of Contemporary History* 45, no. 4 (2010): 768–87.

Frances, H. 'Ans Westra remembers'. *NZ Memories* 50 (Oct./Nov. 2004): 28–33.

Gómez Cruz, E., and E. T. Meyer. 'Creation and control in the photographic process: iPhones and the emerging fifth moment of photography'. *Photographies* 5, no. 2 (2012): 203–21.

Griffen, C. 'Towards an urban social history for New Zealand'. *New Zealand Journal of History* 20, no. 2 (1986): 111–31.

Gualtieri, E. 'The impossible art: Virginia Woolf on modern biography'. *Cambridge Quarterly* 29, no. 4 (2000): 349–61.

Haenga-Collins, M., and A. Gibbs. '"Walking between worlds': The experiences of New Zealand Māori cross-cultural adoptees'. *Adoption & Fostering* 39, no. 1 (2015): 62–75.

Hall, A. 'The rise of blame and recreancy in the United Kingdom: A cultural, political and scientific autopsy of the North Sea flood of 1953'. *Environment and History* 17, no. 3 (2011): 379–408.

Hartog, J., and R. Winkelmann. 'Comparing migrants to non-migrants: The case of Dutch migration to New Zealand'. *Journal of Population Economics* 16, no. 4 (2003): 683–705.

Hatch, K. '"Something Else": Ed Ruscha's photographic books', *October* 111 (Winter 2005): 107–26.

Heyward, P., and E. Fitzpatrick. 'Speaking to the ghost: An autoethnographic journey with Elwyn'. *Educational Philosophy and Theory* 48, no. 7 (2016): 697–710.

Horn, M. 'The Great Depression: Past and Present'. *Journal of Canadian Studies* 11, no. 1 (1976): 41–50.

Jay, B. '*The Family of Man*: A reappraisal of the greatest exhibition of all time'. *Insight, Bristol Workshops in Photography* 1 (1989): 1–9.

Keats, P. A. 'The moment is frozen in time: Photojournalists' metaphors in describing trauma photography'. *Journal of Constructivist Psychology* 23, no. 3 (2010): 231–55.

Keech, M., and B. Houlihan. 'Sport and the end of apartheid'. *The Round Table* 88, no. 349 (1999): 109–21.

Kelly, D. 'Review. *A Private View: An Exhibition by Ans Westra*, Taj Mahal Gallery, Wellington, September 1976.' *PhotoForum* (December 1976/January 1977): 14.

Kizi, R., M. Kizi and N. Yulduz. 'The image of trees in folklore: Genesis and poetic interpretations'. *International Journal of Psychosocial Rehabilitation* 24, no. 4 (2020): 6342–49.

Labrum, B. 'Not on our street: New urban spaces of interracial intimacy in 1950s and 1960s New Zealand'. *Journal of New Zealand Studies* 14 (2013): 67–86.

Lafuente, P. 'Art and the foreigner's gaze: A report on contemporary Arab representations'. *Afterall: A Journal of Art, Context and Enquiry* 15 (2007): 12–23.

Lange, D. 'Photographing the familiar'. *Aperture* 1, no. 2 (1952): 4–15.

Lisanby, S. H. 'Electroconvulsive therapy for depression'. *New England Journal of Medicine* 357, no. 19 (2007): 1939–45.

Loewenberg, I. 'Reflections on self-portraiture in photography'. *Feminist Studies* 25, no. 2 (1999): 399–408.

Loo, C., N. Katalinic, P. B. Mitchell and B. Greenberg. 'Physical treatments for bipolar disorder: A review of electroconvulsive therapy, stereotactic surgery and other brain stimulation techniques'. *Journal of Affective Disorders* 132, nos 1–2 (2011): 1–13.

Manchester, S. 'Collection: The secondary market for applied arts'. *Journal of Australian Ceramics* 52, no. 1 (2013): 116–18.

McAvoy, E. 'Basement biopsies'. *Landfall* 238 (2019): 64–72.

McCarthy, C. 'The rules of (Maori) art: Bourdieu's cultural sociology and Maori visitors in New Zealand museums'. *Journal of Sociology* 49, nos 2–3 (2013): 173–93.

McCredie, A. 'Pictures on a page: Towards a history of the photobook in New Zealand'. *Back Story Journal of New Zealand Art, Media & Design History* 5 (2018): 5–21.

McDonnell, B. '*Washday at the Pa* (1964), History of a Controversy'. *Journal of New Zealand & Pacific Studies* 1, no. 2 (2013): 131–49.

McMaster, G., J. Lum and K. McCormick. 'The entangled gaze: Indigenous and European views of each other'. *Ab-Original: Journal of Indigenous Studies and First Nations and First Peoples' Cultures* 2, no. 2 (2018): 125–40.

Mol, J. J. 'The religious affiliations of the New Zealand Maoris'. *Oceania* 35, no. 2 (1964): 136–43.

Morgan, B. 'The Theme Show: A contemporary exhibition technique'. *Aperture* 3, no. 2 (1955): 24–27.

Oettli, M. 'They say you want a revolution'. *Landfall* 231 (2016): 191–94.

Panoho, R. 'The harakeke — no place for the bellbird to sing: Western colonization of Maori art in Aotearoa'. *Cultural Studies* 9, no. 1 (1995): 11–25.

Pardington, N., and R. Leonard. 'No good going to bed with cold feet: Ans Westra's *Washday at the Pa* and the debate surrounding it'. *Photofile* (Spring 1988): 11–17.

Parsons, T. 'Evolutionary universals in society'. *American Sociological Review* 29 (1964): 339–57.

Pawson, E., and G. Scott. 'The regional consequences of economic restructuring: The West Coast, New Zealand (1984–1991)'. *Journal of Rural Studies* 8, no. 4 (1992): 373–86.

Peet, J. R. 'Comparative policy analysis: Neoliberalising New Zealand'. *New Zealand Geographer* 68, no. 3 (2012): 151–67.

Penfold, M. 'Reviewed work: *Tamariki: Our children today* by Katerina Mataira and Ans Westra'. *Journal of the Polynesian Society* 76, no. 1 (March 1967): 112.

Phillips, J. 'Māori and royal visits, 1869–2015: From Rotorua to Waitangi'. *Royal Studies Journal* 5, no. 1 (2018): 34–54.

Saker, J. 'City interview: Ans Westra'. *Wellington City Magazine* (April 1986): 20–28.

Sandeen, E. J. 'The international reception of *The Family of Man*'. *History of Photography* 29, no. 4 (2005): 344–55.

Scharf, A. 'Painting, photography, and the image of movement'. *The Burlington Magazine* 104, no. 710 (1962): 186–95.

Schwartz, V. R. 'Walter Benjamin for historians'. *American Historical Review* 106, no. 5 (December 2001): 1721–43.

Sibley, M. Q. 'Utopian thought and technology'. *American Journal of Political Science* (1973): 255–81.

Simmel, G. 'On art exhibitions'. *Theory, Culture & Society* 32, no. 1 (2015): 87–92.

Skinner, D. 'The eye of an outsider: A conversation with Ans Westra'. *Art New Zealand* 100 (Spring 2001): 94–100.

Snyder, J., and N. W. Allen. 'Photography, vision, and representation'. *Critical Inquiry* 2, no. 1 (1975): 143–69.

Stenhouse, J. '"A disappearing race before we came here": Doctor Alfred Kingcome Newman, the dying Maori and Victorian scientific racism'. *New Zealand Journal of History* 30, no. 2 (1996): 124–40.

Stephenson, S. 'Cry, the beloved country'. *North & South* (June 2013): 74–78.

Stevenson, S. 'The empire looks back: Subverting the imperial gaze'. *History of Photography* 35, no. 2 (2011): 142–56.

Stott, A. 'Dutch utopia: Paintings by antimodern American artists of the nineteenth century'. *Smithsonian Studies in American Art* 3, no. 2 (1989): 47–61.

Szarkowski, J. 'The art of photography: A contradiction in terms?'. *Newsweek*, 7 October 1968.

Thompson, C. 'Modernizing for trade: Institutionalizing design promotion in New Zealand, 1958–1967'. *Journal of Design History* 24, no. 3 (2011): 223–39.

Tuaño, P. A., and J. Cruz. 'Structural inequality in the Philippines'. *Journal of Southeast Asian Economies* 36, no. 3 (2019): 304–28.

Turner, P. 'Of love & other strangers: New Zealand photographed by Ans Westra'. *New Zealand Journal of Photography* 56 (Spring 2004): 24–27.

van der Boon, A. 'Through the lens of Ans Westra: Modern Aotearoa in the making'. Media release, *Dutch Connections*, 8 April 2023.

Van Haute, B. 'African tourist art as tradition and product of the postcolonial exotic'. *International Journal of African Renaissance Studies* 3, no. 2 (2008): 21–38.

Vestberg, N. L. 'Photography as cultural memory: Imag(in)ing France in the 1950s'. *Journal of Romance Studies* 5, no. 2 (2005): 75–91.

Walsh, D. S. 'Inter-ethnic relations in New Zealand: A recent controversy'. *Journal of the Polynesian Society* 73, no. 3 (1964): 340–42.

Walsh, D. S. 'Review'. *Journal of the Polynesian Society* 79, no. 4 (1970): 449–51.

Weatherall, B. 'Ans Westra: Concerned photographer'. In *Photographic Art & History* 3 (October 1970): 8–12.

Wells, P. 'Incandescent moment: Fiona Clark's "Go Girl"'. *Art New Zealand* 106 (Autumn 2003).

Welten, R. 'Paul Gauguin and the complexity of the primitivist gaze'. *Journal of Art Historiography* 12 (2015): 1–13.

Wheoki, J. M. 'Art's histories in Aotearoa New Zealand'. *Journal of Art Historiography* 4 (2011): 2–12.

Wilson, D. M. 'Facing the camera: Self-portraits of photographers as artists'. *Journal of Aesthetics and Art Criticism* 70, no. 1 (2012): 55–66.

Wood, A. P. 'Kees Hos: Printmaker, gallerist, teacher, war hero'. *EyeContact*, 23 December 2015.

THESES

Avery, J. 'Māori performing arts and the weaving together of local, national and international communities'. MA thesis, Te Kōkī New Zealand School of Music, Wellington, 2015.

Chan, M. A. 'Dawn and *Te Ao Hou*: Popular perspectives on assimilation and integration, 1950s–1960s'. BA (Hons) dissertation, University of Otago, Dunedin, 2008.

Harlow, A. 'Art, craft, and hip hop: A history of the Dowse 1971–2006'. MA thesis, Victoria University of Wellington, 2006.

Ivey, S. 'Focusing on the female gaze: Women as photographers and heroines'. BA thesis, Florida International University, 2019.

Kelderman, M. 'Te Whare Wānanga o Hoani Waititi Marae'. MA thesis, Unitec, Auckland, 2014.

Luoni, D. 'Museum leadership in practice: A New Zealand case study'. MA thesis, Victoria University of Wellington, 2011.

Maguire, J. 'Depicting the macabre: The lasting influence of German Expressionism on photography'. MA thesis, University of Huddersfield, 2020.

McCredie, A. 'Going public: New Zealand art museums in the 1970s'. MA thesis, Massey University, Palmerston North, 1999.

McDonald, L. 'Camera Antipode: Ans Westra: Photography as a form of ethnographic and historical writing'. PhD thesis, Massey University, Palmerston North, 2011.

McKirdy, C. B. 'Falling branches, dying roots? Bank branch closure in small towns'. BA (Hons) thesis, University of Otago, Dunedin, 2000.

Newman, A. 'The religious beliefs, rituals and values of the Ringatū Church'. MA thesis, Massey University, Palmerston North, 1986.

Palmer, G. R. 'Birth mothers: Adoption in New Zealand and the social control of women, 1881–1985'. MA thesis, University of Canterbury, Christchurch, 1991.

Simpson, M. 'Radical spaces: New Zealand's resistance bookshops, 1969–1977'. MA thesis, Victoria University of Wellington, 2007.

FILM

Amery, M. (producer). *Curators of Cuba: {Suite} Gallery with Ans Westra*. Wellington Independent Arts Trust, 2020.

Bieringa, L. *Ans Westra: Private Journeys/Public Signposts*. Television documentary, 2006.

Television New Zealand, 'Ans Westra's Full Circle exhibition returns to rural NZ'. *Marae*, 2013.

CORRESPONDENCE

Items in this section without archival references are from the family's personal collection.

Bantz, S., to E. Geiringer, 19 July 1991.

Barapatre, C., to AW, 7 January 1999.

Connew, B., L. Aberhart, A. Noble and AW to J. Zimmermann, 6 March 1992.
Connor, J., to AW, 4 July 1989, Ans Westra Archive, CA000617/2, Te Papa Archives.
Dallimore, D., to AW, 6 June 1986, Ans Westra Archive, CA000621/10, Te Papa Archives.
Duvillaret, A., to AW, 10 April 1991.
Godman, L., to AW, 30 July 1997.
Goody, K. M., to N. Anderson, 27 January 1989.
Halstead, D., to AW, 8 July 1996.
Keay, R., to D. Brasell, 2 September 1993, Ans Westra Archive, CA000617/2, Te Papa Archives.
Kinsella, A., to Dominion Secretary, Maori Women's Welfare League, 7 August 1964, John B. Turner Archive, RC2016/1, Auckland Art Gallery.
Leuthart, J., to B. Milbank, 2 November 1992.
Leuthart, L., to AW, 26 May 1993, Ans Westra Archive, CA000621/1, Te Papa Archives.
Mack, J., to AW, 30 September 1988.
McCredie, P., to AW, 9 March 1990, Ans Westra Archive, CA000621/3, Te Papa Archives.
Mellsop, G., to C. Shand, 21 December 1992.
Milbank, B., to AW, 24 April 1992.
Ministry for Culture and Heritage to AW, 4 December 1992, Ans Westra Archive, CA000621/1, Te Papa Archives.
School Publications Branch, memorandum for Miss Ans Westra, 22 December 1970.
School Publications Branch, memorandum for Miss Ans Westra, 8 June 1972.
Skinner, D., to AW, 2 October 2000.
Skinner, D., to AW, c. 20 October 2000.
Telecom Wellington to AW, 22 April 1991.
Trotter, S., to AW, 24 March 1993, Ans Westra Archive, CA000621/1, Te Papa Archives.
Volkering, M., to AW, 2 April 1982, Ans Westra Archive, CA000621/3, Te Papa Archives.
von Dadelszen, J. M., to AW, 6 May 1992.
Wagemaker, P., to AW, 16 February 1996, Ans Westra Archive, CA000617/2, Te Papa Archives.
AW to L. Aberhart, c. March 1992.
AW to J. B. Turner, 12 August 1986, John B. Turner Archive, RC2016/1, Auckland Art Gallery.
AW to J. B. Turner, 29 October 1986, John B. Turner Archive, RC2016/1, Auckland Art Gallery.
AW to E. Derks, 13 April 1992.
AW to J. M. von Dadelszen, 16 July 1992.
AW to J. Zimmermann, 31 March 1992.
AW to L. Godman, 13 July 1997.
AW to P. Harper, 8 April 1991.
AW to J. Leuthart, May 1993, Ans Westra Archive, CA000621/1, Te Papa Archives.
AW to P. McCredie, 20 March 1990, Ans Westra Archive, CA000621/3, Te Papa Archives.
AW to J. B. Turner, 18 April 1981, John B. Turner Archive, RC2016/1, Auckland Art Gallery.

AW to J. B. Turner, 9 June 1981, John B. Turner Archive, RC2016/1, Auckland Art Gallery.
Zimmermann, J., and A. Somerville-Shaw to AW, January 1992.
Zimmermann, J., to L. Aberhart, 23 March 1992.
Zimmermann, J., to AW, 27 February 1992.

EXHIBITIONS
Chronological list of individual and group exhibitions mentioned in the text.

The Active Eye: Contemporary New Zealand Photography. Manawatu Art Gallery, Palmerston North, 1975.
17 Wellington Photographers. National Art Gallery, Wellington, 1978.
A Private View — Take Two: Photographs by Ans Westra. Real Pictures Gallery, Auckland, 1980.
Collection 80. PhotoForum Gallery, Wellington, 1980.
Opening Show. Wellington City Art Gallery, 1980.
By Batons and Barbed Wire. Real Pictures Gallery, Auckland, 1981.
PhotoForum Members Show. Auckland Museum, 1983.
Early '70s. Exposures Gallery, Wellington, 1984.
Maori Portraits. Exposures Gallery, Wellington, 1984.
PhotoForum. Exposures Gallery, Wellington, 1984.
Retrospective II: Early 70s. Exposures Gallery, Wellington, 1984.
Black on White. Auckland Art Gallery, 1985.
Retrospective III: Demonstration Decade. Exposures Gallery, Wellington, 1985.
Retrospective IV: Maori Today. Exposures Gallery, Wellington, 1985.
1950s–1980s. Exposures Gallery, Wellington, 1985.
The Body in Question. Auckland Art Gallery, 1985.
Whaiora: Recent Maori Portraits. Exposures Gallery, Wellington, 1986; Chicago: Museum of Contemporary Photography, 1986; Adelaide: Contemporary Arts Centre of South Australia, 1987.
Women View Women. International Foto Ausstellung der Munich Volkshochschule, 1986.
A Week in New York. Exposures Gallery, Wellington, 1987.
People Power: 'Freedom' in the Philippines: Photographs by Ans Westra. Victoria University Library, Wellington, 1988.
Rear Vision: A History of PhotoForum Wellington to 1988. City Gallery, Wellington, 1988.
Cheap Shots. Real Pictures Gallery, Auckland, 1989.
Art and Organised Labour. Wellington City Art Gallery, 1990.
Pictures from the Big 'A'. Auckland Public Library, 1990.
Portrait of the Hutt. Dowse Art Museum, Lower Hutt, 1991.
Wanganui Seen 1960–1993. Sarjeant Gallery, Whanganui, 1995/96.
Bluff Smelter Anniversary Exhibition. Southland Art Museum, Invercargill, 1996.
Ans Westra's Landscape. Christopher Moore Gallery, Wellington, 1998.

Ans Westra: Masterprints. Christopher Moore Gallery, Wellington, 1999.

Rotorua Visits 1963–2000. Rotorua Art Museum, 2000.

Ans Westra: Behind the Curtain: Photographs of the Sex Industry. Manawatu Gallery, Palmerston North, 2000; John Leech Gallery, Auckland, 2001; City Gallery, Wellington, 2001.

Handboek: Ans Westra Photographs. National Library gallery, Wellington, 2004; Auckland Art Gallery, 2005.

Ans Westra: To the Pleasure Garden. FHE Galleries, Auckland, 2005.

Within Memory. National Library gallery, Wellington, 2006.

Toy-Land. {Suite} Gallery, Wellington, 2008; FHE Galleries, Auckland, 2008.

The Crescent Moon: The Asian Face of Islam in New Zealand. Pataka Museum of Arts and Cultures, Porirua, 2009.

PhotoForum Members' Show 2018. Studio 514, Auckland, 2018.

Toyland (Again). {Suite} Gallery, Wellington, 2019.

After Handboek: Ans Westra Photographs. Māpuna Kabinet Art Gallery, Foxton, 2022.

ANS WESTRA WORK IN *TE AO HOU*

Chronological list of work by Ans Westra featured in *Te Ao Hou: The New World*, published in Wellington by the Maori Purposes Fund Board.

Mason, B. E. G. (ed.). 'Brief notices'. *Te Ao Hou* 31 (June 1960).

Mason, B. E. G. (ed.). 'Brief notices'. *Te Ao Hou* 32 (September 1960).

'Hui topu was a great success'. *Te Ao Hou* 39 (June 1962).

'Is this man right?'. *Te Ao Hou* 39 (June 1962).

'M.M.W.L. garden party'. *Te Ao Hou* 39 (June 1962).

'Passion play at Hastings'. *Te Ao Hou* 39 (June 1962).

AW. 'Henare Gilbert comes again'. *Te Ao Hou* 39 (June 1962).

'Auckland's community centre'. *Te Ao Hou* 40 (September 1962).

'Annual celebrations at Ngaruawahia'. *Te Ao Hou* 41 (December 1962).

'Hostel luxury at freezing works'. *Te Ao Hou* 41 (December 1962).

'A Ringatu meeting at Ruatoki'. *Te Ao Hou* 42 (March 1963).

'T. W. Ratana and the Ratana Church'. *Te Ao Hou* 42 (March 1963).

'From Jerusalem'. *Te Ao Hou* 43 (June 1963).

AW. 'Para Matchitt: Painter and sculptor'. *Te Ao Hou* 45 (December 1963).

AW. 'Hone Tuwhare: Poet'. *Te Ao Hou* 48 (September 1964).

Ruha, P. J. '*Washday at the Pa*'. *Te Ao Hou* 50 (March 1965).

'Ratana pilgrimage to Te Rere a Kapuni'. *Te Ao Hou* 51 (June 1965).

'Rebecca and the Maoris'. *Te Ao Hou* 52 (September 1965).

'The sculpture of Arnold Wilson'. *Te Ao Hou* 52 (September 1965).

Ihimaera, W. '*We Live by a Lake*'. *Te Ao Hou* 75 (March 1974).

MISCELLANEOUS

A. H. & A. W. Reed Ltd. Memorandum of Agreement with Ans Westra, May 1975, family collection.

A. H. & A. W. Reed Ltd. Memorandum of Agreement with Ans Westra and Margery Elizabeth Renwick, June 1976, family collection.

Alister Taylor. Memorandum of Agreement with Anna Jacoba Westra, August 1972, family collection.

Baxter, J. K. 'The country and the people'. Draft essay, family collection, 1–6.

Heinemann Ltd. Memorandum of Agreement with Ans Westra and Noel Hilliard, 25 November 1971, family collection.

Industrieschool voor Miesjes, Rotterdam. Akte van Bekwaamheid vor Nijverheidsonderwijs Ns, 21 June 1957, translation (NZ Department of Internal Affairs, 30 October 1958), family collection.

Minutes of meeting of planning committee for New Zealand's first International Symposium of Photography held in the Department of Continuing Education, University of Canterbury, 1 March 1991, family collection.

Seja, N. and G. H. Short. 'History in the taking: 40 years of PhotoForum, Gus Fisher Gallery 6–8 June 2014'. Curation notes, 2014, family collection.

Turner, J. B. 'Ans Westra'. MS notes, c. 1987, family collection.

Turner, J. B. Diary entry, c. January 1965. In 'Good Luck John' (Wellington: 1985), 57.

AW and P. Maunder. *Te Ao Hurihuri: The Moving World — A Year in the Life of Pito-One, Calendar 1992'*. National Library, ref. Eph-C-CALENDAR-1992.

Whitcombe & Tombs Ltd. Memorandum of Agreement with Ans Westra and Noel Hilliard, 28 December 1973, family collection.

Glossary

WORDS IN TE REO MĀORI (the Māori language) appear in this book with macrons where appropriate, in accordance with current orthographic conventions. However, text quoted directly from other sources is reproduced in its original version, which may not have had macrons.

āwhina	assistant, helper
haka	to dance, perform the haka, perform
hapū	sub-tribe, kinship group
haupoi	Māori hockey
hui	meeting, gathering
iwi	tribe, nation
kapa haka	Māori cultural group, Māori performing group
kaumātua	elder, older person of status
kawa	protocols, procedures
koha	gift, offering, donation
korowai	cloak made of muka (New Zealand flax fibre)
koruru	carved face on the gable of a meeting house
kōwhaiwhai	ornamental patterns, usually in meeting house
kuia	female elder, elderly woman
mana	prestige, status, honour

Māori	New Zealand's indigenous people
marae	courtyard in front of wharenui, meeting house
mihi	speech of greeting
mihimihi	speech of greeting, tribute
moko	tattooing design
mokopuna	grandchild
moko kauae	a traditional tattoo, usually worn by women on the lips and chin
pā	settlement, village, defended site
Pākehā	non-Māori, European
papakāinga	home settlement, communal land
pepeha	an expression of ancestry, a formulaic saying
piupiu	a waistband with traditional motifs
pou/pou whenua	post, boundary-marker
pōwhiri	formal welcoming ceremony, encounter ritual
tā moko	traditional Māori tattoo
tangata whenua	people of the land, indigenous people
tangi/tangihanga	traditional Māori funeral rite
tapu	sacred, off-limits
te reo Māori	the Māori language
tiki	small carved figure in human form
tīpare	a traditionally styled headband
urupā	cemetery, burial ground
whakataukī	proverb, saying, instruction
whānau	family, extended family
whare	house, building, residence
wharekai	dining hall, refectory, café
wharenui	meeting house, large house
whenua	land

Acknowledgements

MANY PEOPLE HAVE ASSISTED in various ways with this work, and they are acknowledged in the text at relevant points. However, some deserve special mention. Heading this list of course is Ans Westra herself. Not only was she extraordinarily patient with interviewers over the decades, but she was also honest with her views, genuine and forthright in her discussions with others, and, despite the enormity of her accomplishments, she was completely free of any pretentiousness. But beyond the personal is the professional, and the country owes a collective expression of gratitude for her unparalleled contribution to the nation.

This book was very much a collaborative undertaking, and would not have come into existence without the involvement of many people. Ans' agent and close friend David Alsop worked unfailingly to locate obscure and seemingly inaccessible sources for this work, and delivered these to me by the boxload. He also suggested leads to follow up, and individuals to interview.

Ans' daughter Lisa and her sons Erik and Jacob were generous and candid, allowing us to glimpse another side of their mother. Ans' half-sister, Yvonne Westra, was similarly sincere and open, and likewise shared details that would not have been available elsewhere.

Hugo Manson's interviews with Ans for an oral history project produced material of the highest value, and this work would have been impossible in

its present form without access to that archive. John B. Turner — possibly one of the closest and certainly the longest-standing of Ans' colleagues and friends — generously opened up his vast personal archive to me, which proved invaluable. He has also been a sharp-eyed adviser on various aspects of Ans' photography, and directed me to particular archival material that greatly enhanced my understanding of her life and work.

Lawrence McDonald's magisterial doctoral thesis on aspects of Ans' life and career, 'Camera Antipode: Ans Westra', is a superb resource, and he shared a great deal of useful information with me about the context and perceptions of her work. Athol McCredie offered vital information on Ans' photographic style, and also sage advice on the person beyond the public image.

In the background, Professor Pare Keiha has been a strong supporter of this book from the outset, and in several ways was instrumental in enabling me to complete it. Several years ago Mervyn Cohen, a dear friend, gave me an original copy of *Washday at the Pa* — a copy he had personally rescued from destruction in 1964. This rekindled my longstanding interest in Ans' photography, and led to a series of events of which this book is the outcome.

Desmond Kelly shared my enthusiasm for Ans' work and provided an intimate insight into her style and the historical significance of her work. Mark Stocker has been a wonderful friend, confidant and adviser, and was always happy to discuss the project.

Nicola Legat, publisher of Massey University Press, saw enough merit in this project to publish this book, and was sympathetic to the sort of treatment I suggested. Rachel Scott and Mike Wagg added their editorial expertise to my manuscript, suggesting improvements and smoothing out some of the literary bumps. Any that remain are entirely my own responsibility.

Discussion, interviews and guidance from many individuals have been crucial. Some prefer not to be named, but among the others are Simon Woolf, Jeanne Lomax, Niyaz Martin-Wilson and Ron Trubuhovich. Then there are all those who work in the country's libraries and archives, including Jennifer Twist, archivist at the Museum of New Zealand Te Papa Tongarewa; Elwyn Sheehan, librarian at the AUT Library; Tamsyn Bayliss, gallery librarian at

the E. H. McCormick Research Library, Auckland Art Gallery; and the staff at AUT and Massey University libraries.

Without all these generous and dedicated collaborators, this book simply would not have been possible.

Paul Moon
Auckland, 2024

Index

Entries in **bold** indicate photographs

17 Wellington Photographers 171

A

A. H. & A. W. Reed 100–103, 123–24, 169–70
A view of the Murderers' Bay 70
Abel 16–19, 21
Aberhart, Laurence 236
The Active Eye 158
Advertising Standards Authority 158
Alexander Turnbull Library 186, 210–12, 254
Allen & Unwin 197
Alsop, David 88, 253–55, 267–68, 271, **272**
Ans Westra Photographs: After Handboek 268
Ans Westra: Private Journey/Public Signposts 242, 246–47
Ans Westra's Landscape 229
'Ans Westra's World' 236
Aotea Square, Auckland 193
Art New Zealand 254–55
Arts Council 184, 213
Arts Foundation Icon 234–35
Ashton-Warner, Sylvia 100
Asia New Zealand Foundation 258
Assignment No. 2 36

atheism 50–51 *see also* religions
Auckland
 Aotea Square 193
 Auckland Art Gallery 159
 Auckland Public Library 218–20
 Auckland Society of Arts 217
 Auckland University Students' Association 206
 Avondale Racecourse 178, 218
 Hoani Waititi marae 172
 Okahu Bay 106–07, **108**
 Ōrākei 178
The Australians 122
Avondale Racecourse 178

B

Baker, Mr 38
Barry Lett Galleries 137
Barton, Christina 243–44
Baxter, James K. 82, 123–24, 127–28, 142–45, **144**
Baxter, John 145
Bayly, Janet 199
Behind the Curtain 240–41, **241**
Bell, Leonard 252
Belmont School, Lower Hutt 173, **176**
Bieringa, Jan 246

Bieringa, Luit 158, 242–43, 246, 268
Black Power 190 *see also* gangs
Blank, Pius 35, 104
Blumhardt, Doreen 26
Bradley, Eymard 87–88
Brake, Brian 39
Broadley, Colin 153
Bronson, Ron 132
Brown, Gordon 158
Brown, Ingeborg 119
Buis, Simon 155
Bullshit and Jellybeans 124
Bunyan, Rhonda 260
Burgess, Malcolm 254–55
Burt, Denise 224
By Batons and Barbed Wire 183

C

Cambridge **211**
Campbell, Alistair Te Ariki 82
Carsten, Hester 35, 104
Caxton Press 78, 85
'Celebrating Life: A Hutt Documentary' 237
'Changing Times in New Zealand' 237–38
children
 'Children of Fiji' 66
 Children of Holland 119, **120**
 photographs 33, 55, 60, 62, 75, 81, 84, 88, 98, 120, 147, 149, 174, 176, 179, 211, 215, 227
Christchurch
 Mosque attacks 260
 University of Canterbury 219–20
Christmas at the Cape 225
Christopher Moore Gallery 229
cityscapes, photographs **110**, **120**, **163**, **165**, **179**, **185**, **195**
 see also specific places

Clark, Fiona 158–59
Cleveland, Les 35, 199
Cole, Janet 207–08
Collection 80 171
Commonwealth Photography Award 202
Companion of the New Zealand Order of Merit 234–35
'Concerned Photographer' 154
Connew, Bruce 236
Cook, James 58
Cooper, Whina 160, 252
Correspondence School 245
Covid protest, 2022 268–69
Covid-19 268–69
Craccum 206–08
Creative New Zealand 88
The Crescent Moon **258**, 258–61
criticism & controversy 9–10, 71–90, 128, 130, 134, 158–59, 192, 199
 see also specific works
Crown Lynn 26
Crump, Barry 91–95, 132–34, **133**, 139, 142
cultural assumptions *see* Pākehā gaze; permission to photograph; race relations

D

Dean of Dunedin 77
death *see* tangi & death
Dennis, Jonathan 246
Department of Education 58, 76, 82, 166–67
Department of Maori Affairs 29
Dominion 135
Douglas, Roger 210
Down Under the Plum Trees 134–37, **137**
Dowse Art Gallery 138
Dowse Art Museum 212–13, 225, 229–30

E

Easton, Brian 210
Evening Post 145, 232
Ex Camera 169
Exposures Gallery 198
Expressionism 45

F

Families of New Zealand 225–26, **227**
The Family of Man exhibition 21, 102, 112, 216–17, 243
Fat Freddy's Drop 247
fathers, photographs 15, **211**
feminism 197
Festival of Wellington, Arts Committee 36
Fiji 66–67
'Five Photographers' 236
Foxton 268
Freeman, Fred 34
Friedlander, Marti 131–32, 251–52
Friendly Islands 58–64
Full Circle 267

G

gangs 188–91, **189**
gaze *see also* Pākehā gaze
　　artistic 69–70
　　female 40
Geiringer, Erich 91–92, 94
Gilsemans, Isaack 70
Gisborne 172–73
A Good Keen Man 91
Goodman, Robert B. 122

H

Haarlem 116–17

Haarlem Railway Station 119, **120**
Haas, Ernst 229
Halstead, Diane 238
Handboek: Ans Westra Photographs 242–47, 251, 253
Hanly, Gil 155
Hargest, Miles 218
Hastings, passion play, 44–45, **46**
Henri Cartier-Bresson Prize 217
Hikurangi **196**
Hilliard, Kiriwai 101, 145, 265
Hilliard, Moana, Harvey & Hinemoa 145–48, **147**, **149**
Hilliard, Noel 100, 145–50, 161, 166, 265
Hinchcliff, John 210
Hipkins, Gavin 243
Hirsh, Walter 210
Hoani Waititi marae 172
Holland *see Children of Holland*; Netherlands
Hos, Kees (Cornelis) & Tine 27
hui 86, 113, 230
Hunn Report, 1961 200
Hura, Te Reo 48
Hutchins, Tom 158
Hutt Valley 212–15, **215**, 217, 229–30, 237
　　Belmont School 173, **176**
　　Dowse Art Gallery 138
　　Dowse Art Museum 212–13, 225, 229–30
　　Lower Hutt City Council 213
　　Naenae 214, **215**
　　Petone 213–14
　　Trentham A&P Show **126**, 130
　　Waiwhetu marae 72

I

Iberia 122
Ihimaera, Witi 148–50, 191–93

indecency 134–35, 159
 Indecent Publications Act 159
 Indecent Publications Tribunal 134–35
Industrieschool voor Meisjes 19
intellectual property 252–53
Inter-View Photo Agency 235–36
Irwin, John 246

J

Jansen, Adrienne 258–61
jewellery 103

K

Kaa, Sophie 150–52
Kaikohe 178
Kelly, Desmond 35, 153–54, 171, 190–91, 216
Kelly, Joseph 272
King, Greg 231
King, Michael 131–32
King Movement (Te Kīngitanga) 38
Kinsella, Arthur 77–78

L

Labour government 210
Labour Party 45
Lake Karāpiro camp 142–43
Land March, 1975 160
Landfall 104
landscapes, photographs 60, 80, 147, 151, 250, 262 *see also* specific places
Lange, David 208, 265, 266–67
Lange, Dorothea 121
Leiden 11–17, **15**, 19, 25, 27, 253
Leonard, Robert 85
Leuthart, John 224
'Life Around the Churches' 230

Listener 167, 252–53
Lomax, Jeanne 87–88
Lower Hutt *see* Hutt Valley

M

Mack, James 213
Magnum Photos 141
Manawatu Art Gallery 158, 240
Mangakino 145–46
Māori 27, 42, 52–53, 67–68, 72–90
 & art 69–70, 78
 & religion 45–48, **46**, **49**, 50, 67, 96–97, **98**, **108**, **114–15**, 175–76, **176**
 activism 76, 160, 174–75, **176**
 assimilation & social transition 37, 70, 72, 85, 105, 109–10, 113, 116, 123–24, 175, 200
 children, photographs 33, **55**, **176**, **179**
 children, photographs with family 33, **75**, **81**, **84**, **88**, **98**, **176**, **179**, **227**
 Maori 101–18, 127, 198
 Maori Affairs Department 76
 Maori Community Centre 52–53
 Maori Education Foundation 44, 54, 99
 Māori Women's Welfare League 53–54, **55**, 76–80, 86–87, 187, 232
 photographs 44, **46**, **50**, **55**, **75**, **81**, **84**, **88**, **98**, **108**, **111**, **114–15**, **117**, **176**, **189**, **195** (*see also* specific people & groups)
 te reo Māori 29, 37, 71, 172, 187, 200
 urbanisation 35, 42, 52–53, 76, 89, 107–18, 129, 160, 172, 178, 193–96, 199–200, 226
Māori Women's Welfare League **55**
Māpuna Kabinet Art Gallery 268
'March for Mana' 175, **176**
Mason, Helen 26

Massey University 234–35
Masterton 179–80
Mataira, Julian 99
Mataira, Katerina 99, 187–89, 191, 193–94, 197–98
Matchitt, Paratene 54, **56**, 56–57, 106
Matthews, Christopher 218
McCredie, Athol 183, 199, 212, 217
McCredie, Paul 218–19
McDonald, Glen 93–94
McDonald, Lawrence 197, 242–43, 251
McFarlane, Kyla 243
McNamara, T. J. 256
Mead, Margaret 89
Melser, John 73, 77
Mezzanine Gallery 139
Milburn, Jim & Barbara 166
Miller, Wayne 270
Minginui 51
Ministry for Culture and Heritage 223–24
Ministry of Foreign Affairs 205
Moko: Maori Tattooing in the Twentieth Century 131–32
Mongrel Mob **189**, 189–90 *see also* gangs
Montana-Lindauer Art Awards 217
Morrison, Robin 135, 229
mothers, photographs **15**, **75**, **84**, **88**, **96**, **151**, **215**
Mudpool Modernism 236–37
Muru, Selwyn 80
Museum for Ethnic Art, Leiden 253

N

Naenae 214, **215**
National Art Gallery 171
National Bank 57
National Geographic 58
National Library 254
National Library gallery **211**, 212, 245
National Publicity Studios 101
Netherlands 11–24, 26, 102–5, 118–22, 210, 232–33
 photographs **15**, **22**, **120**
The New Photography 217
New Vision Gallery 27
New Zealand Academy of Fine Arts 169
New Zealand Festival of the Arts, 2007 251–52
New Zealand Herald 256
New Zealand Listener 167, 252–53
New Zealand Maori Council 80
New Zealand On Air 246
New Zealand Photography 140, 154
New Zealand Polynesian Festival 178
New Zealand Students' Art Council 206
The New Zealanders 122
Newnham, Tom 183
Ngā Tau e Waru, Te Oreore marae 179–81
Nga Tau Ki Muri: Our Future 261–67, **262**
Ngāruawāhia 38–39, 41–42, 73, **114**, **117**, 249
Ngata, Apirana 109
Ngāti Pōneke 71–72, 172, 175
Ngāti Whakaue 31
Ngāti Whātua 178, **179**
Noble, Anne 236
Norman, Russel 264
Northland 177–78
 Hikurangi **196**
 Kaikohe 178
 Waimamaku **211**
 Waitangi 42–43, **44**, 160, 178, 196
Notes on the Country I Live In 123–30, **126**, 132, **133**, 134, 143
nuclear power 208–09

O

Oettli, Max 155, **156**
Okahu Bay 106–07, **108**
Opening Show 171
Ōrākei 178
Orbell, Margaret 31, 47, 116
O'Regan, Tipene 80
Otago Polytechnic 238

P

Pacific Islands 58–68
Page, Stuart 218
Pākehā gaze & cultural assumptions 9, 30, 37, 51, 57, 67, 69–70, 76–80, 85, 101–02, 104–05 *see also* permission to photograph; race relations
Palmerston North, Manawatu Art Gallery 158
Parapara **250**
Pardington, Neil 85, 242
Parekowhai, Cushla 243
Parikino School **108**, 109–10
Pascoe, John 35, 199
passion play, Hastings 44–45, **46**
Pat Unger 199
'Peaceful Islands' 208–10, 232, 264–65, 267
Peasant Woman Digging Up Potatoes 197
Penfold, Merimeri 99–100
Penguin Books 210
People Power: 'Freedom' in the Philippines 206, **207**
Percy Thomson Gallery 260
permission to photograph 38, 47, 51, 80, 88, 160, 191–93, 197, 203, 214, 223, 230–31, 249, 255 *see also* permission to photograph; race relations
Petone 213–14, 217–18

Philippines 205–8, **207**
PhotoForum 154–57, 161, 170, 199, 219, 226–28
 PhotoForum Gallery 171
 Photo-Forum magazine 154–55
 PhotoForum Wellington 212
Photographic Art & History 153–54
Photography 36
PhotoPrize Amsterdam 103
Pictures from the Big 'A' 218
Pictures of Everyday Life 202, **204**
Pipiriki 230–31
Pipitea marae 172
Pohio, Manu 175
Polyphoto 36
Portrait of the Hutt 212–15, **215**, 217
Powell, Lesley 104
Press 78, 130
Preston, Gaylene 246
Price, Hugh & Beverley 166
Price Milburn 166
Private View — Take Two: Photographs by Ans Westra 171
Putiki marae, Whanganui 115

Q

Queen Elizabeth II 42–43
Queen Elizabeth II Arts Council 123, 158
Queen's Birthday Honours 234

R

race relations 160, 174–75, **176**, 199 *see also* Pākehā gaze; permission to photograph
Rātahi, Puhi 47
Rātana, Tahupōtiki Wiremu & Rātana church 45–48, **49**, 96–97, **98**

Real Pictures Gallery 171
Rebecca and the Maoris 101–02
Reeds 100–103, 123–24, 169–70
Rehua 198
religions 44–50, 64, 67, 106–7, **144**, 230
 see also atheism
 Rātana 45–48, **49**, 96–97, **98**
 Ringatū Church 48, 50
Rembrandt's 36
Retrospective exhibitions 198
'Riemke' 119, **120**
Riethmaier, Gregory 101–02
Ringatū Church 48, 50, 67
Ritchie, James 100–118, 188
Robert McDougall Art Gallery 138, 159
Rotorua 31
 Rotorua Museum of Art and History 236–37, 242
 Rotorua Visits 1963–2000 242
 St Faith's Church 31
Royal, Tūroa 167
Rūātoki 48, 50
Ruatōria 73, 172–73
Ruha, P. J. 95

S

Sage, Ruiha 79–80
St Faith's Church, Rotorua 31
St Joseph's Catholic Church, Whanganui River 143, **144**
Salmon, John 34
Sarah of the Valley 225
Sarjeant Gallery 228–29
School Journal 58–59, 66, 73
School Publications 58–59, 68, 71, 73, 77, 82, 225
Schoon, Theo 35, 104
Schwimmer, Erik 30–31

Secretary for Justice 135
sex industry 240–41, **241**
Shadbolt, Tim 124, 127–28
Shaw, Peter 255–56
Sieben, Hubert 139
The Silent Land 35
Skinner, Damian 243
Smith, Ernest 159
Smythe, Kelvin 225
Springbok Tour & South Africa 175–77, 180, 181–84, **185**, 196, 253, 254
Steichen, Edward 21
Suffrage Centennial Year Trust 223–24
Suite Tirohanga Limited 254
Suite Gallery 83, 253–55, 261–64
Sutch, W. B. (Bill) 36

T

Taj Mahal, Cambridge Terrace 155
Tamariki: Our Children Today 99–100
tangi & death 45, 51, 113, **115**, 116, 150, 263
Taputeranga marae 193
Taylor, Alister 123–27, 131, 134–35
Te Ao Hou: The New World 29–57, **33**, 68, 95–99, 265
 photographs **33**, **46**, **98**
Te Kaha **115**
Te Kanawa, Kiri 252–53
Te Kīngitanga (the King Movement) 38
Te Kooti, Arikirangi Te Tūruki 50
Te Motopaika (*The Motorbike*) 187
Te Oreore marae, Ngā Tau e Waru 179–81
Te Papaiouru, Rotorua 31
Te Rere a Kāpuni 96–97, **98**
Te Roopu o te Matakite 160
Te Runa whānau 73, 75, 78, 83, 87–88 *see also Washday at the Pa*
Te wehenga o Rangi rāua ko Papa 56–57, 106

Television New Zealand 246
Tenga of Waikuta 225–26, 227
'The Plastic Society' 238
Three Photographers 187
'To Be a Child' 270
To the Pleasure Garden 247–49, **249**, **250**
Tonga 58–64
The Tour 183, **185**
Toy-Land (Toyland) 255–57, **257**
Treaty of Waitangi Act 160
Trentham A&P Show **126**, 130
Tūrangawaewae marae 38, **114**, **117**
Tūrangi **195**
Turi: The Story of a Little Boy 104
Turnbull Pictures 243
Turner, John B. 32, 153–54, 157–58, 181, 209, 242–43
 as critic 125, 198
Tūwhare, Hone 145, 244–45, 264–65, **266**

U

UNICEF 205
United-Sarjeant Art Award 217
University of Canterbury 219–20
Urewera 50, 51

V

van der Keuken, Johan 23, 42
van Dorn, Hendrika *see* Westra, Hendrika
van Gogh, Vincent 197
van Hulst, John 136–37, 139–42, **151**, 157, 222
van Hulst, Lisa & Jacob 139–41, **151**, 167, 173–74, **174**
Viliami & *Viliami of the Friendly Islands* 58–65, 59–65, **60**, **62**, 71, 73–74, 77

W

Waikato Art Gallery 138
Waimamaku **211**
Wairoa 111, 112
Waitangi 42–43, **44**, 160, 178, 196
Waiwhetu marae 72
Walker, Geoff 210
Walters, Gordon 116
Wanganui Seen 228
Waring, Marilyn 210
Washday at the Pa 64, 71–91, **75**, **81**, **84**, 107, 139, 145, 150, 153, 192, 249
 criticism 8, 76–85, 87, 91, 95–96, 100, 102, 135, 187, 192
 photographs **75**, **81**, **84**, **88**
 revised 83, *88*, **88**–89, 90, 233–34, 254
We Live by a Lake 145–50, **147**, **149**
Weatherall, Bruce 153–54, 157
Wellington 110, **111**, 112, 155, 181–82, 193, **204**
 Festival of Wellington 36
 nursing home 203
 Pipitea marae 172
 Taj Mahal 155
 Taputeranga marae 193
 Wellington Camera Club 32–35
 Wellington: City Alive 161–66, **163**, **165**
 Wellington City Art Gallery 171, 199
 Wellington Hospital 220–23
 Wellington International Film Festival, 2006 246
 'Wellington Streets' 36
Westra, Ans (Anna Jacoba) 15, 22, 25, 96, **151**, **156**, **272**
 archives 186, 218, 243, 254–55
 awards & prizes 36, 202, 205, 217, 234–35
 books (*see* specific books & bibliography)

cameras 23, 36, 141, 154, 215–16, 229
education 17, 19–23
exhibitions (see specific exhibitions
 & bibliography)
health 220–23, 267, 271–73
as a mother 96, 100, 150, 152, 167–68,
 170 (see also her children)
move to NZ 24–28
Netherlands 11–24, 26, 102–5, 118–22,
 210, 232, 233, 253
photography style 8–9, 32, 38–41,
 43–44, 63, 65–66, 129, 154, 167–68,
 173–74, 179–83, 197, 201–05, 214, 216
residencies 212–13, 225, 228–32,
 238–39
travel (see specific countries)
Westra, Arvid 18
Westra, Erik John **96**, 197, 221
 & Barry Crump 91–95, 132–34, 142
 growing up **96**, 102–3, 118–19, 122,
 138–40, 167, 170
Westra, Hans 11–12
Westra, Hendrika 12–19, **15**, 24–25, 36, 50,
 100–03, 119, 221
Westra, Jackie 24–25
Westra, Jacob 37
Westra, Jetta 16, 18, 23
Westra, Pieter 11–14, **15**, 16–18, 23–27, 95,
 221, 232–33
Westra, Robert 24–25
Westra, Yvonne 24–26, 223, 272
Whaiora: The Pursuit of Life 187–89,
 191–97, **195**, **196**, 200
Whanganui 115, 194, **195**, 228–32
 Putiki marae **115**
 St Joseph's Catholic Church,
 Whanganui River 143, **144**
 Wanganui Seen 228
Whitcoulls 161

Wij Zijn 17 (*We Are 17*) 23
Wilson, Arnold, & pou 97–99, **98**
Within Memory **211**, 212
Witness to Change 199–200, 243
Woolf, Ronald 34, 159
World War II 13–16
Worship 229–30

Z

Zimmermann, Jenner 236

First published in 2024 by Massey University Press
Private Bag 102904, North Shore Mail Centre
Auckland 0745, New Zealand
www.masseypress.ac.nz

Text copyright © Paul Moon, 2024
Images copyright © Ans Westra Estate, 2024,
except for page 33 copyright © Māori Purposes Fund Board and
page 258 copyright © Asia New Zealand Foundation
Page 265: 'Friend' by Hone Tūwhare, reproduced with permission

Design by Floor van Lierop, thisisthem.com
Cover design by Dick and Jane
Cover photograph by Adrienne Martyn

The moral right of the author has been asserted

All rights reserved. Except as provided by the Copyright Act 1994,
no part of this book may be reproduced, stored in or introduced
into a retrieval system or transmitted in any form or by any means
(electronic, mechanical, photocopying, recording or otherwise)
without the prior written permission of both the copyright owner(s)
and the publisher.

A catalogue record for this book is available from the
National Library of New Zealand

Printed and bound in China by 1010 Printing Asia

ISBN: 978-1-99-101677-5
eISBN: 978-1-99-101655-3

The assistance of Creative New Zealand and {Suite} is gratefully
acknowledged by the publisher